D0914831

POST- TO NEO-

OTHER BOOKS BY CALVIN TOMKINS

POST- TO NEO-

THE ART WORLD OF THE 1980s

CALVIN TOMKINS

HENRY HOLT AND COMPANY
NEW YORK

Library of Congress Cataloging in Publication Data
Tomkins, Calvin, 1925–
Post- to Neo-
1. Art, American. 2. Art, Modern—20th century—
United States. 3. Art and society—United States.
4. United States—Social life and customs—1971–
I. Title
N6512.T64 1988 701'.03'0973 88-4481
ISBN 0-8050-0663-X

Most of the contents of this book originally appeared
in *The New Yorker* in somewhat different form.

First Edition

Designed by Katy Riegel
Printed in the United States of America
1 3 5 7 9 10 8 6 4 2

ISBN 0-8050-0663-X

To William Shawn

CONTENTS

POST- TO NEO-

INTRODUCTION

Some years ago, when Harold Rosenberg was writing "The Art World" column for *The New Yorker*, he gave me a useful piece of advice. I had gone to his ground-floor apartment in Greenwich Village to ask him about certain art-world events and personalities of the nineteen-fifties, and as I was leaving he said, in his penetrating voice, "Remember, the art world is a comedy!" Rereading some of Rosenberg's *New Yorker* essays a few months later, after the shock of his sudden death, I was surprised to find (it had not struck me on first reading) how funny he could be. His scorn for so much of the new art of that period (the nineteen-seventies) was witty rather than bad tempered, and when he skewered an artist or a trend, he did so in high rhetorical style. There was never any doubt, though, about Rosenberg's critical stance. He believed that the work of the first-generation Abstract Expressionists—Willem de Kooning, Franz Kline, Jackson Pollock, Barnett Newman, Mark Rothko, Ad Reinhardt, Clyfford Still, and a few others—constituted one of the major achievements of modern art, and he was convinced that nothing that had been done since Abstract Expressionism's decline could compare to it in quality or importance. For Rosenberg and the handful of *engagés* who had been present at the birth of the first advanced, indigenous New York School of painters in the late forties, the art world of the seventies—and this applied to art and artists as well as to dealers, new-rich collectors, and all the assorted types who battened on to the ever-expanding and ever-more-fashionable milieu of advanced art—was by contrast a joke, a farce, a comedy.

There is more than one sort of comedy, though, and to me Rosenberg's remark had wider implications. I had entered the art world through a side door, so to speak. In the late fifties I worked for *Newsweek*, writing stories on a variety of subjects in the "back of the book"—that is, stories that were not about national, international, or economic affairs. *Newsweek* had no regular writer on the visual arts in those days. It had a researcher who kept track of art-world events, and from time to time, when some such event seemed to require coverage, a writer would be pulled from some other section to cover it. I had been pulled once or twice, and some time in 1958 I was asked to go and interview Marcel Duchamp. Robert Lebel's book on him had just come out in English, and Duchamp, to the surprise of some people, including me, was living right here in New York, a naturalized American citizen since 1955. The interview, which took place over lunch in the King Cole Room of the St. Regis Hotel, was a revelation. I had never met anyone as interesting as Duchamp, although it would have been virtually impossible for me to say why he interested me so much. (One of my *Newsweek* colleagues, after reading my piece in galleys, observed that he had never read an interview in which so little got said.) When I asked Duchamp how he spent his time now that he had given up making art, he said he was just "a breather." "I am one of the lazies," he told me. "I don't see why one should have to work, do you?" He *was* working, as we know now, and he would continue to work in secret right up to the year of his death, 1968, on the astonishing trompe l'oeil peep show called *Étant Donnés: 1. la chute d'eau; 2. le gaz d'éclairage* ("Given: 1. the waterfall; 2. the illuminating gas"), which today is permanently installed in the Philadelphia Museum of Art, and which sums up and also undermines, in typically Duchampian fashion, the major themes of his early career.

Some of the Abstract Expressionists considered Duchamp an enemy—an unassailable enemy, because he had supposedly withdrawn from the arena. Duchamp had subverted the whole tradition of high art with his "readymades"—common manufactured objects such as hat racks or snow shovels promoted to the status of works of art by the mere fact that they had been chosen and signed by the artist. Duchamp's iconoclasm, his scathing wit, his disdain for the notion of artistic genius, his famous decision (misinterpreted, as it turned out) to stop making art—all this was rather annoying and off-putting, and it was no accident that the period of Abstract Expressionism's worldwide triumph coincided

with the virtual eclipse of Duchamp's reputation. But then, rather suddenly, the ground shifted. Jasper Johns' *Target with Four Faces* appeared on the cover of the January, 1958, issue of *ARTnews*, the magazine that had become, under Thomas B. Hess, the Abstract Expressionists' strongest champion. Johns and his close friend Robert Rauschenberg were leading the way out of Abstract Expressionism. Although their paintings had the spontaneous brushwork and dripped paint of de Kooning's or Kline's, their sensibility was very different; they wanted to get beyond the expression of subjective states of mind. In their attempt to make art that encompassed and reflected the real world, both had come to feel a strong affinity to the work and the ideas of Duchamp and of John Cage, the composer, whose thinking was powerfully influenced by Duchamp. Johns and Rauschenberg, in turn, would exert a decisive influence on the next generation of American artists, the Pop Art generation of Roy Lichtenstein, Claes Oldenburg, James Rosenquist, and Andy Warhol.

This is really where I came in. In 1960 I joined *The New Yorker* as a writer of profiles and other "long fact" pieces, as they were called at the magazine. The subject of my first profile was Jean Tinguely, the Swiss kinetic sculptor whose giant mechanical monster, called *Homage to New York*, had made a hilarious show of destroying itself in the garden of the Museum of Modern Art that spring. Tinguely had asked Rauschenberg and other young New York artists to participate in the spectacle, and Rauschenberg had complied by making a "money thrower," which showered coins on the suicidal machine. The Tinguely profile led naturally enough to my doing one on Rauschenberg, and that one led to profiles of Cage, Merce Cunningham, and eventually Duchamp himself. I responded to all these artists with uncritical delight. No question about it, I was on their side. The energy, the wit, the zest, and the irreverence with which they pursued their goal of an art beyond self-expression struck me as absolutely right—right for them and right for the times, those euphoric years before JFK was shot and before Vietnam.

Pop Art was not the only sixties innovation, of course. Color-field painting, which came out of the work of Helen Frankenthaler and which was related to the non-"gestural" wing of Abstract Expressionism, emerged at about the same time as Pop, with which it would eventually be seen to have a lot in common. Minimal art and Conceptual art had become firmly established before the decade was out; as cohesive move-

ments they actually proved to have more staying power than Pop, especially in the art schools. All three tendencies found greater favor with the critics, many of whom simply dismissed Rauschenberg, Cage, and the Pop artists at first, taking the line that they were not serious. But their refusal to take themselves too seriously was what I liked best about these artists. The comedy, I thought, was high comedy, and just as valid as existential anguish. The message that came from Rauschenberg and Cage was that life, everyday life, was not only more important but more interesting than art, and that the open, experimental, nonstructured way of making art could be a guide to a freer and more human life for the rest of us. "It has never bothered me a bit when people say that what I am doing is not art," Rauschenberg told me. "I don't think of myself as making art. I do what I do because I want to, because painting is the best way I've found to get along with myself."

Well, so much for euphoria. The ground shifted again, as it always does. The chaotic energy of the early sixties gave way to the tedium and disillusionment of the seventies, when contemporary art became very serious indeed. The difference lay to some degree in the new young artists' approach to their work. This was the first college-trained generation of American artists. Most of them had been through one or another of the schools that awarded undergraduate or graduate degrees in fine art (the growth of university art departments was a phenomenon of American postwar education), and many of them seemed to look upon the practice of art as a perfectly viable profession, in which it was not unreasonable to expect a decent financial return. The rapid expansion of the art market—more and more galleries, more collectors, escalating prices, and the social rewards that went with being a recognized artist—attracted bright young men who might never have thought of becoming artists if they had been born ten years earlier. It also attracted bright young women in unprecedented numbers. The emergence of Susan Rothenberg, Jennifer Bartlett, Nancy Graves, Elizabeth Murray, Lois Lane, Alice Aycock, Lynda Benglis, Mary Miss, Nancy Holt, and others in this decade seemed to put women on virtually an equal footing with men in the struggle for recognition, a phenomenon not repeated in the generation that followed.

A dry, academic smog pressed down on the art scene nevertheless. Although there was no longer a dominant style, a great many of the college-trained young artists had been spoon-fed large doses of Minimal and Conceptual art in school, and they tended afterward to think in

terms of an art reduced to its basic essentials of shape, line, and color (Minimal), or else an art in which ideas took precedence over physical artifacts (Conceptual). Both tendencies came right out of Duchamp, who had been rediscovered in the late sixties by earnest ideologues who carried Duchampian ideas to their logical (and therefore non-Duchampian) conclusion. There were significant exceptions to this kind of work in the seventies. Body art, process art, performance art, environmental or earth art (whose practitioners built or dug or relocated vast quantities of soil or stone in areas so remote that few people ever got to see them except in photographs)—all the manifold attempts by artists of this period to work outside the gallery system, which they found increasingly commercialized and corrupting—helped to keep alive the treasured notion of an avant-garde. But the newly art-conscious stockbrokers accepted these rebels as smoothly as they had accepted the Pop artists. The avant-garde had become the mainstream, which was the same as saying that it had ceased to exist.

In 1980, I began writing "The Art World" column for *The New Yorker*. The column had not appeared in the magazine since 1978, when Rosenberg died, and one of the things people said about my pieces, which appeared approximately once a month, was that they certainly were different from Rosenberg's. When I had talked with William Shawn, the editor, about reviving the column, we had agreed that I was a reporter, not a critic, and that essentially I would be reporting on the New York art scene as it continued to expand and exfoliate. I can't say that this program was strictly adhered to; critical comments seem to have inveigled their way into the text from time to time, but the impure mixture that evolved over the next eight years was, I think, a fair reflection of the "pluralistic" art world of the nineteen-eighties, which turned out to be a much livelier period in contemporary art than the nineteen-seventies.

Painting, which it had become fashionable to declare over and done with, came back into favor as the preferred medium for young artists, many of whom seemed to be in full rebellion against the austerities of Minimalism and Conceptualism. The frankly ornamental style called pattern painting (or pattern-and-decoration) gained wide visibility when Holly Solomon started showing it in 1980 in her SoHo gallery. It was soon eclipsed, however, by the huge international success of Neo-Expressionism, which peaked more or less simultaneously in Germany, Italy, and the United States. Whatever else it accomplished, Neo-

Expressionism gave the art market a terrific shot in the arm. Collectors who had stopped buying contemporary work because they were bored with Minimalism and Conceptualism fell all over themselves in their haste to buy the large-scale, figurative, deliberately crude, but highly ambitious paintings of Julian Schnabel, David Salle, Robert Longo, Eric Fischl, and their European counterparts. The excitement that greeted the new work was fanned by aggressive marketing and promotion on the part of their young dealers. Schnabel's paintings on broken plates, which were priced at two thousand dollars apiece in his first show, had jumped to forty thousand apiece by his third, which did not keep the artist from leaving his dealer, Mary Boone, to join the bluer-chip Pace Gallery on Fifty-seventh Street. New collectors and new money flooded the market; there was a ton of new money around, as a result of the post-1982 boom on Wall Street, and contemporary art struck any number of corporate raiders and junk-bond barons as the place to put it.

Dozens of art dealers found that they could sell anything in the eighties—even graffiti art, whose practitioners were delighted to graduate from spray-painting subway cars to attending their own openings in East Village galleries. Dozens of large corporations began building corporate collections of the very latest art, following the trail blazed by the Chase Manhattan Bank and a few others in the sixties and seventies. At the top level of the market, important works by Jasper Johns, Frank Stella, and other acknowledged contemporary masters sold at auction for prices comparable to those of the major Impressionists and Post-Impressionists—Johns' *Out the Window* brought $3,630,000 at Sotheby in 1986. Every city in America was either building a new museum or enlarging an old one, it seemed, and most of the new museum premises concentrated, *faute de mieux*, on contemporary art.

The whole frenetic scene was overshadowed, however, by a fairly large question mark. Was contemporary art in the eighties really any good? Did all this high-profile, extremely lucrative activity have anything to do with aesthetic quality, or did it reflect mainly the native American penchant for hype, faddism, and general-purpose humbug? The question was rarely asked out loud. It tended to emerge, though, in the argument that dominated critical discourse in the eighties—the argument over postmodernism. If the modern movement in the arts was now over, as so many trend-spotters said it was, then how should we define what had replaced it, and what sort of standards could be applied to the new whatever-it-was?

Clement Greenberg, the finest and most influential art critic of our time, addressed this question as early as 1979, in a lecture entitled "Modern and Post-Modern." Setting out the terms of the argument with his customary clarity, Greenberg defined modernism as the rigorous struggle to maintain aesthetic quality on the level of great art of the past, in the face of a powerful counter-pressure brought about by "the relative democratization of culture under industrialism." The " 'postmodern' business," Greenberg concluded, was simply a retreat from modernism's lofty standards—"a way, above all, to justify oneself in preferring less demanding art without being called reactionary or retarded." According to Greenberg this retreat had started a long time ago. "The yearning for relaxation became outspoken in presumably avant-garde circles for the first time with Duchamp and Dada, and then in certain aspects of Surrealism. But it was with Pop art that it became a fully confident expression. . . . What I notice is that the succession of these trends has involved, from the first, a retreat from major to minor in quality . . . the hailing of the minor as major, or else the claim that the difference between the two isn't important."

Quite a few writers on art have echoed Greenberg's harsh judgment in recent years. They range from Hilton Kramer, who regularly discerns a sinister conspiracy on the part of certain museum directors, art dealers, and other malign forces to drag down aesthetic standards, to John Russell, whose intelligent generosity of spirit toward new art has not kept him from asking whether "there is not in the very notion of postmodernism an element of that vindictive philistinism that now permeates so many departments of our national life." Basically it is the same argument that used to be levelled against Rauschenberg and Cage in the early sixties, before postmodernism was invented: Art is serious, these people are not. I respect the argument. I can even agree with it some of the time, just as I can admire the integrity with which certain American artists (Jasper Johns, Frank Stella, Isamu Noguchi, Willem de Kooning) have pursued and still pursue the ideal of aesthetic quality on the highest level. Some of the more recent developments in art here strike me as frivolous indeed, and almost certain to vanish in the cloud of their own pretentiousness. I can find almost nothing to see in, or to say about, the current fad of "appropriation," whose point seems to be that if you copy another artist's work exactly, and call the result your own, you are making a statement about originality. Most artists use or build on previous art, of course, but hardly in the appropriationist mode

of direct copying; I would have thought, moreover, that Duchamp's readymades—appropriations of factory-made objects—still functioned quite effectively as the last word on aesthetic originality.

A vast amount of inventive energy still enlivens the current art scene, however, and one development in particular, the new art of public spaces, suggests to me that there could be, after all, a postmodern aesthetic that is not just a downhill slide. The artists (sculptors, mainly) who were commissioned to make large works for public places in the nineteen-seventies have been displaced in the eighties (in my mind, at least) by a new group of men and women who are not really interested in making specific *works* at all. Robert Irwin, Nancy Holt, Richard Fleischner, Mary Miss, Siah Armajani, Scott Burton, and a growing number of others across the country have committed themselves to working in collaboration with architects, city planners, urban designers, landscape architects, municipal authorities, and neighborhood citizen groups on the over-all design of parks, playgrounds, esplanades, gardens, bridges, traffic islands, and other public areas. They bring the artist's open-ended, experimental approach to bear on all aspects of a specific project, not excluding the functional aspects of how an area will be used, and by whom. Burton and Armajani have said that to work successfully in the public area, an artist must be willing to change his entire approach—must to a certain extent relinquish his ego, and all the notions of autonomous genius that go with it. The concept certainly hints at a new role for the artist in modern society, and as several of the essays that follow indicate, I believe that the results of some pioneer collaborations in new public art projects are the most exciting developments on the current scene.

Although modern art always seemed to be about the future, "the whole enterprise of modernism," as Greenberg put it, "can be seen as backward-looking." High modernist art was for the happy few, those who could still respond to aesthetic quality in an art that "no longer needs to be justified in other terms than its own." The mass public took up modern art and embraced it, though, "appropriated" it, as the mass public appropriates everything that the happy few once claimed as their private domain, and in the process, inevitably, the standards were lowered. We can see this process at work throughout the culture, and nowhere more visibly than in our museums, where so many docile consumers line up to see the masterworks of twenty centuries in block-

buster loan shows that any sort of direct encounter with aesthetic quality is cancelled out. The mass public for art is a fact of life, however; we are not going to restrict museum access to those who can demonstrate the appropriate response to works of art. That being the case, it seems significant to me that some artists here are feeling their way toward an art that is populist in spirit, rather than aristocratic. A public art whose purpose is not to produce unique and costly objects for the elite, but rather to enhance and enliven the daily experience of people who may not even be aware that they are in contact with art at all—this seems worthwhile, and it does not require any lowering of aesthetic standards. What it does require is the recognition that daily life is a matter of some importance (maybe even the highest importance), and that daily life, at least a good deal of the time, is a comedy. As John Cage said years ago, "In general I prefer laughter to tears."

—Calvin Tomkins
February, 1988

Note: *The essays are presented here in the chronological order of their writing, with one or two exceptions. For occasional redundancies and overlappings I beg the reader's indulgence. What follows is a highly personal and selective chronicle of events and observations, circa 1980–1988.*

C.T.

A GOOD EYE
AND A GOOD EAR

Early in his career, the painter Robert Rauschenberg made a statement that became famous. "Painting relates to both art and life," he said. "Neither can be made. (I try to act in the gap between the two.)" Like many often quoted statements, this one was Delphic enough to suggest

varying interpretations, and many a seminar on contemporary art has bogged down in Rauschenberg's gap. It could be argued, however, that the area between art and life is not so much the artist's province as it is the art dealer's, and that this circumstance may help to explain the low esteem in which the majority of dealers have always been held. Marcel Duchamp once referred to dealers as "lice on the backs of the artists"—useful and necessary lice, he added, but lice all the same. Similar sentiments are frequently expressed by contemporary artists; although most of them concede that they could not exist without the services of a dealer, the process by which their heroic studio labors are transmuted, at least temporarily, into marketable objects is not something that artists like to dwell on, particularly if the objects do not sell— or do not sell at prices commensurate with the artists' expectations.

Art objects have been selling at stratospheric prices in recent years (after a shaky period during the middle seventies), and art dealers are regularly chastised for encouraging this trend and thereby corrupting the cultural fabric of society. Curiously, one of the few dealers about whom this is rarely said is Leo Castelli, who happens to be the most influential purveyor of contemporary art in the world today. The Castelli Gallery, founded in 1957, represents a roster of international art stars that includes Rauschenberg, Jasper Johns, Frank Stella, Roy Lichtenstein, Claes Oldenburg, James Rosenquist, Robert Morris, Ellsworth Kelly, Kenneth Noland, Cy Twombly, Dan Flavin, Bruce Nauman, Richard Serra, and Andy Warhol—artists who dominate not only the contemporary art market but also the kind of art being produced today in many countries. For Castelli, however, commercial success never seems to be the main concern. "Leo has always maintained the essential attitude that an art object is a feeling object, related to the person who made it and to the person who owns it," a museum director said the other day. "The artist always comes before the money."

Castelli's reputation as the *grand seigneur* of an often dubious profession is of fairly recent origin. In the past, he was sometimes portrayed as an immensely shrewd manipulator of prices and reputations, a suave supersalesman who could sell anything, and who, in fact, by a combination of questionable business tactics and slick public relations, managed to kill off Abstract Expressionism and to put over first Rauschenberg, Johns, and Stella, then Pop, Minimal, Conceptual, and Video Art, in that abominable order. Castelli was invariably hurt by such portrayals, but he was in some part responsible for the misconceptions. He loves

to talk, in any of the five languages he handles fluently, and if a reporter asked him, for example, about the charge that he had killed the second-generation Abstract Expressionists, he might say (as he did some years back to a *Times* writer), "But they were dead already. I just helped remove the bodies." Small of stature, impeccably dressed, combining a Venetian politeness with the kind of enthusiasm that tends to verbal excess, Castelli often managed to seem too *rara* an *avis* for his own good. "Leo is successful, and elegant, and European," Rauschenberg once observed, "and that's bound to give rise to bad-mouthing. In the U.S.A., anybody who's all that *must* be a crook."

Ivan Karp, who was the gallery's manager from 1959 to 1969, has always scoffed at the notion of Castelli the supersalesman. "There's no salesmanship involved, on any level," he said recently. "People who know Leo feel comfortable with him, with his mixture of European charm and American ease, but he has absolutely no selling techniques or devices and no real business acumen. The two of us couldn't even add up a column of figures. Once, we had to do that for a client who wanted to pay on the spot—very rare situation—and we ended up cheating ourselves out of several thousand dollars. The gallery was under financial stress much of the ten years I was there. I was always trying to cut down expenses, to reduce the drain of Leo's reckless generosity and his European patrician attitude—if Leo wanted to move a bench in the gallery, he'd hire an architect. I'll tell you the final formula for Leo: He wants to be loved by everybody. He wants affection and dedication and love from everyone, and he may sometimes sacrifice his goals and principles to achieve that."

Although the gallery grossed three and a half million dollars last year, Castelli put most of the money right back into various gallery or gallery-related activities, the primary beneficiaries of which are his artists. Many artists in the gallery get a monthly stipend, which is applied against sales of their work. Frequently, sales result in a surplus, which is paid to the artist periodically; sometimes there is a deficit in an artist's account, and in the case of at least one artist the deficit has risen on occasion to more than two hundred thousand dollars. "Until fairly recently, it was really a giant shoestring operation," according to Nancy Friedberg, who has been Castelli's bookkeeper for the last sixteen years. "Often, I've gone home at night wondering how we're going to pay next month's bills. But luckily something always seems to turn up."

Castelli himself lives on a far from penurious scale. The fact remains,

however, that his scale of living is a good deal less lavish than that of several of his major artists, and that he never really gets away from the gallery and its demands. "I know of nobody who is less oriented toward the purely financial aspects of art dealing," William Rubin, the director of painting and sculpture at the Museum of Modern Art, said not long ago. "Leo is always ready to sacrifice his own interests to those of his artists. In general, there has been a tendency on the part of certain people to demean art dealers, but the history of modern art would have been very different if it hadn't been for the work of some enlightened ones. I think Leo's played that role. I think he's in the tradition of men like Ambroise Vollard, who have been devoted and committed to the artists they handled, to helping their art find its rightful place. To me, he is a model art dealer."

It is sometimes said that Rauschenberg and Johns, who were among the first artists to join the Castelli Gallery, and who are considered two of the most influential artists alive, had a large part in charting the directions that the gallery has followed. "Bob and Jasper never actually advised me," Castelli said reflectively one day. "But it's really very complex, how you come to certain decisions. It's true that Bob and Jasper, and very sensitive people like David Whitney and Richard Bellamy, who seem to function as barometers, do influence my judgment. You have to have a good eye but also a good ear. Sometimes that's said scathingly, but there is no other way if you want to make a good choice. You hear things, feel vibrations, gauge reactions. In the beginning, you're unconscious of what you're doing—you just pick artists. Then you come to the point where you pick trends. In the beginning, it was Bob and Jasper. They seemed to have recognizable elements out of the past, out of Dada, out of Abstract Expressionism. Then Frank Stella— I felt in an obscure way that his geometric abstraction was related to Jasper. Then come the Pop Artists—back to Dada again. A whole group that emerges suddenly, all influenced by Jasper's first show—they all admit it; the spirit of his work and Rauschenberg's permitted them to do what they did. Then back to the simplicities of color and form with the Minimal movement. You spot movements emerging and you try to pick the best practitioners. And also your judgments are based to some extent on your feelings about the personality of the artist. If there is no substance to the personality, there is probably no substance to the work."

Listening carefully to the artists you represent is by no means unusual in the gallery business. The late Peggy Guggenheim, whose Art of This Century Gallery provided the springboard for the Abstract Expressionist takeoff in the nineteen-forties, depended very largely on the advice of Marcel Duchamp, Max Ernst (to whom she was married briefly), and Frederick Kiesler, while Betty Parsons, who took on several of the leading Abstract Expressionists when Miss Guggenheim closed up shop and went to live in Venice, was guided by her friend Barnett Newman. Listening to artists is probably the best way to find new artists, in spite of the dangers involved. Castelli, however, has done more than listen. He has supported his artists to a degree that most dealers would consider suicidal—has supported some of them for years, even when they were not only not selling but not producing works of art. His faith in artists has been the hallmark of the gallery, and it has been repaid in various ways. Artists tend to change galleries as restlessly as writers change publishers, but with one or two exceptions no major artist who has joined Castelli has left him, and several artists have been with him since he started.

"It's not that he's skimmed off the cream," Jasper Johns once said of Castelli. "I think one of the interesting things about Leo's activity is that he has behaved in such a way as to suggest that he's able to spot certain ideas on his own. He's not just making relationships between things as presented. At any rate, I'm very grateful that I haven't had to work with any other dealer."

Salvatore Scarpitta, an American-born artist, has been with Castelli nearly as long as Johns. Scarpitta made shaped canvases before anyone else did. In the years between 1965 and 1970, he also made prototypes of classic American dirt-track racing cars (they had to be assembled in the gallery, because they would not fit through the door). Hardly any-body bought them, or paid them much attention, but Castelli kept on paying Scarpitta's monthly stipend. During the run of a 1974 exhibition of canvases and cars Scarpitta was having in Turin, he found a way to express his gratitude. A young Italian wanted one of the works in the show and offered his automobile in exchange for it. The automobile happened to be a 4.9-litre Maserati Mexico, the most powerful Maserati made. Scarpitta, who loves cars, says he "knew at once that it belonged to Leo." He accepted the offer and set out in the car, with a friend, for the South of France, where Castelli and his wife were spending the

summer. He crossed the Alps twice, just to have the fun of making the turns a second time. "The customs officials at the border questioned me hard," Scarpitta said not long ago. "Mentally, I had divorced myself from that car, so that I looked extraneous to it, and they must have thought it couldn't be mine. And when I delivered it to Leo, I had the satisfaction of knowing that it was the only time one of his artists had given something back that was worthy of him. In that car, Leo looked as though he were sitting in his gallery! I flew back to Turin tourist class, and I've never felt so rich in my life."

For someone who performs so admirably in his profession, Castelli got a surprisingly late start. He was almost fifty when he opened his gallery, in 1957, and his life up to that point had been pleasant, indolent, and directionless. His present wife, Toiny, has expressed regret that she did not know him in the days before all his energy was channelled into running the gallery. "I married Leo too late," she said once. "I missed all the fun."

He grew up in Trieste, a thoroughly international city, which until it was ceded to Italy, in 1919, served as the chief seaport of the disintegrating Austro-Hungarian Empire. Children of the educated classes there learned to speak German in school, for commercial and cultural reasons, but at home everyone spoke Italian. The Castellis—Leo's mother's side of the family—had lived in Trieste for generations; his father, whose name was Ernest Krauss, had come there from his native Hungary as a young man, and after the annexation by Italy he changed his name to Krauss-Castelli. (In time, the family dropped the Krauss name entirely.) He rose through the ranks in a branch of the leading Austrian bank, which subsequently became an independent Italian bank. He became its chief executive. Leo had a sister, Silvia, who was a year and a half older than he was, and a brother, Giorgio, who was four years younger. The family lived in a comfortable villa, with a garden, on the Via Michelangelo.

During the First World War, they moved to Vienna, where Leo's father worked for the home office of his bank and the children attended Austrian schools. When the family returned to Trieste after the war, the father joined the Banca Commerciale Triestina, the leading Italian bank there, and became very successful. He moved his family into a larger villa, with a bigger garden, and life, as Castelli remembers it,

"became very pleasant, with lots of pretty girls, and tennis, and swimming, and things like that." Castelli's interests at the time were mainly literary and sportive. He neglected his schoolwork to read current novels in English, French, and German, and he spent as much time as possible climbing in the Dolomites (rock climbing, with ropes and pitons) and skiing in the Alps. Four years at the University of Milan provided him with a law degree, but he felt no pressing urge to practice. His father arranged a job for him with a large insurance company, but insurance did not fire his enthusiasm, either. After a year with the firm, he told his father that he would like to quit and study comparative literature, with a view to teaching it. "My father was a kind man, and he said he would let me do that, but first he would like to send me abroad," Castelli recalls. "There was a branch of the same insurance company in Bucharest, so I was transplanted there in the spring of 1932. I was as bored as ever with the insurance business, but the social situation was very lively."

Among the ornaments of Bucharest society was a girl named Eve Schapira, whose father happened to be one of Rumania's leading industrial magnates. Castelli fell somewhat in love with Eve, but a few months later he fell considerably more in love with Eve's younger sister, Ileana, who had been visiting Paris with her mother. Ileana was beautiful and intelligent and spoiled. She was seventeen when they met, but she still had a French governess, whom she was forever scheming to elude. Castelli married her the following autumn. Mihail Schapira, Ileana's father, set them up in a comfortable apartment, and Castelli devoted less time than ever to his job. He and Ileana did a lot of travelling—to Paris for the shopping, to Saint Moritz for the skiing—and they scoured the local countryside for antiques, especially early Meissen pitchers and mugs, which they were collecting. Castelli's fellow-employees were disconcerted when Ileana came by the office in their chauffeur-driven Chrysler to pick Leo up for lunch, so she took to parking around the corner. In 1934, he quit the insurance job and went to work for a bank; its director was a close friend of Schapira and of his father. That job lasted a year or so—until, through considerable string-pulling, he got a position with the Paris branch of the Banca d'Italia.

The Castellis had a fine time in Paris. They made a lot of friends, among them a young French architect and interior designer named René Drouin, who was married to an old school friend of Ileana's from

Bucharest. Drouin did over the Castellis' apartment, in Neuilly, and they continued to see a lot of him afterward. One day in 1938, Drouin proposed to Castelli that they open a gallery together, in the former quarters of the Knoedler Gallery, on the Place Vendôme, between the Hotel Ritz and Schiaparelli's. It was an elegant space, with marble columns, a grand staircase, and walls covered in faded velvet. Castelli's father-in-law, who wanted him to find an occupation that engaged his interest, looked with favor on the idea—enough to put up the money to rent and redecorate the gallery—and Castelli and Drouin threw themselves into the project full time. Their idea then was to show modern furniture designed by Drouin, antique furniture altered to suit modern tastes (Renaissance tables bleached white, Louis XVI chairs covered in contemporary fabrics), furniture designed by contemporary artists, and objets d'art.

Neither of them knew very much about contemporary art. Castelli had taken a three-year art-history course in high school, and he had read one book on contemporary art, Clive Bell's *Since Cézanne*, dealing with Post-Impressionism, but in 1939 he knew far less about painting and sculpture than Ileana, who had spent many hours of her childhood wandering through museums while her mother and her older sister were doing the shops of one city or another. In Paris, though, Castelli had run across the painter Leonor Fini, whom he had known as a child in Trieste. Mlle. Fini was a member of the Paris Surrealist group, and when Castelli and Drouin let it be known that they were opening a gallery, they became of interest to Max Ernst, Pavel Tchelitchew, Salvador Dali, Meret Oppenheim, and other friends of hers. The first exhibition, before the formal opening, at what Castelli and Drouin had named the Galerie René Drouin was devoted to a single new painting by Tchelitchew, called *Phenomena*; it hung in the downstairs room, illuminated by candlelight. The Surrealists more or less took over the opening exhibition at the Galerie René Drouin in the late spring of 1939. Drouin's Art Deco furniture was overshadowed by such fantastic objects as a Fini armoire with doors in the shape of swan-women, Eugène Berman's armoire representing picturesque ruins, and Meret Oppenheim's mirror surrounded by flowing golden hair sculptured in wood. Dali planned to contribute a chair that breathed, but he failed to do so. There were also paintings and sculptures by other initiates of the waning Surrealist movement. *Le tout Paris* showed up for the

opening, and Castelli and Drouin found themselves the height of chic. They closed the gallery for the summer, went on vacation, and that was that; the war broke out in early September.

The Castellis were not unduly alarmed. The family, which now included a three-year-old daughter, Nina, went south to stay with Ileana's father, in his large house in Cannes, pending further developments. They stayed there until the fall of France, and then, a year later, with much difficulty, they made their way to Casablanca, where they spent an anxious few months trying to get visas for the United States. In spite of everything, they managed to have a good time in Morocco, sight-seeing in Marrakesh and continuing to live comfortably on money provided by Schapira, who had already made his way to New York. His money enabled them finally to procure visas, and after a rather harrowing trip by train to Tangier, by boat across the strait to Algeciras, and by train again across Spain to the northern seaport of Vigo, they boarded an ancient vessel, the *Marques Comillas*, and crossed to Cuba and then to New York, arriving in March of 1941, with many trunks, much hand baggage, a long-haired dachshund, and Nina's English nanny.

Schapira was well established in New York by then. He installed them in an apartment on upper Fifth Avenue, and in the fall of 1942 he reinstalled them on the fourth floor of a town house he had bought and done over into apartments for himself and his family, at 4 East Seventy-seventh Street. The Castellis furnished their apartment with Victorian antiques and bought a Packard for trips to the Adirondacks and eastern Long Island. Feeling somewhat at loose ends, Castelli registered at Columbia University as a graduate student in economic history; once again he was thinking of becoming a teacher. He continued his studies until late in 1943, when he joined the Army and was sent to Fort Bragg for basic training in the Field Artillery. After basic training, the captain of his company had him sent to the Intelligence branch, and for several months he was trained at Camp Ritchie, Maryland, for operations behind enemy lines in France. By the time his training was completed, in the late summer of 1944, France was in Allied hands again and his mission was obsolete. He stayed on at Camp Ritchie to become an instructor, and then was asked if he would be willing to go on assignment overseas, to an undisclosed destination, and he said he would. The destination turned out to be Bucharest, and there he spent

the next fifteen months as an interpreter for the Allied Control Commission.

Although Castelli had not received a commission, which had been promised him when he was training for Intelligence work in France (he rose no higher than technical sergeant), he naturally managed to have an agreeable time in Bucharest. He lived in the best hotel and dined splendidly, and, because it was soon apparent that the Russians were going to run things their way and the Allied Control Commission was nothing more than an observation post, his time was more or less his own. He made contact with his sister, Silvia, who had married a Hungarian banker and had spent the war years in Budapest. (Silvia now lives, with her husband, in Riverdale. Giorgio, their younger brother, came to the United States in 1939, changed his name to George E. Crane, and became a research psychiatrist; he was for some years the clinical director of a mental hospital in Jamestown, North Dakota, and is now retired.) From Silvia, Castelli learned that their parents had both died during the war, in Budapest—their mother of multiple sclerosis and their father from a foot infection that went untreated. Castelli had had no word from them since 1941, and the news hit him hard. "Leo admired his father tremendously," Ileana once said. "He had a high position, and he wanted to be fair to everybody, kind to everybody, well liked by everybody, and in a way he achieved that—some kind of ideal behavior. Leo had two models, his father and Castiglione's Courtier. He himself always wants to be good, kind, just, considerate, and loved, and, of course, that's impossible. He wants to be fair to everyone, so he ends up being unjust to some. Leo has enemies for the same reason he has friends."

On furlough in Paris in 1945, Castelli looked up René Drouin. To his surprise, he found him still operating the gallery on the Place Vendôme, where he had assembled an impressive group of modern artists. It was a straight painting-and-sculpture gallery now—no more furniture—and the stable included Kandinsky, Dubuffet, Wols, de Staël, Mondrian, and Antoine Pevsner. Nobody was buying anything then, though, and the future looked highly uncertain. Castelli went back to Bucharest, where he was offered a commission after all and a career in Army Intelligence. He considered the offer and rejected it. He had decided to continue working with Drouin, but not in Paris and not on a formal basis. Having become an American citizen as a result of his

military service, he decided to set himself up as Drouin's representative in New York.

For a few months after he got out of the Army, Castelli tried halfheartedly to complete his graduate studies at Columbia. But his real education was just beginning, and his university was the Museum of Modern Art, where Alfred Barr's exhibitions and catalogues opened up for him a world that he had barely glimpsed before. "I really discovered modern art there," he said recently. "Modern *European* art. Nowhere else in the world was there such a well-structured view of art in this century. The French put the focus on their own art, especially Cubism, but they hardly bothered about Surrealism or German Expressionism or anything else." Dorothy Miller, who was then the curator of painting and sculpture at the Modern, first saw Castelli in 1946, when he came to the museum bringing a gift—a newly published limited edition of a French book on Dubuffet, and two drawings by Salvador Dali. "I just wanted to show my gratitude to that institution, which to me seemed miraculous," Castelli explains.

Dali, Yves Tanguy, André Masson, André Breton, Max Ernst, Matta, and several other members of the Surrealist group had spent the war years in America, and most of them were still here when Castelli got back. Their center was Peggy Guggenheim's Art of This Century Gallery, on West Fifty-seventh Street, and Castelli began spending a lot of time there. The key figure in his art education at this point was the Chilean painter Matta (Roberto Matta Echaurren), a volatile, brilliant, intensely energetic artist, who was younger than the Paris Surrealists and served as a link between them and the American artists who would later become known as Abstract Expressionists. "Matta for me was the prototype of the intelligent, dynamic artist," Castelli recalls. "He was a great catalyst for ideas and developments of all kinds." Matta's emotional life was decidedly expressionistic. When his pregnant wife produced twins, he left her immediately—the responsibility was too daunting—and took up with and later married a girl named Patricia O'Connell. Matta also became involved with Arshile Gorky's wife, Agnes. For Gorky, whose most productive period had been brutally truncated by cancer and by a severe automobile accident that left him crippled, this was too much to bear; when Agnes left him, in the summer of 1948, he hanged himself. Matta left for Europe soon afterward. Most of the European artists had gone back by that time. Their presence in

New York had helped to encourage and focus the energies of the van-
guard Americans, however, and, from 1949 on, the real international
center of modern art was New York.

The gallery situation in the middle forties was not propitious for
American art. Edith Halpert showed some of the leading prewar figures
(Ben Shahn, Reginald Marsh, Yasuo Kuniyoshi) at her Downtown
Gallery, on East Fifty-first Street, but the major galleries, such as Curt
Valentin and Karl Nierendorf and Valentine Dudensing, handled mostly
European artists, and the market was Europe-oriented. This situation
began to change in 1946 and 1947, when Betty Parsons and Sam Kootz
and Charles Egan opened galleries and started showing the New York
School of Abstract Expressionists, many of whom had been cast adrift
by the closing of the Art of This Century Gallery. The violently hostile
reactions of most critics and gallerygoers to the work of Jackson Pollock,
Willem de Kooning, Franz Kline, Mark Rothko, and the others did
not encourage sales, and if their pictures were bought at all, they went
for prices that now seem ridiculous—around a thousand dollars for a
major Pollock. The artists had developed a truculent, damn-the-bour-
geois confidence in their work, however, and there were a few outsiders,
such as the Castellis, who believed in them and became their friends.
Castelli was an early member of the Club, a loose association that met
in a loft on East Eighth Street, with artists, poets, sympathetic critics,
such as Clement Greenberg and Harold Rosenberg, and guest speakers
gathering for lectures and freewheeling discussions, which usually ended
up at the Cedar Tavern, around the corner on University Place. The
mental and emotional climate of these gatherings was somewhat chau-
vinistic, according to Ileana. "People were very defensive," she recalls.
"We were not much interested in new European painting, but we found
American painting fascinating. I myself felt very disillusioned with Eu-
rope then; I never wanted to see it again. John B. Myers, who ran the
Tibor de Nagy Gallery, once called Leo 'Coq au Vin,' which hurt us—
we both felt so strongly attracted to this country, and we were very
much involved with the art scene."

The artists were not quite sure where the Castellis' interests lay.
Castelli seemed to be primarily a collector, but his means were obviously
limited; it was Ileana who occasionally bought a picture. Castelli was
earning his living then in the knit-goods business. Mihail Schapira, in
yet another attempt to help his son-in-law make good, had bought him

an interest in a knit-goods-manufacturing firm that was an offshoot of a larger textile business owned by Schapira himself and a Rumanian colleague. Castelli was irregularly in his office, but the salary paid for food and rent. He was also doing some private dealing in European pictures. Now and then, René Drouin would send over a canvas by Kandinsky—unstretched and rolled up, in the care of an airline pilot he knew, to avoid the shipping charges—and Castelli would sell it to the Baroness Hilla Rebay for her good friend Simon Guggenheim (Peggy's uncle), who kept his collection in a huge apartment at the Plaza. (Later, the collection went to the Guggenheim Museum.) Castelli had also established a relationship with the Nierendorf Gallery, which handled Klee, Kandinsky, and other European masters. In 1947, Kandinsky's widow, in Paris, consigned a large number of early Kandinsky paintings to Nierendorf, and he died soon after receiving them. The gallery's director, afraid that the paintings would be tied up indefinitely in Nierendorf's estate, wired Mrs. Kandinsky for advice. She wired back, "Give them to Castelli," which the director did, and so for a while Castelli had two sources of Kandinskys—early ones from Nierendorf and later ones from Drouin. His only real customer was the Baroness Rebay, and the prices were not spectacular; the costliest, which would be worth half a million dollars today, went for four thousand. Drouin, who was always on the verge of bankruptcy, kept wiring Castelli to send him money to keep the gallery open, so Castelli's meagre profits usually disappeared before they could be reinvested.

Castelli went to France in 1949 to sell his father-in-law's house in Cannes, and while he was there he terminated the business connection with Drouin. Since the gallery had been financed by Schapira in the first place, Drouin gave Castelli a few important works as his share of the partnership—a Léger still-life, three very good Dubuffets, a small Kandinsky, and a metal sculpture by Pevsner. These, in addition to two important Klees and a Mondrian that he had bought from Nierendorf, became the basis for much of Castelli's future activity as an independent dealer.

Castelli was becoming increasingly involved, personally and professionally, with the Abstract Expressionist painters. He and Ileana gave lively parties in their apartment and in a house they had bought in East Hampton, which was where many of the New York artists spent the summer. (The artists lived in the woods on the bay side; the Castellis

lived on Jericho Lane, near the beach.) For two summers, Willem and
Elaine de Kooning lived with them in the East Hampton house. The
Abstract Expressionists were becoming known outside the tiny art world.
In August of 1949, *Life* ran a three-page article on Pollock under the
heading "JACKSON POLLOCK—Is He the Greatest Living Painter in the
United States?" Still, nobody was making any real money. Several of
the New York artists kept urging Castelli to open a gallery. Sam Kootz
offered his space on Fifty-seventh Street to Castelli in 1948, when he
decided to give it up, but Castelli declined. He did not feel confident
enough to open a gallery, he said. He also had a lingering European-
patrician distaste for the idea of being "in trade," and, besides, Mihail
Schapira had reservations about the idea: he had lost a good part of his
fortune in moving to America, and he felt that the art business was
risky and insubstantial. At any rate, the former Kootz space was taken
over by Sidney Janis.

Janis, too, had been in the clothing business—shirt manufacturing.
He and his wife had begun collecting modern art in 1926, and in 1938
he retired from the shirt business and spent the next ten years writing
books about art. He brought to the gallery field a scholarly acumen that
embraced the whole development of modern painting and sculpture,
and his exhibitions of Mondrian, Léger, Picasso, and other European
giants quickly established his gallery as a powerful new force. Castelli
and Janis had known one another since the mid-nineteen-forties, and
in 1948, when Janis opened his gallery, they began to do some business
together. Castelli collaborated on a group show of young French and
American painters at the Janis Gallery in the fall of 1950. In the hanging,
Janis and Castelli paired the French and American painters according
to similarity of style or image: Dubuffet with de Kooning, Soulages with
Kline, de Staël with Rothko, Lanskoy with Pollock, Matta with Gorky
(who presumably turned in his grave), among others. A few years later,
Ileana Castelli bought some pictures from Janis—mainly by Pollock,
who had left Betty Parsons in 1951 and had subsequently joined Janis—
and occasionally Castelli would ask Janis to sell one of his European
pictures. From time to time, Janis and Castelli bought a picture jointly
and split the proceeds of the resale. They used to lunch together often
in those days, and as Janis took on more and more of the Abstract
Expressionists—Kline and Rothko in 1953, Motherwell in 1954—in-
siders speculated that Castelli had become the brains of the Janis Gal-

lery. Castelli is quick to deny this. "Janis knew Pollock and de Kooning before I did," he has said. "Perhaps he was a little more hesitant about them than I was, but he did not take them merely on my advice. Janis was really a product of the Museum of Modern Art. In accuracy, precision, and selection, his shows were in the same class as MOMA's. I had the benefit of Alfred Barr's teaching at one remove, through Janis. People sometimes criticize him today and say he has no original ideas, but this is not true at all. What he did was of enormous importance. He really taught me that a gallery should be run like a museum—he had that kind of rigor. I learned infinitely more from him than he did from me."

An important event in the rise of Abstract Expressionism was the Ninth Street Show, in the late spring of 1951. Many of the artists then lived in Greenwich Village and showed in the small coöperative galleries on or near Tenth Street. When Conrad Marca-Relli, an Abstract Expressionist painter, discovered that a building on Ninth Street near University Place was about to be demolished, he and several other artists got the idea of putting on a big group show there. The plan quickly gained adherents, Castelli among them. "I was the one who appeared to be the richest, so I put up the money to buy some white paint and to get the announcements printed," Castelli recalls. "I spent all in all something like two hundred or three hundred dollars." The show turned out to be mostly an exhibition of Abstract Expressionist work, the largest and most comprehensive ever seen up until then. Sixty-one artists were represented, and it came as a shock to some observers to see how completely the slashing, loose-elbow style of de Kooning and Pollock, which Harold Rosenberg subsequently called Action painting, had taken over the younger generation. The opening was a sort of fiesta, with a great banner stretching across Ninth Street, and with huge crowds of approving or disapproving viewers. Afterward, when Castelli brought Alfred Barr by the Cedar Tavern to discuss the show and then to the Eighth Street Club, where many of the artists had gathered to celebrate, he and Barr were greeted by a round of spontaneous applause.

More than ever after the Ninth Street Show, the artists wondered why Castelli didn't do something. His keen interest in the new painting was obvious. He had sold his share in the knit-goods business that year and was using the money to buy work by de Kooning and others. He spent all his time going around to galleries and studios, talking to artists,

investigating each new development. And yet for several years he hesitated to commit himself. Ileana remembers a summer evening on the beach at East Hampton. "Bill de Kooning was upset, and he attacked Leo for not opening a gallery. I said, 'I think that Leo will open a gallery, and that you won't be one of his artists.' Bill wanted to know why not. I said I thought Leo would be more interested in becoming involved with what was coming up, not with what had already bloomed. Leo was always adventurous—always something of a gambler. Anyway, those were prophetic words."

Schapira and his wife, Marianne, were divorced by this time. Marianne had been in London in 1940, visiting their daughter Eve, and she was not able to get to New York until 1944. For a while, she lived with her husband on the fifth floor of 4 East Seventy-seventh Street; Eve, who was a war widow, lived on the third floor, below the Castellis. Mrs. Schapira later married John Graham, an artist who had once been a cavalry officer in Czarist Russia, and who, before renouncing modern art entirely, in the late fifties, had been a powerful influence on Gorky and de Kooning. Graham and Ileana's mother lived mostly in Southampton, where they had bought a house, but they kept a basement apartment at 4 East Seventy-seventh Street as a pied-à-terre. The Castellis found Graham charming, witty, literate, and eccentric. "He painted very little then," Castelli recalls. "He was interested mainly in collecting antiques and objets d'art, and in studies of magic. He thought of himself as the reincarnation of Cagliostro." When Ileana's mother died, in 1955, Graham stayed on for a couple of years in the basement apartment. He became friendly with Schapira; they used to get together to talk about Marianne, who had been very beautiful and very much loved by both of them. Eventually, Graham went to London, where he died, in 1961.

Castelli never joined forces with Janis on a formal basis, because Janis wanted to keep his gallery in the family. (His two sons have since assumed active roles there.) By 1955, Castelli had finally started to think about opening his own gallery. He went to Paris that year, saw Drouin, and looked at a few pictures by younger European artists; his idea was that he would concentrate on recent work in both Europe and America, putting on exhibitions more or less along the lines of the 1950 show he had done with Janis. Even so, two more years passed before he opened his gallery, and for a while it hardly seemed like a gallery. It

was, in fact, the living room of the Castellis' apartment, on the fourth floor of 4 East Seventy-seventh. Their daughter, Nina, was away at Radcliffe, so the Castellis made her room their office and used a closet for storage space. There was no sign outside. Visitors had to know where they were going, and they had to squeeze into a tiny, unpredictable elevator to get to the fourth floor. The opening exhibition, in February of 1957, was a group show of well-known Europeans and Americans: de Kooning, Delaunay, Dubuffet, Giacometti, Hartley, Léger, Mondrian, Picabia, Pollock, David Smith, and van Doesburg. "At first, I just showed things we'd been surrounded by," Castelli has said. "Some were borrowed, but most of them were things we owned." They started out in the quietest possible way, by selling from their own collection.

True to Ileana's prophecy, none of the leading Abstract Expressionists joined Castelli's new gallery. By 1957, they were all well established elsewhere—most of them with Sidney Janis, whose astute tactics had launched the rapid rise in their prices. Placing Pollock and de Kooning in the same gallery that showed such Europeans as Mondrian and Léger overcame a lot of buyer resistance to the Americans, but it was also true that Pollock's death, in a 1956 automobile accident, had a leavening effect on prices—his own and others as well. While Castelli did not have the leaders, he nevertheless started out with a few second-generation American abstractionists—Paul Brach, Norman Bluhm, Jon Schueler—and with a couple of young European artists, Viseux (French) and Horia Damian (Rumanian), who were not destined to electrify the art world. Indeed, until the gallery's end-of-season group show that May there were no indications that Castelli was going to break new ground at all. The closing show of "New Work" included two unfamiliar and highly disturbing pictures, however; one was by Robert Rauschenberg, the other by Jasper Johns.

Rauschenberg, who came from Texas by way of the United States Navy, Paris, and Black Mountain College, in North Carolina, was already the enfant terrible of the New York art world. He was interested in pushing the great twentieth-century aesthetic question "What is art?" beyond the limits that most people considered sensible, and in the mid-fifties he had had three one-man shows—at the Betty Parsons, the Stable, and the Egan Galleries—that had aroused the most vitriolic sort of antagonism. Rauschenberg had painted a series of all-white canvases on which no images impinged but the shadows of whatever

moved in front of them. He had made black paintings on torn newsprint, and red paintings that incorporated as collage elements mirrors, umbrellas, comic strips, reproductions of Old Masters, bits of cloth, and flashing light bulbs. He had even done a *Dirt Painting* with growing grass. For Castelli, Rauschenberg's 1954 red show at the Egan Gallery was what he describes as "an epiphany—an astonishing event that at the time did not seem to me to be related to anything else." He adds, "But in spite of my enthusiasm I did not buy a piece—to my great shame." Castelli was somewhat uncertain about asking Rauschenberg to join his gallery. As Rauschenberg remembers it, people kept telling him that he was going with Castelli, but neither Castelli nor Ileana had said anything about it to him. Like many other young artists, Rauschenberg wanted very much to join the new venture. Castelli, he felt, was someone who "was clearly going to do the incredible."

Castelli's second epiphany came in the spring of 1957, when he went with Ilse Getz, an artist who had worked for the Bertha Schaefer Gallery and whom he had hired as his assistant, to an exhibition of new talent put together with the help of the art historian Meyer Schapiro at the Jewish Museum, on upper Fifth Avenue. Rauschenberg had four paintings in the show, Alfred Leslie five, and Joan Mitchell two; several of the second-generation Abstract Expressionists were also represented. Castelli knew the work of all of them well. Ilse Getz remembers Castelli stopping suddenly in front of a green painting that looked something like an archery target. It was painted in encaustic, an unusual technique using a heated-wax base. "Leo was just riveted," she recalls. "He said, 'This is a fantastic painting.' I didn't know if he was out of his mind or serious, because, frankly, I saw nothing in it."

"To me, it was a totally unfamiliar painting," Castelli explains. "I saw it then as a green painting with collage elements, an over-all green picture. I looked at the name under it, Jasper Johns, which also made a great impression on me; it seemed like such an improbable name in connection with that painting. Anyway, I went home with that name going around in my head." Ileana was at home with the flu that day. She remembers that Castelli came in and sat on the bed and talked for quite a while about the green painting.

Two days later, the Castellis and Ilse Getz went to Rauschenberg's studio, on Pearl Street, at the edge of the financial district. They had known Rauschenberg for some time; the purpose of the evening was to

come to a decision about his work. Ileana and Ilse Getz were enthusiastic about the work and also about the artist. "The first time I saw Bob was at that Ninth Street Show, in 1951," Ileana recalls. "Here was this young man, so handsome, laughing, and happy—quite a contrast to some of the others. I thought his work was absolutely eccentric, but what I don't understand I usually like. Well, we went to Bob's that night—it was a rainy Sunday—and there were lots of beautiful paintings. And then Bob said he was going downstairs to Jasper Johns' loft to get ice for drinks—it turned out that Jasper lived in the studio on the floor beneath, and that they had only one refrigerator between them."

Castelli could hardly contain his excitement. He asked to meet Johns, and Rauschenberg obligingly brought him upstairs, and from that moment it was obvious to everyone that Castelli was not concentrating on Rauschenberg's pictures. He couldn't wait to go downstairs and see Johns' work, and they did so a few minutes later. Ileana was surprised to find what looked like a one-man exhibition in his studio. "Many, many marvellous paintings—paintings of targets, of flags, of numbers, all very strange and very beautiful. We were overwhelmed."

Castelli told Johns that he was excited by his work and wanted to show it. Johns, in his taciturn way, said that that would be fine. They went back upstairs and finished their drinks, and not until several days later did they realize how crushing the experience had been for Rauschenberg. He came to the gallery when Castelli was out, and talked to Ileana, telling her that he had to know whether or not they planned to give him a show, because if they didn't he would go to another gallery. Ileana gave him a firm date for a show the following March.

Jasper Johns' first one-man show at Castelli's, in January of 1958, hit the art world like a meteor. Even before the opening, his *Target with Four Faces* had appeared on the cover of *ARTnews*, with a note about the artist and a one-paragraph review of the show inside. Thomas B. Hess, the executive editor of *ARTnews*, had come into Castelli's one day and asked if he could borrow the picture—an encaustic painting with four wooden boxes nailed to the top of the stretcher, in each of which appeared a plaster cast of that portion of a man's face from the eyes to the chin—and Castelli, a great admirer of Hess's critical writings on Abstract Expressionism, had said he could. Hess had taken it away in a taxi and put it on the cover of the January issue, and the reper-

cussions were felt from Milan to Tokyo. The message was that Abstract Expressionism's hegemony was broken.

Alfred Barr came to the gallery on opening day and stayed for three hours. He called Dorothy Miller and had her come, too, to help him select work for the museum—not one painting but four, as it turned out. Barr wanted very much to buy the *Target with Plaster Casts*, a large encaustic-on-canvas surmounted by nine wooden boxes, in each of which was placed a cast of some part of the human body, including a green-painted penis. Barr wondered whether it would be all right to keep the doors to some of the boxes closed (each box had a door, or lid, that could be opened or closed), and Castelli said the question could be answered only by the artist, who was in the back room. Johns appeared, was questioned by Barr, and replied that it would be all right to have some of the doors closed some of the time but not all the time, whereupon Barr regretfully decided he would have to choose another. He chose, and presented to the trustees, the *Target with Four Faces*, and he also chose the *Green Target*, which Castelli had seen at the Jewish Museum; a painting called *White Numbers*; and a painting of the American flag. But Barr felt the flag painting might be misunderstood as unpatriotic (the taint of McCarthyism was still in the air), so Philip Johnson, the architect, offered to buy it for future donation. Johnson became so fond of the picture that he didn't want to give it up, however, and it was not until 1973 that he gave the *Flag* to the museum, in honor of Barr.

Several trustees of the museum also bought works from the Johns show, and so did Donald Peters, Mrs. Henry Epstein, Ben Heller, and other important collectors. A Dutch dealer named Jan Streep wanted to buy out the entire exhibition; when Castelli told him that that was impossible, he angrily refused to buy anything. Only two pictures remained unsold at the end of the show—a large *White Flag* and the *Target with Plaster Casts*. Johns decided to keep the *Flag*, and Castelli bought the *Target*; the price was twelve hundred dollars, and in the euphoria of the moment Castelli waived his commission and paid the artist the entire amount. If he wanted to sell the work today—he does not—it would probably bring, he estimates, well over half a million dollars. *

Rauschenberg's first show, two months later, was, by contrast, a *succès*

*That was in 1980. In 1987, an early Johns painting brought $3,600,000 at auction.

de scandale. Johns' talent has always been austere and elegant, disturbing yet beautifully controlled; Rauschenberg's is impulsive, risky, on the verge of chaos. The tension between chaos and order is one source of his great strength as an artist, but his work has always been "difficult," and the 1958 show at Castelli's, which included *Odalisk*, a freestanding construction with a stuffed rooster on top, and *Bed*, a quilt and pillow painted over in gaudy colors, was about as difficult as they come. Some people thought that *Bed* represented the scene of an axe murder. Almost everyone was offended by the show, and only two works were sold. A Baltimore woman bought, for two hundred dollars, a small *Collage with Red*. The other sale was to Castelli, who bought *Bed*. The Museum of Modern Art bought nothing. The following year, however, Dorothy Miller included both Rauschenberg and Johns in one of the museum's famous group shows, called "Sixteen Americans." Rauschenberg's official recognition dates from that show, but there were very few sales of his work for the next two years.

Every cent the Castellis made went back into the gallery. Constance Trimble, who answered an ad in the *Times* and came to work for them in November of 1957 (Ilse Getz was leaving, to go to Paris), had the impression at first that her new employers were trying to lose money; to her they seemed like rich people playing at a game they loved. The gallery floors were waxed twice a week, and the walls were repainted for every show. Castelli wanted Mrs. Trimble to organize the files along museum lines: photographs of every work shown there were to be made available to anyone who wanted to see them, together with reviews and other pertinent materials. Although the methods were professional, the atmosphere remained very much that of a private apartment. A few months after the gallery opened, the Castellis moved from the back bedroom at 4 East Seventy-seventh Street to a small apartment in the neighborhood, but the gallery was their real home. Visitors were greeted by the furious barking of Ileana's long-haired dachshund, Piccina, who remained underfoot at all times. There was a long sofa, usually occupied by artists or friends. Frederick Kiesler, the diminutive Viennese architect and sculptor, was nearly always there in the early days, and so was Michael Sonnabend, an American who had spent many years in Paris; Sonnabend had met Ileana during the war, at Columbia, where she was studying psychology and he was studying Dante, and he had become a friend of the family.

Castelli concedes that his aesthetic judgment was somewhat shaky in

those days. Once, he sold a painted metal sculpture by David Smith, the leading Abstract Expressionist sculptor, to a man who wanted to remove the red paint; Castelli told him to go ahead, and when Smith found out about it he was furious. (Castelli did not represent Smith; he had simply bought the piece and put it in a group show.) "There was absolutely no excuse for my doing that," Castelli admits. "It was just an awful mistake." The abstract painter Paul Brach, who had become a friend of the Castellis before they opened the gallery, said recently that he thought Castelli was unsure of his future direction as a dealer until the first Johns show. The response to Johns' work by Alfred Barr and others confirmed Castelli's own feeling about it, and from that moment it became clear to Brach, Friedel Dzubas, Norman Bluhm, Esteban Vicente, and others in the gallery that the tide was not running their way. Castelli was incapable of telling an artist to go elsewhere; Brach and the others did so on their own initiative. Even today, though, Brach says that he can't go into Castelli's without a nostalgic sense that it is his gallery.

In 1959, the apartment on the second floor at 4 East Seventy-seventh became available, and the gallery moved downstairs two flights. The move coincided with the arrival of Ivan Karp as manager. People sometimes wonder how Castelli and Karp could have worked together for ten years, considering their almost antithetical personalities and backgrounds. Karp, born in the Bronx and brought up in Brooklyn, a fast-talking, ebullient extrovert, had been the *Village Voice*'s first art critic, and in the middle fifties he and Richard Bellamy had run the Hansa Gallery, an artists' coöperative, on Central Park South. "Leo was one of the few significant dealers who came to the Hansa," Karp recalls. "Dick and I had code names for all the art-world figures, and we called Leo the Count—he was always well dressed, and he always had clean fingernails, which you seldom saw then in the art world." Karp left the Hansa in 1958, and he was working for the Martha Jackson Gallery when Castelli offered him a job, at a hundred dollars a week. This was not much more than he was getting at Martha Jackson's, but he decided that the gallery that had Johns and Rauschenberg was the place to be. "Leo and I always got along extremely well," he said not long ago. "One bond between us was that we both loved women. Leo has a great sense of amorous style. He's not in any way a sexist; he treats women

with great respect, really admires them." Castelli's amorous style had led by this time to a certain degree of estrangement from Ileana, but they continued to work together in the gallery.

A group show opened the second-floor gallery in the fall of 1959. It contained several new names, one of which was Frank Stella. Only twenty-three at the time, Stella had begun as a Princeton undergraduate to paint in a rigorous abstract style that owed nothing to Abstract Expressionism. In the show, he was represented by a large, rectangular canvas on which precisely ruled black stripes separated by narrow bands of unpainted canvas formed a concentric series of geometric rectangles. Stella explained in an interview, "My painting is based on the fact that only what can be seen there *is* there"—in other words, no illusionism, no emotion, no "painterly" qualities that would tend to make the picture look like something it wasn't. This no-nonsense approach outraged the outrageable critics, such as Emily Genauer (who referred to Stella as "the pinstripe boy"), but it struck Castelli as another epiphany, and it also found favor with Alfred Barr. Dorothy Miller put Stella in her "Sixteen Americans" show later that year, and Barr bought a black Stella called *The Marriage of Reason and Squalor* for the museum. (Castelli reduced the price from twelve hundred dollars to seven hundred and fifty so that Barr could buy it out of special funds and avoid having to seek the board's approval.) Another meteoric career was launched.

As Castelli became more confident in his decisions, the gallery became more uncompromisingly avant-garde. Nearly every show presented works that were difficult to adjust to at the first look, or even at the seventeenth: John Chamberlain's welded sculptures of battered automobile parts; Cy Twombly's paintings that looked something like a child's crayon or chalk scribblings on a wall; Scarpitta's overlapping webs of epoxied canvas stripping; Lee Bontecou's strange constructions of bent wire and taut canvas, with their menacing dark interiors. Marisol, the Venezuelan sculptor, whom Castelli had shown in 1957, came back from two years in Europe and decided that the atmosphere of the gallery no longer suited her; she took her satiric wood carvings to Janis, where the climate seemed gentler. Johns and Rauschenberg were more than ever the Castelli stars. *Monogram*, a Rauschenberg "combine" that incorporated a stuffed Angora goat with an automobile tire around its middle, went to Europe on tour and came back in a state of collapse, because a Swiss museum director had sat on the goat to have his picture

taken. Several of Rauschenberg's collage-paintings were defaced by angry viewers, who scribbled obscenities on them with ball-point pens. (The artist was very upset by all this.) Meanwhile, he was at work on a series of thirty-four drawings for Dante's *Inferno*. It took him two and a half years, and became his first important work to be acquired by the Museum of Modern Art. (The museum had bought two photographs by Rauschenberg in 1952, but nothing since.) The sale of the drawings came about in a curious fashion. One day in 1963, Karp was approached in the gallery by what he describes as "an Oriental gentleman, named Wen Shih," who said he was interested in buying the Dante drawings to give to the museum. Karp was skeptical, never having seen the gentleman or heard his name before, but later that afternoon Castelli called Alfred Barr and learned that the customer was a Chinese architect and had indeed approached Barr, saying he wanted to make a gift to the museum, and that Barr, who felt rather embarrassed at being unable to appreciate Rauschenberg's paintings and combines but who did like the Dante drawings, had suggested that he give those. The Chinese architect returned a few days later and had a pleasant chat with Castelli. From time to time, he produced a hip flask, from which he offered Castelli a slug of Jack Daniel's. At the conclusion of their chat, he agreed to give the museum a check for thirty thousand dollars, the price of the Dante series, explaining that it was income-tax time and that he would rather give to the museum than to the Internal Revenue Service.

Several important collectors had become regular customers of Castelli's. Emily Tremaine, who, with her husband, Burton, had built a superb collection of twentieth-century masters and Abstract Expressionist Americans, most of which they got from Janis, bought *Tango* and a white-flag painting from Jasper Johns around the time of his first exhibition, and continued to buy work by Johns and other Castelli artists. Philip Johnson, the Tremaines, and Robert Scull came to every show and usually bought something. Scull's passion for the latest art seemed unslakable. A self-made man who owned a fleet of taxicabs, he had bought a Johns *White Numbers* painting from the Galerie Rive Droite in Paris in 1958 (the word on Johns had gone abroad almost immediately), and as soon as he got back to New York he went to Castelli's and bought Rauschenberg's combine-painting *Thaw*. That was the beginning of a relationship that Karp has described as being "full of anxiety, warmth, humor, and pain." Karp once said, "Leo was

always affable with Scull, but I don't believe he ever felt comfortable with him for one minute. The man's visual involvement was really there—you can't take that away from him—but he behaved toward art the same way he behaved toward his taxi business. There was always a contest about the price, and he would take a long period of time to pay. There were always misunderstandings and turmoil and anxiety, but Leo would put up with it, because 'he likes our artists.' " Scull wanted to buy *Monogram* to give to the Museum of Modern Art; he said he couldn't keep it at home, because his two sons would climb on the goat. Castelli called Barr, who asked uneasy questions: Wouldn't the piece disintegrate rather soon? Were there vermin in it? In the end, he declined the gift. *Monogram* was purchased in 1965 by the Moderna Museet, in Stockholm.

Scull wanted to know the artists personally. He and his wife, Ethel, would invite them to big parties at their house in Great Neck, together with museum people and friendly dealers, like Castelli. Once, Castelli took the Italian collector Giuseppe Panza—Count Panza di Biumo— to a luncheon at the Sculls', and that was a mistake. Panza was collecting vanguard art on a scale far more lavish than Scull's. He had bought many Rauschenbergs, and was transforming his eighteenth-century palazzo in Varese, near Milan, into a museum of the most advanced art. Scull and Panza did not hit it off.

Nor did the Sculls feel altogether kindly toward the Tremaines. Emily and Burton Tremaine went to Johns' studio before his second one-man show at Castelli's, in 1959, and picked out a painting called *Device Circle*. Scull also went to the studio and picked two paintings— *False Start* and *Out the Window*. But a day or so later Scull decided that he had made a mistake, and that the picture he really wanted was *Device Circle*. He was immensely displeased to learn that it had been spoken for by the Tremaines. The rivalry thus begun erupted a few years later, over the first of the Johns *Maps*. Johns made a large painting that was a map of the United States (you could not really call it a painting *of* a map, because it *was* a map, with all the states where they belonged, but painted in such bravura style that it hardly mattered; many of his early works—the flags and the targets—posed a similar problem), and, naturally, the Tremaines and the Sculls both wanted it. Johns insisted that the picture go to a museum. Scull said he would buy it and give it to the Museum of Modern Art at some point, but

Johns said that wouldn't do, so Scull agreed to donate the painting immediately, reserving the right to keep it at his apartment part-time if he so wished. Having given his first Johns *Map* to MOMA, Scull wanted another one. A few months later, Scull heard that Frederick Weisman, a Los Angeles collector, having learned that Johns was about to begin a new map painting, had bought it unbegun; Johns needed the money to give to the Merce Cunningham Dance Company, for which he was raising funds. The following summer, when Scull heard that Ben Heller had bought a third Johns *Map*, he blew up. Relations between Johns and the Sculls (which had been deteriorating anyway), were severed, and Castelli had to use all his diplomacy to patch things up in time for a big Johns retrospective at the Jewish Museum in 1964; the Sculls refused until the last moment to lend anything from their collection but did so after Johns visited Mrs. Scull. Johns had painted a new picture (it was included in the show), called *Arrive/Depart*, in which there appeared a rather ominous little image of a skull. The breach was smoothed over, but relations were never quite the same afterward.

A natural division of authority had evolved early on within the gallery. Castelli dealt with Rauschenberg, Johns, Stella, and the other artists of the gallery's inner circle; with the majority of the well-to-do collectors; and with the European dealers and museum people who invariably dropped by when they were in town. Ivan Karp dealt with the rougher and hairier artists—John Chamberlain, for one—and with the endless stream of unknowns who came in off the street to show slides of their work. During their early years together, once a week or so Karp and Castelli would go around to the studios of the artists whose work Karp thought looked interesting. Many of the most interesting contemporary artists in New York wanted to be with Castelli. By the mid-sixties, the gallery was paying monthly stipends to most of its artists—a fairly common practice in Europe, but not here, where the usual system then (and now) was for the gallery to take work on consignment and pay the artist his share (sixty per cent, usually) when it was sold. Johns and Rauschenberg had been among the first to go on regular stipends (five hundred dollars a month at the start), which were applied against their earnings; by the mid-sixties, most of the artists were on them, and several were running up considerable debts to the gallery. This never

seemed to bother Castelli, but it was a strain on Nancy Friedberg, who came in 1964 to handle the bookkeeping. Castelli always insisted that the artists be paid first. If there was not enough money to pay the other monthly bills, it would turn up eventually, he said. It always did— sometimes out of the blue. A customer would pay a long-overdue bill, and financial disaster would be averted—although every summer Castelli had to take out a bank loan to carry the gallery through the slack season. One time, when Chamberlain was in an unproductive period and his debt to the gallery stood at more than forty thousand dollars, Karp suggested that they cut his monthly stipend in half. "How could I?" Castelli replied, in a shocked tone. "He couldn't get along on that." The regular stipend continued.

Karp's role in the gallery has been much debated. He brought Chamberlain over from Martha Jackson, and his enthusiasm for other artists, such as Andy Warhol and Roy Lichtenstein, obviously played a large part in Castelli's thinking. In the first years, Castelli had depended a lot on Ileana's responses. "Ileana was more sensual and imaginative, while Leo was more analytical and art-history-aware, and it was the tension between their two approaches that made the gallery," Rauschenberg once said. The Castellis were divorced in 1960. Three years later, Castelli married Antoinette Fraisseix du Bost, an attractive Parisienne. Meanwhile, Ileana had married Michael Sonnabend and moved to Europe, where she opened a gallery in Paris. Whenever Karp and Castelli decided to take on a new artist after Castelli's divorce, the decision was a joint one. This was certainly true in the case of Roy Lichtenstein, the gallery's first Pop Artist.

In 1961, Lichtenstein was teaching art at Douglass College, the female side of Rutgers. Allan Kaprow, who taught art history at Rutgers, and who got around a lot in the art world, told Karp he should look at Lichtenstein's work, and one day, while Karp was guiding a group of art students through a show at Castelli's, Lichtenstein turned up with several paintings. The paintings were based on comic-strip images. The art students started to giggle. Karp sent them into the next room and looked hard at the new pictures. "They were really strange, unreasonable, outrageous," he recalls. "I got chills from those pictures. I decided that I'd have to show them to Leo, but in such a way that he wouldn't hate them on sight, so I told Roy to leave them with us, and I hid them in the back room. When Leo got back from lunch, I said, 'Leo,

I've got these very *peculiar* pictures,' and he said, 'Yes? Where are they?' I tried to prepare him a little, but he was too impatient, so I brought one of them out. And Leo was not distressed! Leo didn't even know the comics they were taken from, he didn't have any background, but he appeared to be fascinated. For me, this was one of the heroic moments. Leo never had automatic responses. He always had good eyes, and he trusted his eyes."

Pop Art was about to burst on the scene then, but nobody knew that it existed—not even the artists who were making it. Lichtenstein had been painting Cubist-derived and Abstract Expressionist pictures until a year or so before. (He had shown some of them to Castelli, and Castelli had not been impressed.) He had also been using cartoon characters—Bugs Bunny, Mickey Mouse, Donald Duck—veiled in an Abstract Expressionist style. In 1961, he decided to do a painting of Mickey and Donald in the manner of the originals but much enlarged, and free of Expressionist influence. Lichtenstein painted Donald and Mickey complete with enlarged benday dots, of the sort that then made up the background of newspaper reproductions, and after that he got interested in working with blown-up images from love comics and war comics and commercial advertisements. He also painted common objects—a ball of twine, an automobile tire, a foot stepping on the pedal of a garbage can—in the same flat, mechanical style: in simplified colors, without perspective, absolutely banal, yet far more memorable than the originals. Meanwhile, in a studio down on Coenties Slip, near the Battery, James Rosenquist, who earned his living painting billboards in Times Square, was using hugely enlarged details from advertising art—spaghetti with tomato sauce, toothpaste smiles, automobile fenders—as elements in his paintings; and in a studio on Lexington Avenue, uptown, a commercial illustrator named Andy Warhol was doing a series of paintings based on *Dick Tracy* and another series on cans of Campbell's soup. And none of them knew what the others were doing! In the summer of 1961, Ileana Sonnabend heard about Rosenquist's work and went to his studio. She, in turn, told Bellamy and Karp, who then made the pilgrimage to Coenties Slip. Next, Karp brought Castelli down. Not long after Castelli had taken on Lichtenstein, Warhol came into Castelli's to buy a Jasper Johns drawing and saw in the back room some comic-strip paintings by Lichtenstein. "I do paintings like that," he said, in a small, aggrieved voice.

Castelli and Karp considered taking both Rosenquist and Warhol, but Castelli found that Rosenquist's work was a little too close to Surrealism, and they both felt that Warhol's was too close to Lichtenstein's and not as strong. Warhol eventually went to the Stable Gallery, and Rosenquist joined Richard Bellamy's Green Gallery, which was being financed by Robert Scull. His first show there came a month after Lichtenstein's first show at Castelli, in the spring of 1962. Two months before that, Claes Oldenburg had opened his famous "Store," a storefront on East Second Street that he had filled with plaster and papier-mâché replicas of the sort of goods found in real stores on the lower East Side. To conservative critics, it was clear that something perfectly awful was happening—this was not the "return to the figure" that they had been demanding as an antidote to Abstract Expressionism—but for some time the new thing didn't even have a name. Karp called it Commonism for a while, but that didn't stick. Finally, a term coined by the English critic Lawrence Alloway in the mid-fifties did stick: Pop Art. By then, Warhol had shown his soup-can paintings at the Ferus Gallery, in Los Angeles, and commercial imagery was cropping up in paintings by Jim Dine, Tom Wesselman, Robert Indiana, and a host of others. Sidney Janis put his imprimatur on the movement in the spring of 1962, with a show of what he called the New Realists; these included European as well as American artists. Soon afterward, Janis's Abstract Expressionist artists left the gallery—all except de Kooning, who would leave ten years later. They felt betrayed by Janis, who subsequently took on Oldenburg, Dine, Wesselman, and other Pop Artists, but they felt even more betrayed by their old friend Castelli. "Give Leo Castelli two beer cans and he could sell them," de Kooning said one night at the Cedar Tavern. Jasper Johns, hearing of the remark, made a bronze sculpture of two realistic-looking cans of Ballantine Ale, and Castelli sold it for nine hundred and sixty dollars to Scull (who sold it at auction in 1973 for ninety thousand dollars). Johns says he wasn't trying to prove anything. He was making small sculptures of light bulbs and flashlights and other common objects at the time, and de Kooning's remark just "gave me a subject in line with what I was trying to do."

For a while, Lichtenstein seemed to be the most shocking of the Pop Artists. Oldenburg, Rosenquist, and even Warhol showed some suggestion of painterly qualities here and there, but Lichtenstein's pictures appeared at first glance to be virtually indistinguishable from their com-

mercial models. Johns and Rauschenberg saw nothing in them initially, according to Castelli; it took Rauschenberg a week to change his mind, and Johns somewhat longer. The critics were venomous. Brian O'Doherty, writing in the *Times*, described Lichtenstein as "one of the worst artists in America" and his work as "an unworthy graft to the body of art." Max Kozloff, in *The Nation*, said, "A painting by Lichtenstein is at once ingenuous and vicious, repulsive and modish—the latest sensation." The newsweeklies and the fashion magazines, always alert to *scandale*, gleefully publicized the new movement, which lent itself readily to such treatment; abstract painting had always been hard to talk about, but Pop was a journalists' playground. It had been evident for some time, of course, that what the New York critics said about new art had little or no effect on anyone. Several collectors bought Lichtenstein right away, among them the Tremaines, Richard Brown Baker, and Giuseppe Panza. Also Leon Kraushar, a voluble insurance man, who used to come into the gallery every Saturday with his pockets full of money—he paid cash on the line! Kraushar bought more than sixty pictures from Castelli, rarely paying more than a thousand dollars for any one. He died of a heart attack in 1967, and six months later his widow sold the collection for six hundred thousand dollars to Karl Ströher, a German collector. It is now in the Darmstadt museum.

The media's delighted response to Pop gave its detractors a sort of bitter satisfaction. The pioneer Abstract Expressionists had worked in virtual isolation for years, forging their private myths. It was clear to them that the new generation was not serious. When Robert Motherwell was asked about the brash new movement, he said scathingly that it was "nice to see those young fellows having a good time." Beneath the surface, there was anger and anxiety. The demand for work by the leading Abstract Expressionists continued to hold up in the sixties, but there was a sharp drop in the prices of the school's second-generation practitioners, because nobody was interested in them. Some dealers urged their clients to switch to Pop, which was spreading like a fungus in the art schools.

It was inevitable, perhaps, that after a decade of difficult abstract art the appearance of a new figurative style would be welcomed. Pop Art was amusing, iconoclastic, and topical. It looked out at the world rather than in upon the artist's private emotions, and the world it looked out at was the highly familiar one of popular culture; it was easy to like,

once the initial shock had passed; and it coincided with a mood of openness and excitement in the larger society. "Kennedy was President," Castelli has observed, "and the whole atmosphere of the country was more hopeful." There was also a new spirit abroad in the art world. Avant-garde art had become hugely fashionable. The major museum and gallery openings were primary social events, to which people would come dressed as though for a society ball. Getting named to the board of the Museum of Modern Art was the ultimate goal of the socially ambitious, and getting to a new artist's studio ahead of the dealer was the passionate concern of collectors like Scull. In all this, the Abstract Expressionists and certain critics saw evidence of a conspiracy—a vast and subtle plot, engineered by a small cabal of dealers and public relations men, to dethrone true quality and capture the market. To those who knew a conspiracy when they saw one, the mastermind behind it was Castelli, and the proof was Castelli's coup in "fixing" the 1964 Venice Biennale.

Alan Solomon, the man named by the fine-arts section of the United States Information Agency to be in charge of this country's representation at the Biennale, was a close friend of Castelli's. In 1958, while Solomon was director of the Andrew Dickson White Museum (now the Herbert F. Johnson Museum of Art), at Cornell, he had come down to see the first Rauschenberg show at the Castelli Gallery and had been so excited by it that he persuaded his museum to buy a painting—the first Rauschenberg canvas to enter a museum. He came regularly after that, and when he was named director of the newly enlarged and refurbished Jewish Museum, in 1962, the relationship became much closer. Most people find it hard to be on intimate terms with Castelli, to penetrate the overlay of politeness and reserve; Solomon, though, from 1962 until his death, of heart disease, in 1970, was Castelli's close friend. "Coming to New York opened up a whole new life for him," Castelli said last winter. "He got rid of his wife. He had an operation that let him dispense with his hearing aid. He grew a rich, Oriental sort of beard, he started to dress with great elegance and originality, and he had many relationships with women—incredibly deep relationships. He was so sure of himself that nobody could resist him."

Some members of the Jewish Museum board were appalled by the big Rauschenberg retrospective that Solomon mounted there in 1963. Works such as *Monogram* and *Bed* did not seem to them to belong in

a museum whose main function in previous years had been to preserve and display liturgical objects. But Solomon had the support of Albert and Vera List and other influential trustees, and he went on to mount the equally ambitious Jasper Johns retrospective and other exhibitions of new and daring art. The artists that Solomon chose to show at the Biennale, the oldest and most distinguished of the big international art expositions, represented what he considered the two major tendencies in recent American art: Rauschenberg and Johns, who had led the way out of Abstract Expressionism; and Morris Louis and Kenneth Noland, the leading exponents of what was being called color-field abstraction—the exploration of pure chromatic relationships. Color-field painting had been promoted actively by Clement Greenberg, the most influential critic of the period. In addition to writing about it, Greenberg had organized exhibitions and had shown the work at French & Company's contemporary gallery, in New York, to which he was a consultant in 1959 and 1960. When that gallery closed, in 1960, Louis and Noland went with the André Emmerich Gallery. Castelli, much as he admired Greenberg, was never in thrall to his opinions.

In addition to the four "primary" artists, Solomon included four younger artists who he felt indicated further developments along the same general lines. These were Frank Stella (geometric abstraction) and John Chamberlain, along with Claes Oldenburg and Jim Dine, who at the time were lumped under the umbrella of Pop. It did not escape notice that four of his eight selections were Castelli artists. Castelli was in Venice for a week before the official opening, and the art world's rumor mill made much of his activities. Castelli, it was said, had handpicked the artists for Solomon and was working day and night, in several languages, on the international panel of judges who would award the Biennale prizes; Castelli had moved additional Rauschenberg paintings onto the Biennale grounds, under cover of darkness, to bring further pressure on the judges; Castelli had even arranged for Rauschenberg to arrive in Venice on the eve of the official opening, as the lighting and set designer for the Merce Cunningham Dance Company, whose performance in the eighteenth-century Fenice Theatre that week was a brilliantly controversial event. When Rauschenberg won the International Grand Prize for Painting—the first time in the Biennale's history that this award had gone to an American artist—the New York art critic Hilton Kramer saw the choice as evidence of "cultural imperialism" by the Castelli cabal.

In Venice, of course, Castelli was in his element. ("What's deep in Leo is his absorption of different European cultures," Ileana once said.) Indefatigable and seemingly omnipresent, he dashed from the Biennale grounds, in the parklike Giardini Pubblici, to the former United States Consulate building, on the Grand Canal (where Solomon had installed all the Rauschenberg and Johns paintings, on the assumption that they would be eligible there for the prize judging), and on to the outdoor tables at Florian's, on the Piazza San Marco, or the indoor ones at Harry's Bar, to the finer restaurants, where he ordered for everyone in his flawless Italian (and invariably picked up the check), and to private parties and public receptions and a thousand points in between. Castelli, with his languages and his Italianate charm and his consuming thirst for information of every kind, perhaps began to feel that he actually *was* influencing events, but those who were there at the time report that he had no contact whatsoever with the judges, and that Solomon's mistaken assumption that the paintings hanging in the Consulate would be eligible for the prize (he had misunderstood the official ruling on this point) nearly cost Rauschenberg his triumph. Learning that the jury was leaning heavily toward Rauschenberg but that its president balked at awarding the prize to an artist not represented on the official Biennale grounds, Solomon had one work by Rauschenberg and one by Johns transported by boat (in broad daylight) from the Consulate building to the United States Pavilion at the Giardini—a move that satisfied everyone but the conspiracy buffs.

Winning the Biennale naturally boosted Rauschenberg's prices and certified his international reputation. The silk-screened paintings that he had been selling for two thousand to four thousand dollars in 1963 were soon going for ten thousand to fifteen thousand. Rauschenberg—unpredictable, as always—reacted to this by withdrawing almost entirely from painting to devote his time to Experiments in Art and Technology, a foundation that he and two associates formed in 1965 to promote collaborations between artists and engineers on projects involving the latest technology—what they called "projects outside art." Always slow, Johns' production became even slower at about this time, for he became increasingly interested in making prints. Lichtenstein and Stella became the Castelli Gallery's main supports, along with Warhol, who joined in 1964, and Rosenquist, who came the same year. For some time, Bellamy had been telling Rosenquist that he was planning to close the Green Gallery, and Castelli said that if Rosenquist ever decided to leave

the Green, he should give first consideration to moving to Castelli.

The following year, the Green Gallery did close. Bellamy had discovered and shown more important new artists even than Castelli, among them Oldenburg, Rosenquist, Robert Morris, George Segal, Larry Poons, and Donald Judd. His eye was seemingly infallible, but in spite of Scull's backing he could not make a go of things financially. He offered Castelli the first choice of the Green Gallery artists, and Castelli chose Poons, Morris, and Judd. Poons was an obvious choice—a strong young abstractionist who filled large canvases with small, precise ovals of color that vibrated optically against the background color. Castelli was somewhat more hesitant about Morris and Judd. Morris, whom he had rejected a few years before, because his early work seemed too closely related to Johns' (a common problem among artists after Johns' first show), had become a maker of "primary structures"—the simplified, noncommittal, machined-looking sculptures that would soon become known as Minimal Art. Judd was also a Minimalist. He had metal boxes of his design made up by a machine shop and fixed them to a wall like shelving, in vertical or horizontal rows. Minimal Art carried over into sculpture the rigorous negations of Frank Stella's paintings; characterized by an extreme spareness and impersonality, it was an art stripped down to the bare bones of shape, line, and color, by artists who believed in covering their traces (no more Expressionism). Not surprisingly, it proved hard to sell. Moreover, the work could be expensive to handle if the cost of fabricating and shipping the larger pieces was borne by the dealer (as it was at Castelli's), and Morris, especially, tended to work on a big scale. Castelli's decision in these two cases was almost certainly influenced by Frank Stella and Barbara Rose, the critic, who was then Stella's wife. Barbara Rose wrote penetrating articles about Minimal Art in the international art journals, and she was a close friend of Judd's. She and Stella spent a lot of time at the gallery—it still served as a sort of club and discussion center for artists—and their intellectual authority was impressive.

Ivan Karp once said that the only time he ever saw Castelli lose his temper was when he came back from lunch one day and found Stella sitting on the floor in his customary paint-spattered clothes and smoking his customary cigar. "You can't sit around my gallery like that," the immaculate Castelli suddenly burst out. "Get up! Put your teeth in!" (Castelli vehemently denies this story.) That was in the early days,

though; by 1965, Stella could do whatever he wanted and Castelli wouldn't object. Stella, in fact, was not even represented exclusively by Castelli anymore. When his friend Larry Rubin (William Rubin's brother), a dealer who had been selling his work in Paris, came back in 1967 and established a gallery in New York, Stella decided to distribute his yearly production more or less equally between the two galleries. Karp urged Castelli not to put up with this, but Castelli had lunch with Rubin and, as usual, reached an accommodation. After that, Stella exhibited alternately at Castelli and at the Lawrence Rubin Gallery—an arrangement that added substantially to his income and made it possible for him to buy a half interest in a breeding farm for race horses. At any rate, Stella and his wife were strongly in favor of Castelli's taking on Morris and Judd, and the gallery's commitment to the Minimal movement was sealed.

Castelli and Karp had broken with the custom of Tuesday-night openings. They felt that these had become social events, at which no one looked at the art, and so in 1962 they began having their openings on Saturday—all day Saturday, with no special invitations and no liquor—and sooner or later most of the other galleries followed their lead. The active collectors dropped by Castelli's frequently. "There were times in the mid-sixties when you felt that if you didn't get to Leo's every other day you were going to miss out on something," according to Victor Ganz. Having started out in the forties as a collector of Picasso, Ganz had had his epiphany at the 1963 Rauschenberg retrospective at the Jewish Museum; a few days later, he went to Castelli's and bought a Rauschenberg combine-painting called *Winter Pool*, and he has been buying from the gallery ever since—mainly Rauschenberg, Johns, and Stella. Castelli has never made the slightest effort to "sell" him paintings, Ganz has said. Indeed, Ganz, a connoisseur as well as a collector, cannot even recall an instance of Castelli's discussing a work of art in aesthetic terms, although he says that once, not long after he remarked to Castelli that a Johns painting on the wall reminded him of a late Beethoven quartet, he happened to overhear Castelli tell another visitor that Johns' paintings were like late Beethoven quartets. Some of the gallery artists used to refer to Castelli as Mighty Mouse (behind his back, of course). But the artists knew that Castelli was on their side. What Castelli really sold, according to Barbara Rose, was a sense of art

history being made right then and there. Johns, Rauschenberg, Lichtenstein, Stella, and the others were for him in the same league and the same tradition as Cézanne, Matisse, and Picasso. "He believed it," she said recently, "and he made collectors believe it, too, and so maybe in this sense he was a supersalesman after all."

Sometimes customers lost their bearings in this heady atmosphere. When one collector, who has since become a dealer, learned that a small Lichtenstein painting he coveted had been sold to someone else, he snatched it off the gallery wall and ran out with it; Karp had to chase him down the street to get it back. ("He was going to pay, of course," Karp explains. "He just felt he had to have that picture.") Jill Kornblee, a younger dealer, who says that she learned everything she knows about running a gallery from watching Castelli run his, claims that she actually saw a client weep at Castelli's knee: "It was a couple from out of town. She was wearing a mink coat—not a Maximilian mink, an out-of-town mink—and saying they just *had* to have a Rauschenberg, and couldn't Leo *please* help them out, and Leo, in no hurry to make a sale, said he would do what he could but they must be patient until the right one came along. He always had this sense of placing pictures where they would do the most good for the artist's reputation."

Scull used to complain that Castelli was letting important pictures go to other collectors, and now and then a client who thought he had reserved a piece would become incensed when he found that it had been sold to someone else. "There were lapses of memory," Karp concedes. "Enthusiasms washed away by the next enthusiasm. Leo is a very sentimental person—he gets carried away. But if somebody seemed to be ill treated, it was always by inadvertence." Important collectors who were regular clients, buying from nearly every show, would often get an automatic discount on their purchases, and some, like Count Panza and Dr. Peter Ludwig, the German chocolate tycoon, would get discounts of up to twenty per cent. Castelli has been criticized for giving discounts, although it is a common practice among art dealers. Scull bought Rosenquist's huge painting *F-111* from Castelli in 1965, and the press reported that the price had been sixty thousand dollars; when it later came out that Scull had paid considerably less than that, Castelli was accused of seeking to inflate Rosenquist's prices artificially. But it was not Castelli who released the figure of sixty thousand, and, like most dealers, he would not brag about high prices.

Castelli has also been accused of "buying in" works by his own artists at auctions, at prices above what they would normally bring on the market, as a means of driving those prices higher. This he indignantly denies doing. He would like to be able to buy works of his artists when they come up for auction, he says, not in order to boost prices but simply to keep them from going below the levels at which he sells them in the gallery—but, for financial reasons, he is unable to do even this. "I don't have the means," he said recently. "I just have to hope for the best." As for his giving special prices to his clients, Castelli's argument is that he has a right to sell at whatever prices he chooses, and that in any event what he does is for the artist's benefit rather than his own. "You just have to keep on doing things even when it makes no sense financially," Castelli said last winter. "If Rosenquist doesn't want to sell a painting for less than ten thousand dollars, let us say, and Panza offers me eight thousand for it, maybe I will just give Jim his full share on ten thousand and take less for myself. To hell with them! What matters is that the painting gets out where people can see it."

All art dealers give a discount to museums, Castelli points out, so why not to collectors whose acquisitions will almost certainly end up in museums? The collections of Panza and Ludwig are museums in themselves—vast holdings, already too large for any existing museum to accommodate. Panza, who started with Italian contemporaries in the nineteen-fifties and progressed to European painters such as Fautrier (French) and Tàpies (Spanish), then broke into the American market by buying Rothkos and Klines, has always insisted on having many examples of the work of the artists he likes. (He missed out on de Kooning and Johns for this reason; by the time he got around to them, there was not enough of their work available.) He has filled the rooms of his apartment in Milan and his family palazzo in Varese with dozens of Rauschenbergs, Morrises, Judds, and Oldenburgs, and has turned the stables and garden house and servants' quarters into repositories of the work of the earth artists Michael Heizer and Walter De Maria, the Minimalists Dan Flavin, Carl Andre, and Robert Irwin, and the Conceptualists Bruce Nauman, Joseph Kosuth, Douglas Huebler, Lawrence Weiner, Hanne Darboven, and Jan Dibbets (most of whom show at Castelli). He is now making plans to distribute this enormous accumulation of mostly American avant-garde art among a few European museums, some of which do not yet exist. Peter Ludwig, whose fortune

comes from chocolate factories in several German cities, has installed the greater part of his collection on several floors of the Wallraf-Richartz Museum, in Cologne, and another part in a museum in Aachen, where he has his offices. Recently, he concluded an agreement to donate part of the collection to the city of Cologne, which is building a large new museum to house it. Panza and Ludwig fully deserve the twenty-percent discount offered to museums, Castelli feels. Other dealers, Janis among them, insist that giving discounts to private customers is bad business. At any rate, the issue appears to involve a business decision, and not, as is sometimes suggested, a moral one.

Private collectors of advanced contemporary art—serious, habitual buyers, that is—have been until quite recently a rare and elusive species. Castelli decided early in his career that the way to cope with this situation was to collaborate with other dealers rather than to compete with them. Over the years, he has built up a network of what he calls "friendly galleries" in this country and abroad, where the work of Castelli artists is shown regularly, and often exclusively. The friendly gallery gets the work at a discount—generally up to thirty per cent, leaving a twenty-per-cent profit for Castelli if the work is sold there. (Castelli usually takes a commission of forty to fifty per cent on sales in his own gallery.) During the nineteen-seventies, the gallery network became increasingly important to Castelli's operations. Scull and most of the other big New York collectors more or less dropped out of the market, partly because of the soaring prices for major works and partly, one can guess, because so much of the new art does not exactly lend itself to domestic arrangements. Up to the mid-seventies, approximately seventy per cent of Castelli's sales were to other galleries, nearly half of them in Europe. Americans, it seemed, were emulating the French in allowing the art of their own period to leave the country.

Ludwig began buying American vanguard art in 1964, in the conviction that the American way of life was becoming universal and that American artists drew their power from being closest to the source. "The American people probably need more time to realize the importance of recent American art," he said a while ago. "It is a little like a father whose son has become a great scientist—he can't quite believe it for a time. The most influential critics in your country were shocked when Lichtenstein first appeared, but the museum in Amsterdam, the museum in Stockholm, the museum in London bought these works in

the first moment. And you will have to do the same. Most American museums don't have important works by Johns and Rauschenberg, remember, but they will buy them, and prices will continue to go up. I feel we are far from reaching the highest price for Johns and Rauschenberg." When a Johns painting called *According to What* was sold in 1978 to an American collector for six hundred thousand dollars, Ludwig, who says that by American standards he is a poor man, was not in the least surprised.

Castelli and Ileana Sonnabend did not open the European market to American art single-handed, as has sometimes been suggested. The New American Painting exhibition that Dorothy Miller organized for the Museum of Modern Art and that was shown in eight European countries in 1958 and 1959 had a tremendous impact. For many younger European artists, this show made it clear that New York had replaced Paris as the energy center for new developments, and the new American painting and sculpture were bound to find European buyers. American art was also helped by the enthusiasm of European critics and dealers. But Castelli in New York and Ileana Sonnabend in Paris certainly did more than any other dealers to further the trend. In 1962, the year Mrs. Sonnabend established her gallery in Paris, Castelli had made it possible for Rauschenberg to have a show at Daniel Cordier's gallery there. Castelli paid all the expenses of shipping and insurance and volunteered to waive his own commission on sales. (There were none.) The Sonnabend Gallery's initial exhibitions of Johns, Rauschenberg, Stella, Lichtenstein, and other Castelli artists were revolutionary events in Paris. "People were shocked but enthusiastic," Mrs. Sonnabend recalls. "The gallery was full every day." Mrs. Sonnabend arranged for most of these shows to be seen elsewhere in Europe, at friendly galleries in Milan, Turin, Rome, Zurich, Munich, Hamburg, and Cologne. One consequence was that Rauschenberg became a hero to the young artists in those countries. His European reputation was immense by the time of the 1964 Biennale, and it was no surprise to the European artists that he won the painting prize. What Sidney Janis had not done for the Abstract Expressionists (the first American artists to achieve an international influence, their work was not shown in European galleries until the early nineteen-fifties), Castelli and Sonnabend did for Rauschenberg and Johns, for the Pop and, later, the Minimal Artists. Castelli made their work available to Sonnabend on

the most favorable terms—"ruinous terms," Ivan Karp called them.
Castelli was willing to take a loss in order to have his artists seen in
Europe. His faith now looks like business acumen: Castelli's biggest
client is Ludwig.

In this country, the Castelli network began with Virginia Dwan's
gallery, in Los Angeles, at a time in the early nineteen-sixties when
Castelli and others believed that Los Angeles was developing into an
important modern-art center. Los Angeles did not really fulfill its prom-
ise, for a variety of reasons: not enough strong collectors, not enough
support by the local museum, and the takeover of the Pasadena Art
Museum by Norton Simon. In any event, Castelli currently maintains
connections with the Margo Leavin Gallery, the James Corcoran Gal-
leries, and the Ace Gallery, in Los Angeles; with John Berggruen, in
San Francisco; with Ronald Greenberg, in St. Louis; with Janie C.
Lee, in Houston; with Young-Hoffman, in Chicago; and with the Sable-
Castelli Gallery, in Toronto. Several of these galleries have engendered
and are currently nourishing important collectors of advanced art—
wealthy buyers who no longer feel that in order to get the best things
they have to come to New York. Castelli, in fact, has done a lot to
decentralize the art market, and, as usual, things have worked out to
his advantage. Having gone out of his way to help dealers in what he
calls "the provinces," he now shares in the benefits of their success.
"He's an incredible accommodator of people and situations," Irving
Blum, the director of the Blum-Helman Gallery, in New York, said
the other day. "It always seems he's giving up an enormous amount,
but then you see that he has been enormously clever, and that he's
more than compensated when things get difficult. All these satellite
galleries are willing to sacrifice for him, because he's done so much for
them." Another New York dealer, Robert Elkon, has remarked, "Leo
is the Metternich of the art world. He thinks four or five moves ahead,
like a good chess player, and the ramifications become clear only later
on."

During the seventies, Castelli expanded his operations at a dizzying
rate. In 1971, he opened a large new gallery at 420 West Broadway,
in SoHo, which has since become the city's new art ghetto, and in
February 1979 he inaugurated a spectacular annex at 142 Greene Street,
two blocks to the east. The Greene Street building was to have been
used mainly for storage, but Castelli fell in love with the proportions

of the huge ground-floor space (ninety-five feet long and thirty-seven wide) and ended up putting a sizable chunk of the gallery's 1979 profits into replacing the floor there and making the space a pristine showroom for paintings and sculptures too large to be accommodated at 420 West Broadway. Meanwhile, 4 East Seventy-seventh Street has become the site of Castelli Graphics, a print-and-photography gallery run by Castelli's wife.

The Castelli Gallery took on a number of new artists during this period, some of them well-established names, such as Claes Oldenburg and Ellsworth Kelly (both of whom came from Janis), and some relatively unknown. The general feeling around the art world is that the nineteen-seventies produced no new artists of major stature, and Castelli's stable reflects this view: he has not shown anyone whose work did not catch his eye before 1971. Of the thirty-two artists currently represented by the downtown gallery, fifteen could be described as either Minimalists or Conceptualists. Castelli looked at and rejected the Photo- (or Super-) Realists, who paint pictures that look exactly like blowups of the deliberately banal photographs on which they are based. Ivan Karp, who left Castelli in 1969 and in the fall of that year opened his own gallery (called O.K. Harris), in SoHo, promoted what he chooses to call the Hyper-Realism movement, among other things, and has done extremely well, but to Castelli "Super-Realism seemed an offshoot of Pop Art, not a move beyond Pop." For the first time since his early days, he now shows several European artists, including Hanne Darboven, from Germany, and Jan Dibbets, from Holland. Some of the Americans in the gallery see this as an indication of pressure from Konrad Fischer and Gian Enzo Sperone, dealers in Düsseldorf and Turin, respectively, who represent many of Castelli's people abroad, and who presumably feel that the system should work both ways. Despite the fact that the seventies, unlike the sixties, did not produce great stars, artistic activity was strong, and New York remains *the* energy center of artistic activity. Nevertheless, thanks in some part to the proselytizing efforts of Castelli and a few others, contemporary art has become truly international and pluralistic, with a free-flowing interchange among many marketplaces.

Castelli, meanwhile, has taken on some of the star quality of his major artists. He appeared twice on *The Dick Cavett Show* in January, and

he was featured in a recent Italian television documentary on the art world, produced by Gianfranco Gorgoni. He was one of a group of New York artists, writers, performers, and public citizens to receive the first annual Mayor's Award of Honor for Arts and Culture, in 1976, and this spring he was the recipient of the first annual Manhattan Cultural Awards prize "in the field of art," given for "his outstanding contribution to the Borough of Manhattan" as a "major force in the development of contemporary American painting since 1957" and for having "discovered and encouraged an entire generation of artists." Buoyed by such accolades, perhaps, and also by the recent boom in art sales, Castelli commissioned a public work of sculpture by Richard Serra, one of his artists. Large sculptures for public spaces are being commissioned by federal, state, and city agencies and by private corporations throughout the country these days, in increasing numbers. Serra, who was invited to participate in the design of a public space by the Pennsylvania Avenue Development Corporation, in Washington, D.C., quit the three-man design team because of conflicting ideas about how the project should be realized. He subsequently expressed a yearning to do something big in New York, and Castelli, whose greatest pleasure is to make it possible for his artists to do what they want, rather rashly agreed to finance the work himself. A two-hundred-foot-long-by-twelve-foot-high arc in Cor-Ten steel, it went up in April near the entrance to the Holland Tunnel, in lower Manhattan.

Castelli's friends often wonder why he keeps on expanding and exfoliating. He could make a lot more money by dealing exclusively in the work of the artists who made him famous. "Leo has passed up opportunities to buy back works by Lichtenstein, by Kelly, by other artists of his on which he could have realized a great profit," according to Irving Blum, who specializes in just that kind of "secondary market" buying and selling of contemporary art. "He never has the money to do that. He doesn't even have a great collection of his own. Why, my collection of works by Leo's artists is at least equivalent to his." Toiny Castelli has said that they would have no collection at all—aside from *Bed* and *Target with Plaster Casts*—if she had not insisted on buying some things herself, several of which now belong to their sixteen-year-old son, Jean-Christophe. As Castelli grows older (he is now seventy-two), his addiction to the gallery shows no signs of flagging. He makes more appointments than he can keep, and he is usually half an hour

late for everything. His enthusiasm sometimes outruns even his extraordinary energy.

At a dinner party some time ago, Castelli suddenly blacked out and had to be rushed to the hospital. It was not a heart attack, as several doctors present had feared at first; for years, he had had an abnormally slow pulse, and that night his pulse had just missed a beat or two. A pacemaker device was installed, and Castelli bounced back with barely a pause. He had even managed to have a telephone at his elbow in the intensive-care unit after his operation, so he could talk to Susan Brundage, his chief assistant at the gallery, and within a few days of leaving the hospital he told Blum that he had more energy than before. ("Oh, my God," was Blum's aghast reply.) Certainly it is obvious that Castelli is not going to slow down. "Leo's great merit is not to stop," Ileana Sonnabend said not long ago. "He has kept the freshness and the enthusiasm he had in the beginning. I once told Leo, 'You know, both of us are such adolescents.' Leo laughed and laughed. 'That's true,' he said. 'And nobody knows it but us.' "

(May 26, 1980)

There has been no perceptible slowing down on Castelli's part in the nineteen-eighties. He has taken on several new European artists (Gerard Garouste and Robert Combas, from France; Jiri Georg Dokoupil, from Germany; Miquel Barceló, from Spain), and, in partnership with Mary Boone, Pat Hearn, and other dealers, he has given shows to several of the rising or risen stars of the newest generation of Americans: Julian Schnabel, David Salle, Peter Schuyff, Ti Shan Hsu, and Meyer Vaisman. He keeps up, but he no longer pioneers. Since the seventies, as Castelli readily concedes, he himself has made "no new discoveries."

Toiny Castelli died of cancer in 1987. In 1988, Robert Rauschenberg ended his exclusive thirty-year association with the gallery; temporarily, at least, Rauschenberg went to M. Knoedler & Co., Inc. where his ambitious and costly plan for a globe-girdling project of work and exhibitions will be furthered by the firm's president, Armand Hammer. Castelli was deeply saddened by both these losses. His enthusiasm is undimmed, however, and his friends have come to suspect that he will outlive them all. The city of Trieste bestowed its San Giusto d'Oro award upon him in 1987, in a colorful ceremony that cited him as one of its most famous sons. Galleries and museums throughout the world jostle one another in

their efforts to mount "anniversary" exhibitions in honor of Castelli and
his artists. Castelli clearly relishes the attention. In his late seventies,
and in spite of his success, he seems to go right on having a fine time.

MATISSE'S ARMCHAIR

Modern Art may be finished, but nobody has figured out what to call
its successor. "Postmodern," the term being advanced these days, is no
more than a stopgap, a reminder of the problem. For three-quarters of
a century, serious artists have comforted themselves with the thought
that they were enlisted in the high and rigorous cause of Modern Art,
a comfort denied to artists in earlier periods; the Old Masters may have
thought they were creating Modern Art, too, but that knowledge alone
was not sustainingly uppercase—they were obliged to concentrate on
painting well. In our century, painters have worried less and less about
painting well, or painting at all. What mattered was to be modern,
which meant, for some, purifying art by reducing it to the rock-bottom
essentials of color and form, and, for others, extending art's reach by
knocking down the barriers between it and everyday life. Neither course
seems to hold out the slightest appeal to young artists today. In fact,
the most recent tendencies appear to be not only postmodern but anti-
modern.

What could be more *retardataire* than the current rediscovery of
decoration as an aesthetic principle? The word "decorative" has been
a term of contempt for decades, a sure and easy way to dismiss an artist's
claims to serious attention. ("No, painting is not made to decorate
apartments. It is an instrument of war, for attack and defense against
the enemy"—Picasso, in 1944.) In the second half of the seventies,
however, a dozen or so American painters and sculptors have cultivated
extravagantly decorative styles, often borrowing their motifs from pre-
modern sources such as Oriental rugs, Chinese porcelains, and Islamic
interiors. Their work, referred to as "pattern painting" or "pattern-and-
decoration," has caused an immoderate stir in Europe, where important

collectors are buying it up as fast as they can, and it is now catching on here as well. No museum has embraced the trend as yet, but several group shows have been organized, critical appraisals have appeared in the art press, and prices are rising predictably. Clearly the art market will have no trouble accommodating itself to the latest heresy. One can almost hear a susurrus of relief. Real painting again, after the lean years of "specific objects"—those impersonal, bland, repetitive products of Minimal art. Something to look at, for a change, after the glum verbosities of Conceptualism. The accompanying obbligato of scorn is audible as well. Pattern painting's instant success confirms long-held convictions that the art world is by now totally corrupt and commercialized, that serious art is no longer possible inside "the system."

Pattern painting came right out of the contemporary art-support system, no doubt about that. Virtually every one of its practitioners holds either a B.F.A. or an M.F.A. degree from one or another of the accredited college art departments that turn out fifteen thousand graduates each year in this country. Robert Kushner and Kim MacConnel, two of the movement's best-sellers, were classmates at the University of California at San Diego; Joyce Kozloff took her B.F.A. at Carnegie Tech and her M.F.A. at Columbia; Ned Smyth graduated from Kenyon with high honors in art; Brad Davis studied at the Art Institute of Chicago and took his B.F.A. at the University of Minnesota; Tina Girouard is a B.F.A. graduate of the University of Southwestern Louisiana. And so on. No college dropouts in this group. They came out of school knowing all there was to know about Modern Art, its significant battles and dates, its wars of succession, its multiple discoveries and the theories to go with them. They also learned some earlier art history, and looked at a lot of reproductions (even some originals) of pre-Modern, non-Western painting, sculpture, architecture, and decorative art.

By the time these bright young men and women graduated, in the late sixties and the early seventies, the advanced art being shown in New York and elsewhere was Minimal or Conceptual. Some of them started in there, of course, painting monochromatic squares or making pencil marks on walls. But the feeling had already spread that Minimal and Conceptual were dead-end styles, signposts marking the last few kilometres of modernism's long path. Minimal and Conceptual were so *boring*, so relentlessly drab and self-referential, that it began to seem as though their real underlying purpose was to bring down the system itself, to undermine the art world (corrupt and commercialized) and to

set up something else in its place: the artist as shaman, perhaps. But the younger artists were not interested in becoming shapersons.

Kushner, who had started making fantastic-looking costumes while he was still in college—costumes that doubled as wall pieces when he was not using them in performance works—came to New York in 1972, got a job in a SoHo restaurant, and spent a lot of his free time making calligraphic drawings with India ink on rolls of cheap paper. A two-month trip to Iran in 1974 rekindled his interest in Oriental rugs (MacConnel and his wife had turned him on to them when all three were still in San Diego). When Kushner got back to New York, he apprenticed himself to a rug repairer and worked at that trade until his calligraphic, Orientalized pattern paintings started to sell. MacConnel, who also came to New York, and who remained in close touch with his former classmate, acquired a sewing machine and some bolts of printed cloth from yard-goods stores; he cut and sewed strips of patterned cloth together with plain cloth on which he painted his own designs to make fabric collages that he pinned, unframed, to the wall. Brad Davis, who came East (from Minnesota) in 1966, had his epiphany at Hunter College in 1970, in a graduate course on Islamic art. The following year, he began making pictures that looked like enlarged Persian miniatures or Chinese vase paintings, with images of stylized trees, plants, lean hounds, and waving grass. Joyce Kozloff dates her disenchantment with formalized abstract painting from a 1973 trip to Mexico, where she sketched the brick and tile and stonework façades of ancient Mayan temples and Churrigueresque churches. Miriam Schapiro's exuberant fabric collages, or "Femmages," as she calls them, are the direct outgrowth of her involvement in the feminist movement. Well known for two decades as an Abstract painter, Schapiro has said that feminism was for her "a way of questioning all assumptions, including assumptions about art. I stopped worrying whether this or that approach was 'legitimate.'"

Miriam Schapiro and her husband, the painter Paul Brach, were teaching in the Art Department at the University of California at San Diego when Kushner and MacConnel were students there. It became evident to them at the time that other artists, independently, were breaking out of the Minimalist straitjacket, and when Schapiro visited New York in 1974 she and Robert Zakanitch, who was also doing decorative paintings, organized an open meeting of some twenty of these artists; slides were shown, and the general impression spread that a new sensibility was afoot. Feminism had apparently influenced the

men as well as the women. Everyone was questioning old assumptions, and the men felt free to experiment with "decorative" materials and techniques long considered to be the province of women.

A number of the younger artists in the group gravitated to 112 Greene Street and 98 Greene Street, in SoHo—two of the early "alternative spaces" that emerged in the seventies to show not only painting and sculpture but also video and film works, and the sort of performance pieces that came out of Conceptual Art. Kushner did a performance in 1972 called *Robert Kushner and Friends Eat Their Clothes*, in which the artist and his associates came out costumed from head to toe in fresh fruit and vegetables, which were consumed or otherwise redistributed in the course of the performance. Holly Solomon, who ran 98 Greene Street, was very much impressed by Kushner. He told her that he wanted to elevate decoration and fashion to a higher aesthetic status. Decoration and fashion were the most derogatory categories in art, he said, and what interested him was trying to lift them up, just as the Pop artists had elevated commercial art.

Holly Solomon was an actress manquée. She had spent years auditioning for parts, taking acting classes, working occasionally Off Off Broadway, but getting nowhere. Her husband, Horace, had his own business (women's hair accessories), so she didn't starve. After making the rounds of the casting offices each day, she got in the habit of visiting the Museum of Modern Art, or the Whitney, or the Guggenheim, and that led her to visit art galleries. Eventually, in the mid-sixties, the Solomons started to buy pictures. They bought Pop Art at first, until the prices soared out of their range. They investigated Earth Art. In the fall of 1969, they rented the small loft at 98 Greene Street. Holly presented some short plays she had written—she had not yet abandoned the theatre entirely. There were also poetry readings, dance recitals, performances by artists, video and film showings, and exhibitions of new art—some Minimal, some Conceptual, and some blatantly decorative. When she took the commercial plunge in 1975 and opened the Holly Solomon Gallery, on West Broadway, her stable of artists included Kushner, MacConnel, Davis, Smyth, Girouard, Zakanitch, Joe Zucker, and several other pattern artists, most of whom are still with her. Other dealers and several artist friends told her she was making a huge mistake—pattern-and-decoration was not and would never be "mainstream." After two lean seasons, though, a Swiss private dealer, Thomas Ammann, came in out of a snowstorm and bought several

pattern works, and the rush was on. So far, the major buyers have been
European. Dr. Peter Ludwig, the West German chocolate manufac-
turer and Medici of contemporary art collecting, has bought in depth.
A group exhibition of Herr Ludwig's holdings in this line is currently
on view at the Neue Galerie-Ludwig Collection in Aix-la-Chapelle,
under the title "The New Fauves." Other dealers have lost no time
catching the decorative wave: James Mayor in London, Daniel Templon
in Paris, Bruno Bischofberger in Zurich, Rudolf Zwirner in Cologne,
and Robert Miller, Tibor de Nagy, and the Lerner-Heller Gallery in
New York.

Fauvism is assuredly among the historical sources employed by the
pattern artists, or at any rate by some of them. MacConnel, who seems
to me the most accomplished of the group so far, has obviously looked
long and hard at Matisse, and not only at Fauve-period Matisse.
MacConnel's overstuffed furniture—armchairs, sofas, ottomans—which
he bought in Mexico and painted over in his opulent, flowing style,
suggests a sort of irreverent homage to the Master, who once said that
he dreamed of an art that would be "like a good armchair which provides
relaxation from physical fatigue." Matisse borrowed design motifs from
the decorative arts, of course, and painted odalisques in Moorish in-
teriors. The great synthesis of drawing, color, form, and composition
that made his art one of the century's monumental achievements has
been rather narrowly interpreted by his recent followers; Matisse reduced
to his purest and narrowest comes out Ellsworth Kelly. A younger artist
who looked hard at Matisse today, though, might easily decide that
decoration was not such a derogatory category after all.

Are MacConnel, Kushner, et al., really and truly anti-modern, then?
A few of their sources are more contemporary even than Matisse, as a
glance at the new architecture makes clear. The Bauhaus-pure severity
of the International Style succumbed several years ago to the battering
of a new eclecticism, a zestful willingness on the part of young architects
to ransack the past, and even to experiment with the sort of ornamental
detail that we all supposed Mies van der Rohe had expunged for good.
Most of the pattern artists are interested in the architectural use of space.
They want their work to surround the viewer; Ned Smyth and Thomas
Lanigan-Schmidt make whole-room "environments" suggesting gaudy
temples or shrines—wildly fanciful spaces done in a spirit of playful
exoticism that has more than a little in common with the "illogical"
architecture of Frank Gehry or Stanley Tigerman.

There is, moreover, the interesting question of Frank Stella's latest work. Stella is one of the most influential artists around. His early black-and-white-striped paintings, and his insistence that there were no humanistic values to be found in them—that "only what can be seen is there"—functioned as a major inspiration for Minimal Art. His concentration on certain highly specific "problems" in abstract painting provided fuel for the pseudo-scientific theorizing of Conceptualism. Yet Stella has said that his main interest is "to make what is popularly called decorative painting truly viable in unequivocal abstract terms." He wants his pictures to be not conventionally decorative but decorative "in a good sense, in the sense that it is applied to Matisse." Stella's two most recent shows jolted his ardent admirers. The series of brilliantly colored paintings on aluminum which he called *Exotic Birds*, shown at Knoedler in 1976, and the series of *Indian Birds*, at Leo Castelli's in 1979, were gorgeous pictures, opulent and seductive. To the Minimally dulled eye, they were baroque, overpowering, embarrassing. Both shows sold out—by no means the usual thing for Stella. Not everyone was embarrassed.

Which brings us back to the problem of what comes after Modern Art. I suppose the answer is simply modern art. If the decorative impulse is not anti-modern, after all—and it is not—then perhaps the time has come to acknowledge that there is not and never has been such a thing as Modern Art. All new art is modern for a while; the mistake was to posit a style called Modern. As Marcel Duchamp once said in another context, "There is no solution because there is no problem."

(February 25, 1980)

ROCKS

"Being half-Japanese and half-American, I am always nowhere," Isamu Noguchi said the other day. Although he said it humorously, in his brisk and cultivated voice—we were sitting in the kitchen of his studio in Long Island City, in a nondescript industrial neighborhood that is itself a sort of nowhere—he was making a somewhat bitter point. At

the age of seventy-five, Noguchi had three exhibitions running in New York. The Whitney Museum's "Isamu Noguchi: The Sculpture of Spaces" (through April 6th) focusses on his career as a stage designer, principally for Martha Graham, and on his emergence in the last decade as one of the world's most active sculptors of large commissioned works for public spaces. Concurrently, the André Emmerich Gallery was showing a group of his horizontal, tablelike stone and marble "landscapes," done over the last decade; and twenty-four of his more recent, small stone pieces were on view at the Pace. In spite of this freshet of public recognition, however, Noguchi's place in contemporary art remains strangely elusive and uncertain. He is a master whose credentials are still in doubt.

To some extent, this is the result of prevailing critical winds. As a sculptor whose natural mode is *taille directe*, or direct cutting and shaping of materials, Noguchi has gone against the critical doctrine that saw in Picasso's welded metal constructions of the nineteen-thirties the true path of modernism. Nor have his excursions into theatre, architectural sculpture, and industrial design won him any points with the so-called formalist critics, who find his work too tasteful, too commercial, or simply too unconstrained. But critical doctrine does not make or break reputations in the visual arts. The real trouble seems to be that Noguchi, for reasons that bear directly on his development as an artist, has never settled long enough in one place, geographically or aesthetically, to make it his own.

He was born in 1904, in California. His father, Yonejiro (Yone) Noguchi, was a Japanese poet, an art historian, and a professor of English. His mother was Leonie Gilmour, an American writer and schoolteacher of Scotch-Irish and American Indian parentage. Shortly before his son was born, Yone Noguchi resumed his teaching position at Keio University in Tokyo, and by the time Leonie and Isamu were able to follow him, two years later, he had taken a Japanese wife. Isamu was brought up by his mother in Japan. He went first to a Japanese elementary school and then to a French Jesuit academy in Yokohama. When he was thirteen, his spirited mother used her savings to send him to school in America. Yone Noguchi, who had largely ignored his cast-off family until then, intervened to oppose the move, but Leonie Gilmour was determined. She put Isamu on a boat to San Francisco, and from there he made his way, alone, to the Interlaken School in

Rolling Prairie, Indiana. Two months later—this was in 1918—the school was commandeered by the United States Army as a transport-training center. Noguchi stayed on for a year, living with a caretaker on the property, until Dr. Edward A. Rumely, the founder of Interlaken School, took him in hand. Rumely was a single-tax Socialist and a friend of S. S. McClure, the press lord. He became the first of Noguchi's important teachers, giving him books by Theodore Dreiser and Frank Norris, instilling his own populist ideas (later Rumely grew increasingly right-wing), and arranging for him to live with a Swedenborgian minister's family in nearby La Porte, where he finished high school. "So, you see, I'm a Hoosier," Noguchi told me. "I had a Japanese childhood but an American boyhood, with a paper route and all those things."

Dr. Rumely wanted him to study medicine. But when Noguchi said he thought he wanted to be an artist, Rumely managed to get him apprenticed to Gutzon Borglum, the violator of Mount Rushmore. Borglum had a big place near Stamford, Connecticut. Noguchi tutored Borglum's young son, cut firewood, and posed on a horse for an equestrian statue of General Sheridan. After three months of this, Borglum told him he would never be a sculptor. Noguchi decided to take Rumely's advice and study medicine. A group of Rumely's friends raised the money, and he entered Columbia in 1923. That year, Leonie Gilmour came back to America. She took a small apartment on East Tenth Street, and it was she who persuaded Noguchi to enroll in the Leonardo da Vinci Art School, at Tenth Street and Avenue A. Within three months, Onorio Ruotolo, the school's director, had turned him into an astonishingly facile academic sculptor. Noguchi's skill so impressed the Old Guard of the National Sculpture Society that he was elected a member and had works exhibited at the National Academy of Design and the Architectural League. Naturally, he dropped out of Columbia. But he also discovered Modern Art, at Alfred Stieglitz's An American Place and at J. B. Neumann's New Art Circle, and this made him dubious about his own sentimental nudes and portrait heads. Constantin Brancusi's famous New York show at the Brummer Gallery in 1926 crystallized these uncertainties. Noguchi applied for and won a Guggenheim Fellowship and hurried off to Paris, and the day after he got there Robert McAlmon, one of the most visible American expatriate writers, introduced him to his second great teacher, Brancusi. For the next few months, he worked in Brancusi's studio in the Impasse Ronsin,

learning by example, for Brancusi spoke no English and Noguchi no French. It was a world in white. "He wore white, his beard was then already white," Noguchi wrote in his autobiography, A *Sculptor's World* (1967). "He had two white dogs that he fed with lettuce floating in milk. My memory of Brancusi is always of whiteness and of his bright and smiling eyes."

After Brancusi came Buckminster Fuller. When Noguchi got back to New York, in 1929, Fuller was in full early cry, expounding salvation-through-design at the rate of seven thousand words a minute. About the only people willing to listen to his ideas in those days were artists. Fuller and Noguchi became lifelong friends. "I was impressed by Bucky's non-aesthetic," Noguchi told me, "by his considering structure more important than aesthetics. Also, he was really preaching social revolution, and that appealed very much to me. We would walk all over New York, him talking and me listening." Noguchi supported himself in this phase by sculpting portrait heads. It was partly a way to earn a living, partly a way to meet important people, and partly a reaction against Brancusi and abstract art.

His Japanese side rebelled eventually against Fuller's technological utopia. In 1930, he travelled to Peking, where for eight months he studied traditional Chinese brush drawing. Then to Japan—in spite of a letter from Yonejiro Noguchi telling him not to come there using the Noguchi name. (Noguchi had changed his name officially, from Gilmour, in 1924.) A *Sculptor's World* describes their stiff reunion: "My father would come to call on me, and we would hold long silent conversations." Back once again in New York, he exhibited the brush drawings and ceramic sculptures he had done in China and Japan, but sales were so few that he went back to doing portrait heads. Martha Graham, one of his subjects, commissioned him in 1935 to do a set for a new dance, *Frontier*. Noguchi's spare and evocative contribution— a white rope that stretched in a wide V from a wooden fence at stage center to the top of the proscenium on either side—was the first set Graham had ever used, and the start of a collaboration that extended over twenty years. On his own, Noguchi conceived a pyramid-shaped playground that he called *Play Mountain*, and took a model of it to show to Parks Commissioner Robert Moses. Noguchi would later describe *Play Mountain* as a response to his own unhappy childhood, and an attempt to "join the city . . . to belong." Moses treated it "with thorough sarcasm," he recalls, but for the next three decades Noguchi

returned to the idea whenever he had a chance, designing at least three more playgrounds that New York's city fathers found one reason or another not to build.

Pearl Harbor turned him overnight into a nisei. He spent seven months in a government relocation camp for Japanese-Americans in Arizona, and came out with mixed feelings about his citizenship. In 1944, however, he began to carve the interlocking marble-slab sculptures that established him as an artist. Abstract, elegant, superbly finished, and powerfully hieratic, they showed the influence of Surrealism and of Picasso's "bone" paintings of the thirties. Noguchi knew most of the artists of the emerging New York School, whose reactions to the European Surrealists-in-exile among them during the war had led to the series of individual breakthroughs that would be called Abstract Expressionism. The artist he was closest to was Arshile Gorky. Willem de Kooning brought him into the Charles Egan Gallery, where in 1948 he had his first New York show in thirteen years. At this crucial stage in the development of postwar American art, however, Noguchi dropped out. The Bollingen Foundation granted him a travelling fellowship, and for two years he wandered through England, France, Italy, Greece, Egypt, India, Thailand, and Bali. He went on to Japan, where in 1951 he was commissioned to design a garden for the new *Reader's Digest* building in Tokyo—the first of his environmental projects to be carried out. The following year, he went back to Tokyo to design a garden and a room at Keio University in honor of his father, who had died soon after the war. He married Yoshiko Yamaguchi, the Japanese film star. Three years later, they were divorced.

In the expanding New York art world of the nineteen-fifties and sixties, Noguchi was an infrequent and enigmatic sojourner. He could be counted on to leave town, for Europe or Japan or some other part of the world, the day before an exhibition of his work opened. When Arne Ekstrom, of Cordier & Ekstrom, his dealer throughout the sixties, once complained about this habit, Noguchi carved a wooden effigy of himself in profile, to stand in for him at the gallery. He grew secretive about his work, refusing to sell unless he needed money. His sculpture became stronger, less finished, less "tasteful." He worked with aluminum, bronze, wood, steel, and clay, but always he returned to stone—"the basic element of sculpture," as he called it, "the unassailable absolute." He designed and built many gardens: the *jardin japonais* for UNESCO's headquarters, in Paris; the Zen-like white marble patio of the Beinecke

Rare Book Library, at Yale; the sunken court of Chase Manhattan Plaza, in downtown Manhattan. In addition, he designed furniture, and he made and marketed fragile, feather-light, mulberry-paper-and-bamboo lamps that he called *akari* ("light" in Japanese). It was all too much, too confusingly diverse. How could such an outpouring be reconciled with the severities of late-twentieth-century art?

In 1969, he built a house and studio on the Japanese island of Shikoku, and went into partnership with one of the local stonecutters. "It is a stone island," he said, "a real stone place." His New York studio came to serve mainly as headquarters for his many environmental and urban projects; also as a private museum of his work. Most of Noguchi's sculptures now are done on Shikoku. He has mastered the use of large power tools to core and split and polish huge granite and basalt boulders—monoliths weighing up to three or four tons. Few of these roughly worked, primitive-looking pieces have been shown publicly; no gallery or museum floor would support their weight. Thirteen of them stand in the outdoor walled court behind his converted-factory studio in Long Island City.* "Put your head inside that one," he ordered, directing me toward an upright granite pillar with two large, smooth tunnels drilled into it, horizontally and vertically. "There, now you know what stone is!

"I work on two different levels," he said as we walked on. "I work with basic material like stone, and then I also work with technology— coring drills with diamond bits, tensioned steel rods to hold separate elements together, things like that. I'm still a friend of Bucky's, remember. My Japanese side is associated with the past, with old Japan. To be modern means nothing to me, and for that reason young Japanese look askance at what I do. But for me the dichotomy is not so opposed. Ultimately, I like to think, when you get to the furthest point of technology, when you get to outer space, what do you find to bring back? Rocks!"

Noguchi is one of those artists whose talent feeds on contradiction. His career has been a dialectic between tradition and innovation, craft and technology, geometric form and organic form, weight (stone) and weightlessness (paper), the rough and the finished, Japan and America.

*This court and the building next to it now comprise the Isamu Noguchi Garden Museum, which opened to the public in 1985.

Sculpture conducts its own dialectic, of course, between solid volumes and the space around them. "It is space itself that gives validity to sculpture," Noguchi has said. The uncanny, live presence of Noguchi's work must come in some degree from the contradictions of his life. His great strength is that he does not belong.

(March 24, 1980)

THE ART INCARNATE

Andy Warhol has been around so long that he should have started to bore us. His one rival as an artist celebrity, Salvador Dali, became an egregious bore after only a few years in the spotlight, and Dali, unlike Warhol, had the advantage of being able to debase extraordinary gifts. However one views Warhol's gifts, the Warhol phenomenon has continued to amuse, astonish, or appall us for nearly twenty years, and the explanation, I suspect, is that Warhol has worked at it much harder than anyone realizes.

People tend to think of Warhol as a sort of ghostly presence, a pale and languid voyeur who stands in the shadows and occasionally, almost inadvertently, wafts into being a new image. This is part of his myth, but it is wholly misleading. From the moment he came to New York, from Pittsburgh, in 1949, Warhol pursued fame with the single-mindedness of a spawning salmon. He made himself one of the highest-paid commercial artists in New York through hard work as much as through native talent, and then, realizing that a commercial artist's fame was necessarily limited, he pushed on into the less anonymous fields of "fine art," movies, rock music, multimedia spectacles—getting as much exposure as he could out of each, measuring his success by the publicity he generated. He exemplified the sixties notion that anybody could do anything, and for an ecstatic year or so in the middle sixties he seemed on the verge of making it come true. He had the art world, the fashion world, the underground-film world, and the rock-

music world covered, and, having acquired a tape recorder and a couple of high-school girls to turn his tapes into a "novel," he was about to preëmpt the literary world as well. This was the high point in his career, the moment at which, by his own standards, he was most truly intimate with fame.

Now Warhol has written a book about that period. It is called *POPism: The Warhol '60s* (Harcourt Brace Jovanovich, 1980), and it is anything but boring. *POPism* does not read like an edited tape, which may or may not reflect the skill of its co-author, Pat Hackett, a Barnard graduate identified on the jacket only as someone who "has written several screenplays, including Andy Warhol's *Bad*," and who "has known Andy Warhol since 1968." It reads like a novel. The dialogue is terrific, and the violent subplot creates suspense. The book is also social history of the rarest kind, set down in ultra-sharp focus by someone who helped to shape the events he describes, and a good deal of effort has clearly gone into getting the facts right. It is arguably the best piece of work that Warhol has yet given us, in any medium.

Larry Rivers, another artist who has collaborated on an interesting book—*Drawings and Digressions*, with Carol Brightman (Clarkson N. Potter, 1979)—remembers that in the early sixties it became apparent "that one could go into art as a career the same as law, medicine, or government." This was not exactly common knowledge at the time. Most New York artists still saw themselves then as being outside society (heroically so), even though the pioneer Abstract Expressionists were starting to sell their pictures at rapidly escalating prices. Warhol, who had made a lot of money drawing shoe ads for I. Miller, among other clients, was way ahead of the crowd in being able to look on art—fine art—as a career, but he was having trouble getting started. He did some paintings that were based on comic-strip images (Dick Tracy, Nancy, Popeye), and then found, to his dismay, that Leo Castelli had just taken on a young painter named Roy Lichtenstein, who was also using comic-strip images, and doing it better. Like any rising careerist, Warhol got advice from the right people. Emile de Antonio, an artists' agent who later became a filmmaker, came over to Warhol's studio one day and looked at two paintings of a Coca-Cola bottle, one done with a lot of Abstract Expressionist brushwork here and there, the other just "a stark, outlined Coke bottle in black and white." De Antonio told him to destroy the first and show the second. Warhol asked a lot of people for ideas on what to paint. He asked de Antonio, and Ivan Karp, the

associate director of the Castelli Gallery, and Henry Geldzahler, then a curatorial assistant in the American Paintings and Sculpture Department at the Metropolitan Museum, and often he did what they suggested. He had already learned the first great lesson of Pop Art (or Popism, as he has now significantly rechristened it), which was that "Pop comes from the outside." But Warhol was shrewder than his mentors about some things. He asked de Antonio why Robert Rauschenberg and Jasper Johns, the two artists he particularly admired, did not like him. De Antonio said, "Okay, Andy, if you really want to hear it straight, I'll lay it out for you. You're too swish, and that upsets them." This hurt Warhol's feelings, he tells us, but it did not alter his style.

The homosexual issue in sixties art has been exaggerated, thanks in no small part to Warhol. After the hard-drinking, tough-talking machismo of the Abstract Expressionist fifties, some sort of reaction was inevitable on the part of the new artist generation, in social behavior as well as in aesthetics. But Pop Art, per se, was no more homosexual than Impressionism. (Is there such a thing as homosexual art? I doubt it.) Warhol, however, was one of the first to see that homosexual (camp) behavior, openly flaunted, could get you a lot of attention—could be used to advance a career. Warhol played up and exploited the changing attitudes toward sex roles in the sixties. Although he gave the impression of being sexually inactive himself, his studio on Forty-seventh Street near Lexington, painted silver from floor to ceiling and known as the Factory, became a hangout for deviant types of the most flamboyant sort—speed freaks and drag queens and self-dramatizers like Pope Ondine, Rotten Rita, the Duchess, and Silver George, all of whom are vividly memorialized in POPism. The Factory was a tabloid journalist's paradise. "Photographers never had to arrange for 'sittings' at the Factory," Warhol recalls. "All they had to do was come by and shoot."

The Factory produced a lot of artwork. Warhol found out about the silk-screen process, in which images are mechanically reproduced on silk and then transferred to canvas (or other surfaces) by forcing inks through the fine mesh. He hired assistants and marketed hundreds of silk-screen paintings. In the summer of 1963, he bought a Bolex camera and started making movies. It was only natural. As a Pop artist, he was beginning to meet movie stars. Judy Garland and Rudolf Nureyev came to a Factory party, and later in the evening Garland (Warhol's idol when he was a teen-ager) sang "Over the Rainbow" with her mouth

full of spaghetti. Famous movie stars were more famous than famous artists, of course, so Warhol turned the Factory into a sort of low-budget film studio. He made movies the way he had made paintings, which meant "playing up what things really were"—e.g., a six-hour film of a man sleeping, or an hour and a half of Henry Geldzahler smoking a cigar, or eight hours of the Empire State Building just standing there. Any doubts he might have had about this course were assuaged in the fall of 1965, at the opening of a Warhol retrospective at the Institute of Contemporary Art, in Philadelphia. Four thousand students jammed their way into the gallery, crowding it so dangerously that the paintings had to be removed. When Warhol and Edie Sedgwick, his first movie "superstar," made their appearance, the students started screaming and trying to touch them. They took refuge on some iron stairs leading to a sealed-off door and stood there for two hours, unable to leave until the fire department broke through the sealed door and led them over the roof and down a fire escape. "I wondered what it was that had made all those people scream," Warhol tells us. "I'd seen kids scream over Elvis and the Beatles and the Stones—rock idols and movie stars—but it was incredible to think of it happening at an *art* opening. . . . But then, we weren't just *at* the art exhibit—we *were* the art exhibit, we were the art incarnate and the sixties were really about people, not about what they did; 'the singer/not the song,' etc. Nobody had even cared that the paintings were all off the walls. I was really glad I was making movies instead."

Eventually, he became somewhat disillusioned with filmmaking. The truth was that he wanted to get into the big time there, too, just the way he had in art, and he was disappointed to find that the movie business did not operate in the same way as the art business. Warhol was no "underground" filmmaker. Although he spoke of his movies now and then as "a joke," he kept expecting Hollywood to offer him large sums to make big-budget jokes. It annoyed him when, two years after he had made a film about a male prostitute called *My Hustler*, Hollywood gave somebody else the money to make *Midnight Cowboy*: "I still felt that our films, full of the strange, funny people we picked up on, were unique, and I couldn't understand why no big studio had come forward to push us forward." In addition to movies, though, Warhol was also involved with his own rock band, the Velvet Underground, and with his multimedia discothèque and other activities. He had all the major avenues to fame covered, and he felt, as he tells us,

"like I was finally the right type in the right place at the right time. It was all luck and it was all fabulous. Whatever I didn't have that I wanted, I felt that it was just a matter of any day now."

The Warhol express to stardom bypassed vast areas of other people's experience in the sixties. When John F. Kennedy was shot, for example, Warhol happened to be alone in his studio, painting. "I don't think I missed a stroke," he recalls. "I'd been thrilled having Kennedy as president . . . but it didn't bother me that much that he was dead." The civil-rights movement makes a cameo appearance in one or two Warhol paintings (silk-screened news photos of a black man being attacked by police dogs), but Vietnam barely rates a mention, in the new book or elsewhere. What we do get in *POPism*, on the other hand, is a closeup look at the developing drug scene, with its undercurrents of violence and squalor. Several of the Factory faithful die drug-related deaths, some quite spectacular. Freddy Herko, a dancer who exists mainly on amphetamines, goes to a friend's apartment in Greenwich Village, sends everybody out of the room, puts Mozart's *Coronation* Mass on the hi-fi, and, when the record gets to the Sanctus, dances out the window "with a leap so huge he was carried halfway down the block onto Cornelia Street five stories below." Another speed freak, Jimmy Smith, a compulsively violent type who "only stole from his friends," dies in a fall from another fifth-floor window, presumably while attempting a robbery. Edie Sedgwick retires to California, where in 1971 she dies of "acute barbital intoxication." Although Warhol intimates that he never took drugs, he apparently made no effort to discourage those around him from doing so. It reached a point, he says, where "you never knew if you were getting to know the person or getting to know the drug they were on."

Violence kept seeping into the Factory itself, in spite of Warhol's and his associates' random efforts to keep it out. There were occasional fistfights in the back room, where the homosexual acts and the shooting-up took place. In 1964, a woman whom Warhol vaguely remembered having seen once or twice before came in, took out a gun, and shot a hole through four paintings of Marilyn Monroe that were stacked against the wall. Three years later, a strange man pulled a gun on the whole Factory crew and made them sit on the couch while he ranted crazily about money that was owed him until Taylor Mead (Taylor Mead! Wispy, fey, slightly lopsided Taylor Mead, the comic underground-film star who looked as though a good gust of wind would carry him

off) sprang on his back like an enraged chipmunk and the gunman ran away. Soon after that incident, Warhol & Company moved to new and, they hoped, safer quarters, in an office building on Union Square West. And it was there, one day in 1968, that Valerie Solanis rode up in the elevator with Warhol, wandered in, and started shooting. Valerie Solanis was the founder and sole member of an organization called SCUM, whose letters stood for the Society for Cutting Up Men. She had written a film script that she wanted Warhol to produce, but it was too dirty even for Warhol. She also had a .32–calibre automatic in a paper bag, with which she shot Warhol two times at close range, penetrating his stomach, liver, spleen, esophagus, and both lungs.

Somehow Warhol survived. Months later, though, when he was still in great pain but out of danger, he was terrified that the shooting might have ended his career. "I was afraid that without the crazy, druggy people around jabbering away and doing their insane things, I would lose my creativity," he confides. "After all, they'd been my total inspiration since '64, and I didn't know if I could make it without them." Warhol's freaks and superstars sank back into the mire of anonymity, but Warhol did not, which ought to suggest something about his motivation. Warhol bided his time for a couple of months, and then went back to work. In the fall of 1969, he started a magazine, *Andy Warhol's Interview*, a jet-set gossip sheet that is still going strong. He began painting again—mostly portraits, some on commission and some on his own. Warhol has always been basically a portraitist: his films were portraits; even his early soup-can paintings were portraits; his ads for I. Miller were portraits of shoes. The Warhol portraits of the seventies, for the most part, are of wealthy or socially prominent men and women (Giovanni and Marella Agnelli, Kay Fortson, Diane von Furstenberg) or else of famous international stars, living or dead (Liza Minnelli, Mick Jagger, Mao Tse-tung). They are derived from photographs, blown up on silk screens and transferred to canvas, with hand-painted backgrounds and applications of pigment here and there by Warhol, who took most of the original photographs himself. Warhol likes to take pictures of celebrities, his notion of a good photograph being "one that's in focus and of a famous person doing something unfamous," such as Bianca Jagger shaving under her arm. In 1979, he published a book of these, called *Andy Warhol's Exposures* (Grosset & Dunlap). The principal difference between his *Exposures* and his silk-screen portraits seems to be that the *Exposures* are not retouched. When the Whitney Museum

showed a selection of his silk-screen portraits in the fall of 1979, the catalogue note by the adventurous and always entertaining art historian Robert Rosenblum placed Warhol in the pantheon of portrait art somewhere between Édouard Manet and John Singer Sargent.

Apart from Warhol's survival as a human being, an artist, and a celebrity, the interesting thing is that he has so often been taken more seriously, in certain art-world circles, than he takes himself. Warhol has consistently made it clear that what he cares about is fame, period. He has pushed a clever, minor talent to its utmost to achieve this goal, working harder than anyone gives him credit for, showing a toughness and an instinct for the main chance that one expects of a child of immigrants (which he is), making sure that if Popism, as he remarks at one point, is "doing the easiest thing," then he is going to do it more assiduously and thoroughly than anybody else. Warhol's whole career is an up-to-the-minute indication that fame can be more than its own reward.

(May 5, 1980)

Warhol died on February 22, 1987, of a heart attack, a few hours after undergoing gall bladder surgery at the New York Hospital–Cornell Medical Center in Manhattan. He was fifty-eight at the time. The extent of his fame was dramatically evident at the subsequent memorial service, which was the occasion for these paragraphs in The New Yorker's *"Notes and Comment" section.*

Andy Warhol was the most famous artist of our time. The memorial Mass in his honor at St. Patrick's Cathedral on April 1st made this abundantly clear; it had the character of a state funeral, with people coming from as far away as Los Angeles and Milan to attend. There were so many celebrities among the more than two thousand mourners that traffic on Fifth Avenue was disrupted by spectators and photographers trying to get a glimpse of them. No other twentieth-century artist— not even Picasso—could have drawn this sort of crowd, and it is difficult to think of any other public personality who could have done so, either.

All this is a little hard to account for. Warhol's fame did not seem to have much to do with his art. He was neither the best nor the most popular artist of his era, and his prices—a reliable barometer in the commercialized art world that Warhol did so much to foster—did not keep pace with those of several of his less famous contemporaries. Except

for the paintings of Campbell's soup cans, with which he began his career in art (his second career, that is; he had already made it big as a commercial artist), and those silk screens of Marilyn and Mao, who outside the art world could identify a single picture by Warhol? And yet nearly everyone knew him by sight—those strange, masklike features and that thatch of chalk-white hair. I was walking up Madison Avenue one day in the mid-nineteen-seventies, past a building site where construction workers were taking their lunch break, and I heard one of them say, "Look, there's Andy." Sure enough, Warhol was on the opposite corner. What other contemporary artist had that kind of instant recognizability?

Nevertheless, he was not really a public figure. He turned up often enough in the gossip columns, as a guest at this party or that social event, but for the most part he lived quietly, kept to himself, and was famously mute. The truth is that the man who lived behind Warhol's mask was virtually unknown. So what is the explanation? How did this sickly child of immigrant (Czech) working-class parents in Pittsburgh become so famous and stay so famous, right through the nineteen-seventies and into the nineteen-eighties? The answer, I think, is that he was in some sense a true mirror of his time.

In a thoroughly unsystematic effort to test this theory, I have made a list of qualities that I associate with Warhol's life and Warhol's career. Other people would no doubt come up with an entirely different list— mine leaves out a lot—but I offer it anyway to sociologists of the future, on the assumption that you have to start somewhere:

His all-embracing permissiveness. The idea behind Pop Art, he said, was that "anybody could do anything," and he applied this to life as well as art. Warhol became a hero to many young people in the sixties because he seemed to be the ultimate anti-parent. Anything you did was O.K., even if you killed yourself doing it.

His passivity. In what went on at the Factory—the drug-taking, the sexual deviation, the exhibitionism—Warhol was never an active participant. He was a voyeur, a lens, registering every nuance of behavior with a movie camera. Some people claimed he exploited sick egos for his own profit, but Warhol's films did not make money. What took place inside the Factory was a pressure-cooker version of certain trends in the culture at large—for example, the disavowal of male authority.

His obsession with fame and celebrity and stardom. This was no put-

on. Warhol really did worship Judy Garland, Liz Taylor, Marlon Brando, Marilyn Monroe, Jacqueline Kennedy, and the other subjects of his multiple-image silk-screen paintings. They formed a glamorous and highly effective defense against the real world—and against any potential pressure for self-knowledge or self-disclosure.

His boundless, though well-concealed, capacity for hard work, and his highly successful effort to equate art-making with money-making in other fields. "Why do people think artists are special?" he said. "It's just another job." His admirers tended to think he was kidding when he talked like that, but I think he meant it.

His apparent lack of emotion. Warhol's most highly charged images—automobile wrecks, electric chairs, Jackie Kennedy in the aftermath of her husband's death—came across with the same deadpan, affectless candor that characterized his silk-screened flowers and his portraits of a cow. Not one ounce of sentiment disturbs the numb silence of these images. "If you want to know all about Andy Warhol," he said, "just look at the surface—of my paintings and films and me—and there I am. There's nothing behind it."

If there is a common thread running through this brief list, it should become clearer in time. What seems striking right now is that the man who once said that in the future everybody would be famous for fifteen minutes has turned out to have such a durable hold on our collective imagination.

(April 27, 1987)

A THOUSAND FLOWERS

A balmy spring Saturday on Spring Street, warm sun and cool breezes, not a cloud in the sky. It is 1 P.M., a little early for the uptowners and the suburbanites, for whom SoHo and its art galleries, boutiques, restaurants, bars, and sidewalk entertainments offer the best free show in town. The show has started nevertheless. Near the corner of Spring and

West Broadway, two dozen people who look like natives have paused to listen to a fiddler and a banjo player knocking out the music of the Southern Appalachians. The fiddler is young, with a chestnut mustache and beard; bright suspenders hold up his jeans, and he beats energetic time with one booted foot. The banjo player has a black beard and a black hat, and, strumming a mile a minute, he gives the impression of being motionless. The audience lolls back against the parked cars and applauds each number. The young fiddler grins and bobs his head as he thanks them. "Old instrument gettin' warmed up," he says.

Down the block on West Broadway, Ivan Karp is in the back room of his O.K. Harris Gallery, looking at slides of an artist's work. He keeps up a melodious obbligato of comment and banter which may or may not put the artist at ease. Karp, an effervescent man and the fastest talker in SoHo, claims that he looks at the work of a hundred and fifty to two hundred artists a week, without appointment. About a third of the artists he sees are fully professional, he says, and out of that number maybe twenty deserve to be shown in a New York gallery. Karp's gallery was one of the first to open in SoHo, in 1969, and it is still the largest. It has eleven thousand square feet of floor space divided into five exhibition areas; Karp puts on four one-artist shows a month—forty-one shows a year. Naturally, every artist comes to see him. He has taken on only two new artists in the last year, he says, but his expectations are forever buoyant. After all, this was how he discovered Roy Lichtenstein, back in 1961. Karp was the associate director of Leo Castelli's gallery on East Seventy-seventh Street then, and one day Lichtenstein just walked in, unannounced, with a couple of Pop Art paintings under his arm—this was before Karp or anyone else knew there would be such a thing as Pop Art. The new genius might turn up at any time. "It's what makes all this anguish and folly possible," Karp says. "We're all really looking for Jesus."

Undiscovered artists no longer live in SoHo, of course. The industrial loft buildings where button-makers and garment workers once toiled, now expensively converted to residential use, sell for upward of fifty dollars a square foot, and all sorts of people manage somehow to meet the municipal requirement that you have to be an artist to live there. But SoHo is still the nexus, the community center of the downtown art world. On Saturdays, it is a souk, a pageant. On the sidewalk in front of O.K. Harris, two young women are dancing on stilts, accompanied by a young man with a harp. The dancers are costumed in

flowing silks, with flowers woven into their long, Botticelli hair. On-lookers toss coins into a battered felt hat on the sidewalk. A block north, on the other side of Spring Street, a puppeteer puts a disco-dancer puppet through her paces, to music from a transistor tape player. A woman emerges from the boutique behind him wearing a purple jump-suit and green leather boots. Traffic, both pedestrian and automotive, is building up steadily.

"What's good?" the gallerygoers ask each other. "What have you seen?" Replies tend to be vague and noncommittal. Lots of good shows, few surprises. Pluralism reigns in the visual arts. A thousand flowers bloom, a thousand schools contend—yet everything looks just a bit familiar. Ivan Karp perceives a new wave that he calls "illusionism": dozens of young people around the country making trompe-l'oeil objects of one material (clay, for example) which look exactly as if they were made of some other material (leather, for example); painters creating the illusion of visual depth through the use of cast shadows; artists everywhere rediscovering the techniques of pre-modern art. Barbara Rose, an influential critic, teacher, and art historian, recently stirred up a lot of indignation by organizing a travelling exhibition called "American Painting: The Eighties." (It is now in Paris.) The indignation referred partly to Rose's seeming to preëmpt the next decade, and partly to the show's premise, which was that abstract painting has returned from the dead. To date, however, the season's most exhilarating gallery show has been last month's exhibition "Eight Painters of the 1960s," from the collection of Mr. and Mrs. Burton Tremaine, at the Pace Gallery, uptown.

It is frequently observed that no major new artists emerged in America during the nineteen-seventies, and that the most impressive work today is the new work of Frank Stella, Jasper Johns, and one or two other six-ties stars. Of course, the next genius may be right in front of us, working away in a manner so unfamiliar that nobody can see what he's up to. During the early sixties, a curator at the Museum of Modern Art asked me what I was up to, and expressed great surprise and disdain when I said I was writing a Profile of Robert Rauschenberg for *The New Yorker.* A number of New York artists thought this same curator was unsym-pathetic to their work, and they felt much happier when he moved to California. At a MOMA opening shortly before he left the Museum, he saw Stella chatting with two other painters, and paused to ask if any of them knew what time it was. "Time to go to California," said Stella.

In 1980, though, it is hard to believe that a new Stella or a new Rauschenberg could go unrecognized, even for a week. More than a hundred galleries in New York concentrate on showing contemporary work (as against a dozen or so in 1960).* American colleges and universities turn out close to fifteen thousand arts graduates a year, young men and women schooled in the talismans of vanguardism and fully sympathetic to what Harold Rosenberg called "the tradition of the new." Nobody is obliged to cut off his ear in this society. Is it possible, in fact, that the practice of art today has become too easy? All those college grads know that art is whatever the artist decides to make (or not to make, if he happens to be a Conceptualist), and the key question— How Do You Know You're an Artist?—rarely gets asked. One *decides* to be an artist, acquires a B.F.A. or M.F.A. degree, and after that whatever one makes must be art. Having no dominant style to assimilate or to rebel against, the young artist confronts a limitless range of possibilities; it could also be argued that this makes the practice of art more difficult than ever. Where originality is so highly placed, mere novelty obtrudes. Any number of budding talents appear sui generis to a fault.

In the absence of new geniuses, though, there is plenty to look at, and not only in the galleries. The mood of SoHo is easygoing and a little decadent. On a brick wall down near Laight Street somebody has written in foot-high capitals, "NEW YORK IS THE ART SACRILEGE," but who cares? The established artists dine expensively with their dealers at Da Silvano's or Ballato's, the restaurants most in favor right now. (New restaurants open all the time. *Anderson & Archer's SoHo: The Essential Guide to Art and Life in Lower Manhattan*—a well-informed paperback published by Simon & Schuster in 1979—listed sixty restaurants and bars in the immediate area.) At a sidewalk table in front of Ben's Gallo Nero, just south of Broome Street on West Broadway, two young men listen attentively while a young woman plays a complicated solo on a French horn. Nearby, a dancer made up to look like Charlie Chaplin performs to Chopin (on tape) while a colleague passes out leaflets advertising their dance company. Informal exhibitions of photographs, prints, drawings, collages, and even sculptures enliven the grimy exteriors of the buildings along West Broadway, a few of which still harbor industries unrelated to art. An artfully lettered sign, weathered but grammatical,

*By 1987 the total was more like four hundred.

reads: "Stay Sharp—Nine Out of Ten Persons Passing Here Need Something Sharpened." Venders sell hand puppets, knitted hats, herbal sachets, exotic foodstuffs. A middle-aged man stands on a tiny stool under a sign reading "Stories Poems and Other Surprises." A pretty woman with long dark hair sits on a window ledge quietly weeping. The Saturday crowd meanders up and down and spills over into the street, where traffic is at a standstill. Couples push strollers or carry their young in canvas slings. Three more purple jumpsuits are counted.

In the Holly Solomon Gallery, I bump into Letty Lou Eisenhauer, someone I haven't seen for years. Letty Lou was an active participant in the sixties art scene. The first time I saw her, she was performing in Allan Kaprow's *A Spring Happening*, at the Reuben Gallery, in 1961. Kaprow liked to involve the audience physically in his happenings, and for this one we were herded into a narrow makeshift tunnel with windows of clear plastic, through which we strained to see what was going on in the darkened space outside. What we saw, toward the end of the performance, was Letty Lou, in a flesh-colored body stocking, tossing bits of fresh broccoli into the beam of an erratically roving spotlight. In the seventies, Letty Lou went into arts-administration work, and I lost track of her. Now she is a psychiatric interne. "It turns out I'm very good with schizophrenics," she says, and we both laugh.

Sixties art makes SoHo possible. We are still drawing on energies generated twenty years ago, and that knowledge lends the SoHo scene its diffuse, uneasy glamour.

(May 19, 1980)

AUTOBIOGRAPHY

Once you get beyond the virtuosity of his student work—the first of countless dazzlements in the chronological cornucopia of "Pablo Picasso: A Retrospective," at the Museum of Modern Art—the next order

of fascination is in the early self-portraits. We seem to be dealing with several different and incompatible selves. In the spring and summer of 1901, he made two self-portraits in which he is looking straight at you, with a gaze so powerful and aggressive that you have trouble meeting it. (Fernande Olivier, his first long-term mistress, would later remember those famous eyes as "dark, deep, piercing, strange, and almost staring.") Paint-loaded brushstrokes in the van Gogh manner define his black hair and thick, sensual nose and mouth. Picasso was nineteen years old, on his second trip to Paris, and already launched—fifteen paintings sold even before the opening of his first exhibition at Ambroise Vollard's gallery, that June. Clearly, nothing would stop this juggernaut, this arrogantly self-confident ruffian who subtitled one self-portrait *Yo Picasso* ("I Picasso"). Toward the end of 1901, he painted himself again, this time as a sombre, hollow-cheeked outsider in a black overcoat, against a blue-green background. Picasso was on the verge of his Blue Period, and self-pity lay just around the corner. He planned to use his own face for the nude male figure in an allegorical painting called *La Vie*, did a sketch that made him out to be as handsome as a film star, then decided to use instead the sad face of his Barcelona friend Carlos Casagemas, who had recently killed himself in a Paris café. Meanwhile, a 1901 oil-on-paper gives us Picasso the man-about-town (in a top hat), and quick sketches in 1902 and 1903 show him as a sporty type walking his dog, as an overdressed bourgeois, and, in caricature, as a naked, grinning ape with paintbrushes behind both ears. In the 1904 painting *Meditation*, he reappears as a sensitive, poetic, yet virile lover, sitting pensively by the bedside of the sleeping Fernande.

It is true that the entire exhibition—nearly a thousand paintings, sculptures, drawings, prints, and other works, filling all three floors of the museum until mid-September—can be viewed as a self-portrait. Picasso was the most subjective artist who has ever lived. "I paint the way some people write their autobiography," he told Françoise Gilot, the mother of two of his children. "The paintings, finished or not, are the pages of my journal, and as such they are valid. The future will choose the pages it prefers." All the same, it is probably futile to search the paintings for clues to the man. There were always too many selves, and some of them were truly incompatible. Although he revealed himself at every turn, he remained as enigmatic, as impenetrable, as the Iberian stone carvings with which he shattered all those centuries of Western art.

▲▲▲

The *Portrait of Gertrude Stein* obsessed him for months. Stein submitted to eighty or ninety sittings in the winter and spring of 1905–06, but before Picasso went away on vacation to Gosol, in the Pyrenees, he became dissatisfied with the head and painted it out. When he came back to Paris in the fall, he finished the painting without asking Stein to sit again. The masklike, "Iberian" face is truer than any likeness. ("We all know that art is not truth," Picasso said in 1923. "Art is a lie that makes us realize truth.") As Stein once wrote, the portrait "is the only reproduction of me which is always I, for me."

One summer morning in the twenties, on the beach at Antibes, Picasso's American friends Gerald and Sara Murphy saw him walking toward them laughing and waving a letter. The letter was from Gertrude Stein, and in it she said (according to Picasso's paraphrase) that she had just seen, at the Rosenberg Gallery in Paris, a recent Picasso painting that she admired intensely and she wondered whether she could have it in exchange for his portrait of her—the 1905–06 portrait, which had given him so much trouble, and which he had presented to her as a gift. The Murphys were shocked, and said so. "*Ah, oui,*" Picasso said, still chuckling, "*mais je l'aime tellement.*"

In the first two galleries on the museum's second floor, the energy is so concentrated, so intense, that viewers tend unconsciously to lower their voices. Picasso's Analytic Cubist paintings of 1910–12 may represent the high point of his career, but they are also unique: never before or afterward was there such a suppression of self. William Rubin, the director of MOMA's Department of Painting and Sculpture, who planned and organized this great exhibition together with Dominique Bozo, the curator-in-charge of the not yet opened Musée Picasso in Paris, has come to the conclusion that Picasso's extraordinarily disciplined activity during these crucial years was traceable in large part to the influence of Georges Braque. Rubin wrote in *Art in America* last year, "I am convinced that Picasso's collaboration with the Cézanne-possessed, stolid, systematic, relentless Norman that was Georges Braque not only provided certain constituents of Picasso's formal language but encouraged a rhythm of thinking and working not to be found elsewhere in Picasso's career. The interaction with Braque helped him, I believe, to realize a kind of picture it had to be in him to achieve, but which he might never have realized otherwise."

Braque went off to the war in 1914, and by the time he came back Picasso was in league with Diaghilev and the *beau monde*. They never resumed the friendship. In later years, when someone mentioned his former colleague, Picasso would say, *"Braque? C'était ma femme."*

The minotaur entered Picasso's bestiary in 1928, in a large, decorative collage-drawing that is all head and running legs. (The drawing, which belongs to the Centre National d'Art et de Culture Georges Pompidou, in Paris, can be seen on MOMA's third floor.) By 1933, it was well established as one of Picasso's recurrent self-images—the horned bull-god that is half man and half beast, the ravisher of women, the artist as a force of nature. In the 1935 etching called *Minotauromachy*, the monster seems to look for guidance to a little girl who faces him fearlessly, holding a candle aloft in one hand and a bunch of flowers in the other. Between them is a dying horse whose belly has been ripped open so that the intestines spill out; a female matador lies across the horse's back, her breasts bared, an *espada* still clutched in her lifeless hand. At the far left, a bearded man climbs a ladder while looking back apprehensively at the minotaur. Alfred H. Barr, Jr., once described this work as "a moral melodramatic charade of the soul, though probably of so highly intuitive a character that Picasso himself could not or would not explain it in words."

When he was nearing eighty, Picasso told his friend Dor de la Souchère, "If all the ways I have been along were marked on a map and joined up with a line, it might represent a minotaur."

The important women in Picasso's life often have the look (in his paintings of them) of being no strangers to grief. This is understandable. "Living with my father," said Paloma Picasso, "for us the main thing was to survive." In the many paintings that he made of Marie-Thérèse Walter during the nineteen-thirties, however, there is no suggestion of grief, or even of melancholy. The dominant note in this outpouring of gorgeously sexy pictures is physical delight.

He met her for the first time in 1927, a seventeen-year-old girl standing outside the Galeries Lafayette, in Paris. "Mademoiselle, you have an interesting face," he is reported to have said. "I would like to make your portrait. I am Picasso." She had never heard of him. He kept their affair secret for five years—although his 1931 *Still-Life on a Pedestal Table*, with its softly rounded forms and fresh colors, is believed

to be a disguised portrait of her. Later in 1931, he executed a suite of lyrically erotic engravings inspired by their liaison, and he also began to sculpt her head in clay. During the first three months of 1932, she was the model for a series of paintings of sleeping women, and for what would be the masterpiece of this period, MOMA's own *Girl Before a Mirror*. The pose here suggests the traditional "Vanity" theme in Christian art, in which a woman looking into the mirror sees her death's-head. Marie-Thérèse sees nothing of the sort. She appears to be gazing placidly into the depths of her own voluptuous nature. It is as though Picasso, in his rage to encompass and depict the world simultaneously from every angle, had possessed his beloved inside and out, body and soul.

One wonders how Marie-Thérèse survived it. She bore him one child, Maïa, and he lived with them, off and on, while pursuing his affairs with other women, until the mid-forties. On January 21, 1939, he painted two pictures of the same subject—a woman reclining on a couch. (Neither painting is in the current exhibition, although both are reprinted in the catalogue.) One was Marie-Thérèse, the other was Dora Maar, his current *número uno*. Both show the familiar anatomical distortions and dislocations, but Dora Maar's face is grotesque and somewhat menacing, while Marie-Thérèse, who is reading a book, looks wholly content. She committed suicide in 1977.

There was a time, in the thirties, when any number of American artists felt frustrated and trapped inside the immense transatlantic shadow of Picasso. Arshile Gorky once called a meeting of the New York artists, in Willem de Kooning's studio, to discuss the situation. He suggested that since they could never catch up to Picasso they pool their talents and work coöperatively. Nothing came of that bright idea. Gorky and his friends eventually broke through into Abstract Expressionism, and Picasso entered what is generally believed to have been the long aesthetic decline of his later years. The fact that the entire Museum of Modern Art has now been turned into a Picasso showcase, with its permanent collection placed in storage or on loan to other institutions, strikes some people as an insult to a great many other artists, Americans in particular. Grumblings to this effect have been heard among the museum's staff, although not openly; the feeling there is that Picasso and William Rubin are both a bit like giant bulls charging down narrow streets—it is a good idea to stay out of their way.

I have talked with several American artists during the last two weeks, though, and none of them seemed to be feeling insulted. Robert Rauschenberg came to the gala opening on the night of May 15th, and, while he did not get above the museum's second floor ("I kept running into people who said they wanted to talk to me in the garden"), he told me later that he had taken away a whole new image of Picasso, and a much livelier one than he used to have. "The man was so alive and sensual, and responsive to every little piece of trivia. That's what I think is at least a quarter of his genius. Everything was interesting to him—and almost of equal importance."

Claes Oldenburg, who in 1969 executed a "soft" version of the maquette for Picasso's monumental steel sculpture in the Chicago Civic Center (Oldenburg's was made of canvas and rope), conceded that he had felt no great personal need for a Picasso show at this time, but he went on to say that his wife, a Dutch art historian named Coosje van Bruggen, had recently been studying early Cubism, and that as a result of her interest he, too, was grateful for the opportunity to see Picasso's early Cubist pictures in such depth. "I have a hard time looking at the post-Cubist work," he said. "But I think one could really reëxamine those early paintings and get a lot out of them. It seems to have been such a devoted activity—really a painting activity—before everything got so notoriously involved with history and so bombastic."

The extreme mobility of Picasso's "periods" and styles strikes Jasper Johns as being particularly pertinent to our current sensibility. "I think we have a sense now that makes this show very touching," Johns said. "A kind of fragmented experience—of paying attention in ways that are not connected. Of course, I also think he is a very great artist, and I think it's shameful that we don't have a permanent Picasso museum in this country."

George Segal was enormously excited by the show. "I was staggered, and I had a new revelation," he told me. "It dawned on me that he was a master imitator—that he picked up all the ideas that were in the air, and that he was able to leap from one philosophical point to another without pause. Any idea anybody had he could use. Cubism? O.K., we'll try Cubism. Primitive sculpture, with its invisible-spirit stuff? We'll put that in. Copy photographs? Sure. Classical Greek figurations? We'll do those. I suspect he was able to move that blithely because they were all different aspects of the same thing. That's what struck me. I suspect he was after a grand synthesis, but maybe unconsciously."

If Segal is right, it must also be said that Picasso failed to achieve his synthesis. There was no final flowering, no great last period to set alongside Matisse's cut-paper masterworks.* Picasso's daughter Maïa reports that he was terrified of death, of ending; for him, the main thing was to keep going—forever, if possible. Matisse was a great artist and a great man; Picasso, to himself and to many others, was a god. That being the case, he could afford to be a monster. He could even afford to turn out many bad paintings. "I often paint fake Picassos," he said.

Would Picasso have approved of this exhibition? Of course. He might also have hated it. "Museums are just a lot of lies," he said in 1935, "and the people who make art their business are mostly impostors."

(June 30, 1980)

ÉLITISM VS. MOBOCRACY

The concept of limits to growth does not appeal very much to museum directors or trustees. In the face of continuing deficits, expansion remains the main order of business at the Metropolitan and at the Museum of Modern Art, as it does at many other art institutions around the country. MOMA hopes to resolve its financial crisis by a complex real-estate deal involving commercial development of the airspace above its property—a deal that will also double the museum's current exhibition space. The Metropolitan, whose projected operating deficit this year is more than half a million dollars, celebrated in June the opening of its new eighteen-million-dollar American Wing—another stage in the grandiose master plan laid out during Thomas Hoving's administration, which calls for five new wings and fifty per cent more gallery space. Although Hoving has gone, hubris has not; the Met is committed to its goal of becoming the world's premier encyclopedic museum by the year 2000.

*See "Late Picasso," page 176.

The astonishing growth of art museums in this country might be easier to comprehend if we knew why we value them so highly. Are any other public institutions so unclear about their essential function? For a century or more, American museums have based their claims to public and private funding on that great be-all and end-all education. "We may well regard this Museum, together with our Public Library, as the crown of our educational system," Boston's Mayor Samuel Cobb said at the opening of the Boston Museum of Fine Arts, in 1876. Similar sentiments attended the founding of the Metropolitan, the Corcoran, the Art Institute of Chicago, and most of the others. It was typically American, this educational bias. In Europe, where art museums emerged toward the end of the eighteenth century, often as a result of the revolutionary confiscation of royal collections, curators have always felt that their primary responsibility was to artists, connoisseurs, and scholars; European museums to this day have not gone in for the myriad educational activities that American museums carry out as a matter of course. Very few American museum authorities, on the other hand, have asked themselves what sort of education it is that can be gained by looking at or learning about works of art.

The founders of the Metropolitan had some rather queer notions along this line. Prosperous bankers, railroad men, and merchants, for the most part, they seemed to think that art, like theology, had a built-in moral value. They were greatly impressed by a speech that William Cullen Bryant made at the Union League Club in 1869, the year before the Metropolitan was established. Addressing a meeting of prominent New Yorkers who were thought to have some interest in the museum project, Bryant, the city's reigning literary lion, listed all the self-evident reasons that a great city like theirs both deserved and required a repository of art. He then went on to cite "another view of the subject, and a most important one"—the fact that New York attracted not only the best but also the worst of the human species. "My friends," he said, "it is important that we should encounter [sic] the temptations to vice in this great and too rapidly growing capital by attractive entertainments of an innocent and improving character." Passing through the museum on his criminal way to Central Park, perhaps, the potential mugger or rapist would chance upon a trecento Madonna and repent. The New York burgher liked to think that art would also be good for business. Joseph H. Choate, the most influential lawyer among the Metropolitan's founding trustees, once told them, "Every nation that has tried it has

found that every wise investment in the development of art pays more than compound interest."

The Metropolitan and the Boston Museum of Fine Arts served as models for the museums that up-and-coming American cities soon felt themselves obliged to have. By 1914, there were at least sixty art museums around the country; by 1938, according to the museum historian Laurence Vail Coleman, there were three hundred and eighty-seven, and "new museums are coming into being at the rate of one or more a week." Karl E. Meyer, in his 1979 book *The Art Museum*, informs us that during the last thirty years at least half a billion dollars has been spent in this country on the construction of ten million two hundred thousand square feet of art museums and visual arts centers—"the equivalent in footage of 13.6 Louvres." Here and there in this unbroken success story, a voice has been heard to question the educational basis of the museum movement. "Neither in scope nor in value is the purpose of an art museum a pedagogic one," said Benjamin Ives Gilman, the Boston museum's secretary from 1894 to 1924. The museum's purpose was aesthetic, Gilman said, and aesthetic values could not be instilled by dogmatic means. In our own times, Sherman E. Lee, the director of the Cleveland Museum of Art, has held out with great verve and tenacity for the aesthetic ideal. "Most museums are caught in activities which they were never intended to sustain and for which they should not be held responsible," he said some years ago. "Our first responsibility is to the object, and to the person who wants to respond to it in a private way. Art is not therapy or fashion or social uplift, and a museum is not a community center." By and large, though, most American museums have continued to lay heavy emphasis on their educational raison d'être, and to devote a great deal of time and money to public lectures, school visits, and community "outreach" programs, such as artmobiles and travelling exhibitions. Mere aesthetic pleasure, it seems, is never enough to justify the enormous operating expenses that museums require. Art must be good for us in other ways.

How, then, are we to account for the exponential increase in museum attendance in this country? Do the throngs who fill our museums to bursting come in search of an educational experience? One thing they certainly do not come for, apparently, is the one-to-one aesthetic confrontation that Sherman Lee talks about—the chance to respond to a work of art in a private way. In the recently opened André Meyer Galleries for nineteenth-century European art, at the Met, several hundred

paintings coexist in a vast space, where the viewer is never unaware, even for a moment, of other paintings or other viewers. It is not unlike the unbroken vistas of the Beaubourg, in Paris. People can develop the ability to create visual privacy in such a space, it is true, just as they can learn to read a book on the subway, but it takes some practice.

I have a running argument with a friend of mine on this score. She was brought up in New York, and she spent a great many rewarding hours, from adolescence on, in the paintings galleries of the Metropolitan, the Frick, and the Museum of Modern Art. It was usually possible, in those days, to respond to the individual works of art in a private way, and the question she asks now is why she and others like her should be deprived of that pleasure. She agrees that the development of the mass audience for visual art is an irrevocable fact, and she concedes that there is a good deal to be said for the efforts of publicly funded museums to make themselves more accessible and more appealing to a broad public. She does not begrudge the broad public its experience, she insists—but why should it preclude hers? Why can't a museum somehow provide for both? Our running argument generally bogs down in the morass of élitism vs. mobocracy. But lately it has set me to thinking about William Ivins and his views on museum growth.

William M. Ivins, Jr., who established the Metropolitan's Department of Prints and served as its curator from 1916 to 1946, was one of the most brilliant museum men of his time, and almost certainly the hardest to get along with. Trained as a lawyer, he took an intense delight in demolishing the scholarly premises of his fellow-curators in the staff dining room. Greek art was his particular bête noire. He claimed to detest the "abstract lack of personality" of the celebrated marbles; he found the Venus of Melos to be "the final epitome of all the dumbness of all the Dumb Doras—utterly devoid of thought, emotion, and expression." Ivins also liked to ridicule the scholarship that dealt so confidently with the "development" of Greek art when there was so little certainty about dates. Classical scholarship, he wrote, was "a field of learning in which circularity of reasoning, explicit as well as implicit, is recognized as a legitimate procedure." He won too many arguments, and made too many enemies, for his own good at the museum. Although he was named acting director on two occasions, and fully expected to become the director in 1939, when Herbert Winlock retired, he was passed over.

Francis Henry Taylor was named instead, and the Met, after lying fallow during the war years, embarked on a major program of revitalization and expansion.

Hoping to soften the disappointment for Ivins, the trustees gave him the somewhat vague title of Counsellor of the Museum, and naturally they solicited his views on the museum's postwar development. What he had to say was rather a long way from what anybody wanted to hear. After twenty-seven years at the museum, Ivins had concluded that museum curators usually tried to show too much material. A large proportion of the art objects in every department, with the exception of the paintings department, were essentially duplicates, he said; a vast array of them on exhibition simply cancelled out interest and exhausted the viewer. "It is doubtful whether there should ever be more material on exhibition of any one variety than can be conveniently looked at by an intelligent visitor in, say, an hour or an hour and a half," he wrote in a 1941 report.

Ivins believed that the vast bulk of a department's holdings should be put into what he called "study storage." This was not a new idea by any means. Sir Charles Eastlake, the director of the National Gallery in London, had proposed in 1853 that museums be divided into two parts—one for the general public and one for the specialist or scholar. The Victoria and Albert Museum, when it was reorganized in 1945, took up this notion and put its masterpieces in what it called "primary galleries" and the rest of its holdings in study galleries. Shortly before the Boston Museum of Fine Arts moved from Copley Square to Back Bay, in 1909, it had tried a similar arrangement, putting its best things on the main, or second, floor and its "study collections" on the ground floor. The Boston Plan, as it was called, excited a lot of interest at the time in museum circles, but it never worked very well, because the two floors were equally accessible to the public, and "the uninitiated would never guess what was intended," according to Coleman. As the museum and the collections grew, the plan was scrapped. In Ivins' opinion, though, the study-storage idea had never been properly tested. He thought that there should be galleries in each department for the major works— galleries whose exhibits would continually change, with new and enlivening combinations of objects—and that right alongside them, available to anyone with a special interest, there should be study-storage galleries in which a great many objects could be made visible by in-

genious methods of stacking. Such a system, he maintained, would "provide room for at least twenty years' growth of the collections without the erection of a single new addition to the building." The conversion of existing exhibition galleries to study-storage galleries could be made quite easily and inexpensively, Ivins pointed out, and "a vast amount of material could be removed from the exhibition galleries without being removed from the public's use."

Of course, nobody took the idea seriously. Taylor and his trustees had new wings in mind, and the Metropolitan, with occasional pauses for breath, has been expanding and exfoliating ever since. "The primary exhibition problem is that of changing an attitude which, with at least the tacit approval of the Trustees, has long reigned in most of the departments," Ivins wrote in a 1943 memorandum. "This attitude is that all the fine things in every department should always be on exhibition in the galleries, and that the more there is on continuous exhibition in any department, the greater and better the department is." It was an attitude, he said, that "allows pride of knowledge and possession to swamp and destroy educational values and therefore popular interest." It is an attitude that has not changed from that day to this. A few study-storage galleries exist at the Met today, but the master plan was clearly designed to flatter each department's pride of possession. A recent press release states that the new American Wing, when completed, will show "virtually the entire collection of American art." (Some of it will be in a study-storage area on the mezzanine; to judge from the space allotted to this area, however, it is obvious that most of the American material will be "out" on display.) The André Meyer Galleries contain seventy-five per cent of the museum's holdings in nineteenth-century European art. The rebuilt galleries of Egyptian art will place on exhibit the Metropolitan's entire Egyptian collection—some thirty-five thousand objects in all, most of which Francis Taylor referred to irritably as "archeological study material."

Ivins had something further to say, at the close of that 1943 memorandum, about the basic function of a museum as a social organ. The museum's purpose, he said, "is not to provide so-called aesthetic pleasure but something infinitely more abiding and important. This important and abiding thing is indicated in a quotation made by Lord Acton, the great historian, to the effect that 'The man who is not consciously aware of the Past as his own history has no charac-

ter.' . . .To this I may add that the Museum and the Public Library are the two great tap roots of the community's tradition." Aesthetic pleasure, moral uplift, instruction in good taste, tourist dollars, sexual fantasies—all these may or may not be among the benefits that an art museum provides. But, as Ivins saw it, the museum's truly educational role was to offer us a sense of the past.

(September 15, 1980)

BOOM

Oblivious of recession or recovery, the art market goes right on booming. The Whitney Museum recently paid a million dollars for Jasper Johns' 1958 painting *Three Flags*—the highest price to date for a work by a living artist. The sale buoyed the spirits of dealers and chilled the hopes of museum curators, who can count on having to pay more dearly for important contemporary works as a result. New collectors enter the market every day. The Pace Gallery's president, Arnold Glimcher, who engineered the *Three Flags* sale, has said that he used to know three-quarters of his customers personally but now the proportion is reversed—three-quarters of the current buyers are people he has never seen before. Collectors compete for the work of certain "hot" artists the way they did in the late sixties, and exhibitions by these artists are often sold out before they open. Some of this activity no doubt reflects the belief that contemporary art is a sound investment in an inflationary period—a questionable belief, considering the uncertainty and spottiness in contemporary auction sales. (Two important pictures by Johns failed to meet their reserve price at Sotheby Parke Bernet last May.) The majority of the new customers are serious collectors, though—people who have informed themselves thoroughly about modern art and seem to know just what they want. The conjunction of this new audience and the latest crop of artists lends a febrile glow to the current scene—a nervous excitement that is good for business, if not necessarily for art.

The latest crop does not represent a new movement, or even a group of more or less kindred spirits. Several of the most widely discussed young artists fall into the category of New Image painting—a broad spectrum unified by the tendency to use recognizable but crudely rendered subject matter, often personal or autobiographical in origin. Others are closer to the Pattern and Decoration impulse, and some appear untouched by any current trends. At least half of them are women, and so are their dealers: Susan Rothenberg and Lois Lane show at the Willard Gallery, whose young director, Miani Johnson, is the daughter of Marian Willard; Lynda Benglis, Jennifer Bartlett, and Elizabeth Murray are with Paula Cooper; Judy Pfaff is with Holly Solomon, the doyenne of Pattern and Decoration. Together with Jonathan Borofsky, Joel Shapiro, Donald Sultan, Steve Keister, David Salle, Bryan Hunt, Julian Schnabel, and a few others, these under-forty talents have all achieved the novel distinction of the waiting list—a roster of buyers eager to snap up whatever they can get by that artist. A waiting list for an artist on the threshold of a career is something new, and it puts a lot of pressure on the traditional need to take risks, make mistakes, and explore fresh territory.

The demand for Jonathan Borofsky's work, which was on view in October and November 1980 at the Paula Cooper Gallery, has been described by Paula Cooper as "hysterical." One frantic buyer telephoned from Europe before the opening to reserve a piece—any piece. A good deal of the show was not for sale, because Borofsky, who likes his exhibitions to have the atmosphere of his studio, had drawn and painted a lot of it directly on the gallery walls. Black painted silhouettes of larger-than-life running figures spilled across one wall, and became three-dimensional in the form of a twelve-foot-tall, motorized wooden cutout of a man raising and lowering a hammer. Faces and other images from the artist's vivid dreams covered the other walls, along with written dream excerpts (some in mirror writing). Large, erratically shaped canvases dangled or hung aslant from the ceiling, and one perched on top of a ten-foot metal pipe. Viewers were invited to play Ping-Pong on a regulation-size table painted black and white, near which stood a four-foot stack of paper, the result of Borofsky's decision, some years ago, to count from zero toward infinity. (His written count had reached 2,687,585.) A great diversity of objects and images hung or stood or lay about the room, including several hundred copies of an anonymous handwritten anti-littering statement that the artist had picked up on the

boardwalk in Venice, California. Just before the opening, the artist's mother began picking *these* up, until someone told her that Borofsky wanted them underfoot.

Borofsky, who will be thirty-eight this month, dealt with the pressures of the marketplace until quite recently by refusing to have a gallery. His first one-man show was in 1975, at Paula Cooper's. He had been in several group shows before that, and his work had its admirers, but he thought it too personal and too unresolved to present in depth. He supported himself by teaching at the School of Visual Arts, in Manhattan. From 1967 to 1971, he did not paint at all; he spent a lot of time in those years writing down his thoughts and ideas, before that sort of thing came to be known as Conceptual Art. In 1969, he started his written count to infinity, and one day in 1972 the counting led to scribbling, and the scribbling, in turn, led him back to painting—a particularly free and personal kind of painting, with images from dreams, childhood memories, and casual doodles. In the lower right-hand corner of each painting he wrote the number he had reached at that point in his continuing count, which seemed to him a fine way of merging the conceptual-mental-rational side of life with the physical-sensual-emotional side. At the moment, there is such an intense demand for his work and so many invitations to show it, here and in Europe, that Borofsky is thinking about making some changes in his life. He may even quit teaching. He can always go back to it, he reasons, if and when people lose interest in his physical-emotional side.

Compared to Borofsky, Bryan Hunt is a sculptor of Olympian calm. The work on which he made his reputation deals with two specific images—airships and waterfalls—but these images are mainly starting points for sculptures that have been refined in the last few years to the point of near-abstraction. Like all the artists of his generation (Hunt was born in 1947, in Terre Haute, Indiana), he was a student at the apogee of Minimal and Conceptual Art. His own transition from Minimalist abstraction to specific images came in 1974, when he happened to run across two books on lighter-than-air transport. As a child growing up in Florida, where his family moved when he was in the sixth grade, Hunt had been fascinated by the space program. Classes at schools in that area were always let out when a rocket went up from Cape Canaveral. For a time in the late sixties, he actually worked as an engineering draftsman for the Apollo Program, at the Kennedy Space Center. The two books about airships rekindled some of the excitement he had felt

then, and soon afterward he built his first sculpture—a realistic replica of the Empire State Building with a dirigible moored to its mast. Eventually, as he worked again and again with that image, he eliminated the building and pared the dirigible down to a sleek, elongated oval, made of balsa wood, silk paper, and metal leafing in patina-like shades of green and silver. At one end, his airships attach directly to the wall, and this makes them appear to be in flight. More recently, Hunt has been making waterfalls, casting in plaster the shape of water falling through space and then recasting it in bronze. The bronzes sell for ten thousand to thirty thousand dollars apiece, and Blum-Helman, Hunt's gallery, has a waiting list of buyers. At a certain level, Hunt's success gives him a sense of being "indestructible," but there are also times when he feels fragile and uneasy. "When that happens," he says, "I know it's time to start drawing."

The transition from unknown to in-great-demand has been a somewhat unnerving experience for Judy Pfaff. Her first solo show in New York, at the Holly Solomon Gallery in September, brought recognition, sales, and commissions, all for the first time. "My pride has been that no one likes my work, no one understands it," she said two weeks after the show closed. "Now all of a sudden I find I'm sort of representing something, and I'm not at all sure I can do that." Pfaff was born in London, in 1946, and moved to the United States when she was ten. She went to several schools in the Midwest and then to the Yale School of Art, from which she graduated in 1973 with a Master of Fine Arts degree. After "about a hundred false starts," including participation in a lot of group shows, things began to improve very rapidly last year. She got a ten-thousand-dollar grant from the National Endowment for the Arts, and she was invited to be in an important group exhibition at the Neuberger Museum, in Purchase, New York. (Has a suburban community ever been more aptly named?) Pfaff's contribution was the show's major surprise—a room-filling "installation" concocted of gaudily colored wood and wire and plastic elements, with sly references to Archipenko and other grandees of modernism. "It was the first work I was really ready to own up to," she said. Holly Solomon had already offered her a solo show, and Pfaff transformed that gallery's front room into an even gaudier and more exuberant environment, called *Deepwater*, in which viewers had the sense of walking around on the floor of a tropical lagoon. (Pfaff went to the Yucatán last winter for her first vacation in years, and she was absolutely delighted by the Caribbean.)

"I've never been an artist full time until now," she told me. "I'd been teaching steadily, and doing odd jobs on the side—I used to tile floors. It's great to be able to buy all the paint I want. I got a studio in Brooklyn, I got a truck, I got out of debt. I even got a shrink." She finds it easier now to understand why famous artists like Jasper Johns and Frank Stella tend to stay out of sight, and she senses that her own attitude toward success is ambivalent. "A lot of the younger artists I see talk very knowingly about building a career. They're really professional that way," she said. "And *very* competitive."

Which brings us to Julian Schnabel. No young artist today receives more attention than Julian Schnabel or appears more confident in dealing with it. Schnabel is twenty-nine. He grew up in Brooklyn and in Brownsville, Texas, where his family moved when he was fifteen, and he got a Bachelor of Fine Arts degree from the University of Houston. (A surprising number of young artists today have both a bachelor's and a master's degree in art.) He had his first solo New York show in February, 1979, at the Mary Boone Gallery, and since then he has commanded the same kind of hysterical interest as Borofsky. Schnabel does large paintings—eight feet by ten, on the average—with highly aggressive, sometimes stentorian subject matter. His second show at Mary Boone's, in November, 1979, featured paintings done on a ground of plaster and broken plates. *The Exile*, a recent work that has not yet been shown publicly, contains the following elements, left to right: a bare-chested young man who has dropped in from a painting by Caravaggio (*Boy with a Basket of Fruit*), against a gold background; an immense blue image of a wooden doll; various stick-figure people in various colors; patches of brushy paint; a nomad with a strong resemblance to Ayatollah Khomeini, in bilious lavender; and, scattered across the picture, three pairs of real antlers (moose, elk, deer) jutting out from the surface and touched up with paint.

Schnabel has spent quite a bit of time in Italy. He knows Francesco Clemente, Sandro Chia, Enzo Cucchi, Pier Paolo Calzolari, and some of the other young Italian painters who have been making a stir in Europe and are just starting to be seen over here. (Clemente, Chia, and Cucchi showed at Sperone Westwater Fischer this fall, and Mimmo Paladino, who unaccountably neglected to have his surname begin with a "C," was seen at both the Marian Goodman and the Annina Nosei Galleries.) Like the Italians, Schnabel goes in for large-scale, emotionally charged images and for knock-'em-dead juxtapositions. "I feel more

of a zeitgeist relationship with Chia and Clemente than I do with the New Image painters here," he told me. "I'm not involved with signa-turizing—with laying claim to some particular way of doing things. A lot of my images come from books or films—*The Battle of Algiers, Zero for Conduct,* von Stroheim. They're not necessarily personal. I mean, of course they're personal, because I selected them, but I could just as well have chosen others. I'll do anything and use anything. What I'm really looking for is ways to provoke thought." Recently, he started to do paintings on velvet, a surface heretofore associated with souvenir-shop art. Mary Boone's present gallery space, on the ground floor at 420 West Broadway, is too small to accommodate more than a few of his pictures at once, and its expansion will not be completed in time for Schnabel's next show, in April 1981. For this reason and others too Byzantine to unravel, Schnabel will show from now on at both Mary Boone's and the Leo Castelli Gallery, which is universally recognized as the Olympus of contemporary art, and which happens to be one flight up in the same building. It has been several years since Castelli last took on a new artist, but Schnabel's sudden elevation came as no great surprise to Schnabel. "I've been painting since I was four," he said. "It's the only thing I've ever done. By the time all this happened—well, I always knew it would be like this. I think I can use recognition as poetic license to do what I want."

(December 22, 1980)

TO WATCH
OR NOT WATCH

Does video art exist? The question sounds naïve, considering the large number of people currently working as video artists—working with videotape, that is, for purely visual rather than dramatic, narrative, or documentary ends. The Kitchen, a SoHo center that has been a prime

outlet for such work over the last decade, shows tapes by ten different video artists each month; this adds up to about a hundred artists a year, and Mary MacArthur, The Kitchen's director, thinks that that may be about a quarter of the total number of video artists who live in or near Manhattan. The Museum of Modern Art and the Whitney Museum both run active video programs. "Experimental" videotapes—meaning videotapes by artists—are frequently shown at both places, and they will figure prominently in the first National Video Festival, in June 1981, at the Kennedy Center, in Washington, D.C. (Its sponsors are the American Film Institute, which has largely ignored video up to now, and the Sony Corporation of America.) Acceptance of the cathode-ray tube as a fine-art medium seems to be well advanced. After viewing quite a few tapes by video artists in recent weeks, though, I am still not sure that there is, or can be, such a thing as video art.

At the recent Whitney Museum Biennial, videotapes by thirteen artists were shown in a room on the second floor. There were two monitors, showing the same tape at the same time. In front of each monitor there was a sofa. Viewers wandered in and out of the room. Some stood, some sat on the floor. The people who sat on the sofas, I noticed, tended to fall asleep almost immediately. Museum-going is a tiring business, granted, but nothing brings on a nap quicker than a semi-dark room, a sofa, and a little video art. To say that video art is boring is to miss the point of it, I know, I know. Art today demands the active participation of the spectator, as the spectator is forever being reminded; if we are bored, it just means that we are refusing to take part in the process. But how does one take part in a viewing process such as *Zukofsky's Bow*, to choose one example from the Whitney's program? In *Zukofsky's Bow*, by William Anastasi, a blank television screen is invaded at irregular intervals, from its bottom edge, by the tip and sometimes as much as the upper half of a violinist's bow. Presumably, the bow is being employed by Paul Zukofsky, the well-known virtuoso, to make music, but no music can be heard, or any other sound, and the viewer never comes close to a glimpse of the well-known virtuoso's hand. The screen is blank a good part of the time. The piece lasts for thirty-six minutes.

Other tapes at the Whitney contained more visual incident, to be sure. Kit Fitzgerald and John Sanborn's *Olympic Fragments*, a brisk, colorful, ten-minute collage of scenes shot at the 1980 Winter Olym-

pics, was fun to watch, and so was Nam June Paik's four-minute *Lake Placid 80*, in which Paik subjected network footage of the same Olympics to his inimitable brand of electronic distortion and wild juxtaposition. The sort of special effects that are unique to video—multiple superimpositions, lateral and vertical stretchings of images, fragmentation of color and shape and outline—were a prominent element in several tapes, which ranged from literal street scenes to abstract colors and shapes. There was even a conceptual tape, in which the artist Taka Iimura, shown on the monitor alongside a television-set-within-a-set on which he also appeared, held inscrutable discourse with himself ("You are Taka Iimura." "I am Taka Iimura." "You are not Taka Iimura"). The most impressive tape at the Whitney, Bill Viola's *Chott el-Djerid (A Portrait in Light and Heat)*, juxtaposed views of barren, snow-swept plains in Saskatchewan and central Illinois with a long sequence in the Sahara Desert. Viola used a telephoto lens on his video camera to show the watery effects of desert mirages. It was interesting and strange, and also quite nap-inducing.

In the early seventies, video art seemed inevitable. A whole generation had grown up looking at television, and when the first portable, relatively inexpensive video cameras appeared, in the late sixties, that generation's artists found them all but irresistible. Nam June Paik, the Korean-born musician who became the chief pioneer and colonizer of video as artist territory, had prophesied in 1965 that "someday artists will work with capacitors, resistors, and semiconductors as they work today with brushes, violins, and junk," and for a while events seemed to bear him out. Richard Serra, Bruce Nauman, Keith Sonnier, and a number of others who had established major reputations as painters or sculptors began making videotapes. Joan Jonas and other "performance" artists progressed from documenting their performances on video to creating events to be seen on video alone. Howard Wise, whose Fifty-seventh Street gallery had featured work by kinetic artists, closed his gallery in 1970 in order to devote himself exclusively to the developing video movement; his Electronic Arts Intermix provides editing facilities for video artists and a distribution network for tapes. Leo Castelli and Ileana Sonnabend set up a joint distribution system for videotapes by their people. University art departments acquired video equipment, although in many cases video remained under the academic aegis of journalism or "communications." The fast-breaking technology of television held artists in

thrall. They dreamed of large-screen video "installations" in public or private spaces; they talked of getting access to some of the new channels soon to be opened up by cable and satellite transmission—vanguard art on the home screen! Video was so much easier to work with than film. The results could be played back immediately, and if you didn't like them you simply reshot the tape, erasing it as you did so. The process often led to, shall we say, an attitude of self-indulgence. "If I see another videotape of someone shaving pubic hair, I will go mad," Mary MacArthur remarked the other day.

The initial euphoria gradually subsided. Working with videotape turned out to be pretty expensive after all, and, as the technology improved, the costs climbed higher. The amounts that could be charged for the purchase or rental of videotapes (museums, colleges, and libraries were the only real customers) rarely equalled the expense of making them. Nobody seemed to want to invest in large-screen installations. Cable and satellite broadcasting, which were said to be just around the corner in 1970, did not arrive on schedule. Now one hears that 1980 was the watershed year for cable, and that we have at last entered television's New Age, but it seems unlikely that video artists are ever going to gain significant access to broadcast TV in any form. The economics of television are against it. Meanwhile, undaunted, a second generation of video artists is in place. Serra, Nauman, and most of the other big names who latched on to video in the seventies are no longer making tapes, but a host of recent art-department grads—young people whose aesthetic orientation is exclusively in video—are committed to the medium. If four hundred or more of them live in this area, there is a comparable number on the West Coast, with pockets of activity in Chicago, Minneapolis, and other cities. At least, nobody can accuse them of careerism.

The majority of these young people are not committed to video *art* as such. Documentaries and personal narratives of one kind or another probably account for more than three-quarters of the videotape they turn out, and this is surely where the future (if any) of independent noncommercial video must lie. Fitzgerald and Sanborn's *Olympic Fragments* is an example of what can be done to shake up the documentary form. Joan Logue has invented the video portrait—the camera focussed unflinchingly on a stationary person or persons for twenty minutes, during which the subject reveals more than could be surmised from

any still photograph. (One of her portraits, of the composer John Cage, struck me as an altogether captivating narrative.) William Wegman has opened up a corridor of humor that others might do well to explore. Wegman made a number of very short videotapes that are really blackout comedy routines for him and his dog, a weimaraner named Man Ray. In *Spelling Lesson*, for example, Wegman explains to an extraordinarily attentive Man Ray that the only word Man Ray missed the last time was "beach," probably because he confused it with Beech Nut gum (Man Ray looks deeply mournful); the word, Wegman says, is "b-e-a-c-h." Another recent approach, not without humor, is Robert Wilson's *Video 50*, a series of a hundred vignettes, each thirty seconds long, and each a tiny skit complete in itself. Wilson, who is known for his extremely long operas and theatre pieces in vastly slowed-down time, has suggested that the hundred skits could be shown as individual "spots" inserted in regular TV programming or could be viewed together as a fifty-minute whole. Maybe television's New Age will find it needs Logue, Wegman, Wilson, and other creative independents. What the New Age is not going to need, I am almost sure, is video art.

The notion of using video as a purely visual medium seems like a wrong notion to me, for the simple reason that video takes place in time. Visual artists, who are trained to deal with space, often have a very uncertain grasp of time, and of the demands of time-defined arts such as theatre. This was painfully evident in the sixties, when artists put on "happenings": the only happenings that did not bore spectators silly were the ones that lasted about three minutes. Time is more personal than space, maybe because we have less of it. Most of us are extremely reluctant to give up control over time—over "our" time, as we say. We will do so under certain circumstances, to see a play or hear a concert, but, having relinquished that control, we expect our time to be dealt with in a manner that pays dividends; if we are to participate actively in the spectacle before us, we want it to be a spectacle worthy of our time—a spectacle invested with imagination, intelligence, and surprise. When we go to a museum or a gallery to look at pictures, on the other hand, we are in complete control of time. One painting may "hold" us for a spell, but the act of looking at it is entirely voluntary, and the time spent remains our own. Ordinary television-watching is similar in this respect. "I think I'll watch a little TV," we say, without a thought of surrendering to TV time. It is not like going to the movies.

We watch TV with the lights on in the room; we move around, answer the telephone, go out to the kitchen, feed the dog, glance at a magazine. We put up with the most god-awful drivel on television, because we know we don't have to.

Video art asks for the kind of concentration that we are expected to give to painting and sculpture, and it also asks us to give up our time to it. Nothing I have seen to date comes anywhere near to justifying those demands. Nam June Paik, who has thought as astutely as anyone about the medium, and whose videotapes are certainly not boring ("I come from a very poor country," Paik once said, "so I have to entertain all the time"), has more or less decided that he will not ask viewers to surrender control of their time anymore. He now devotes his main efforts to installations such as his *Hanging TV: Fish Flies in the Sky*, which consists of twenty or more TV monitors attached to the ceiling, each one showing a different tape; the viewer may lie down on a mattress to observe this galactic spectacle, but no time span is specified. "You are free to watch or not watch," as Paik puts it. These and other Paik installations will be shown at the Whitney next spring, in a major Paik retrospective that may do for video art what new clothes did for the emperor.

(May 25, 1981)

THE ANTIC MUSE

A former Long Island City public school reborn as an "alternative space" for art and artists, P.S. 1, recently put on a show of humorous art by eight young artists. The New Museum, on lower Fifth Avenue, has scheduled for fall 1981 an exhibition called "Not Just for Laughs," which will consist of what the curator calls "extremely funny works in various media that use paradox, exaggeration, outrage, incongruity, surprise, subversion, and/or false logic as basic formal means." A new trend? It is the fashion in certain circles, of course, to treat the whole

spectacle of contemporary art as a vulgar comedy, but I doubt whether even the holders of that view expect to laugh out loud in an art gallery— as I did last season, for example, at Sharron Quasius's very large sewn and stuffed canvas replicas of famous tableaux, such as *The Raft of the Medusa, The Rape of the Sabines,* and *Custer's Last Stand* at O.K. Harris. I was also much diverted by Robert Arneson's ceramic portraits, at Allan Frumkin, one of which showed Pablo Picasso scratching his back in a gesture exactly matching that of a formerly enigmatic figure in *Les Demoiselles d'Avignon,* and by a show of Polaroid photographs by William Wegman, at Holly Solomon's, in which Wegman's talented weimaraner was caught in a variety of risible costumes and poses with a female model. The season's real boffola, though, was Sam Wiener's *Splendors of the Sohites,* at O.K. Harris in September 1980. A sly parody of blockbuster museum loan shows, right down to the attached gift shop, *Splendors* featured archeological fragments of a supposedly vanished SoHo civilization—"funerary objects" that strangely resembled abandoned hubcaps, heavily patinaed beer-can tabs labelled "hermaphrodite symbols," and other marvels.

Until fairly recently, comedy has been a very minor tributary of the mainstream of art. The priapic paintings on Greek pots, the fanciful beasts that enliven the margins of medieval manuscripts, the grotesqueries of Bosch and Bruegel, the satiric wit of Rowlandson, Hogarth, and Daumier are acceptable to art history, to be sure, but in a peripheral way; there has been no real counterpart of the comic tradition in literature that allows Molière and Mark Twain into the pantheon with Racine and Melville. Serious art could not be humorous, and vice versa. Along with many other aesthetic assumptions, this sober view began to break down early in our century. Picasso, Miró, Klee, and Max Ernst tapped veins of humor and wit without descending to "minor" aesthetic levels: Picasso's *Baboon and Young* sculpture, with two child's toy automobiles for a head, is among his best-known works, while Klee's birdlike, semi-abstract *Twittering Machine* is one of the prizes of the Museum of Modern Art. It was Marcel Duchamp, however, who quietly undermined the whole notion of serious art and its humorless hierarchies. Duchamp's humor was subtle and blasphemous. He had come of age as an artist a few years before the First World War, at a time when art was an intensely serious matter to most of his colleagues (his brothers included). For reasons that are still endlessly debated, Du-

champ recoiled from this attitude. Art, he decided, was "a habit-forming drug," pleasant enough in its way but not nearly so important a thing as daily life. The religion of art, he said, was "not even as good as God." Duchamp's absolute iconoclasm led to his invention of the "ready-made"—a factory-made object, such as a bottle-drying rack or a snow shovel, removed from its utilitarian function and metamorphosed, by the mere act of his signing it, into a work of art. For nearly half a century, Duchamp's message was largely ignored or misunderstood—ignored in Europe, where until the seventies he was considered a minor artist who had gone to live in New York, and misunderstood here, where in recent years his acolytes have attempted to prove, on the basis of his meagre and extremely bizarre oeuvre, that he was the most important artist who has ever lived. It is almost never recalled that Duchamp referred to his *Large Glass*—the "masterpiece" on which he worked, off and on, for eleven years and then left unfinished—as "a hilarious picture." Not many people got the joke.

A few did, though, and they went on to invent Pop Art. Lichtenstein, Oldenburg, Warhol, Rosenquist, and the other Pop artists may not have been thinking of Duchamp when they began using commercial objects and advertising images as subject matter, but they were certainly acting in his spirit. Rauschenberg and Johns, whose influence on the Pops was more immediate, had absorbed certain things from Duchamp—notably the desire to make works that were not reflections of their own personal feelings—but neither of them really went along with Duchamp's iconoclasm. Rauschenberg and Johns still believed that art was a serious matter. Pop Art infuriated people at first, because its perpetrators appeared to be totally unserious. They were making fun of art—not only of Abstract Expressionism, with its cult of the heroically suffering self, but of all art, past and future. How else could you interpret a painting that was an almost verbatim blowup of a Mickey Mouse comic strip, or a stuffed hamburger seven feet across? These things were in the art galleries, and people were laughing, and other people were buying them, and that, the die-easies said, was it—the end of art.

Art has survived, it seems. More surprisingly, the leading Pop artists turned out to be every bit as serious as the Abstract Expressionists. Oldenburg evoked many laughs in the sixties with his drawings of proposed colossal monuments—a giant Teddy bear for the north end of Central Park, a vast toilet float for the Thames in London, a towering

clothespin as a *Late Submission to the Chicago Tribune Architectural Competition of 1922*—but in the seventies some of these actually got built. (A forty-five-foot-tall *Clothespin* stands in Philadelphia's Centre Square.) "Yes, my work is humorous, but you get over that," said Oldenburg, who now devotes most of his time to monumental public commissions. Rosenquist, without abandoning his style of juxtaposed images in large scale, has become an artist whose work is now seen to have a connection to late Surrealism. Warhol, whom the spirit of comedy never touched, was always more interested in notoriety than in art, and there he succeeded beyond all expectations. The only one of the original Pop group who still evokes the antic muse more or less full time is Lichtenstein. Although Lichtenstein is not generally thought of as an artist with followers, I suspect that his enormous success, critical as well as financial, has not been lost on the younger generation. With Lichtenstein, it could be said that humor has finally broken through into the upper brackets of serious art.

The touring retrospective exhibition of Lichtenstein's work of the last decade, organized by Jack Cowart, the curator of nineteenth- and twentieth-century art at the St. Louis Museum,* should solidify Lichtenstein's standing as the most prolific, consistent, and intelligent artist to emerge from the Pop movement. (The exhibition comes to the Whitney Museum in September, 1981.) To this observer, who has followed his career with interest and some perplexity, it is a surprisingly beautiful show. I had never before thought Lichtenstein's work beautiful. The drastic oversimplifications of his well-known style—unmodulated standard colors, heavy black outlines, and the use of enlarged benday dots and striping to simulate the mechanical processes of printing—had seemed to work against the sort of pleasure that one feels, for instance, in looking at a Matisse. Lichtenstein's basic style has not changed much in the work of the last decade. The pictures and the metal sculptures are executed in the same cool, uningratiating, impersonal manner. But the over-all effect is decorative in the best sense: there is an inner harmony that gives pleasure. Lichtenstein has enlarged his palette somewhat. Although he depends mostly on the same unvarying blue, red, yellow, and green that he settled on in the early sixties, he has added subtler hues, which he uses sparingly but to excellent effect—blue-

*He is now curator of twentieth-century art at the National Gallery in Washington, D.C.

greens and pale blues, several shades of gray, peach, silver, rose. He is a clever manipulator of color. Instead of modulating his basic primaries and secondaries, he achieves the color balance he wants by adjustments in scale or by placement; the limitations he chooses to impose make his effects more intense. I am inclined to think, though, that the beauty of this show has a lot to do with the eye of the beholder. When Pop Art first broke on the scene, in 1962, all we could really see of it was the subject matter. Lichtenstein's subjects were in many ways more shocking than either Oldenburg's or Warhol's—war comics and love comics and blowups of the most banal advertising images. Lichtenstein used a great many different images—more than anyone else—but gradually we got used to them, to their crudeness and their cold, commercial look, and began to be able to see what else was going on. A decade of critical exegesis has made the point that Lichtenstein, with his clear, flat color areas and carefully organized pictorial space, has more in common with his contemporaries Ellsworth Kelly, Kenneth Noland, and Frank Stella—abstract painters—than with Oldenburg and Warhol. This helps to explain why his work now looks beautiful. But to turn Lichtenstein into a formalist artist is to blind ourselves in another way. His work, after all, is not abstract. The subject matter may have become acceptable, but it is still there, in a very large way, and it is still humorous, and therefore subversive, and therefore a problem.

"When I get an idea for a picture, it's usually funny," Lichtenstein told me recently. Not necessarily comical, he went on to say—it could be funny in the sense of odd, of something not usually associated with art. In this retrospective, for example, there are some paintings from a series he did of business offices—paintings that mimic the advertisements for chairs and desks which one sees in the back pages of newspapers. The pictures are not "funny," but the idea of doing them was certainly odd. The idea, it seems to me, is distinctly reminiscent of Duchamp's readymades. Lichtenstein simply took the machine-made, utilitarian object at a further remove (its printed reproduction) and converted it into "art." The Duchampian irony was compounded in the sixties when Duchamp's readymades were recreated in multiple sets (the originals had almost all been lost or destroyed) and sold for high prices to collectors. Lichtenstein's paintings of office furniture sell for much higher prices than those today, but the irony goes unnoticed. Is it possible that we are missing half the fun?

In the early seventies, Lichtenstein, whose work usually runs in series, did a number of paintings of mirrors. The paintings are as close as he has come to abstractions. What we see is white canvas interspersed with patches of dots in graduated scale, areas of solid color or black, and occasional curved lines. These mirrors reflect nothing but light and shade—not the light and shade that obsessed the Impressionists and generations of earlier artists but light and shade as shown in cheap commercial ads. He also did a series of "Entablatures," paintings based on the geometric stonework designs under the cornices of buildings on Wall Street and elsewhere; among other things, the Entablatures can be viewed as early Greek Revival Minimal Art. Another series recalls the meticulously painted trompe-l'oeil pictures of the nineteenth-century American artists William Harnett and J. F. Peto; they are imitations of imitations, right down to the fly on the wall, which in Lichtenstein's version will never be mistaken for a real one.

In the sixties, Lichtenstein had "done" Picasso, Mondrian, and Monet, sometimes in direct imitations of specific works but more often by simply appropriating salient characteristics of the master and applying them to paintings à la Lichtenstein, with benday-dot shading and striping. Lichtenstein's versions of Cubism, Purism, Futurism, Surrealism, and Expressionism, all done in the seventies, make up a large part of the St. Louis retrospective. His method, as before, is oversimplification—boiling down the original to the point where it can be "reproduced" in his commercial-printer's style. Often this results in a dazzlingly clear restatement of a complex visual idea—an image that is in some ways stronger than the original, although totally lacking in subtlety or nuance, and a lot truer to the original than most of the color reproductions that we get in art books. What are we to make of such an odd procedure? Lichtenstein's Cubism is not exactly a parody, but something funny is going on all the same. Observe, ladies and gentlemen, how the Lichtenstein art machine can save you work: Understand Cubism in one easy lesson! See how the Futurists tried (and failed) to capture motion on canvas! Penetrate the mysteries of Surrealism without inconveniencing your subconscious! Lichtenstein presents recent art history as a readymade. It is quite conceivable that he will go on to do the same for earlier periods, all the way back to the Old Stone Age.

Much of the art of any period is "about" other art, insofar as it is about anything. Not since Duchamp, though, has an artist treated the

subject of art with such sweeping irreverence. At an early point in his career, Lichtenstein looked around and saw that "almost all of the landscape, all of our environment, seems to be made up partially of the desire to sell products." In the sixties, he painted the products and the idiotic, hard-sell ads behind them. In the seventies, when art became a high-priced commodity promoted by hard-sell techniques, he painted that, too. The joke is there, but the joke is not all that's there. Lichtenstein's most recent series of paintings makes new use of the famous "brushstroke" with which he satirized the spontaneity and emotionalism of Abstract Expressionism in the mid-sixties. The earlier pictures showed one or more large, dripping brushstrokes that filled the frame—simulated brushstrokes, laboriously painted in slow stages. The new paintings are still-lifes—simple and uncluttered images—whose contours are formed by the thick, flowing line of the simulated brushstroke. These are lovely paintings. The pleasure they give is warmer, less cerebral, and more intense than any I have found before in this artist's work. It is as though, after gently kidding Matisse on numerous occasions, Lichtenstein had decided to step into his shoes for a moment. The humor here is very close to high comedy—a grace that touches the emotions.

(August 17, 1981)

ALFRED BARR

The Museum of Modern Art held a memorial service on October 21st, 1981, for Alfred H. Barr, Jr., its first director and its animating spirit, who died last August. Barr had retired from the museum in 1967, and for the last few years he had been incurably ill; in a sense, the service brought him back. The speakers—William S. Paley, chairman of the museum's board of trustees; Mrs. John D. Rockefeller 3rd, president of the board; Meyer Schapiro, the art historian and teacher; Beaumont Newhall, whose long service at the museum included a stint as its first curator of photography; Philip Johnson, who started the Department of

Architecture before becoming an architect himself; and Richard E. Oldenburg, the current director—all paid tribute to Barr's extraordinary qualities as teacher, guide, scholar, and shaper of our visual culture. But it was Johnson, I thought, who put his finger on the essential element, when he spoke of Barr's passion for art—a "torrential passion that I have never known anyone else in my lifetime to have had."

Unless you worked with Barr at the museum or were close to him in other ways, this side of his nature was not readily apparent. He came across as a shy, soft-spoken, exquisitely polite, and deeply thoughtful man, and his silences were famous. When asked a question, he would sometimes look out the window for several minutes, formulating his reply, while the questioner nervously wondered whether his presence, to say nothing of the question, had ceased to register. Once, lecturing to an audience, Barr started to read a definition from a speech by Lenin, fell silent for quite a long time, then looked up with an apologetic smile and said, "I'm sorry. I got interested." His mind on these occasions was never absent. It was occupied full time, at a level of intensity that few of us can sustain. Some of the younger members of his staff never got over being afraid of him. "We were just in awe of his brains," according to Dorothy Miller, who eventually became Barr's principal assistant and, with his encouragement, organized some of the museum's enormously influential exhibitions of new talent.

It is impossible to guess how many careers were leavened by Barr's encouragement. Impossible also to see quite how the man did it—how he first conceived and then built the institution that, more than any other, has influenced the visual culture of our time. There were no precedents when he started. "Alfred got there without a chaperon," his wife, the art historian Margaret Scolari Barr, said once. "He jumped into modern on his own." From the museum's conception, in 1929, Barr wanted to show the modern movement in all its aspects—in movies and buildings and kitchen appliances as well as in painting and sculpture—and during the early years the trustees would occasionally find that a new department had been formed without their notice. Museum trustees who contribute large sums of money to their institutions are not generally inclined to be docile, and MOMA's trustees have been, on the whole, less docile than most. They fired Barr in 1943, exasperated by his policies and by his shortcomings as an administrator. Fortunately, they failed to get rid of him. Although he was the most highly respected

man in his field by then, and could have had a top museum job virtually anywhere in the world, Barr chose to stay put. He was given a tiny office within the museum's library, where he came every day to work on the manuscript of his book on Picasso (*Picasso: Fifty Years of His Art*). "Of course Alfred would not leave," Marga Barr said later. "It was his museum." Staff members kept going to see him in his new quarters, because, as Dorothy Miller explains, "everybody had to ask his advice about everything." In 1947, after a great many upheavals and firings, Barr was given the title of Director of Museum Collections, and René d'Harnoncourt, that extravagantly tactful man, became Director of the Museum; the two of them evolved a miraculous division of authority, which lasted until Barr retired in 1967. D'Harnoncourt told Philip Johnson and others that his one essential function, as he saw it, was "to preserve and nourish the genius of Alfred Barr."

After his return to power, Barr had virtually complete control over acquisitions. He financed many of his most important purchases by selling lesser works from the collection—a practice that has been much maligned of late, but without which MOMA could never have achieved its preëminence. Barr had authority over acquisitions in every department except films, and his eloquence was such that he could usually prevail over the doubts of trustees on the acquisitions committee. He never talked down to anyone, either orally or in his vigorous and lucid writings, and that was one of the secrets of his greatness as a teacher— he raised others to his own level of discourse. When doubts did prevail on a proposed acquisition, Barr often managed to persuade a loyal benefactor to buy the rejected work and present it to the museum in due course as a gift. Philip Johnson performed this useful service many times—notably in the case of Jasper Johns' *Flag*, one of four Johns paintings that Barr had selected from that artist's first one-man show, in 1958. The trustees refused to purchase Meret Oppenheim's fur-lined teacup in 1936, when Barr had it in his Fantastic Art, Dada, and Surrealism show. Barr quietly acquired it for the museum's Study Collection, and in 1946, after the object had become a modernist icon, the trustees were thrilled to accept it for the permanent collection.

Barr and his colleagues were all zealots in the cause of modern art, and most of them lived long enough to see their cause succeed almost too well. J. Carter Brown, the director of the National Gallery, in Washington, D.C., has called MOMA "the most significant tastemak-

ing factor in twentieth-century America." It is in no small part MOMA's
doing that modern art, once considered a hoax or an aberration by a
large proportion of the people who took any notice of it, has become
a social necessity; that every self-respecting city has or yearns for its own
modern museum; and that even the wealthiest of trustees subscribes,
more or less, to what Harold Rosenberg called "the tradition of the
new." The climate of acceptance in which contemporary artists work
is often blamed for the mediocrity of so much of the art being produced
and shown today. We are told, in fact, that the modern movement is
over, its discoveries finished, its vital energies spent. In that case, what
is going on now—all the furious activity in the lofts and the galleries
and the museums—must be something else, something new and dif-
ferent, but, if so, nobody has figured out what it is, and the term "post-
modern" is hardly helpful.

What would Barr have made of the current art scene? Certainly he
would not have dismissed it as irrelevant or without interest. Barr never
stopped *seeing*. He knew how easy that was to do—most collectors reach
a cutoff point where they lose interest in new work. Stephen Clark, an
avid collector of Impressionists and Post-Impressionists, and the presi-
dent of the board of trustees that fired Barr in 1943, quit the acquisitions
committee a few years later becase he could not stand the work of
Alberto Giacometti. Barr was determined not to let this sort of thing
happen to him. I like to think of Barr going around to galleries today,
wrapped in that enormous black overcoat of his (bought for a trip
to Russia and never relinquished), subjecting "new wave" or "narra-
tive" or "energist" works to his quiet and expressionless scrutiny. In
the nineteen-forties and fifties, Barr and Dorothy Miller could make the
rounds of all the leading contemporary galleries in a single day; they
could not do that now—too many galleries and too much work. I doubt
whether the vast expansion of the art world would have dismayed him,
though, any more than the endless variety of species discouraged his
lifelong passion for bird-watching. I also tend to doubt whether he would
have used the term "postmodern." Although Barr did more than anyone
else to spread the gospel of modern art, he resisted the urge to codify
it. "The truth is that modern art cannot be defined with any degree of
finality, in either time or character," he said in 1941. Modern art came
out of the art of earlier periods, as Barr, in his writings and his exhi-
bitions, made brilliantly clear. Certain impulses and preoccupations
may be unique to twentieth-century artists, but the making of works of

art is a continuous activity, and the periods and epochs into which we divide it, mainly to serve the convenience of historians and scholars, are beside the fact. Modern art is neither a hoax nor a religion, and it has neither a beginning nor an end.

Like many gifted individuals, Alfred Barr was modest about his gifts. He had once defined the museum's function as "the conscientious, continuous, resolute distinction of quality from mediocrity," but later, with rueful candor, he said that if one in ten of the museum's choices stood the test of time he and his associates would be doing their job. The distinguishing of quality from mediocrity is a moral action, and above a certain level it requires passion as well as intelligence. MOMA's collections show that Barr's average was a lot higher than one in ten. There is simply no way to thank him.

(November 16, 1981)

AN END TO CHAUVINISM

Contemporary art is no longer a New York exclusive. It never really was, of course, but the belief has been widely held. Ever since Abstract Expressionist painting became the dominant international style, in the late fifties, a great many people both here and abroad have seen this city as the primary source of advanced art—the place where new tendencies germinate, show themselves, and are approved for export. The notion that nothing of interest could be happening anywhere else in the world has caused much irritation among European artists and dealers, to say nothing of their counterparts in Los Angeles, San Francisco, Chicago, and other down-home art towns. Now the wall of chauvinism, real or imagined, appears to be crumbling.

It was breached in 1980 by the so-called Italian trans-avant-garde. Sandro Chia, Francesco Clemente, and Enzo Cucchi, who were shown together and singly at the Sperone Westwater Fischer gallery, in SoHo, and Mimmo Paladino, who appeared at both the uptown Marian Good-

man gallery and the downtown Annina Nosei gallery, attracted a lot of attention and a number of American buyers. The current season belongs to the Germans—two generations of German painters, most of whom are showing here for the first time. The older group—of artists in their forties—is represented by A. R. Penck, Georg Baselitz, and Markus Lüpertz, who are appearing this month at Sonnabend, Xavier Fourcade, and Marian Goodman, respectively; and by K. H. Hödicke, who was on view at Annina Nosei in October, and Anselm Kiefer (age thirty-six), who will be shown at Marian Goodman in April. Of the younger group—painters born around 1950—Rainer Fetting and Helmut Middendorf exhibited together at the Mary Boone gallery last summer, and Bernd Zimmer was at the Barbara Gladstone gallery in October. This month, Fetting is at Mary Boone again, solo, and Salomé (whose real name is Wolfgang Cilarz) is having his first one-man show here, at Annina Nosei. Competition among New York dealers for the new and not so new German work has been intense—one gallery owner used the word "desperate" in describing it to me—and the alliances are not yet stable. Baselitz, after showing at Fourcade this month, will show at Sonnabend in March. Sigmar Polke, another leader of the older generation, has been approached by several dealers but so far is unrepresented here.

What is behind this blitzkrieg? Baselitz, Penck, Lüpertz, and Polke have exhibited widely in Europe since the sixties, and the younger group has been showing since 1977. What made them so suddenly of interest in New York? Various explanations are advanced. The time was not ripe. Until a year or so ago, Minimal and Conceptual Art still held the German dealers in thrall; with few exceptions, they did nothing to promote the decidedly non-Minimal "heftige Malerei" ("vehement painting") of the natives. This line of reasoning suggests that New York's chauvinism was more securely rooted in European minds than it was over here. Nevertheless, the older German artists had all appeared in the large international exhibitions that are an important part of Europe's art scene, and until last year New York had seemed to take no notice of them.

Then, more or less simultaneously, lots of people noticed them. Ileana Sonnabend, Mary Boone, and Marian Goodman date their epiphanies from the last Venice Biennale, in the spring of 1980. Baselitz and Kiefer appeared in the official West German pavilion at the Biennale, and several other Germans were in an international group show

called "Open 80," organized for the Biennale by the Italian critic Achille Bonito Oliva and by the free-lance curator Harald Szeemann—a show that also included work by the Italian "Three C's" (Cucchi, Chia, and Clemente) and by a number of red-hot young Americans (Jedd Garet, Bryan Hunt, Valerie Jaudon, Robert Kushner, Susan Rothenberg, Julian Schnabel, Rodney Ripps, Ned Smyth) and two red-hot middle-aged Americans, Robert Moskowitz and Robert Zakanitch. Annina Nosei and other alert dealers (most of whom seem to be women these days) zeroed in on German artists at the big Royal Academy show called "A New Spirit in Painting," which opened in London last January. Trips to Berlin, Cologne, and other German art centers became de rigueur for New York dealers. All at once, everybody had to sign up a German.

Whatever else it may turn out to be, the new German painting is clearly German. Certain of its characteristics—crude figuration, large scale, strong color, and loose paint handling—are right in line with much of the so-called New Wave painting in New York, but something in the German temper seems to give the work a monolithic weightiness. Baselitz paints his eagles and human figures upside down, for reasons that do not immediately become evident; I have no doubt that he could explain them at length. Kiefer's subject matter is often German history— warriors, leaders, military symbols, and Wagnerian scenes of devastation. At the Biennale, some observers thought that Kiefer's pictures had Fascist overtones; others saw in them a courageous effort to come to terms with the German past. Hödicke is fascinated by the effects of light in cities, and by the human figure. A. R. Penck, who seems to me the most interesting artist of the older group, has adopted a complex language of signs and symbols, many of which derive from Paleolithic cave art. (He also adopted the name A. R. Penck, which belonged to a geologist in the field of Ice Age studies; his real name is Ralf Winkler.) Until 1981, Penck lived in East Germany, where he was unable to show his work publicly. He managed to have his canvases smuggled out rolled up in newspapers, and through the efforts of the Cologne dealer Michael Werner they reached a wide public. Penck's growing reputation in Western Europe made his life in East Germany increasingly difficult. Formally "denationalized" by the East German authorities, he was permitted to leave the country; he now lives in Cologne.

The younger artists are centered in West Berlin. Most of them live in a factory area near the Berlin Wall, called Moritzplatz, where they

started putting on group shows of their work in 1977, and the dealers who have been there report that the place is like SoHo in its early days—full of energy and the spirit of innovation. Several young German artists have made extended visits to New York. With one exception, they depict the contemporary urban scene—streets, night clubs, rock musicians, public baths (male nudes in groups are a frequent subject), tall buildings. The exception is Bernd Zimmer, who paints cows and waterfalls and other nature icons, in such extreme closeup that they verge on abstraction.

Like a great deal of recent art elsewhere, the new German painting reflects a tendency to look backward—to find sustenance in art history. The obvious antecedent of much of what the young Germans are doing is the German Expressionist movement, which began in the early years of this century and continued, with declining energy, until about 1920. Several of them have paid specific homage to the fevered urban sensibility of Ernst Ludwig Kirchner, and Zimmer's rural images owe an obvious debt to Franz Marc. There appears to be a sort of historical necessity at work here, a conscious decision to pick up the broken thread of German art and culture; last season's big Expressionist exhibition at the Guggenheim Museum, sponsored jointly by the West German government and American public and corporate sources, turned out to be perfectly timed. Art never returns full circle, of course, and the new Expressionism is significantly different from the old. While color and line are again being used for maximum emotional effect, today's Expressionists appear to stand somewhere outside their work. What mattered to Kirchner and Die Brücke Expressionists was "communication from within"—the cry of the human spirit in a world that increasingly sought (or so they believed) to drown it out. Fetting, Salomé, and their colleagues offer up no such desperate communications. Their paintings are noisy and violent at times, but without moral protestation. This is how it is, they tell us—how it is in Berlin or New York or any doomed city as the world trembles toward night.

Although much of the new painting in Europe and America can also be seen as a reaction against Minimal Art, the young Germans have retained some of the Minimalists' cool detachment. So have the Italians, whose work is quirkier and less grim than that of the Berliners. Chia's balloon-like figures float above the street, or pursue wild game in pneumatic, piebald mountains. Clemente's nude and often fragmented self-image is a prey to scatological needs. The interesting thing is that the

Italians, like the Germans, seem to be finding nourishment in their own particular art history. De Chirico and Boccioni are two evident sources for Chia. Clemente has mastered the difficult technique of fresco painting. Carlo Maria Mariani, the latest Italian to surface here (at Sperone Westwater Fischer in November), has had the effrontery to paint a vast allegorical picture of the 1981 School of Rome—artists, dealers, critics, and friends, semi-nude or clothed in togas, presented in ultra-realistic seventeenth-century neoclassical detail.

What makes the recent European painting interesting to us right now, I am beginning to think, is its specific German or Italian frame of reference. Minimal Art, the last significant new art to emanate from New York, was virtually without reference to place and time; it could be (and was) done as naturally in Tokyo and Düsseldorf as in New York. Minimal Art was historically inevitable, given the twentieth-century artist's preoccupation with stripping painting and sculpture nude in order to fathom their essential properties. Conceptual Art, Minimal's footnote, was the final stage in this century-long process; if the essence of art was idea, then a way had to be found to convey the idea without the benefit of a "work." At that point, art disappeared into philosophy, and Americans, by and large, lost interest. The only major collectors of Conceptual Art have been Europeans, who often seem to be more comfortable with ideas—or, at least, with words—than with works.

The inevitable reaction to the Minimal/Conceptual end game gave rise in New York to the period of "pluralism" in art. Many of the new approaches—Pattern and Decoration, New Image, Narrative, and the current catchall New Wave—have been based on some form of rec-ognizable-image-making, as though in rejecting Minimal one had to reject abstract art as well. The results have been inconclusive: a great deal of activity but no clear signs of where it is leading. And to this observer the pluralistic expedients share with Minimal a lack of specific reference. They do not have a New York "look." Unlike Abstract Expres-sionism or Pop Art, they could have cropped up anywhere in the world.

Seen in this light, the erosion of New York chauvinism assumes added significance. It may be as important for New York artists to break out as it is for Europeans to break in. Julian Schnabel and David Salle, two of the most widely admired young artists on the local scene, both travelled in Europe during the period when they were evolving their styles. They saw the work of the new Italian and German painters and met some of them, and there is a good deal of debate, some of it

acrimonious, as to who influenced whom. At any rate, for the first time in at least a dozen years the aesthetic currents seem to be running in both directions between Europe and America, and this is only the start of it. Eighteen New York galleries have undertaken to show the work of young French artists in February 1982. There is talk of new developments in Austria and in Holland. Meanwhile, "American Painting, 1930–80," the largest exhibition of American art ever presented in Germany (it was organized by the Whitney Museum), recently went on view at the Haus der Kunst in Munich, where it remains through January, 1982. If these cross-currents continue, American artists may rediscover their own sources reflected in next season's German painting.

(December 7, 1981)

THE NATURAL PROBLEM

For several years, young artists have been looking more to the past than to the future. This is partly the result of their education. Many of them have been through at least four years of training in university or college art departments, where they absorbed a lot of art history and looked at a lot of slides. Professionally savvy about recent art, they are well aware of the premium on novelty—the near-necessity of coming up with a specific image or "look" that will catch the eye of dealers and collectors—and it is only natural for them to ransack the image bank of the museum-without-walls. In another sense, though, the current looking backward reflects the widespread belief that modernism is dead—that a century of experimentation with new materials and new ideas and new attitudes has run its course—and that, since this is the case, one might as well go back to painting on canvas, and reëxamine tried-and-true styles (German Expressionism, for example) and subjects (landscape, portraiture). One of the more significant aspects of the current "Robert Smithson: Sculpture" exhibition at the Whitney Museum is that it upsets this whole notion of the modernist demise. Organized by Robert Hobbs, curator of contemporary art at the Herbert F. Johnson

Museum, in Ithaca, New York, where it opened in November, 1980, the exhibition has also been on view at the Walker Art Center, in Minneapolis; the Museum of Contemporary Art, in Chicago; the La Jolla Museum of Contemporary Art; and the Laguna Gloria Art Museum, in Austin, Texas. After leaving the Whitney, in April, 1981, it moves on to Europe, where it will be the official United States exhibition at the 1982 Venice Biennale. My guess is that it is having and will continue to have a powerful impact on younger artists, some of whom may now have to think twice about looking backward.

When Robert Smithson died, in 1973, at the age of thirty-five, he was known mainly as an earth artist. Smithson, Michael Heizer, Walter De Maria, and a few others had carried out large-scale sculptural projects in remote areas of the world during the late sixties and the early seventies—projects that used the land as material and heavy-duty machinery as sculptural tools. *Spiral Jetty*, Smithson's fifteen-hundred-foot-long, gently curling peninsula of rocks and mud at the north end of the Great Salt Lake, in Utah, was, to my mind, the most impressive of these, and the only one that became familiar to a large number of people, through photographs published in art magazines and also in the mass media. (The work has been under water since the mid-seventies, when the lake rose and covered it.) Heizer and De Maria have continued to work on earth projects in the years since 1973, but the movement itself has received little attention, for fairly obvious reasons. Most of the existing earthworks are situated so far from urban art centers that few people have actually seen one. Both Heizer and De Maria have made it clear that a photograph is no substitute for the experience of seeing their work *in situ*, but they have not yet solved the personal problem that their work poses; namely, how to function as an artist outside the gallery system while depending primarily on that system for support and recognition. Smithson was very much aware of this problem. He spent the last two years of his life trying to resolve it, and his solution, as Hobbs makes clear in the exhibition and in the excellently organized book that serves as its catalogue, was as ambitious as they come.

The urge to be "outside art" has been a persistent one in our century. Oppressed by tradition and art history, certain artists have longed to throw it all off and start out from zero. "I wanted to be like a new-born child, knowing nothing, absolutely nothing of Europe," Paul Klee wrote in 1902. The Dadaists' all-purpose derision fell most scathingly on art and artists, not excluding the masters of modernism; Picabia once ex-

hibited a child's stuffed monkey and called it *Portrait of Cézanne*. Marcel Duchamp thought reverence for art a form of heresy. Fifty years later, some of these ideas still have force, and their influence shows up in the work of artists as far apart as Jean Tinguely and Joseph Beuys. Tinguely, the Swiss-born fabricator of poetic machines, has spent much of the last decade working on a gigantic construction in the forest of Fontainebleau, sometimes by himself and sometimes in the company of like-minded artists whom he invites to collaborate with him. The construction is in the form of a mechanomorphic human head, some eighty feet high, with an interior network of capillary chutes through which metal spheres roll noisily at intervals; its lavish tongue is a slide for children. The head in the forest may become public property one day, but for the time being the artist has no such plans. He is content to be working on it, outside art.

The commercial success of Pop Art in the sixties came as a nasty shock to Tinguely, Yves Klein, and the other European *nouveaux réalistes*. They, too, were interested in the contemporary reality of advertising and popular culture, but they felt that the artist's job was to find new pathways to individual freedom through the thickets of mass-market conformity. Once the contemporary American art boom got going, nobody paid much attention to the artist's social role. Success was its own justification. The boom even accommodated itself to Minimal Art, which had seemed at its first appearance a severe antidote to the jocose vulgarity of Pop. Those puritanical, high-tech, smoothly finished, single-color minimal shapes, as it turned out, were just what the interior decorators could use. There was no getting beyond the system that way.

Smithson made important contributions to Minimal Art. One of his early Minimal sculptures was in the 1966 "Primary Structures" show at the Jewish Museum—the show that focussed attention on Minimal Art as a movement—and for several years afterward his steel forms and glass "strata," shown at Virginia Dwan's New York gallery and elsewhere, were as strong and severe as anything being done in that line. But Smithson, who started out as an Abstract Expressionist painter, was never entirely comfortable as a Minimalist. He mistrusted abstract art, for one thing. "Abstraction in a funny way seems to take you very far from any kind of natural problem," he said in 1971, "and I've always been drawn to natural problems." As a boy growing up in the grimmer suburbs of New Jersey (Passaic, Rutherford, Clifton), he had wanted to

be a naturalist. His collections of minerals, fossils, and reptiles and other fauna occupied a special room in the basement of the family home. Both parents encouraged this interest; they also indulged his passion for maps by letting him plan their vacation trips by car across the country. Smithson's decision to be an artist rather than a naturalist did not vitiate his concern with "the natural problem." He got deeply interested in crystallography. The formation and growth of crystals came to seem to him a possible paradigm for aesthetic structures, and several of his Minimal sculptures were based on crystalline patterns.

Smithson was a great talker and writer of essays. He did most of his talking informally at Max's Kansas City, the main New York artists' hangout during the sixties, but in 1966 he was invited to be on a panel at Yale to discuss art and the city. An architect in the audience found Smithson's ideas so impressive that he got his firm to hire Smithson as an "artist-consultant" for the firm's major objective at the time, which was to land the contract for the new Dallas–Fort Worth airport. Smithson spent about a year on the project. Although the firm did not get the airport contract, the experience encouraged him to think in terms that were far from Minimal. He began making trips to the New Jersey Pine Barrens and to abandoned quarries, often in the company of other artists, whom he tried to interest in doing collaborative work there. The "Site/Non-Site" works that came as a result of these trips were actually a form of earth art in reverse. Instead of going out to make things in the desert, as Heizer and De Maria were starting to do at about that time, Smithson in 1968 brought back sand samples from the Pine Barrens and exhibited them, in specially constructed wooden bins, at the Dwan, together with an aerial map of the area from which they had come. Natural material "displaced" from its site was thus inserted in the artificial space of the "non-site"—in this case, an art gallery: a "nowhere" white room whose only purpose was to be a temporary container of works of art. He went on to do many more of these works, using geological material from as far away as Mono Lake, California. But for Smithson this was a transitional activity.

Smithson, Heizer, and De Maria itched to break away from galleries and exhibitions, and to make works that existed independently in nature. The sort of works they had in mind were big, and they would cost a lot to make, and this presented a problem. Most of the major earth projects in the seventies were financed by wealthy individuals, either

collectors or dealers. Smithson was able to carry out some smaller projects more or less without subsidy—for example, the "run-downs" of viscous material, which he allowed to take their own course on the land, and the various "mirror displacements," which involved his travelling to specific locales where he would insert a series of mirrors in the landscape at intervals, then photograph and remove them. But *Spiral Jetty*, his major earthwork and the one that established his reputation, was financed by Virginia Dwan, his New York dealer. A more sympathetic and intelligent patron could not have been found. When Virginia Dwan closed her gallery in 1971, she continued to help certain earth artists realize their projects. But even Smithson, who once complained that "photographs steal away the spirit of the work," felt he had to go on showing photographs of *Spiral Jetty* and other pieces in art galleries. "Painting, sculpture, and architecture are finished, but the art habit continues," Smithson wrote in a 1967 essay. The earth artists professed to be contemptuous of the art market and its multiform corruptions. On the other hand, nobody wanted to make invisible art. If only eight people saw your work in the Great Salt Lake or the Nevada desert in the course of a year, was the work really valid? If a tree falls in the forest with no one around to hear it . . . The art habit dies hard.

Relatively widespread publicity about *Spiral Jetty* did not make it any easier for Smithson to carry out his subsequent projects. He travelled restlessly around the country looking for sites and sponsors. He bought a small island off the coast of Maine, then decided it was too "scenic" for the project he had in mind. He went to the Florida Keys and the Salton Sea, in California, but nothing quite panned out. Smithson completed only one major new work after *Spiral Jetty*. It was called *Broken Circle/Spiral Hill*, and it turned his thinking once again in a new direction. Invited by the directors of an international art fair in Holland to create a temporary earthwork for a public park, Smithson elected to make it in an abandoned sand quarry near the town of Emmen. The quarry, which was scheduled to become a recreation area at some future date, had the non-scenic, ravaged look that Smithson liked. *Broken Circle/Spiral Hill* bore a direct relationship to the site and to Holland: one half of the circle was a dike surrounded by water. The people of Emmen liked it so much that they voted to maintain it permanently, which pleased Smithson. The experience also led him to think about land reclamation as the raison d'être of earth art.

Up until 1971, Smithson had shown no interest in this idea. His

unsentimental attitude toward nature usually led him to places that had been scarred or devastated by man—abandoned quarries or dumps or industrial wastelands. He wanted to draw attention to these modern ruins; he saw them as examples of entropy, the universal loss of energy that is also a natural process. Smithson had mixed feelings about the ecology movement, which had been in large part responsible for blocking a 1969 plan of his to cover a barren island near Vancouver, British Columbia, with broken glass. He found a lot of the ecological arguments simplistic and puritanical—especially those that seemed to view man as being outside (and inimical to) nature. "To me nature has three different aspects," he said. "There's wilderness, and there's the country, where man has been, and then there's the urban area. And the urban area is no more unnatural than Yellowstone Park." Mining for coal, to Smithson, was a natural process; and strip-mined hillsides were ideal sites for earthworks. After *Broken Circle/Spiral Hill*, at any rate, Smithson started writing letters to large corporations with proposals for land reclamation through art. Smithson believed that the artist could mediate between industry and the ecologists. He was not out to beautify the strip-mined hillsides. His projects would call attention to what had been done to the land by man, just as the Grand Canyon calls attention to what has been done to it by wind and water. He wanted access to the devastation caused by the gigantic machines of the strip miners, such as Hanna Coal's seven-thousand-ton Gem of Egypt earthmover that stood twenty stories high and could scoop up a hundred and thirty cubic yards of earth in its bucket. What a solution to the dilemma of the artist outside art! "Art should not be considered as merely a luxury," he wrote in one of his proposals to industry, "but should work within the processes of actual production and reclamation."

He was amazed that the big corporations did not see it. The political movement against large-scale strip-mining for coal in the West and Midwest was gaining momentum in 1971. With the help of an influential New York businessman, Smithson put together a prospectus and mailed it to some fifty corporations—Anaconda, U.S. Steel, Union Carbide, Peabody Coal, Kennecott Copper. He designed a specific proposal for Hanna Coal's vast stripping operation in the Egypt Valley of southeastern Ohio: a thousand-acre tract of embankments and jetties that somewhat resembled his Emmen quarry piece but was on a far larger scale. Hanna declined to commission it. Few other corporations bothered to respond at all.

One that did was the Minerals Engineering Company, in Denver. Smithson made several drawings for a *Tailing Pond*, a terraced receptacle for the waste products of this company's silver-and-lead mine in Creede, Colorado. The firm actually decided to commission the piece, and Smithson went out to Colorado in the summer of 1973 to work on it. Work was delayed for technical reasons, though, and while he was waiting for clearance he drove to Texas with a friend and met Stanley Marsh, a wealthy art enthusiast who was interested in commissioning an earthwork for his ranch, near Amarillo. Smithson chose his site and staked out a winding, ascending earthen ramp. Marsh chartered a small airplane, so that Smithson could survey and photograph the site from above. The plane went into a dive and crashed a few hundred feet from the staked-out area, killing Smithson, the pilot, and the photographer.

The period in which Robert Smithson completed all his mature work was remarkably brief—only nine years—but his influence is still very much alive. It can be seen in the work of the so-called site-specific sculptors and in the more recent development of works that lie somewhere between sculpture and architecture. It is also evident in a new generation of earth artists, one of the most interesting of whom is Smithson's widow, Nancy Holt. The people who dismiss Smithson as a failed visionary, an artist who never did get outside art, miss the point of his basic proposition. He believed that art could be an integral force in our society, as it had been at other times and in other societies; he held that the problem of art, like the problem of nature, was neither modern nor postmodern but contemporary.

(March 29, 1982)

TATYANA GROSMAN

There is no accounting for the phenomenon of Tatyana Grosman, who died on July 24, 1982, at the age of seventy-eight. The extraordinary flowering of fine-art lithography that took place in the converted garage

of her modest frame house in West Islip, Long Island, is a well-recognized fact of current art history, but the genius of the presiding spirit defies analysis. This tiny, soft-voiced exile from the Urals—her Russian-accented English was a problem even for close friends—always seemed too fragile, too elegantly insubstantial to have led an aesthetic revolution. At the opening of the Museum of Modern Art's exhibition in honor of her Universal Limited Art Editions' twenty-fifth anniversary—"For 25 Years: Prints from ULAE"—Mrs. Grosman made her appearance very late, leaning on the arm of Bill Goldston, her master printer and successor. She wore a full-length black dress with a high collar, and she carried a pair of long white gloves, which, when everyone in the room turned to welcome her with applause, she waved gaily, youthfully in the air. As her old friend and collaborator Jasper Johns observed, it was a piece of theatre that no one but Tanya could have managed.

ULAE's anniversary is being widely celebrated. In addition to the Museum of Modern Art show, which will run through September 7th, the Art Institute of Chicago has mounted an exhibition of ULAE "highlights" (the museum has acquired ULAE's entire archive of trial proofs and other material relevant to its nearly seven hundred print editions published since 1957), and galleries in New York, Washington, D.C., Chicago, and Düsseldorf are featuring work from ULAE. Prints have become a big business in the international art world. The many new fine-arts presses in this country—Gemini GEL, in Los Angeles; Tyler Graphics, Ltd., in Bedford, New York; Crown Point Press, in Oakland; and Petersburg Press, in New York, are the leaders, along with ULAE—feed a demand for contemporary graphics which scarcely existed before 1957. During the seventies, new print galleries, new collectors, and corporate investors drove prices to levels that can exceed those of rare Old Master prints. Whether all this could have taken place if ULAE had not existed is debatable. Certainly the expansion of the art market, beginning in the late fifties, created a favorable climate for prints; until then there had been few buyers of contemporary art in any form. Nevertheless, it was Tatyana Grosman who took the crucial step from which so much has followed. She decided, quite simply, to publish prints by the best artists she could find, and to make sure that everything was done to serve the artists' needs. "For me, graphics is neither a means of supplying art to young collectors nor a reproduction of an artist's work but, rather, the creative expression of an artist through lithographic

stones or plates," she said some time ago. "What matters is that the print be alive, with the heartbeat of the artist in it."

Her idea, which seems fairly obvious today, was by no means obvious at the time. Printmaking in America had been, for the most part, either a commercial business or an amateur's hobby. Few important painters had given serious attention to it, and those who had—James McNeill Whistler and Mary Cassatt are the only nineteenth-century examples— were expatriates living in Europe. In this century, George Bellows, Edward Hopper, John Marin, Milton Avery, Stuart Davis, and a few others made prints that were not just reproductions of their paintings, but most of the significant modernists were not interested. Printmaking rested securely in the hands of printmakers—craftspeople whose work was of interest almost exclusively to themselves. Lithography, the most "painterly" of the print processes, had virtually ceased to exist as a tool for American artists. In 1950, there were very few professional printers left in the country capable of pulling an image from a lithographic stone or plate, and their facilities were standardized and limited; since lithography involves a complex collaboration between artist and printer, anyone who wanted to take full advantage of the medium had to go to France, where the tradition remained strong in the ateliers of Mourlot, Desjobert, and one or two others. Except for Jackson Pollock, who made some rather undistinguished lithographs in the nineteen-thirties, none of the artists of the New York School took an interest in lithography until the late fifties, when Barnett Newman and Robert Motherwell were invited to work at ULAE. Tatyana Grosman had found two lithographic limestones in her front yard at West Islip—discarded decades before, they were part of the path. She bought a secondhand lithographic press for fifteen dollars and began going after the artists she admired. Within a relatively short time, her "family" of artists included, in addition to Newman and Motherwell, Larry Rivers, Sam Francis, Jasper Johns, Lee Bontecou, Robert Goodnough, Helen Frankenthaler, Jim Dine, Fritz Glarner, Marisol, Claes Oldenburg, and James Rosenquist. Prints became and remained a central preoccupation of most of the members of this elect group. They did things in lithography that had never been done before, and their work, published and distributed with the utmost care, made a lot of other artists want to use the medium. In 1966, Mrs. Grosman received a grant from the National Endowment for the Arts to establish an etching studio. More recently, Bill Goldston

improvised a facility for woodcuts. Although ULAE has remained, by design, a small and intimate workshop—a place where work is interrupted each day for a huge, hot, home-cooked noon meal for everyone working there—its reputation has spread throughout the world. It was at ULAE that printmaking lost its stigma as craft—as minor art—and became a legitimate form for the highest aesthetic ambitions.

What began as an economic necessity—when her husband, the artist Maurice Grosman, had a heart attack, Mrs. Grosman was forced to find some means of supporting them—was carried out with only the barest regard for basic economics. ULAE's prints were always underpriced, and, in terms of the snail-like pace and the extravagant nature of production there, they still are. As the mistress of ULAE, Mrs. Grosman made it clear that compromises were out of the question. Having decided to invite an artist to work there, she would telephone him every day, would even come to the city and wait outside a restaurant at which he was known to eat. She exerted the sort of quiet but insistent pressure from which there is no escape. Some of the curatorial people at the Museum of Modern Art found her unbearable at first. She would appear with her portfolio, asking to see William Lieberman, MOMA's curator of drawings and prints. (He is now curator of twentieth-century art at the Metropolitan.) Informed that Lieberman was out, she would sit down to wait until he came back. Never would she leave her prints with someone's secretary. Her prints were important works of art, and Mrs. Grosman expected them to be treated as such. Some people scoffed at her pretensions. ULAE prints were not always impeccable in the technical sense. What these critics failed to see was that, knowing so little about the technical side of printing, Mrs. Grosman had created a workshop where there were no limits—where the way was open to discoveries of all kinds. She placed her trust in the artists she invited, and the artists pushed the technicians—the printers, who replaced one another with fair frequency in those early days—to solve problems that had never come up before. Rauschenberg made them pull impressions from stones he had imprinted with magazine pages, old lead-type faces, leaves from trees, and other oddities. When a stone he had prepared broke while being put through the press, he had the printer, Ben Burns, print from the broken stone; *Accident*, a collage of images with a great, jagged fissure running down the middle, became one of ULAE's most celebrated prints. Johns, working for months in collaboration with Bill

Goldston, managed in effect to convert a newly acquired photo-offset press, designed for commercial printing, into an exquisitely sensitive instrument for hand-process lithography.

The time and the money spent in serving the artists' needs sometimes struck even ULAE's artists as excessive. An edition might be held up for months, or even years, until Mrs. Grosman found the right paper to print it on. The right paper was her particular obsession; if only eight sheets were available, she would print an edition of eight, and lose money on it. Early on, she discovered a paper-making genius, Douglass Howell, who lived out in Riverhead, and whose standards were, if anything, even more exacting than hers. (The American Craft Museum is currently showing a retrospective of Howell's work.) For *Stones*, a portfolio of lithographs by Larry Rivers and poems by Frank O'Hara, the paper she selected proved so difficult to make that Howell could turn out only a few sheets a day, and only if it wasn't raining that day; the edition took nearly a year to print. "Sometimes, when there were two ways of doing things, I would ask her which cost more," Johns has recalled. "Tanya wouldn't tell me—she said it was for her to worry about. Usually, I didn't care which way we did it, and knowing about the cost would have helped me to decide, but she wouldn't have that. All Tanya's prints show this kind of slowness, this deliberation. Somehow, everything that comes out of there gets stamped with her personality." They all gave in to her—artists, printers, dealers, collectors, and museum people. (MOMA owns the initial copy of all but a few ULAE prints, through the gift of the collectors Armand and Celeste Bartos.) Something about this generous and demanding woman made people knock themselves out to win her approval. "There has always been this thing between Tanya and the artists," Goldston said the other day. "They want to prove themselves to her—which means they want to go beyond themselves." Most of them have done just that, consistently. If the paintings and drawings of Johns, Rauschenberg, Dine, Frankenthaler, Motherwell, and Rosenquist were all to disappear somehow, posterity could still judge their achievement through prints. "It's amazing how few bad prints Tanya has put out," William Lieberman once said. "Maybe one out of twenty-five of her prints doesn't stand up as a work of art, and I don't know of another workshop in the world of which that could be said."

She had been unwell for the last year or so. Production at ULAE

has continued under the direction of Bill Goldston, with no decline in quality. Goldston, who grew up in Oklahoma, studied printing techniques at Oklahoma State, and then came to work at ULAE, says frankly that almost everything he knows, about art and about life, has been learned there, and it is clear that Mrs. Grosman's standards have become his own. No important changes are being contemplated. The same artists come back time and again—Rauschenberg, Johns, Bontecou, and Dine have current work in progress. Goldston would like to invite some new, younger artists, he says, but up to now he has not done so; he feels committed to the established "family," and he finds it difficult to accept the new values in painting. The only recent innovation has to do with books—beautifully printed, limited-edition *livres d'artiste*, in which every effort is made to render color and tone accurately. ULAE recently issued two bound volumes of Rauschenberg photographs (*In and Out of City Limits: Boston* and *In and Out of City Limits: New York*), and a book of Johns' monotypes is due in the fall. The idea itself is not new; when Mrs. Grosman started the press, her original thought was to publish just this sort of book.

The soaring prices for contemporary prints make Goldston and others uneasy. A recent edition of Frank Stella lithographs from Tyler Graphics carried a release price of nine thousand dollars a print. New graphic work by Johns, which would have cost between five hundred and fifteen hundred dollars ten years ago, now brings as much as seven thousand dollars, even at ULAE, and many collectors have been priced out of the market as a result. The recession, which hit the art market hard in 1982, has diminished the resale value of all but the most sought-after prints, and this, in turn, discourages the corporate and investment collectors who have played such a significant part in the print boom. Current print prices are not really out of sync with the art market, though—at least where major artists are involved. The French rule of thumb—if a painting by a certain artist is worth x, then a drawing by the same artist is worth ten per cent of x, and a print is worth twenty per cent of the drawing price—suggests that a print by Johns, one of whose paintings was sold to the Whitney Museum for a million dollars, should be worth twenty thousand. Johns' lithograph *Decoy I* sold for sixteen thousand dollars at a Christie's auction in April, and his magisterial *Ale Cans*, ULAE's most famous print, brought twenty-two thousand at Christie's in 1980. Art works of the highest quality are not

subject to recessions. It may be, though, that a twenty-five-year cycle in graphic art is ending. Prints that are works of art continue to be published, at ULAE and elsewhere, but the extraordinary conjunction of talent and curiosity and total dedication which made ULAE such a phenomenal place shows no sign of repeating itself. With the exception of Jennifer Bartlett and Valerie Jaudon, few of the younger New York artists have explored lithography or etching in any depth. There has been a surge of interest in woodcuts, to be sure; the last of the classic print techniques to be "rediscovered," the woodcut, with its crude and primitive look, has an obvious appeal to the latest crop of Neo-Expressionist painters here and abroad. So far, however, no young artist has produced significant graphic work in any medium. Outside New York, in the universities and in a host of small print workshops, graphics seem once again to be moving away from the mainstream of contemporary art; the trend is back toward conservatism and craftsmanship.

Tatyana Grosman's achievement is as mysterious as any great artist's. She changed the conditions under which art is made, and opened the way to others. Her life is a cause for celebration.

(August 9, 1982)

DALLAS

"DALLAS—CITY OF THE ARTS," it says on the billboard just outside the Dallas–Fort Worth Airport. The slogan might surprise some visitors, but the Dallas *Times Herald*, which paid for it, is not kidding. Plans for a sixty-acre "arts district" now taking shape at the edge of the downtown business center include a new art museum (designed by Edward Larrabee Barnes), a new concert hall (by I. M. Pei), three hotels, several theatres, and a high school for the arts. This being Texas, the arts district is billed as "the largest downtown development ever undertaken in the United States"—a bold civic venture intended to revitalize the city's commercial heart while establishing Dallas in the upper firmament of national culture.

Although the arts district may not be completed for fifteen or twenty years, the museum—which will be called the Dallas Museum of Art—is nearly finished, and is due to open in January 1984. The museum is the key to everything else. It was the engine that got the arts district rolling, and the immense hopes for the future of the project center on the museum's ability to attract large numbers of people from downtown offices, suburban areas, and other parts of the state and the country. Dallas is by no means the only American city to set great store by its new or enlarged museum of art. Atlanta and Richmond as well as Portland, Maine, and Hanover, New Hampshire, have hired leading architects and spent great sums to this effect. (The Whitney Museum devoted an exhibition in 1982 to these and other "New American Art Museums.") The new Dallas Museum of Art, however, bears an unusually heavy weight of expectation. In no other city does a multi-million-dollar urban-renewal scheme lean so heavily on the selling power of the fine arts.

Some years ago, in a series of articles in this magazine, John Bainbridge observed that the rest of the United States tended to view Texas and Texans in much the way that Europeans viewed America and Americans. This is still true to a degree, but during the last two decades the basis for such an outlook has greatly eroded. Dallas, in particular, looks and feels like an up-and-coming city in some other part of the country. Its cluster of steel-and-glass office towers downtown could just as well be in Cincinnati or Hartford; its leafy residential sections suggest Birmingham. Notwithstanding the image projected by one of the world's most widely watched television series—of a wide-open town populated by unscrupulous oilmen who still live with their parents—Dallas has always been primarily a financial center: a city of banks and insurance firms and brokerage houses and, more recently, electronics industries. It has long been a fairly cosmopolitan place, welcoming outsiders and cultivating its ties to the older cities of the industrial Northeast. Dallas businessmen all seem to go to New York often, and that is not surprising, since quite a few of them came from there in the first place.

When, a few years ago, it began to be apparent to some influential Dallas business leaders that the city's cultural life needed upgrading, and that a new and larger art museum was a prime requisite for the process, they had no compunction about choosing Easterners to do the job. Harry S. Parker III, the likable and persuasive young man who came here in 1974 to be director of the Dallas Museum of Fine Arts,

grew up in Boston. He went to Harvard and the New York University Institute of Fine Arts. In 1963, he joined the staff of the Metropolitan Museum as an assistant to James J. Rorimer, the director, and later he became vice director for education under Rorimer's successor, Thomas Hoving. Edward Larrabee Barnes, the New York architect selected to build the new museum, won the job largely because his design thinking came closest to the express wish of the trustees for a building "that would not upstage the art." The trustees wanted a dignified and highly flexible building, in keeping with their view of the city as a mature, international-minded place. There is nothing symbolically Texan about Barnes' building; it is handsome, imposing, and rather conservative in design, and the predominant building material is brown Indiana limestone, from the quarries made famous by the movie *Breaking Away*.

Outsiders may have shaped the museum, but it is generally acknowledged that the incentive behind it came largely from Margaret McDermott, who was born and raised in Dallas, and who has been active in the museum's affairs for more than thirty years. Mrs. McDermott got involved with the museum in 1948, when she went to work there as a paid public-relations person. The museum was a quiet backwater in those days, devoted mainly to showing regional art of the Southwest. Her interest in art grew rapidly, and when she married Eugene McDermott, in 1954, her interest became his. Eugene McDermott was one of the three founders of Texas Instruments. He and his partners, Erik Jonsson and Cecil Green, came to Texas in the early nineteen-thirties, soon after the opening of the East Texas oil fields. (McDermott and Jonsson were from Brooklyn; Green was born in England and was brought up in British Columbia.) They started a small business that provided seismographic services to oil drillers, and their firm, which eventually went into electronics, is one of the great Dallas success stories. Texas Instruments has been exceptionally generous over the years in its corporate grants to educational, health, and cultural institutions throughout the country, and the three founders were highly influential in Dallas affairs. Jonsson, in fact, served as mayor from 1964 to 1971, and he is credited with holding the city together in the terrible aftermath of the Kennedy assassination.

Among Eugene McDermott's many public interests was the Dallas Museum for Contemporary Arts, which was founded in 1957. The Dallas Museum of Fine Arts, which had been around since 1903, was

sympathetic to contemporary art of the Southwest, but it had shown little interest in more advanced trends visible in Europe and New York. At that period, in fact, quite a few Dallas citizens and some museum trustees held the opinion that these advanced trends were part of a Communist conspiracy to overthrow the government. Local patriotic groups had pressed this issue with such fervor that in 1955 the trustees of the Museum of Fine Arts issued a statement promising that the museum would not "knowingly exhibit or acquire the work of a person known by us to be now a Communist or of Communist-front affiliation." Some of the more enlightened trustees—notably Betty Marcus, whose husband, Edward, became the first president of the Museum for Contemporary Arts—persuaded the board to rescind this policy a few months later. Modern art was still a fairly suspect category, however, when the Museum for Contemporary Arts was founded. Douglas MacAgy, a former Museum of Modern Art official who came down in 1958 to be the first director, put on several highly innovative exhibitions and acquired a number of important modernist works, but he also received telephone calls in the middle of the night warning him to get "that goddam Commie art" out of town quick, or else. The Museum for Contemporary Arts lost its rent-free quarters in 1962, and MacAgy went back to New York. The members of the board thereupon entered into gingerly negotiations with the board of the Museum of Fine Arts, and the result was a merger of the two museums and their boards. (Actual ownership of the Museum for Contemporary Arts' collection reverted to a specially created Foundation for the Arts, in case the older museum's trustees should decide at some future date that the pictures were a threat to the Republic.) The president of the board of the combined museums was Margaret McDermott, a firm ally of modern art. For this and other reasons—one of which was that the board members of the Museum for Contemporary Arts tended to be young and energetic—modern and contemporary art became a significant part of the Fine Arts Museum's collection.

The first director of the combined museums, Merrill C. Rueppel, had learned his trade at the Minneapolis Institute of Arts and the St. Louis Art Museum, and his horizons extended well beyond regional art. Rueppel had a brilliant eye and a shrewd talent for buying "against the market," as they say; he made important acquisitions in such relatively unfashionable areas as classical antiquities and pre-Columbian,

African, Oriental, and contemporary art without spending vast sums of money (which the museum did not have in any case). In his eight years as director (he left in 1973 to become director of the Boston Museum of Fine Arts), Rueppel gave the Dallas museum real stature, but he did not endear himself either to the Dallas millionaires or to the general public, and museum admissions declined during his tenure. This did not distress the trustees nearly as much as the opening, in 1972, of the Kimbell Art Museum, in Fort Worth, only half an hour's drive away. Rivalry between Dallas and Fort Worth had been a half-serious joke for generations—everyone loves to tell how old Amon Carter, Fort Worth's preëminent millionaire, used to carry his lunch in a paper bag when he had to go to Dallas on business, so he would not be obliged to patronize an enemy restaurant. Kay Kimbell, Carter's contemporary, had made his money in the grain market before branching out into wholesale food operations. He started buying art at about the same time as Carter and Sid Richardson, a Fort Worth oilman, but instead of buying cowboy-and-Indian paintings by Frederic Remington and Charles Russell, as they did, he went in for eighteenth-century English portraits—especially portraits of children and pretty women. When Kimbell died, in 1964, he left his collection to the Kimbell Art Foundation, whose trustees undertook to build a museum. One of the trustees' first acts was to hire Richard F. Brown, the director of the Los Angeles County Museum of Art, to run their as yet unbuilt museum, and Brown, who had presided unhappily over the construction of the architecturally mediocre museum in Los Angeles, persuaded them to engage the great Louis I. Kahn as the architect. Kahn's strikingly beautiful small museum rapidly began to fill up with masterpieces that had never been owned by Kay Kimbell. Through the generosity of Kimbell's widow, the museum endowment provided an acquisitions budget larger than that of almost any other museum in the country. (Today, it is said to be second only to that of the Getty Museum, in Malibu, California.) Ric Brown employed this resource to great effect, buying Old Masters and Chinese porcelains and medieval objects and a great many fine works of European art. Under Brown and his successor, Edmund Pillsbury, a Yale man who took over as director in 1980, the Kimbell achieved international renown as an important collection in a major architectural setting—all of which came as something of a blow to Dallas civic pride.

Imagine the dismay! Here was Dallas—cosmopolitan, sophisticated

Dallas—virtually eclipsed in the all-important fine-arts arena by insular, cattle-baron Fort Worth. And it was not just the Kimbell. The Amon Carter Museum of Western Art, established in 1961 in a building designed by Philip Johnson only a block from the Kimbell site, had decided to take a more expansive view of "Western" art than that of its late benefactor. It exhibited a fairly broad range of American art of the nineteenth and early twentieth centuries, including fine examples by such non-Westerners as Arthur Dove and Stuart Davis. In addition, the venerable Fort Worth Art Museum, a city-sponsored, privately endowed institution with its own energetic board of trustees, was turning into a lively center of international modern and contemporary art. Fort Worth, half the size of Dallas, had made itself into a world-class museum town. Important art experts sometimes flew in and out of the Dallas–Fort Worth Airport (built precisely equidistant from the two cities) without bothering to visit Dallas. Nor could you blame them. The Dallas Museum of Fine Arts had a much-improved collection, thanks to Merrill Rueppel, but the collection hung in an outmoded and outgrown building in an unfashionable part of town—Fair Park, the site of the annual Texas State Fair. (In October, when the fair was on, you couldn't even get into the museum without paying admission to the fairgrounds and fighting your way through the chili-dog stands and the livestock pens; and at any time of year people hesitated to go out there after dark.)

Harry Parker, who began proselytizing for a new building soon after he took the job of director, found he had a lot of pent-up civic pride to work with. He also had Margaret McDermott (who became chairman of the board of trustees in 1974) and Betty Marcus (who had been the museum's president in 1973–74). Mrs. McDermott and Mrs. Marcus believed fervently in the need for a new building, and so did John D. Murchison, the museum's president and one of Dallas's wealthier citizens, whose political views and tastes in art were somewhat less definitive than those of his self-made father. What Parker did not have, then or now, was a super-millionaire with a yen for his own museum. The Dallas Museum of Fine Arts had always been a *city* museum, founded and largely supported by municipal funds; that made it, in Texas, almost a unique institution. This could be viewed as an asset, in the sense that its professional independence was not subject to personal pressures, and Parker and his associates chose to view it that way. They appealed to

the pride of the citizenry, at the same time making it clear that any new museum would remain a *Dallas* museum—there would be no wings or auditoriums or special rooms named after individual donors. They have no doubt that they lost several potentially large gifts as a result. The important Dallas collectors came through, however, and so did the business leaders. Margaret McDermott pledged a very substantial gift of money to the new museum, and also an important part of the collection of Impressionists, Post-Impressionists, and classical modern paintings that she and her late husband (Eugene McDermott died in 1973) had assembled. The oilman Algur H. Meadows matched both her pledge and her gift. Meadows had been a trustee of the museum for several years. He had suffered much embarrassment as a collector, having once been informed by the Art Dealers Association of America that of fifty-eight French paintings hanging in his Dallas home at least forty-four were forgeries. Instead of giving up art, Meadows simply said he would have to get better advice, and he did. He kept right on buying, and his donation to the museum included thirty-eight fully authenticated paintings and sculptures, ranging from Impressionism through the New York School of the nineteen-fifties and sixties. A third major gift came from Lillian Clark, who donated five superb Mondrians and three Légers from the collection that she and her late husband, the Dallas financier James H. Clark, had put together with great discrimination over a twenty-year period.

Although Dallas is one of the wealthiest cities in the country, the fact is that art collecting is not yet a widespread passion there. Margaret McDermott, Harry Parker, and their colleagues hope the new museum will encourage more people to collect, and there is some evidence that this has already begun to happen. Nelson Bunker Hunt and William Herbert Hunt, sons of the well-known enthusiast of right-wing causes H. L. Hunt, recently started collecting ancient gold, silver, and bronze coins (it is tempting to wonder if this was a by-product of the Hunt brothers' recent activities in the international silver market), and they went on to acquire some important Greek vases and bronze sculptures, most of which will be in an exhibition that opens at the Kimbell Museum in June 1983, travels to several other museums, and winds up at the new Dallas Museum the following April. Lamar Hunt, another son, has a large collection of paintings by the nineteenth-century American landscapist Thomas Moran, and has served on the museum's

acquisitions committee. When Frederick Church's huge painting *The Icebergs*, purchased at auction in 1979 for two million five hundred thousand dollars, came to the Dallas Museum of Fine Arts that year through an anonymous donor, everybody seemed to know that the donor was Lamar Hunt. Several Dallas tycoons help support the booming market for modern cowboy art, which they consider far superior to anything else in the modern line. It is not inconceivable, however, that the social attractions of membership on the museum's board of trustees might eventually lead them to a greater catholicity of taste.

Nobody quite knows what would have happened if some millionaire had offered the trustees fifteen million dollars to build a new museum. At any rate, nobody did, and Parker and his trustees proceeded on the assumption that to get a new building for their public museum they would have to depend to a considerable extent on the public. The issue was first proposed to the voters in 1978, as part of a fifty-million-dollar bond issue for the new cultural center. The trustees were advised not to campaign for their cause, because Dallas voters never turned down bond issues. They didn't campaign, and the voters turned them down. Stunned but undaunted, George Charlton (then the museum's president), Irvin Levy (the chairman of the board of trustees), Vincent Carrozza, Richard Haynes, and other influential trustees persuaded the city fathers to give them another try. For the next twelve months, they campaigned ferociously, spending more than two hundred and fifty thousand dollars to sell their case to the public on radio and television, in the press, and in every other possible forum, and in November, 1979, the voters gave them twenty-five million dollars—what is said to be the largest sum ever raised by public referendum in this country for a cultural project. With a matching twenty-five million from private sources, the museum's future was assured.

By this time, planning for the expanded arts district had gone into high gear, and real-estate speculation in the formerly derelict downtown area adjoining the museum had driven prices from ten dollars a square foot to a hundred and fifty. A master plan for the district, drawn up by Sasaki Associates, of Watertown, Massachusetts, envisaged pedestrian plazas, outdoor restaurants, parks, residential units, and all manner of European-style urban amenities along the Flora Street axis linking Ed Barnes' museum and I. M. Pei's concert hall. The prospect was for a cultural complex that would vibrate day and night—a major tourist

attraction, as beneficial to business as it was to art. It certainly would outshine anything in Fort Worth, not to mention Houston, which most Dallas loyalists see as their city's true rival. Houston has several first-class museums, and a major new one—the Menil Collection—is under construction. It has more galleries than Dallas, and more artists, and a livelier art "scene," but these activities take place all over the city, and its downtown area is often dead and forbidding after dark. Houston is like Los Angeles—a dozen suburbs in search of a city. The arts district offers Dallas a chance at something more—well, civilized.

A lot of thought has been given to the new museum's function as a social center. Situated at the edge of the business district, it will serve—or so the planners hope—as a meeting place for office workers at the lunch hour and after work. An unusually large area on the museum's second floor is devoted to restaurant and lounge space. Visitors from the business district will enter the museum through a sculpture garden divided into several outdoor "rooms" by limestone walls, some of which will have water flowing down them, as in New York's Paley Plaza. Music and theatre groups are being encouraged to perform there at noontime and in the late afternoon. Film showings, lectures, and other public events will be scheduled inside the museum at night. The museum, which has depended on city funds for about sixteen per cent of its operating budget, will be asking for greatly increased municipal support in its new quarters, and it will undoubtedly try to justify this support by pointing to the greatly increased number of people it serves. The change of the museum's name—from the Dallas Museum of Fine Arts to the Dallas Museum of Art—suggests a democratic outlook, both toward the public and toward art itself. It is clear that unless the museum attracts a broad range of visitors the arts district is not going to become the "revitalizing" center that the planners have in mind.

Not that Harry Parker wants to create a populist palace. His priorities for the future, after the new building opens, are to build the collection by filling major gaps; to develop a public program with special emphasis on museum use by the public schools; and to devote increased attention to scholarship—catalogues, publications, research.* He has already

*Harry Parker resigned as director of the Dallas Museum in 1987, because he felt his authority was being undermined by the new chairman of the museum's board of directors. He is now the director of the San Francisco Museum of Modern Art.

brought several highly competent young museum professionals to Dallas: Steven Nash, from the Albright-Knox Art Gallery, is the new chief curator and assistant director, and Sue Graze, a Rockefeller Foundation Fellow from the University of California at Riverside (she was born in Manhattan), is in charge of contemporary art. Although Parker himself is not a specialist in twentieth-century art, he believes that, in view of present holdings and anticipated gifts, within the next couple of decades the museum could have one of the finest twentieth-century collections anywhere. This in itself is somewhat ironic, considering past attitudes toward modern art in Dallas. Even today, the museum regularly receives letters from visitors complaining that the several large works of contemporary art that dominate the main lobby of the building in Fair Park are "not a good introduction" to the collection. The same objection will no doubt be raised about the central gallery in the Barnes building— a barrel-vaulted, forty-foot-high space that is to contain immense works by Frank Stella, Robert Rauschenberg, James Rosenquist, and other contemporaries. The museum has commissioned Claes Oldenburg to do a monumental sculpture for this space, as a gift from the Murchison family in honor of the late John D. Murchison. Entitled *Stake Hitch*, the sculpture will have the form of a huge stake rising sixteen feet from the floor, at an angle; to it will be attached a length of rope twenty inches in diameter, whose other end will disappear into the ceiling. Oldenburg had originally suggested a sculpture consisting of three gigantic nails that would appear to be driven right through the ceiling— the heads visible outside, on the roof, and the points emerging through the pristine white vault inside—but Ed Barnes and others felt this would not be appropriate. Contemporary art is going to be prominent in the new museum, at any rate, and some people may not be pleased.

In the general climate of pride and congratulation about the museum, critical questions so far have been muted. The *Times Herald* did run a thoughtful piece by one of its reporters, Sean Mitchell, suggesting that the arts district was not going to do much for the local community of artists—a community that Sue Graze estimates to be somewhere between a hundred and fifty and two hundred. Soaring land values in the district will prevent artists from living or working there, and will probably also rule out small, informal spaces for performing groups. "The feeling persists," Mitchell wrote, "that the arts have been appropriated here primarily to sell a massive real estate development." At the

moment, though, nobody seems to question the idea of an art museum as a social center, a magnet for crowds of people with an hour to kill and a generalized belief in the benefits of high culture. And in this respect, as in many others, Dallas undoubtedly reflects the thinking in other parts of the country.

(June 13, 1983)

MANET AND DE KOONING

If modern art began with Édouard Manet, it may very well have ended with Willem de Kooning. Of course, there is no absolute proof that modern art is finished, in spite of all the recent elegies. A great deal of contemporary painting and sculpture seems at first glance to come straight out of the modernist hopper, and so far nobody has been able to define for us exactly how it has gone on to become something else. All the same, the de Kooning retrospective at the Whitney Museum, following so closely on the heels of the great Manet exhibition at the Metropolitan, does look in many ways like the end of the modernist story. The road that Manet opened when he made art itself the subject of his own art—the road followed by so many of the great modernists— reaches with de Kooning a sort of heroic dead end, which subsequent artists have had to find a way out of. I can't remember seeing any two major exhibitions that commented more fluently on one another, or on the last hundred years of visual art.

Viewed in such proximity, Manet and de Kooning turned out to have more in common than we might have thought. Virtuoso painters, deeply rooted in older traditions of art and determined to do work that would hold its own against the art of the museums; charismatic per- sonalities who stood somewhat aloof from the movements that they helped to inspire; radicals in spite of themselves, who managed to shock and alienate both the avant-garde and the conservatives with paintings of women whose brazen attributes offended taste on several levels at

once—they would surely have appreciated each other's company. A world of social difference lay between them, of course. Manet was a *grand bourgeois*, impeccable in all matters of personal style, a frequenter of the Café Tortoni and all the other elegant and socially correct places to be in the Paris of the Second Empire and the Third Republic. Charming, generous, witty—"direct and exuberant about everything," according to his fellow-artist Berthe Morisot—he seems to have been a walking example of those qualities that we think of as superlatively Parisian, although it also appears that none of his many friends knew him very well. De Kooning's background was light-years away in tone—lower middle class, dour, Dutch. His father was a wine and beer distributor in Rotterdam, his mother a barmaid; when they divorced, the father got custody of Willem, but the mother took him away by force and eventually had the custody order reversed. De Kooning held on to certain working-class attitudes for years after he came to this country, in 1926, as an engine-room wiper aboard an English cargo ship. Until 1935, the year he spent on the W.P.A. Federal Art Project, he thought of himself as a workingman who painted on the side, and several of the early paintings at the Whitney are portraits of himself or his friends as workers—melancholy figures in drab, Depression clothes. To his intimates, though, it was always clear that de Kooning was an aristocrat. "He has an aristocrat's sense of irony and manners," the critic Thomas B. Hess, who knew him well, once wrote. Others have noted the wit, the generosity, the charm, and the attractiveness to women.

With all their social and aesthetic gifts, neither Manet nor de Kooning took the path of easy success. "I work out of doubt," de Kooning has said, putting his finger on one of the keys to understanding his work. Doubt, uncertainty, contradiction, the emphasis on becoming rather than being, on process rather than completion, on the journey rather than the arrival—this is the intellectual climate of de Kooning's Abstract Expressionism, and of one whole area of modern art as well. The indeterminate path that dissolves in the turmoil of de Kooning's raw pigment is not so easily discernible to us now in Manet's work, but it was apparent to Manet's contemporaries. *Music in the Tuileries*, the picture with which Manet concluded his apprenticeship to Goya, Velázquez, and other Old Masters and declared his own radical aesthetic, was considered crude and offensive to the eye when it was shown, in 1863, in Manet's first one-man exhibition in Paris. Émile Zola, Manet's

friend and defender, later recalled that "an exasperated visitor went so far as to threaten violence if *Music in the Tuileries* were allowed to remain in the exhibition hall." What viewers disliked in 1863 was not so much the picture's jarring color contrasts as its sketchiness, its lack of "finish." Manet's technique of painting in "patches" of color, which annoyed the critics of his day, has a highly finished look to our eyes. The glossy, resonant blacks of the men's top hats and their long jackets, the flashes of opulent color in the dresses of the seated women, the animation of the outdoor scene give us, if anything, a sense of how much painting lost when it ceased to mirror the physical world. Manet's contemporaries, more aware than we are of how far this picture departed from familiar compositional devices and visual conventions, found it disturbing, arbitrary, crude.

Their discomfort rose to something like fury when they were confronted, at the famous 1863 Salon des Refusés, by *Le Déjeuner sur l'Herbe*. This modernist icon was not in the Metropolitan show, and neither was *Olympia*, painted later the same year; the Louvre refuses, quite understandably, to let them travel. Their absence left a huge gap, for in these two paintings Manet made a peculiarly modern ambiguity the centerpiece of his art. The point of focus in each is a naked woman whose frank, open, and slightly mocking stare is directed unmistakably at the viewer, drawing him or her into the highly equivocal scene and demanding a response. It was evident that Manet, in his *Déjeuner*, was quoting from the Old Masters—principally from Giorgione's *Concert Champêtre* (which is now attributed to Titian). But what on earth is going on in this updated version of a pastoral scene, and how are we to respond to it? Two young men, fully dressed in fashionable clothes of the eighteen-sixties, sit discoursing on the ground of an obviously fake forest while their unclothed female companion looks neither at them nor at nature but at the viewer. The same woman stares out at us from *Olympia* (literally the same one; Victorine Meurent, Manet's favorite model at the time, posed for both pictures), but here she is clearly a prostitute, poised on deliciously white sheets for her client. It is not hard to see why viewers at the 1865 Salon, where *Olympia* was first exhibited, resisted so strenuously her thin-lipped invitation. Was Manet baiting the public? Considering his lifelong desire for success at the Salon, a deliberate provocation on his part seems unlikely. Nevertheless, these two paintings delivered the coup de grâce to academic Salon painting in France, and announced the modern artist's new

demand: the viewer must enter into the world of the painting, decide for himself, with no help from tradition, how to interpret the work, and (as Marcel Duchamp suggested some years later) complete the creative act that the artist had begun.

It is as though Manet, having accepted his friend Baudelaire's challenge to be a painter of modern, urban life in all its transitory aspects, had decided to throw the challenge right back at the onlooker. Modern life in the industrial era implied fragmentation, dislocation, uncertainty, risk; it was full of ironic and inharmonious details—like the black cat arching its back at the end of Olympia's bed. The "heroism of modern life" that Baudelaire referred to in a famous essay required the recognition that there were no longer any comfortable certainties, in life or in art. It is Manet's constant awareness of this situation that makes his paintings, to me, more profound and satisfying than those of the Impressionists, whom he never quite joined in spirit or in fact.

The human subjects in Manet's paintings after 1860 have an air of alienation with which we are only too familiar. Theodore Reff, a leading Manet scholar, has described Manet's aesthetic milieu as "a world of strangers adrift in a seemingly limitless space, who are cut off severely at its edges, reflected ambiguously in its mirrors, remote from each other even when seated together." This is the world of A Bar at the Folies-Bergère, Manet's last great painting (finished in 1882, the year before he died, at the age of fifty-one), a painting that disturbs and confuses us as powerfully as it draws us into its shifting, smoky light and skewed perspective. Here we can be sure of nothing except the gloriously painted still-life in the foreground—the certainty of objects. The central figure of the young barmaid has a vacant expression that can be (and has been) interpreted in a dozen different ways. Whom is she looking at? Is it the top-hatted man at the extreme right, reflected in a mirror? If so, why is he placed at that impossible angle? The shimmering, blurred figures in the background co-exist uneasily with the precise foreground details—the bottles of Bass ale and of liquors and the compote of mandarin oranges on the marble counter. Seeing the painting at the Metropolitan, I thought it struck a chord of malaise, of corrupted beauty, but that could have been my own contribution. It is a painting that changes as we look at it.

The painters of modern life—a category from which I exclude Mondrian and other artists whose concern was almost exclusively with the formal

properties of line, shape, and color—have all had to come to grips with the issues that Manet raised. For de Kooning, the metaphor of modern life became painting itself. In a statement on "What Abstract Art Means to Me," which was read at a Museum of Modern Art seminar in 1951, de Kooning said that for him and for certain other artists he knew painting "is a way of living today, a style of living so to speak"—"that is where the form of it lies." His own life and his own way of working had by then become the model for countless New York artists, including those who struggled hard (as Rauschenberg and Johns did) to break away from his influence. De Kooning was a legendary figure in the New York art community long before he had his first one-man show, at the Egan Gallery, in 1948. His refusal to show work until he thought it was ready; the immense difficulty he had finishing a picture (dozens of canvases that looked magnificent to his friends were scraped off and re-started, over and over again); the depth of his knowledge of European art history, and his quirky brilliance in discussing it—all this was as impressive to other artists as the paintings that he did manage to finish. De Kooning's influence was and continues to be greater than Jackson Pollock's, although it was de Kooning who, with typical large-mind-edness, said that the seminal achievement of Abstract Expressionism had been Pollock's: "Jackson Pollock broke the ice." Younger artists in the nineteen-fifties used to imitate de Kooning's mannerisms as well as his swooping, calligraphic line; one of them even took to wearing a black wool seaman's cap like de Kooning's, and to speaking with a Dutch accent. At that period in New York, when contemporary art was a matter of serious concern to no more than fifty non-artists, de Koo-ning's aristocratic poverty and his total dedication to painting as "a way of living" served as a moral lodestone; he seemed to establish for every-one else the integrity of advanced abstract art. When *Excavation*, an abstract oil painting into which he put all he had learned in fifteen years of work and experiment, won the major prize at the Art Institute of Chicago's exhibition of painting and sculpture in 1951, the entire New York avant-garde felt vindicated.

By then, however, and to everyone's astonishment, de Kooning had turned away from pure abstraction and started painting his Women. Shock waves fanned out in all directions, comparable in their way to those set off by Manet's *Déjeuner* and *Olympia*. Didn't he know that the human figure was something you could no longer use? Georges

Mathieu, a Paris artist embedded in his own form of gestural abstraction, cabled the Artists' Club in New York to protest de Kooning's betrayal of the abstract cause. A few people saw beyond the shock waves. The Museum of Modern Art bought *Woman, I,* the first of the series—a picture on which de Kooning had worked for nearly two years, scraping and repainting and scraping the image off again. For three weeks in 1950, the canvas had lain crumpled in a corner of his studio, until the art historian Meyer Schapiro came in one day and de Kooning pulled it out to show to him, and then started to work on it again. Neither *Woman, I* nor *Excavation,* which is owned by the Art Institute of Chicago, could be borrowed for the Whitney retrospective, and their absence is roughly equivalent to the absence of *Déjeuner* and *Olympia* from the Manet show. More than a dozen post-1950 *Woman* paintings and a great many drawings are on view, though, each one surprisingly different from the others, and the emotional impact of these violent, scarifying images is the high point of the exhibition.

Even now, thirty years later, de Kooning's ferocious, grimacing, wildly distorted *Woman* paintings tend to make people reach for psychiatric explanations. De Kooning must hate women, they say; his mother really had it in for him. This sort of reaction probably has more to do with the viewer than with the artist. Like Manet, de Kooning was commenting on past art—going back all the way to prehistoric fertility figures and Mesopotamian idols. He also carried the image forward to nineteen-fifties cigarette ads, Fourteenth Street shopgirls, and Marilyn Monroe. "I always seem to be wrapped in the melodrama of vulgarity," he told the 1951 MOMA seminar. What really disturbs us about his *Woman* series is the same thing that disturbed Manet's contemporaries about *Olympia:* there she is, looking straight at you, appearing and disappearing in those storms of dragged, seething, yet somehow perfectly controlled color, demanding that you get into the painting and come to terms with her. Is the viewer expected to re-create the experience that de Kooning had when he painted her? I don't think so. De Kooning's art is not really autobiography, after all. It is too open-ended, too deliberately unfinished for that. De Kooning himself once complained to Tom Hess that in all the verbal hooha over *Woman, I* nobody had noticed that it was funny. Certainly humor is there (de Kooning is one of the few great artists who make room for humor; Manet is another), along with what the critic Irving Sandler has described as "the anxious,

rootless, and violent reality of a swiftly paced urban life." You, the onlooker, are expected to thrash around in that painted reality, with your autobiography as a guide.

Reality in a de Kooning is very different, however, from reality in a Manet. Although Manet is looked upon today as the first artist to make painting itself the subject of his work—and thus as the progenitor of the modernist dictum that a painting should be a thing in its own right, and not just a representation of some other thing—he also concerned himself to a very large degree with the physical world, and his dazzling skill in representing that world is what drew the enormous crowds to the Metropolitan show. The same thing could be said, to a lesser degree, of Picasso and Matisse. It cannot be said of de Kooning. The space in de Kooning's pictures, the pictorial context, is what de Kooning calls a "no-environment." It is an ambiguous, shifting space, impossible to get your bearings in—a space that is a reflection of the artist's mind. In this sense, it is also a cul-de-sac. Why is de Kooning's art still so difficult for a public that accepts, say, Roy Lichtenstein? Much of his painting since the *Woman* series has been rooted in landscape, that most durable of popular favorites. De Kooning's mastery of color and his sheer painterly skill are certainly comparable to Manet's. It used to be said of Picasso that he had the best wrist in the business; by that token de Kooning has the best shoulder—nobody around today can match the authority of those broad, sweeping brushstrokes, which for thirty years have been synonymous with the "look" of Abstract Expressionism. What is it, then, that makes de Kooning's appeal a relatively narrow one?

The question leads back, I think, to that more general issue the end of modern art. De Kooning is still with us, still painting, still upholding the integrity of advanced modern art. Compared with the paintings, drawings, and sculptures in the Whitney retrospective (twenty-four bronzes that he did between 1969 and 1974 are also on display), nearly everything produced by younger artists in this country and in Europe during the last ten years looks trivial. There is more to be seen, more complex activity, in one square inch of a de Kooning than in an entire show by some of our current art stars. The Whitney retrospective, in fact, may turn out to have an unexpectedly adverse effect on the vogue for Neo-Expressionism, which depends to such a large extent on the achievements of previous generations of artists. What postmodern art

lacks, it seems to me, is precisely de Kooning's sense of painting as a way of living, as something that matters absolutely—more than recognition, or career, or life itself.

Art replaced life for de Kooning, and for certain others of his generation. The process had begun before the turn of the century, when artist after artist decided that it was demeaning to imitate, or "represent," the natural world. Illusion came to be seen as fraud. Painting became its own raison d'être, and the artist—the kind of artist, at any rate, who chose to deal with "modern life"—came increasingly to identify that life with the experience of making art. For de Kooning, carrying the process to its furthest point, reality resides exclusively in the paint on the canvas. Those sun-dappled, slightly hilarious beach girls in his post-1963 paintings, those color-drenched hints of landscape in the later abstractions are all that is left of a world other than paint. They are the residue of what de Kooning has called his "slipping glimpse"—that momentary flash of something seen out of the corner of the eye, that fractional nod by an intelligence that does not wander from the canvas in the Long Island studio. Real life is somewhere else—on the other side of the impenetrable curtain that modern art had become.

<div align="right">(February 6, 1984)</div>

THE SPACE AROUND
REAL THINGS

One of the principal honors of the academic life in America is to be named Charles Eliot Norton Professor of Poetry at Harvard. The annual appointment, which requires the appointee to give a series of six public lectures, is predicated on a very broad definition of poetry; its recipients have included T. S. Eliot, Igor Stravinsky, Ben Shahn, and R. Buckminster Fuller. The 1983 Norton lecturer was Frank Stella, a forty-eight-year-old abstract painter whom many people consider one of the

most important living artists. Stella's lectures covered a lot of art-history ground, from the Renaissance to the present day, and they contained such a profusion of ideas, presented from such an unfamiliar point of view—the point of view of a practicing artist, rather than of an art historian—that they were often difficult to follow. The difficulty was compounded by his rapid-fire delivery, and by his tendency not to pay much attention to the slides being projected on three large screens; the listener was often on his own in making the visual connections. Under the circumstances, it might have been expected that the audience would dwindle a bit from one lecture to the next—Stella had been warned that this nearly always happened during the Norton series. It did not happen in his case. The lectures, which were moved from their orig-inally scheduled site to the larger auditorium of Sanders Theatre because of a heavy demand for tickets to the first one, continued to draw a capacity audience each time. The complexity of the argument did not appear to dismay the heterogeneous audience of students, teachers, and non-university people from as far away as New York City and Wash-ington, D.C., that packed the wonderful old wood-panelled theatre to the rafters. A great many people seemed to find excitement and pleasure in the mere act of listening to this short, wiry, intense man who so clearly represented the factor of genius in contemporary art.

Stardom of this magnitude has descended on very few living artists. Andy Warhol achieved it, to be sure, but Warhol's art form was essen-tially publicity; for Stella, a painter committed to abstract art, the phe-nomenon is new, and hard to explain. His work has never really appealed to a large public, and his private life has remained private. Somehow, though, Stella's career has become an exemplary one, a kind of guar-antee of the integrity of the whole art enterprise. Constantly pushing his talent, he has produced an immense and prodigiously varied body of work, which was, until recently, quite difficult to sell; prospective buyers admired it without wanting to own it. Today, however, every museum of modern art must have a representative collection of Stellas, and the price of his early work has hit the stratosphere—one of the austere black-stripe paintings with which he established his reputation and which sold for twelve hundred dollars in 1960 was recently resold for more than a million. Stella's example of sustained energy, intelli-gence, and daring has made him a hero to any number of artists here and abroad, and his influence can be detected throughout contemporary

art. His stripe paintings of the early nineteen-sixties prepared the ground for Minimal Art, although by the time Minimalism surfaced, about 1965, Stella himself was onto something less restrictive. His show of *Exotic Birds* paintings, in 1976, certainly influenced the pattern and decoration style that emerged a few years later, and his gaudily painted *Indian Birds* have had an incalculable effect on all those artists here and in Europe who now mine the Neo-Expressionist vein. (Stella has always worked in series, exploring each pictorial idea through many permutations.) Through all the metamorphoses of his own style, however, Stella has never deviated from his original commitment to abstract art. The so-called return to figuration that has been a major factor in Neo-Expressionist painting strikes him as misguided, to say the least, and he sees no future whatever for realist or representational art. Abstraction has been the twentieth century's major contribution to visual art, he believes, and it is still the mainstream. One of the sub-themes of his Charles Eliot Norton lectures, in fact, was the crisis into which abstract art has fallen in the last decade, and the course he thinks it must follow to regain its dominant position.

Stella's first lecture dealt mainly with the sixteenth century in Italy— a period, he said, when a crisis comparable to the current crisis of abstraction confronted the heirs to the High Renaissance. "What painting was going to stand up to Leonardo, Michelangelo, and Raphael?" he said. "What painting was going to glow as brightly as Giorgione's and Titian's?" Since the past could not be improved on, something new had to come into painting, and that something new, according to Stella, was the genius of Caravaggio. Caravaggio "created the kind of pictoriality we take for granted when we call a painting great, a kind of pictoriality that had not existed before." His great contribution, Stella said, was a method of depicting space which gave sculptural depth, roundness, and completeness to the human figure. Renaissance space gave viewers the illusion of looking through an invisible window into a receding foreground, middle ground, and distance. Caravaggio's space came forward from the painting to envelop the artist and the viewer. It provided "the sensation of real presence and real action," of human bodies that were "touchably there," according to Stella, and in doing so it greatly intensified the pictorial drama that "is everything in art." Caravaggio made the illusion of art more real, thereby providing a basis for its future development.

Since Stella's career had begun with an all-out effort to banish illusion from his own painting, it was a little strange to hear him extol Caravaggio's illusory space. As the lectures progressed, though, it became clear that Stella's thinking had changed over the years almost as dramatically as his work has. What he loved about Caravaggio's illusionism was that it struggled to be "real" and at the same time to be painting. Rubens had taken this double-edged approach much farther, Stella said in his third lecture. Rubens' work "always declares itself as painting," and in this sense it is one of the foundations of modern art: "The sense of painting that we have today is formed by the space that Caravaggio created being set in motion by the force that Rubens supplied." Stella devoted a large part of the first three lectures to Caravaggio and Rubens, and he kept coming back to them in the next one, which dealt primarily with Picasso and Kandinsky. His approach to these modern masters was as fresh and original (and often as hard to follow) as his approach to Caravaggio and Rubens had been, and it centered on their treatment of pictorial space. Picasso had turned away from complete abstraction, which he had come close to in his analytical Cubist period—had turned away in part because abstraction seemed to deny the role of volume, of "the space around real things," and in part because, as he once said, "Abstract art is only painting. What about drama?" It had been left to Kandinsky, Malevich, and Mondrian to explore the possibilities of spatial expression in a completely nonrepresentational art, and each of these artists had made brilliant discoveries—discoveries that had helped to make possible the Abstract Expressionist breakthrough of the late nineteen-forties and the fifties. Jackson Pollock, Willem de Kooning, Franz Kline, Arshile Gorky, Barnett Newman, Mark Rothko, and Clyfford Still had provided, in their turn, a burst of pictorial energy that, Stella said, was comparable to Rubens' achievement in the seventeenth century. But then in the nineteen-seventies a hiatus had set in. The great promise of abstract art had not been fulfilled. And the main reason it had not, in Stella's view, was that abstract art had still not solved its central problem: it had not come up with a really viable substitute for the human figure.

Up to this point, Stella had said little or nothing about himself. He had discussed many artists, without offering a shred of biographical detail about any of them—something of a feat in the case of Caravaggio, whose violent life is seen by many art historians as having had at least

a peripheral bearing on the way he painted. It came as something of a shock, therefore, when, midway through the sixth and final lecture, the impassioned theorist started to talk in disarmingly personal terms about his own career. He described how it had felt for a young artist in the late fifties to be surrounded and sustained—"held . . . up physically and emotionally"—by the painting of the first generation of Abstract Expressionists. Stella talked about his own commitment to abstract art, which had begun thirty years ago at Phillips Academy, Andover, and he talked about his ambition to make abstract paintings that would inhabit a world of their own. At the end, he returned to the decline of abstract painting in the last ten years, and suggested what he thought the remedy might be. Abstract painting after Pollock and de Kooning, he said, had been based primarily on the metaphysical ideas of Kandinsky, Malevich, and Mondrian—all Northern Europeans, who tended to stress the intellectual and spiritual aspects of art. A new pictorial energy was needed now, and to Stella it was obvious what its source was: "the tough, stubborn materialism of Cézanne, Monet, and Picasso"—Southern Europeans for whom pictorial values outweighed ideas. If abstraction was to become again the driving force in contemporary art, "it must make painting real—real like the painting which flourished in sixteenth-century Italy."

Indirectly, of course, Stella had been talking about himself the whole time. Much of his own energy and ambition in recent years has gone into the effort to create "real" pictorial space and "real" pictorial drama in his work. While he did not exactly say that his role in the generation after Pollock's was analogous to Caravaggio's role in the period after Raphael and Titian, the implication was there. And in fact Stella does not feel that the decline he speaks of in contemporary abstraction applies to his own work. Stella has a character trait that he shares with several other leading contemporary artists: total self-confidence without arrogance. His conviction that he is on the right track—that he has made very few serious mistakes in his career and has applied his talent in the best possible way—somehow comes across sounding unemotional and unforced, as a mere statement of fact. He can talk that way because of what he has achieved.

In recent years, Stella's outward success has matched his inner conviction. Although he lives fairly simply, in Greenwich Village, spends no money on his clothes (work pants and T-shirts serve him for most

occasions), and, for recreation, plays squash at a far from fashionable downtown club, he has not entirely shirked the trappings of wealth. He owns two very expensive automobiles—a Ferrari and an Audi—which he drives at breakneck speeds; he is part owner of an upstate–New York farm that breeds race horses; he travels first class whenever he feels like it, and stays in the best hotels. A major part of his income finds its way back into his work, however, which is not very surprising in view of the fact that his work has gradually assumed the proportions of a sizable industry. Although Stella himself employs only two assistants, at his downtown studio, three print technicians operate an offset press in his house which turns out Stella editions exclusively; five men work full-time on his big metal-relief paintings in a factory in Bridgeport, Connecticut; and at frequent intervals he provides employment for eight more printers at Tyler Graphics, Ltd., in Bedford, New York, and for two or more people at a small Brooklyn shop that does specialized carpentry and metalwork for him. In 1983, he also had projects that involved a ceramics factory in New Jersey and a computer firm on Long Island. (The computer plotted variations in some of his designs.)

Stella gets along fine with the people who work for him. He has a great admiration for technical skill in any form, and occasionally he will ask one of the factory hands for an opinion about a work in progress, and will listen attentively to what he has to say. Stella's early paintings were carefully plotted in preliminary drawings, so that no design decisions were required during their actual making. These days, his methods are much freer—he did not even make maquettes for the latest series of metal reliefs, which he put together at the Bridgeport factory from scrap aluminum pieces left over from earlier series. He started his career as a rigidly disciplined solver of pictorial problems and has become a master of improvisation, and somehow the process has been entirely logical. Each series of works has led to the next; if they are seen in sequence, the progression is always apparent. No other American artist has travelled such tremendous distances in his work, though, and no artist's future work is less predictable.

Stella said a few years ago that he sees his work as being "determined by the fact that I was born in 1936"—at a time, that is, when the triumph of abstract art was no longer in question. He belongs to the first generation of American artists to have grown up in the climate of

abstraction, and he has never attempted or been seriously pressed to paint any other way. "When I was at Andover, I thought representational painting was commercial art," he told me. "I thought abstract art had happened, and artists had stopped painting any other way."

He was exceptionally lucky in going to Andover, one of the few secondary schools that provide an active and highly professional studio art program. Patrick Morgan, the art teacher when Stella was there, gave a course that was divided about half and half between art history and time in the studio, where students had access to as much paint as they wanted. Morgan was a painter himself, and so was his wife, Maud, who showed her work at the Betty Parsons Gallery, in New York. Carl Andre, the Minimalist sculptor, who was at Andover at the same time Stella was, remembers that "the two of them just set you on fire." The Morgans had abstract paintings by Hans Hofmann and Arthur Dove in their house, where students were always welcome, and they seemed to know about everything that was going on in the New York art world. In order to take the second-year studio course, students had to show some real interest in painting or drawing. Confronted with a still-life arrangement and told to make a painting of it, Stella experienced a mental crisis. He sat for a long time staring glumly at the pot of ivy on the table and thinking how little he wanted to reproduce it. "I want to paint like Dove or Hofmann," he remembers thinking. His mind wandered. He thought about all sorts of unrelated things, and then he recalled a lecture that Morgan had given on Seurat, and something clicked in his head. In the next thirty minutes, he completed a semi-abstract picture that looked something like Seurat and not at all like a pot of sickly ivy on a table. Morgan accepted him for the studio course. And, as Stella said in the last of his Norton lectures, "In the thirty or so years since that date, nothing in my experience of looking at and making paintings has given me cause to doubt what I believed then and what I believe now."

At the time, though, he had no idea of becoming an artist. He loved painting, and thought maybe he would always pursue it as a hobby, but real life, as his parents often impressed upon him, did not allow much time for doing what you loved. Stella's parents were both first-generation Italian-Americans. His mother's people had come from Calabria, his father's from Sicily, and the work ethic was strong in both of them. Frank Stella, Sr., was a small-town doctor, a gynecologist.

Although he never urged Frank, the eldest of three children, to follow his example, he did want him to enter one of the respectable professions—preferably the law—and Andover was to be a step in that direction.

Stella himself had not really wanted to go to Andover. As a boy growing up in Malden, Massachusetts, a blue-collar town about five miles north of Boston, he had always gone to public schools, and he would have preferred to stay with his friends at the local high school. A cocky, self-reliant kid who was small for his age and had a reputation for shooting his mouth off, he had been in a fair amount of teen-age trouble—shoplifting, cutting classes, that sort of thing—and it was mainly as a punishment, he feels, that his parents decided to send him away to boarding school. Stella and his father were very close, and frequently in conflict. They spent a lot of time together, going off at least twice a year on fishing or hunting trips to New Hampshire. The father had paid his way through medical school by painting department stores, and he taught his son all he knew about that sort of work by enlisting him as an assistant whenever the house in Malden or the Stellas' summer cottage, in Ipswich, needed repainting. He had been a top-notch amateur wrestler in his youth, and under his guidance Frank became one, too. They went around together to local and out-of-state wrestling meets, where young Frank did well, although not quite as well as his old man had—his father had advanced all the way to the National Championships, where he lost in the final. "He lost only three times in a hundred bouts," Stella told me. "The best I ever did was runner-up in the New England A.A.U. championships when I was seventeen."

When Stella entered Andover as a freshman, in 1950, it was with the clear understanding that his parents were making a financial sacrifice to send him there and that he was expected to do well. He did only fairly well in his academic courses, and this added to the tension between him and his father. Andover's standards are famously high, however, and his grades were good enough to get him into college. His father gave him a choice: he could go to any college he wanted, but the only three his father would pay for were Harvard, Yale, or Princeton. Stella ruled out Harvard because it was too near home. Yale was where a lot of his Andover classmates were headed, so that was out. He had no particular feeling about Princeton, but he knew it was only an hour

from New York, and that sounded promising. He applied to Princeton, was accepted, and entered in the fall of 1954.

While Princeton was no longer the aristocrats' playground that it had been in Scott Fitzgerald's day, it was certainly not the place to go if you were thinking about becoming an artist. The Department of Art and Archeology had a reputation for turning out art historians, not painters, and there was not even a studio art course when Stella arrived. By another stroke of luck, though, Stella's four years there happened to coincide with the presence (quite temporary, as it turned out) of several teachers who had a lively interest in contemporary art. William Seitz, who taught art history (and who subsequently became a curator at the Museum of Modern Art), was a painter himself. Seitz was just finishing his doctoral thesis, which was on "Abstract Expressionist Painting in America" and was probably the first graduate thesis on living artists ever accepted by an American university. He knew de Kooning and most of the other artists of the New York School, and he encouraged students to see their shows. James Holderbaum, who taught art history (and who now teaches at Smith), actually bought works by artists of the post–Abstract Expressionist generation; he acquired a small flag painting by Jasper Johns while Stella was in college, and he also bought one of Stella's student paintings. Robert Rosenblum lectured on nineteenth- and twentieth-century art; he knew a lot of the younger artists in New York, and he followed current exhibitions keenly. (Fifteen years later, Rosenblum published an important monograph on Stella.) In Stella's sophomore year, Seitz managed to establish a non-credit studio art course at Princeton, and he got Stephen Greene, a very well-regarded abstract painter, to come down from New York to teach it.

Stella had not done very well as a freshman. He was taking liberal-arts courses, and a lot of the material in them was familiar to him from Andover. He was bored and restless. The studio art course changed everything for him. He started painting several hours a day. His work at the time was loose, messy, and Abstract Expressionist in feeling— "sort of a cross between Franz Kline and Helen Frankenthaler," he says—and his attitude was somewhat belligerent. Occasionally, Greene brought in a model to pose for life drawings; Stella would scribble "I Can't Draw" in large letters across his canvas, and leave it at that. Both Greene and Seitz were understanding—"which couldn't have been easy," Stella recalls, "because I was pretty obnoxious, sort of blustery

and awkward." Although he was painfully shy, he gave the impression of being a tough street kid. He had lost three front teeth at Andover, roughhousing in the dorm, and because a temporary dental plate fit him so poorly, he refused for several years to go back to the dentist for permanent repairs. He went out for wrestling at Princeton but quit after losing an elimination bout; after that, he played lacrosse. He was a tenacious, aggressive, fiercely competitive player—a natural athlete, who seemed to love going all out. As his sophomore year advanced, though, he spent more and more of his free time in the painting studio. Stephen Greene decided early that Stella was the most gifted student he had ever seen. Rosenblum says that they all thought Stella was some kind of genius in their midst, although none of his teachers ever got to know him well.

The encouragement Stella received from Seitz and the others still did not make him think he could be an artist. He majored in history in his last two years, and thought vaguely about going to law school— his father kept leaning on him to decide what he was going to do for a living. In the summer before his senior year, when he was at their house in Ipswich, his father got him out of bed at five-thirty one morning to work on a stone wall they were building together in back of the house. Stella got dressed, walked out to the stone wall, and kept on walking. With twenty dollars in his pocket and not even a change of socks, he decided to hitchhike across the country and enroll in the University of California at Los Angeles, where he had heard there was a good art department. He got as far as Colorado Springs. A college classmate, Sidney Guberman, lived there, so he called him, and stayed with the Gubermans until he got a job as a dishwasher at a nearby resort hotel. After about two weeks, Stella's conscience asserted itself. He telephoned home, told his mother where he was, and started back, returning by way of New Orleans, where he went to hear some live jazz. He had decided to go back to Princeton for his senior year—in part, he says, to "punish" his father, who would have to pay for it.

The major event of his last year at Princeton was his going to see Jasper Johns' first one-man show, at the Leo Castelli Gallery, in New York. He had heard a great deal about Johns, from Rosenblum and others, and the paintings made a strong impression on him. They were not abstractions. Johns painted simple, iconic images—flags, targets, numerals—in a brushy, bravura style that was derived from Abstract

Expressionism. What struck Stella was Johns' method of organizing them in repetitive patterns, such as the alternating red and white horizontal stripes in the flag pictures. The stripes went all the way to the edge of the canvas, so that there was no sense of a background. These works were not really paintings *of* flags—they *were* flags. This identification of image and surface, which had such an immense influence on later artists, was soon reflected in Stella's work at Princeton. That spring, he stopped painting like Frankenthaler and Kline, and started doing canvases divided by wide bands of color, with a block of solid color placed not in the upper-left corner, as in Johns' flags, but somewhere near the center.

Stella graduated from Princeton in June, 1958, and came straight to New York. His father had given him three hundred dollars as a graduation present. The draft was in effect then, and Stella had been notified that he was due to take his Army physical examination in early September, in Boston. He was sure he would be drafted, which was all right with him, because it meant he didn't have to worry about what he was going to do for a living. With his graduation present, he rented, for fifty dollars a month, a small, narrow, first-floor room that had formerly been a jeweller's shop on Eldridge Street, on the lower East Side, and spent the summer there, painting.

He went to Boston in September and, to his great surprise, was rejected for military service. He had a physical problem that stemmed from a childhood accident: a large ornamental urn had fallen over on his left hand while he was playing with some friends, and he had lost half of the forefinger and part of the thumb. The Army physical showed that as a result he had faulty opposition between thumb and fingers. Somewhat stunned, Stella went back to Eldridge Street, bypassing Malden. What he really wanted to do was to go on painting, even though there seemed no possibility of making a living that way. He didn't see how he could get a decent job ("I didn't have any skills. I couldn't do commercial art"), and his father was certainly not going to support him. His father dismissed the idea of his becoming an artist—it was not only improvident but, somehow, unseemly. Stella still had no sense of his own talent. Being the most gifted art student at Princeton didn't seem to him to prove anything at all. Nevertheless, he decided to keep on doing what he liked. He also registered with several employment agencies as a housepainter (the one skill he *had* picked up, thanks to his

father), and found that he could get plenty of jobs that way—jobs that lasted two or three days and gave him enough to live on for the rest of the week. The work took him mainly to outlying neighborhoods: Bedford-Stuyvesant, in Brooklyn; Astoria, in Queens. "I was excited, being on my own, and I felt very much at the edge," he remembers. "I guess I was scared, too, because I knew I wasn't going back."

In the narrow room on Eldridge Street, each painting led to the next. He was still doing striped pictures, experimenting with colors and designs on raw, unsized canvas, sometimes painting one version on top of another, so that the painted-over color showed through in places. He bought ordinary housepaint from supply stores on Essex Street, paying little more than a dollar a gallon for colors nobody else wanted (such as purple or chartreuse); he also used a lot of housepainter's black enamel. The idea for the black paintings came more or less by accident. Stella had been working and reworking a picture that had alternating red and black vertical stripes at the top and the bottom and V-shaped stripes, also red and black, in between. He couldn't seem to make it do what he wanted. As he later explained in an interview, what he was after was a kind of painting that would have a strong and immediate visual "imprint," a kind of painting whose effect would be "direct— right to your eye . . . something that you didn't have to look around— you got the whole thing right away." Frustrated with the black-and-red picture, he painted it all black. "I looked at it, and sort of liked it," he remembers. "The red was showing through a little. It had a kind of presence, an identity. It was something I'd made that didn't look like anybody else's work. Suddenly I was there."

Although Stella considers this his first black painting (its title is *Delta*), it was really a transitional one. The next one he painted, *Morro Castle*, also started out black and red and became all black. *Reichstag*, which followed, was all black from the start. Stella drew pencil lines on the canvas to mark off two-and-three-quarter-inch stripes, which he painted freehand, using a housepainter's brush, and leaving a thin sliver of raw canvas between the stripes. "After that, it became really clear how to organize them," he says, "so I made a bunch of drawings with the various possibilities. I was afraid it might go away—I wanted to hold it down and establish control." The drawings were for different configurations of vertical, horizontal, or diagonal black bands. During the

next sixteen months, he finished twenty-one more black-stripe pictures, all quite large—the smallest seven feet by five feet, the largest seven and a half by eleven.

A great deal has been written about the black paintings. They have been seen as a rebuke to the "painterly" excesses of Abstract Expressionism and to the high-flown rhetoric used by some of the Abstract Expressionists in discussing their work; they have also been seen as logical extensions of Pollock's "allover" style of composition. (Stella himself has endorsed the latter view, although he says he was halfway through the series before he began to "see the importance of Pollock.") The paintings look desolate and empty to some viewers, incredibly elegant to others. When they were first shown, some of the critics described them as "white pin-stripe pictures," not having noticed that the white lines between the black bands were simply strips of unpainted canvas. The journalist critics tended to ridicule them as some kind of joke—one that Emily Genauer, in the *Herald Tribune*, found "unspeakably boring." But the black paintings had already left an indelible imprint on several people whose opinions were far more influential. Dorothy Miller, who was the principal assistant to Alfred H. Barr, Jr., the guiding spirit of the Museum of Modern Art, had chosen four of them for a group show of new talent, called "Sixteen Americans," scheduled to open at the museum in December, 1959. Barr himself, writing about the black paintings a year later, said he had been "baffled" by them at first but "deeply impressed by their conviction," and had finally been "spellbound, held by a mystery." Leo Castelli had responded to them in the same way he had responded to the work of Jasper Johns. It was Castelli who had taken Dorothy Miller to see them, in Stella's new studio, on the corner of West Broadway and Broome Street, in the early fall of 1959. Afterward, a minor dispute had developed over who would show them first: if Miller took four for her "Sixteen Americans" exhibition, Castelli would not have enough for the Stella show he was planning at his gallery in the fall. Stella said he would rather show them at Castelli's, which led a lot of art-world initiates to conclude that he was overly mercenary. Actually, according to Stella, he had not understood what sort of show Miller was planning; he had thought that the museum was just going to hang them temporarily in the members' dining room, on the sixth floor. In the end, Stella and Castelli graciously conceded to Miller, and she got the four

paintings. (Stella had his first one-man show at Castelli's a year later.) Castelli also made it possible for Barr to buy a black painting for the museum's permanent collection. The asking price for *The Marriage of Reason and Squalor*, Barr's choice, was twelve hundred dollars, but when Barr explained that he could not go over a thousand Castelli agreed to sell it to the museum for less than nine hundred.

The intensity of feeling that the black paintings aroused came as a surprise to Stella. He was by no means the first contemporary artist to make predominantly black pictures. Robert Rauschenberg had done a series of them in 1952—black paint on a collage base of crumpled newspapers. Stella knew about these, but had not seen them, when he did his. Pollock, de Kooning, and Kline had all worked in black and white. (Ad Reinhardt, whose work and ideas Stella admired, began in 1960 the series of all-black paintings which he continued until his death, seven years later.) Stella had not been trying for some form of extreme statement. He wanted to make paintings that declared themselves completely and immediately to the eye—paintings he called "non-relational," meaning that their elements did not relate to one another (either in balance or in opposition) or to anything outside the painting. In addition, he wanted to get rid of the illusion of spatial depth. Abstract Expressionist painting, with its agitated, "painterly" brushwork, tended to give the illusion of depth, simply because of the tendency of some colors to appear to come forward and others to recede. By using a symmetrical pattern of stripes which covered the entire canvas, Stella was working to force "illusionistic space out of the painting at a constant rate," as he put it. All this sounds somewhat cold and negative, and very much in the spirit of Jasper Johns. (Johns once described his own work as "a constant negation of impulses.") Although the black paintings had a handmade look, they were far more impersonal than anything Johns was doing then—there was no visible brushwork, no painterly "signature." And yet, to people who did not dismiss them as boring jokes, there was something compelling about them, a remote and majestic austerity. It seemed incredible that they had been painted by someone who was only twenty-three years old.

There were very few sales at first. Stella traded one or two and virtually gave away several others to friends, and immediately started work on a new series of paintings. Having heard that Castelli was giving Johns and Rauschenberg each a monthly retainer, Stella asked for and received

three hundred dollars a month against future sales. Thanks to this arrangement, he could now afford to devote all his time to painting. Stella knew Johns and Rauschenberg—Robert Rosenblum had brought them together for dinner one night in 1959—but they did not become close friends of his. He had his own circle of friends: Carl Andre; Michael Fried and Walter Darby Bannard, both of whom he had known at Princeton (Fried was becoming an art historian, Bannard an abstract painter); and Hollis Frampton, a filmmaker who had roomed with Andre at Andover when Stella was there. Stella had known Frampton at Andover, but Stella and Andre, although they had both haunted the school's painting studio, somehow had never met until they got together in New York. "He made a tremendous impression on me then," Andre recalls. "By the time of the black paintings, Frank was a thoroughly mature artist—the only one I knew like that. He had the intensity and the rigor. He was very quiet, very self-contained, and very smart. There's a big misconception about Frank, by the way. The black paintings were definitely not a reaction against Abstract Expressionism. Frank was a great admirer of Pollock and de Kooning, but he hated the generation that came after them and tried to imitate their work. His black paintings were an attempt to continue the vitality of the first generation, to be as original and profound as they were." Andre and Frampton shared a cold-water flat on Mulberry Street. There wasn't much room to make sculptures in it, so Stella used to invite Andre (and, later on, other friends) to work in his West Broadway loft. Andre was carving big wooden beams at the time, under the influence of Brancusi. One day, Stella came in and saw one of the beams standing on end. He looked at the carved side and then ran his hand down the back of the beam, which was untouched, and said, "You know, Carl, that's sculpture, too." It turned out to be a moment of revelation for Andre, who from that day to this has been using his materials (wooden beams, bricks, metal plates) in an untouched state—using them as "cuts" in the space that surrounds them, shaping the space itself.

Andre helped Stella choose the titles for several of his black pictures. *The Marriage of Reason and Squalor* was a title that Andre had used for a series of pastel drawings he had made and then destroyed—he had been reading William Blake's "The Marriage of Heaven and Hell," and may also, he thinks, have had in mind the J. D. Salinger story "For Esmé—with Love and Squalor." Several of the black paintings

have titles relating to the depressed neighborhoods where Stella worked as a housepainter: *Tomlinson Square Park* refers to a park in Bedford-Stuyvesant, and *Arundel Castle* is the name of an apartment building there. Three of the titles have Nazi connotations (*Reichstag, Die Fahne Hoch,* and *Arbeit Macht Frei*), while others refer to famous disasters (*Morro Castle*) and to small jazz clubs, which Stella loved to go to in that period. The titles have no direct connection to the paintings, except to suggest Stella's state of mind when he was painting them—the state of living "at the edge." It is significant, though, that he did not follow the example of those abstract artists who simply numbered their paintings instead of naming them. Throughout his career, his titles have added an element of drama or a sense of place to the visual impact of the paintings. (The same can be said of Rauschenberg and, to a lesser extent, of Johns.) His intention, it would appear, has never been quite as blunt and matter-of-fact as he has sometimes suggested.

Living at the edge seemed to require, in Stella's case, a degree of personal reserve which struck Carl Andre as "Sicilian." Stella's silences made people uneasy. It was partly that his shyness made him incapable of small talk. He could be quite funny at times, with his caustic wit, and once he got going he would talk a blue streak, throwing out ideas with such articulate brilliance that people just listened in awe. He dressed in torn T-shirts and paint-splashed chinos, and he had a habit of sucking his thumb; it was suggested that maybe the reason he so rarely wore the permanent dental plate he had finally been fitted for was that the gap left by the missing front teeth made such a convenient resting place for the thumb. He smoked expensive cigars when he could afford to, but he drank very little. Most of the New York artists drank a lot in those days, and Stella's abstemiousness was considered weird. Another oddity was his habit of giving himself an annual birthday party, with a cake and candles, to which he would invite all sorts of art-world notables. (Some of them actually came.) The parties were held in a loft on East Broadway that Andre and Frampton had moved into; Stella had planned to live there, too, but he never did.

In the fall of 1959, Carl Andre introduced him to Barbara Rose, a Smith graduate who was working for her Ph.D. in art history at Columbia. Andre and Rose used to have lunch together fairly often at the cafeteria in the Central Park Zoo, and one day Andre brought Stella

along. "A short boy in a T-shirt with holes in it, a ten-day growth of beard, no front teeth, and a mop of fuzzy black hair" is how Rose recalls him. "He didn't talk at all at first, but he had that extreme intensity. Later, Frank used to say that what he'd always wanted was a blond Smith girl in a camel's-hair coat. Well, that was me."

At the time, though, they did not hit it off. Stella fell in love with Barbara Rose's roommate, a young poet named Terry Brook, with whom Andre had earlier been in love. The two young women shared an apartment below the Hansa Gallery, on Central Park South—a co-öperative avant-garde gallery that Stella had thought about joining until he went with Castelli. (Stella had also thought about joining the Tibor de Nagy Gallery, but neither John B. Myers, who ran Tibor de Nagy, nor Richard Bellamy, the Hansa's director, had come to his studio to see the work.) Stella took Terry Brook out a number of times, until it became clear that his feelings were not reciprocated. (Later, she told Emile de Antonio, the man she did marry, that Stella had proposed to her, and that she had said she could never marry a man who sucked his thumb.) In the meantime, Barbara Rose had married someone else. Her marriage lasted only a short while, and it interfered hardly at all with her lunches with Carl Andre or her developing friendship with Stella. Although her field of study at Columbia was Spanish Old Master painting, she was becoming interested in contemporary art; after seeing the black paintings, she decided that Stella was the most important artist of her generation.

The day after Stella's twenty-fifth birthday party, in the spring of 1961, Barbara Rose (who was no longer married) was sitting in a bar with a male friend. They had both been to the birthday party the night before, and the friend had left his raincoat behind. Stella came into the bar at this point. When he heard about the raincoat, he told them he would go back and get it, "in exchange for Barbara." He returned about fifteen minutes later with the coat, handed it to the friend, and said to Barbara, "Now you're mine." She was very impressed to find he meant it. He moved in with her soon after.

Some of Stella's admirers wondered what could possibly follow the black paintings. There was such an aura of finality about them. His next paintings turned out to be just as uncompromising as the black ones, and a good deal harder to like. This time, he covered a series of large canvases with precisely ruled, symmetrical stripes painted a

hard metallic silver—the medium was commercial aluminum-based paint. The aluminum paintings, although painted freehand, looked less hand-made than the black ones, and the designs were more complex. The repetitive unit was a straight line that made a right-angle jog, then turned again to resume its original direction. This created a problem of leftover spaces at the edge of the canvas where the design ran out. Stella's Princteon friend Darby Bannard suggested a solution: cut these sections out. Stella did so, notching the canvas and its wooden stretcher so that the over-all pattern of the stripes was carried out in the shape of the canvas. Stella's "shaped" canvases had an immediate effect on any number of artists. Even more than Johns' targets and flags, they made the point that a painting was also an object—a two-dimensional object that did not make any pretense of being three-dimensional. It was this implacably literal approach that helped to prepare the way for Minimal Art.

The canvas underwent much more radical shaping in Stella's next pictures, whose internal stripe patterns made them take the form of giant crosses, zigzags, and T-squares, among other configurations. This was the Copper Series, named for its thoroughly uningratiating color. On a weekend visit to his parents' house in Ipswich in the summer of 1960, Stella had helped his father paint the bottom of a boat with copper paint. He took a liking to the paint, he said, "because it was so anti-art. It was made to resist barnacles underwater. I didn't really like going into an art-supply store and buying paint that thousands of other painters used. And I was attracted to the physical properties of copper paint, to the way the particles ride to the surface and sit there. It's very abstract, in the sense that it doesn't blend in with the real world. Metallic pigment had all the qualities of paint and then some."

The aluminum paintings were shown in Stella's first one-man exhibition at Castelli's, in the fall of 1960. Only two or three were sold, which did not discourage him from going ahead with the Copper Series. He and Barbara Rose had both applied for Fulbright grants; they decided that if either grant came through they would both go abroad on it. Stella's application, for study in Japan, was turned down. Barbara had applied for a year's study in Spain—she was writing her thesis on sixteenth-century Navarrese painting—and her proposal was accepted. She left in the fall of 1961, and he followed a month or so later. Before leaving, he moved from his West Broadway loft to a larger place, on

Walker Street, a few blocks south. He carried everything himself, down-stairs and up, making many trips. On one trip, he decided his load was too heavy, and deposited a large, rolled-up canvas in a trash can at the corner of West Broadway and Canal Street. It was *Gavotte*, one of the black paintings. "I don't know why I did that," he remarked to me recently. "The design hadn't come out just right, and I might have been planning to repaint it." Stella never did repaint it, and he now thinks it might have been one of the best in the series.

Stella and Barbara Rose lived for much of the next year in Pamplona (the old capital of Navarre), where he sat in their hotel room and made drawings while she worked in the Cathedral archives. Until a few years ago, all Stella's paintings have come from ideas first worked out in drawings, and he did a lot of drawing in Spain. Although the Fulbright money did not allow them much leeway, they did manage a trip to Morocco. Later, they went to London to get married (it was too difficult to do so in Spain), and from London they went to Paris for the opening of a Stella show at the Galerie Lawrence. Lawrence Rubin, the gallery's American owner, had learned about Stella's work from his brother William, an art historian and teacher, who subsequently became di-rector of painting and sculpture at the Museum of Modern Art. Stella painted six new pictures for his Paris show—large, square pictures with relatively simple patterns of right-angle stripes and no cutouts. Instead of continuing his investigations of shape, he had decided to investigate color; each canvas was painted one of the primary or secondary colors, in Benjamin Moore flat wall paint straight from the can. (The group is known as the Benjamin Moore Series, although the individual paint-ings are named after Civil War battles.) The show got little attention in Paris. Joseph Hirshhorn, the collector, came to it and bought nothing (later, he bought a great many Stellas, at much higher prices), but when he learned that the artist had just been married he took out his wallet and peeled off a hundred-dollar bill as a wedding present. Barbara used it to buy herself a winter coat.

Stella and Larry Rubin liked each other from the start. They were nearly the same age, and they had a lot of interests in common. Al-though Rubin couldn't sell any of the Benjamin Moore paintings, his enthusiasm for Stella and his work was unreserved. In addition to giving him a stipend of two hundred and fifty dollars a month, Rubin also began buying new Stella paintings outright from time to time, which

at that stage of his career was a big boost financially and psychologically.
From 1960 to 1965, Rubin was able to sell only one Stella painting.

Stella came back from Europe ahead of Barbara, in February, 1962,
to look for an apartment. She had given hers up, and his new loft on
Walker Street was not big enough for them to live in—they were
expecting a baby in the summer. He had found nothing by the time
she returned, and after spending one night on Walker Street she went
to stay temporarily with friends uptown. The Stellas moved twice during
the next year—first to Madison Avenue and then to Sixteenth Street
just east of Union Square. "Frank painted the apartment while I was
in the hospital having Rachel," Barbara recalls. "He built a couch,
and a desk for me—I wrote my dissertation on it—and a crib. We
had a mattress on the floor for a bed. The first person who came to
visit us was Andy Warhol, bringing a huge stuffed panda for Rachel.
Jasper Johns came a lot, and Henry Geldzahler"—the Metropolitan
Museum's ebullient young emissary to the avant-garde—"was there all
the time. Henry worshipped Frank, and got a lot of ideas from him—
and sometimes he'd come over and just watch Frank watch TV. Don
Judd"—the Minimalist sculptor—"lived around the corner. We had
no money for babysitters, so our apartment became a sort of meeting
place. We ate a lot of burned pork chops in those days." Jean Tinguely,
the Swiss artist, whose great, mechanized assemblage of junk metal had
destroyed itself in the garden of the Museum of Modern Art in 1960,
was living and working in the loft above Stella's, on Walker Street, and
they became good friends. When Tinguely, Rauschenberg, and Niki
de Saint-Phalle put on their collaborative theatrical "event," entitled
The Construction of Boston, in the spring of 1962, Stella was enlisted
to play the part of Rauschenberg's alter ego. He and Rauschenberg
came onstage at the Maidman Playhouse in oversized rain capes, with
photoflood reflectors where their heads should have been. Stella was
supposed to speak Rauschenberg's lines. Instead, he had the words
reproduced on slides, which he projected against the back wall of the
stage with a portable slide projector. The event was enormous fun for
the participants, although the capacity audience had mixed reactions.

Stella was in the curious position of being an acclaimed genius whose
work did not sell. The copper paintings, which he had spent months
repainting—the originals, exposed to direct sunlight at Walker Street
while Stella was in Europe, had faded badly—found no buyers when

Castelli showed them, in the spring of 1962. This show was the occasion of a minor dispute between the artist and his dealer. Stella had done some small versions of the copper paintings, thinking they might be easier to sell. Castelli also thought the small pictures would be easier to sell, but by this time Stella was not happy with them; he told Castelli that if they were in the show they had to be in the hall or the back room. There was an argument, which Stella won by threatening to remove the small pictures entirely. Stella does not believe that he can work successfully on a small scale. "I don't think I've made a passable picture in the sort of three-foot range and rarely attempted it," he told William Rubin. "Those few times I have, it's been a kind of disaster." When I asked him about this last winter, he reiterated that he felt more comfortable working on a large scale. "I guess because I'm a little man, a little bigger than life size seems about the right size for me. When you're hoping for things to sort of open up, you need room for them to do it in."

Stella and Castelli have never been really at ease with one another, in spite of the admiration on both sides. Stella's daunting silences, his habit of dressing like a bum, and his well-known indifference to collectors are all somewhat jarring to someone of Castelli's elegant and courtly demeanor. Stella has been known to sit through an entire dinner without saying more than six words to an important collector who had asked to meet him. His surly or ungracious side is offset by a thoughtfulness that takes people by surprise, but this is more likely to come out with people his own age or younger. Ironically, it was Castelli who labored to reassure Stella's parents about their son's career. They came down for all his openings, and what they saw of the art world did little to allay their continuing anxieties.

The Stellas moved uptown in 1963, to an apartment on Seventy-third Street near Madison Avenue, which the dealer John Myers had helped them find. The rent was three hundred dollars a month, much more than they had been paying on Sixteenth Street but a bargain for that part of town. Barbara was writing articles for *Art in America*, and Castelli had increased Stella's monthly stipend, so their financial situation was a bit better. Every Saturday afternoon, they had a sort of open house for artists, dealers, writers, and friends who had been making the rounds of the art galleries. Although Barbara was mainly responsible for these gatherings, Stella seemed to enjoy them. He also enjoyed

being a family man. The main reason they had moved uptown was to be near Central Park, for their daughter's sake, and they both spent a lot of time in the Park with her. People gaped at them because of the way they dressed. Barbara bought her clothes in thrift shops, inventively, and Frank usually had on paint-spotted work clothes, and this tended to identify them as hippies. The police looked with little favor on hippies. One afternoon, a patrolman told Barbara to take her feet off the park bench she was sitting on, and her spirited reply caused him to put her under arrest. Stella, seeing him push her and Rachel toward a squad car, went berserk. In the ensuing melee, Stella bit the cop on the hand as he was being pummelled into submission, and matters would probably have deteriorated even further if a police sergeant had not arrived on the scene and calmed everyone down. Barbara and Rachel were taken to the nearest police station, and from there she telephoned their friend Emile de Antonio to come and get Rachel. De Antonio then called Castelli's associate Ivan Karp, who sent a lawyer down to get Barbara released. Springing Stella was more difficult. He was booked on a charge of felonious assault, and spent that night in the Tombs. He was released on bail the next day and eventually got off with a suspended sentence.

Castelli was on more relaxed terms with Barbara Rose than he was with Stella. She knew a lot of artists, she kept up with the latest developments, and she had a sort of proprietary interest in his gallery, which was becoming a major force in the expanding New York art world. In addition to Johns and Rauschenberg, Castelli showed Cy Twombly, John Chamberlain, Lee Bontecou, and the Pop artist Roy Lichtenstein. (He soon took on Andy Warhol, James Rosenquist, and, eventually, Claes Oldenburg.) Pop Art had burst on the scene in 1962 with a brash and blatant élan that threatened to put some older artists out of business. There were bitter feelings among the second generation of Abstract Expressionists, several of whom saw the market for their work dry up as collectors switched to Pop. Stella, an artist committed to abstraction, had mixed feelings about the new movement, whose clearly recognizable images came from commercial art, the comics, and other low sources. He thought that Lichtenstein, Warhol, and some of their colleagues were good artists, serious artists (the Abstract Expressionists denied their seriousness), but he also thought that they were on the

wrong track. Even Johns, for whom Stella retained an immense respect, sometimes struck him as an obstacle in the path. Johns' work was poised midway between realism and abstraction, and to a great many young artists this seemed the most interesting place to be. It was not that Stella felt isolated. Kenneth Noland, Ellsworth Kelly, Jack Youngerman, Larry Poons, Helen Frankenthaler, and others were doing abstract work of great merit in the nineteen-sixties, but it sometimes appeared that the energy and momentum of events were going in a different direction.

Stella had enough self-confidence not to worry about it. He was working at a terrific clip, attacking a different (though related) pictorial problem with each new series of his stripe paintings. He completed six series from 1962 to 1965—nearly a hundred pictures in all, some of them enormous. (One of the Running V Series is seven feet tall and more than twenty-three feet long.) Although Stella's work was priced significantly lower than Rauschenberg's or Johns'—never more than three thousand dollars for a painting—Castelli continued to have a relatively hard time selling it. Buyers were put off by the size, or by the industrial look of the metallic paint in some paintings, or by the clash of "impossible" colors in others. There was no hint of spontaneity in a Stella painting. Each design had been precisely plotted in advance, and the evenly painted surfaces had a machine-like, impervious quality.

In a 1964 radio interview that was later printed in ARTnews, Stella set forth his "non-relational" credo in characteristically blunt terms:

I always get into arguments with people who want to retain the old values in painting—the humanistic values that they always find on the canvas. If you pin them down, they always end up asserting that there is something there besides the paint on the canvas. My painting is based on the fact that only what can be seen there is there. . . . All I want anyone to get out of my paintings, and all I ever get out of them, is the fact that you can see the whole idea without any confusion. . . . What you see is what you see.

The statement has been quoted again and again in writings on contemporary art, and it is one of the cornerstones of Minimalist doctrine. The irony is that in 1964, when Minimalism was just emerging, Stella had started to move toward a more widely inclusive aesthetic. He did

not share the Minimalists' interest, inspired to some degree by the critic Clement Greenberg's writings, in reducing art to its essential elements of shape and color. Stella had met Greenberg a couple of times, but the two of them never had a real conversation. Although Greenberg included several Stella paintings in the "Post-Painterly Abstraction" show that he organized in 1964 for the Los Angeles County Museum, he did not entirely approve of Stella's work—not in the same way, at any rate, that he approved of the paintings of Kenneth Noland or Jules Olitski. Greenberg argued that the true course in modern painting was the course of "self-definition," through which every element that was not essential to the art of painting was ruthlessly eliminated. Since the art of painting was essentially the art of putting pigment on a flat surface, any illusion of spatial depth must be avoided at all costs, according to this theory, so as not to violate "the integrity of the picture plane." Stella had tried hard to get rid of illusory space in his black paintings and his early metallic paintings, without entirely succeeding, but in his more recent work, such as the Running V Series, the color bands appeared to move forward and backward very dramatically, and all sorts of spatial tricks went on in the subsequent Moroccan Series, which had contrasting diagonal bands of brilliant Day-Glo colors. By 1965, at any rate, he was eager to break out of what now seemed to him the restrictive space of the stripe paintings.

The following year, he began a group of paintings that differed radically from any he had done before. The Irregular Polygons, as the new series came to be called, had been gestating in his mind since 1962, when he made the drawings on which they were based. Instead of stripes, the new paintings had large areas of unbroken color—geometrically shaped areas that often bore no relation at all to the irregular over-all dimensions of the canvas. Triangular wedges of one color invaded areas of another color, creating dynamic contrasts and rather unsettling visual tensions. For the first time, Stella used two different kinds of paint on the same canvas—matte enamels and glossy Day-Glo acrylics. There were eleven different designs for the Irregular Polygons, each of which he executed in four versions, with a different combination of colors for each version. Their titles (*Chocorua, Tuftonboro, Conway,* etc.) were taken from the New Hampshire hill towns that he and his father used to pass through on their fishing trips.

According to William Rubin, whose 1970 monograph on Stella is

still the major treatment of his early work, "the Irregular Polygons carried Stella into an area of openness, variety, and freedom of choice that resulted in a less steady level of success than was true of his earlier series," and they "range from some of his most daringly beautiful to his most unsatisfyingly overcomplicated pictures." They also pointed directly to the spatial dynamics of Stella's future work, but he did not pursue their lead right away. Instead, he spent the next two and a half years, from 1967 to the end of 1969, painting a final, dazzling series of gigantic color-band paintings, the Protractor Series, which earned him a lot more money than he had ever before made, and which brought him dangerously close to a kind of decorative art that is one of the chief perils of abstraction.

It might be argued that Stella had always shown a leaning toward decorative art, and that the austerity of his early work was a conscious or subconscious effort to resist that leaning. He had done his senior thesis at Princeton on the somewhat arcane decorative tradition of Hiberno-Saxon manuscript illumination. (One reason he chose this subject, he told me, was that not much had been written about it in English, so there wasn't much to read.) He was also drawn to Islamic art, which he had experienced in an intense way during a 1963 trip to Iran. Stanley Woodward, a wealthy retired diplomat and art collector, had invited Henry Geldzahler to go to Iran that year with him and his wife, and had suggested that he bring along a friend. Geldzahler had brought Stella. "The trip was a very big experience for me," Stella remembers. "It was an alien world, but not that alien, and the architecture is so terrific. I'd been so involved with my life in New York, and just seeing something so different and yet so familiar was fascinating. There's all that interlacing, or interweaving, in barbarian decoration— I'd touched on it in my thesis at Princeton. Things doubling back on themselves, like snakes swallowing their tails. This came out in the Protractor pictures."

By far the largest he had ever done—their minimum dimension is a height of ten feet, and some of them are as much as fifty feet long— the pictures in the gorgeously colorful Protractor Series are architectural in scale. Stella mixed many of the fluorescent colors himself—something he had not done before. This was also the first time he had used curvilinear forms. Within half circles formed by a giant protractor, wide bands of evenly applied color interweave in extremely complicated pat-

terns. Stella has said that he was interested in the idea of color "trav-elling" over wide areas. He plotted thirty-one different designs, each of which he executed in three versions, for a total of ninety-three paintings. Many of them are named after ancient circular-plan cities in the Near East, examples of which he had seen in Iran. The series was immensely successful in terms of sales. Priced originally at about four thousand dollars apiece, the paintings were soon bringing twelve thousand. Several collectors who had resisted Stella up to that point succumbed to the sheer beauty of the Protractors. Some of his earlier admirers found the huge pictures a little too pretty, though, and Stella himself now feels that in some of them the over-all structure is not strong enough. No modern artist wants to be called decorative, of course. Stella told William Rubin that he wanted to be decorative "in the good sense, in the sense that it is applied to Matisse," but he knew how difficult that was. Late in 1969, in any event, he was ready to go back to the ideas that he had explored in the Irregular Polygons.

By then, a lot of things in his life had changed. He and his family, which now included a son, Michael, had moved into a three-floor house in Greenwich Village. The architect Richard Meier, an old friend of his, had redesigned the interior free of charge, but the renovations had been expensive. Stella asked Castelli to lend him twenty thousand dollars. When Castelli said he didn't have it, Stella went to Larry Rubin, who didn't have it, either, but who went out and got it. Stella gave Rubin a large number of his unsold paintings in exchange, and Rubin, who had moved from Paris to New York, and who eventually established himself as the contemporary-art branch of Knoedler & Company, began selling these at higher and higher prices. In 1967, Stella decided to give Rubin half his future production, and Castelli accepted the decision with the grace of necessity: Stella would have a show at Castelli's one year and at Rubin's the next. With a less productive artist, this might not have worked out, but as a result of Stella's enormous energy and rising prices the two-gallery arrangement put him in a much stronger economic position. The fact that Rubin was selling early Stellas—the pictures he had received in exchange for the twenty thousand dollars—for ten times what he had paid for them did not bother Stella in the least. Rubin says, "When I'd tell Frank I'd sold one for fifteen thousand, he'd say, 'Terrific! Fantastic! Just don't jack the prices up so high nobody buys them.' "

Stella had also started making prints, which were to become an important source of income to him. He had been invited to be artist-in-residence at the University of California at Irvine in 1967, but when he got out there he found he was required to sign the state's loyalty oath. He refused, and was relieved of academic duties. This gave him some free time, which he used to work with Ken Tyler, a master printer and the co-founder of the Gemini G.E.L. lithography studio, in Los Angeles. Stella was not overly enthusiastic about making prints, and for several years he limited himself to small-scale lithographic versions of his own paintings, from the black series to the Protractors. Eventually, he got hooked by the medium, and in recent years his graphic work has been as innovative, as ambitious, and as complex as his painting.

By the late nineteen-sixties, the Stellas were leading fairly separate lives. Barbara Rose had become an influential art historian whose teaching schedule at Sarah Lawrence College kept her away from New York a good bit. Nevertheless, their formal separation and divorce, in 1969, hit both of them very hard. Stella went into therapy—psychoanalysis was suggested, but he balked at that—and for a year or so he had considerably less energy for painting. In the early nineteen-seventies, together with Larry Rubin, whose wife had died, he bought a seventeenth-century house in Sagaponack, on the South Shore of Long Island, mainly as a summer place for their children. Stella hated the social life in this ultra-fashionable area (Sagaponack is only five miles or so from East Hampton), but he loved the house they had bought, and he thought seriously of restoring it to exactly what it had been when it was built. He sold the house in 1975, though, so that he could buy a commercial building in downtown New York—a former auction house that he made over into his current studio. Unlike many successful New York artists, Stella has never felt any need to live anywhere but New York City. "I've got too much invested here," he told me once. "To me, a jackhammer sounds more natural than crickets. Somehow, painting is a very legitimate enterprise in this city. People who come here really want to paint. And I guess what you have to say about a young artist like Julian Schnabel is that he's more a painter than an artist, which is something you can't say about the Europeans—they're more artists than painters."

Although his life in New York centered on painting, he found time for other interests. He had several love affairs. One of the women he

saw a lot of in the early nineteen-seventies was amazed by his "romantic" gentleness and sweetness, which seemed wholly at odds with the brusque personality that others knew. "I don't remember ever meeting a man who had such a tender touch with regard to feminine things," she said. "He loved to pick out clothes for me and tell me how to stay 'pretty.' He was bluntly poetic, if one can put it that way." He stayed in close touch with his children and with his parents, and when his much younger sister moved to New York Stella let her rent space in the building where he had his studio. He kept himself in top physical shape by playing tennis, which he had taken up with fanatical zeal some years before. After many lessons and much practice, he became so good that some of his former opponents lost interest in playing with him. He threw himself into tennis with the same all-out passion that had gone into lacrosse and wrestling—a passion made more effective because it was under such firm control.

In March of 1970, a major retrospective exhibition of Stella's work, organized by William Rubin, opened at the Museum of Modern Art. "I don't know whether that show changed my perspective and made me feel I had to start all over again or whether I would have done it anyway," he said recently. The turning point came in the fall, at any rate, when he went into Mt. Sinai Hospital for a minor operation. Years of strenuous athletics had weakened the cartilage in his left knee, and corrective surgery was needed. After the operation, an infection set in and kept him in the hospital for more than a month. (Whenever Larry Rubin went to see him, he found Stella's father sitting by the bed. Although they still argued a lot, they continued to see each other often, right up to the father's death, in 1979.) In the hospital on the night before his operation, Stella, unable to sleep, had made more than fifteen drawings related to the Irregular Polygon paintings of 1966 and 1967. When he finally got home again, he made about twenty more. The angular forms he had sketched led him to think of the art of the Russian Constructivists after the First World War. They also became connected in his mind with a book he had seen, put out by the Polish government, that had photographs of many old wooden synagogues in Poland and Russia that had been destroyed by the Nazis. This was the origin of the Polish Village Series of collage paintings, on which Stella worked for the next three years.

The Polish Village paintings are among the most "difficult" of Stella's career. Each of the abstract designs was fabricated in three versions: a flat collage painting, incorporating surface materials such as felt and canvas; a low relief, made of heavier materials, such as pressboard and Masonite; and a high relief, made of laminated-cardboard elements, whose tilted planes came out several inches from the wooden support. "I wanted something physical," Stella told me. "I was really tired of painting on canvas." He was also tired of "the integrity of the picture plane," and of the rigid geometries of his stripe pictures. The Polish Village Series shows him moving away from the problem-solving, cerebral aspects of his earlier work toward a much freer and riskier kind of art. It was a startling change, and it took his audience a while to catch up with him. Larry Rubin and Castelli had a lot of trouble persuading clients that this new work was important. The Polish Village pictures, in fact, are still not much in demand, as their relatively low prices indicate. Part of the problem in this case is that the collage elements tend to become unstuck, making restoration a frequent necessity. In a more important sense, though, the paintings may be too transitional to be fully satisfying as works of art.

His next paintings were on metal—aluminum forms superimposed in low relief, their surfaces scribbled over with lithographic crayons, roughened by a caustic solution, and colored with silk-screen inks. Victor Ganz, an astute collector who had bought two Polish Village pictures, saw this new Brazilian Series (they are named after towns in Brazil) at Castelli's in 1975 and decided that Stella had lost his mind. "He's putting jukeboxes on the wall," Ganz said to his wife. He changed his opinion soon afterward—the Ganzes bought a Brazilian painting, and they have gone on to acquire key works from most of Stella's subsequent series. Trying to keep up with Stella now was just about impossible; you had to take him on faith. A year after the Brazilian pictures, he began work on his Exotic Bird Series (named after extinct or endangered species), which came right out and invaded the viewer's space. Elaborately curved forms suggested by architects' drafting tools stood out in deep relief against the gaudily painted backgrounds of these baroque works; Stella had even added ground glass and "glitter" (reflective particles used in commercial displays) to activate the surface in places, and his neon colors shrieked for attention. Larry Rubin said they were the craziest pictures he had ever seen, and Stella agreed that

they probably wouldn't be able to sell a single one. They were wrong—
the show sold out. (Victor Ganz later bought one of the largest pictures
in this series, *Dove of Tanna*, which he recently donated to the Whitney
Museum; it was much too big to hang anywhere in his apartment, and
in buying it he knew he had gone off the deep end as a collector.) The
Indian Bird Series (1977–78) was even crazier. Here undulating, vio-
lently colorful aluminum forms were cantilevered three or four deep,
so that the whole construction seemed to have a seething inner move-
ment. Instead of being attached to a square or rectangular support, they
projected at various angles from a curved, cylindrical metal grid, coming
out several feet into the room and obliterating any sense of a confining
frame. It seemed incredible that the artist who had made the black
paintings should also have made these. He had gone from something
under absolute control to something that looked totally out of control—
it was not, of course, but it looked that way.

Stella's new work was in direct opposition to most of the advanced
trends of the period. American art in the nineteen-seventies was pre-
dominantly cool and undemonstrative. Color-field abstraction, Mini-
mal art (which was mainly sculpture), and Conceptual art, some of
whose extreme practitioners went in for purely verbal expression, were
the preferred styles, along with the much maligned Photo-Realism. In
this restrained climate, Stella's commandeering of real pictorial space
and real pictorial drama seemed all the more astounding. And not only
was he getting away with it, he was sweeping others along in his wake.
The pattern and decoration movement that surfaced about 1980 clearly
found encouragement (and a good deal else) in Stella's great, glittering
Indian Birds. To the nascent Neo-Expressionists here and in Europe,
and to the graffiti painters, who have surfaced only in the last two years,
Stella's baroque structures and clashing colors offered a sort of open-
ended invitation, a proof that nothing succeeds like excess. The art
world watched his performance with awe. No other major artist was
working at Stella's level of intensity and high risk. The abstract painters
whose work Stella had admired in the sixties were doing more or less
the same things they had been doing then, with greater refinement; the
quality of their work remained high, but none of them were taking the
chances Stella took. He was trying to raise the energy level of the whole
abstract enterprise. Each new Stella show convinced any number of
people that this time he had *really* gone too far.

For a while in the nineteen-seventies, Stella's personal life also seemed a little out of control. In 1976, the B.M.W. automobile company, in Germany, commissioned Stella to design a paint job for one of its racing cars. Stella's work on the commission brought him into fascinated contact with auto racing and with race drivers, several of whom he got to know. Peter Gregg, one of two drivers of the Stella B.M.W. in the twenty-four-hour Le Mans race in 1976, became a close friend of his. Stella began going to Europe to see the major races there. The competitive excitement, the high degree of risk involved, and the precise mechanics of cars and engines appealed to the same aspects of his personality that made him an artist. Stella himself has never raced; the closest he came to it was going on practice runs with Peter Gregg. He had never even owned a car until 1976, but now he began buying expensive models and driving them very fast. He had several close calls. Stella estimates the attrition rate among race drivers at about thirty per cent. When he was driving to Le Mans with Gregg one time, Gregg swerved to avoid an oncoming car and overturned their Porsche; Stella was unhurt, but Gregg suffered injuries from which he never entirely recovered. Ronnie Peterson, another top driver whom Stella got to know, died as a result of injuries in a 1978 Grand Prix event. (Stella dedicated an edition of prints, the Polar Coordinates, to him afterward.) Gregg committed suicide in 1980.

Stella's income rose spectacularly in the late nineteen-seventies, and not all of it went back into his work. One of his tennis partners got him interested in horse breeding, an occupation whose risks are mainly financial. He became part owner of a farm in upstate New York that breeds race horses for sale, and he also invested modestly in an occasional race horse of his own, which ran under the colors of his Magenta Stable. Stella studies the racing forms daily, and he knows a lot about equine bloodlines. Although Magenta Stable has had no stakes winner to date, the breeding farm does quite well, as such things are judged: his share costs him no more than twenty thousand dollars a year, half of which is tax-deductible. Stella himself has no interest in riding. His sport these days is squash, which he took up a few years ago because he was having trouble with his back and tennis seemed to be making it worse.

Stella's life has been a good deal happier since 1978, when he married Harriet McGurk, a pediatrician, who teaches pediatrics at Columbia-

Presbyterian Medical Center. They had known one another for a number of years before their marriage (she used to live in the house next to his in the Village), and Stella's friends feel that the marriage has helped him become more relaxed and more cheerful. The change has been even more apparent since the birth, in 1982, of Peter Alexander Stella, a bright and appealing child, one of whose first complete sentences was "Daddy, drive slow."* His father actually does drive at a reasonable speed when Harriet and Peter are along, although such restraint comes hard for him. He was arrested in 1982 for driving his Ferrari at a hundred and five miles an hour on the Taconic State Parkway. (He was alone at the time.) The local town justice put him in jail. Stella's lawyer got him out on appeal the next day, and the court subsequently accepted a plan proposed by the lawyer under which, instead of serving a thirty-day sentence, Stella agreed to give a series of lectures on art for the benefit of the community. The lectures, which took place in the spring of 1984 in the high-school auditorium in Hudson, New York, were essentially the same as the Charles Eliot Norton lectures he had given at Harvard. His audience in Hudson was attentive but sparse.

When Harvard University invited him to give the Norton lectures, Stella's first thought was that he couldn't afford the honor. It would mean taking a lot of time off from his painting, and the lecture fee would not begin to cover the lost income. On the other hand, he had been working "flat out," as he put it, for three years—longer and harder than at any other time in his life—on a big series of metal reliefs, the so-called Circuits (their serpentine shapes were based on automobile race courses), and on another series of unpainted reliefs, named after South African mining stocks. He was very tired of painting. By coincidence, moreover, he had just received an invitation to be artist-in-residence at the American Academy in Rome. "It sort of seemed as if the two things went together," he told me. "I wanted to take some time off and really look at paintings, although I didn't know then what paintings. I knew a little about nineteenth-century French painting, and a little about Spanish painting, from the time I'd spent in the Prado when Barbara and I were in Spain. But I didn't know much about Italian art. So I guess what I decided was that I'd try to teach myself about Italian painting, and the lecture audience would have to suffer

*A second child, Patrick Francis Emerson Stella, was born in 1984.

through it. But I also knew that the lectures would really turn out to be about me."

The Stellas and their new baby made two extended trips to Rome, in 1982 and 1983. Stella travelled a good deal, visiting museums in London, Paris, Brussels, Antwerp, and Vienna, but it was in the Capitoline Museum, in Rome, that he found the inspiration for his lectures. His private epiphany came while he was looking at Caravaggio's painting *St. John the Baptist*, a very strange picture that shows a nude boy caressing a ram. (Some scholars have found it difficult to reconcile the highly erotic pose with anyone's conception of St. John.) To Stella, the amazing thing about this painting was how far it went beyond illusion, beyond any sort of trompe-l'oeil realism, in establishing a living presence. "The boy was really alive, really *there*, in a very powerful and yet casual way," he remembers thinking. "His flesh registered as flesh but also as painting, so much so that you wanted to touch it. It was the first time I'd had the sense that something could be real and also pictorial at the same time. Seeing it wasn't particularly a visual experience for me, and it was different from my usual reactions to paintings. More tactile. I wasn't impressed by it—I just loved it. And I realized that abstract painting could be equally real, could have that same sense of presence for me. I saw that in a very important sense painting begins for us with Caravaggio."

Stella went to see most of the extant Caravaggio paintings, including the huge *Beheading of St. John*, on the island of Malta. (Malta's harbor and fortifications later became the impetus for a new Stella series of gigantic metal reliefs.) Caravaggio led him to Rubens, whose work seemed to Stella to build on the foundation of "real" space which Caravaggio had established—a tactile space that reached out to include the viewer. And it struck him with great force that the qualities he responded to so strongly in Caravaggio and in Rubens were qualities that painting has always needed but that were lacking in most abstract art: a sense of volume (the space between and around the figures), and a sense of pictorial drama, without which no painting ever comes fully alive.

The question Stella asked himself was whether modern abstract art could ever have the drama and resonance of Caravaggio and Rubens. "Why did abstract painting come into being?" he said to me last spring. We were on our way up to Ken Tyler's lithographic studio in Bedford

(Tyler left Gemini and California some years back), driving in Stella's Audi, and I was trying not to look at the speedometer. "What is expressed in society's desire to have abstract art exist? I mean, we have a pretty good idea why painting is the way it was for four or five centuries. Man was infatuated with himself, was happy to see pictures of himself. And it's hard to look around now and say people don't want to see themselves anymore. What's the real, compelling reason for abstraction to exist? You can see it on a spiritual level, for somebody who wants to get slightly above and beyond mere material representation. But how many people care about that? A triangle is an abstract form, but to care about it enough to go out and paint one—it's not like caring enough about a naked girl. Picasso turned away from abstraction because he thought it lacked drama—he said it was 'merely painting.' " Stella broke off to negotiate a pair of hairpin turns. He has said that he doesn't consider himself an especially good driver.

"I didn't know what I was looking for when I went over there," he continued. "But after seeing *St. John the Baptist* I suddenly felt for the first time that what was there, in Old Master painting, was accessible to abstraction. In other words, what really made that old painting so great could also be done in abstract painting. Not in the same way, not going back, but in the sense that those basic qualities could still be used—in the sense that all that activity, of both the painting and the figuration, exists in a live space. There is space all around the figures, and it's that space around and behind things—that feeling of things not being pasted on top of each other but really having room behind them— that I think it's possible to get in abstraction. We don't have to stay laid down on the Cubist grid. And abstraction has this one great advantage, which we really haven't exploited enough—the freedom from illustration."

What about freedom from illusion, I asked. Weren't the qualities he was talking about dependent on the kind of illusion that he himself had tried to banish from his early work?

"I guess I'm more forgiving about illusionism now," he said, smiling. "There is an element of illusion to every kind of application of paint to a surface. But I could argue that in my attempts to be anti-illusionistic I still wanted to be real. Those stripes were real stripes."

A few days after that conversation, I went to visit Stella in his New York studio, where he was working on some big metal pieces that had

recently come down from the factory in Bridgeport. The studio has two floors, each one a hundred feet long and fifty feet wide. Completed reliefs from the Malta Series hung on the wall at our end of the room, and a number of somewhat smaller, unfinished pieces from his latest series, whose origin is a group of drawings by the Russian Constructivist artist El Lissitzky, ran the length of the room on both sides. At the far end and on the wall behind us hung two tremendous reliefs—the biggest I had seen. They were the culmination of another recent series, called Shards, which had been composed largely out of scraps left over at the factory from previous works. The pieces measured fifteen by seventeen feet, and some of their elements came out several feet from the wall. Stella is often asked whether in these recent works he hasn't finally made the transition to sculpture. He resolutely denies it. They live or die by their pictorial ability, he insists, not by any sort of sculptural presence. They hang on the wall, and they are meant to be seen from the front. The two huge Shards actually have a sort of buoyance, a lift, as though the entire construction were trying to be lighter than air. There is nothing flat about their sense of volume, though, or about the dramatic contrast of their angled planes and serpentine curves. It is possible, of course, that Stella is driving himself into a corner with works like this. He may have to make a decision about sculpture one of these days, and it is quite possible that his work will change drastically as a result, for the third time in his career.

I asked him whether he had thought about his work and his career in relation to Caravaggio's.

"Well, you know, I'd like to think I'm not that far away," he said. He had an unlit cigar clamped between his damaged finger and thumb, and he was drinking from a can of orange diet soda. "When I came back from Italy the first time, last year, after looking at Caravaggio, I finished that picture." He pointed to one of the big Shards reliefs. "I went back to Europe and looked at Rubens, and then I painted that one"—the other Shards. "It seems to me that in those two pictures I put it together the best that I had in my life. Maybe it's not any good, I don't know, but it comes close to looking like it. I mean, my career has had a lot of ups and downs, but the ideas have always been about painting. And after being in Rome I did get a feeling of confidence, a feeling that it was worthwhile to be a painter. Just trying to do what they did seemed worthwhile. And I didn't feel that I was any different. I didn't feel separated by anything except three or four hundred years,

which when you're standing in front of a painting can be relatively meaningless."

We talked for a while about abstraction, and whether or not it was likely to die out. Stella said he wasn't sure. "I don't find in looking at Kandinsky and Mondrian, great as they were, that there is anything— ineradicable. And that makes me wonder. I guess it all boils down to the most important question facing each person who wants to paint: What do you want painting to be? That's what you ask yourself, and then you just have to act on it."

(September 10, 1984)

The Museum of Modern Art's second Stella retrospective ("Frank Stella: 1970–1987"), was not so much a canonization as an act of awed witness-bearing on the part of the museum and William Rubin, the show's organizer. "At fifty-one, Stella seems to me even more inspired, and to be living more dangerously, than at thirty-three, his age at the time of his first Museum of Modern Art retrospective," Rubin wrote in his catalogue essay. ". . . And with the prospect of decades of development lying ahead, one can imagine that there is still greater and more unexpected work yet to come. Certainly no painter has ever committed himself more completely in the quest to 'make it better.' "

LATE PICASSO

Picasso's late work, the object of so much revisionist awe at the Guggenheim Museum—"Picasso: The Last Years"—is consistent with everything we knew, or thought we knew, about the artist of the century. Nobody expected the old artificer to go out of life serenely. He went out, at the age of ninety-one, in a sustained burst of fanatic energy and mordant laughter, much of it directed against himself and his remaining obsessions—death, sex, and the history of Western art.

In the tremendous outpouring of Picasso's paintings, drawings, and prints from 1963 to 1973 there is not a hint of desperation or self-pity.

Impatience, yes—a sort of frantic haste to get down on paper or canvas all the visual impulses that still demanded life at his hand. The rough, coarsely brushed look of the late paintings, with their violent or muddy colors, helped to make them unpalatable to almost everybody until the day before yesterday.

A large number of the pictures in the Guggenheim show are on loan from dealers, whose relief must now be substantial; there had been virtually no market for the late paintings before. The sheer productivity of Picasso's last decade was an embarrassment in itself, although not nearly so much of an embarrassment as the subject matter. The old man couldn't seem to get his mind off sex. Naked women dominate the pictorial scene—naked women at rest or in motion, young and smooth-limbed, their voluptuous bodies reinvented in the new arrangements that Picasso liked to envisage, but nearly always presented in such a way that the organ of sex is central. Some highly graphic copulations occur in the paintings and in the narrative series of etchings known as *Suite 347* (there are three hundred and forty-seven of them, all done in a little over six months in 1968); more often, though, the youthful beauties expose themselves to older men who stare passively, transfixed by the power and majesty of their nakedness. In several etchings, the onlooker is Picasso himself, a wrinkled dwarf who appears bemused by the erotic spectacle.

The shift in critical attitude toward this clearly definable last "period" had not taken place at the time of the Museum of Modern Art's huge Picasso retrospective, in 1980. The relatively few works selected from the last decade by William Rubin, MOMA's director of painting and sculpture, and Dominique Bozo, the curator-in-charge of the Musée Picasso in Paris, the exhibition's organizers, received little attention and virtually no comment. In 1981, however, the Basel Kunstmuseum organized an exhibition of Picasso's last ten years, and in New York the Pace Gallery put on a show of late paintings from the Picasso estate, and the clank of critical gear-shifting could be heard on both continents. Such a revision was inevitable, according to Gert Schiff, the New York University art historian who put together the Guggenheim show. (It was originally supposed to have been at N.Y.U.'s Grey Art Gallery and Study Center, but that enterprising institution ran short of funds, and the Guggenheim stepped in and saved the day.) "The truth is that all through his career Picasso was ahead of his audience by just one 'pe-

riod,' " Schiff writes in the exhibition catalogue. "The time has now come for a dispassionate assessment of his ultimate achievements." Perhaps—but the fact is that critical opinion has tended to dismiss a great deal of what Picasso painted in every decade since the late nineteen-thirties, when (it was said) his work stopped being ahead of any audience but the arrière-garde. And the sudden surge of interest in his late work, as Professor Schiff's catalogue essay indicates, is by no means dispassionate.

There has been a lot of talk about the "prophetic" influence of late Picasso on Neo-Expressionist painting here and in Europe, but I suspect that the influence flowed in another direction: Neo-Expressionism has made it easier for us to accept late Picasso. Until someone instructs me to the contrary, I have my doubts that Georg Baselitz, Julian Schnabel, and the other leading Neos were influenced by, or even particularly aware of, Picasso's ultimate achievements. What Neo-Expressionist painting most clearly lacks, it seems to me, is the savage wit and the concentrated, iconic intensity of Picasso's final period. Impatient as he was toward the end, Picasso kept to the point without ranting. If he failed to exhaust the possibilities of a visual idea in one painting, he tracked them down in any number of others, attacking the subject over and over in a visual shorthand from which every amenity had been torn away—the subtle virtuosity of his earlier styles out the window, the hedonistic succulence of much of his nineteen-fifties work replaced by harsh color and brutal distortions of the human figure. Most of the paintings, drawings, and prints on view at the Guggenheim deal with the human figure, in contexts that were not new to Picasso: the artist and his model, the brothel, the circus, the family. The figures often fill the picture space, facing out toward the viewer and exerting the kind of violent assault on the senses that Picasso had last conjured up in his portraits of Dora Maar, in the nineteen-thirties. There are family groups in which the invariably male, prepotent child looks ready to obliterate the father and rape the mother. *Man and Woman* (dated August 18, 1971) is a frightening image—a naked male giant with hugely out-of-scale eyes in an African mask of a face, and a woman whose body is a maze of dislocated elements. Although the exhibition is not an unusually large one by museum standards, the visual battering is too much to assimilate on one visit. You leave the Guggenheim exhausted.

For all its wildness, though, Picasso's late work is never incoherent.

The old man was after something, and was taking strength from all his own past work as well as from the artist predecessors he loved to paraphrase: Velázquez, Goya, Rembrandt, Delacroix, Ingres, Manet, Degas. The expressionist frenzy of the late paintings is countered by the meticulous control of the drawings and the prints, many of which are classical in feeling, if not in subject matter. Certain paintings, moreover, have been carried off with unerring perfection and economy. The 1971 *Crouching Nude*, painted in subdued tones of ochre and rose, is one of those incredible feats of Picasso legerdemain—a woman shown from the front and the rear simultaneously. Her head is a double profile, split so that the two sides can kiss one another while she embraces with both arms her own luxurious and oddly logical body. Some of the most hurriedly and coarsely painted pictures have this on-target rightness and convincingness. Picasso did not really throw away anything; he merely condensed what he knew. He was after something that he had never quite achieved—to go beyond painting, perhaps, into that vortex of raw emotion where there was no difference between art and life. "I want to say the nude," he once said. "I don't want to do the nude as a nude. I want only to *say* breast, *say* foot, *say* hand or belly. To find the way to say it—that's enough."

It is an ancient dream, this urge to go beyond art. Picasso had always been fascinated by Balzac's "Le Chef-d'Oeuvre Inconnu," the story for which he etched a series of illustrations in 1927. A seventeenth-century master painter named Frenhofer has worked for years, in secret, on the greatest painting of all time, a life-size female nude that will incorporate everything he knows about art and about life; when two younger painters finally see the masterpiece, however, it turns out to be a chaos of meaningless lines and ruined colors—the long struggle with it has driven Frenhofer mad. Throughout his life, Picasso kept returning to the idea of the separation of art from life. It is implicit in his many reworkings of the artist-and-model theme, to cite merely one example. The female model, naked and lovely, is both desire and the object of desire. The artist who paints her or simply gazes at her is on the other side of an invisible wall; he is a voyeur, longing for the power to make her come to life (as Pygmalion did with his statue) so that he may possess her.

In *Suite 347*, this theme undergoes several metamorphoses. The artist here, when it is not Picasso himself in mocking self-portraits, is often one of his "musketeers"—gentlemen in seventeenth-century cloaks and

ruffled collars, who appeared suddenly in Picasso's paintings in 1966 as a result, according to Gert Schiff, of his renewed interest in Rembrandt. The musketeers pursue semi-naked prostitutes, carry them off, or simply bow low to them in courtly obeisance. Sometimes the lady poses for a musketeer who stands with brushes and palette before an easel. In two etchings, the musketeer-artist applies his brush directly to the nude model's body, handily bridging the gap between art and life. Twenty-four prints in the series play erotic variations on Ingres's famous painting *Raphael and La Fornarina*: they show the artist (now in Renaissance dress) continuing to ply his paintbrush while passionately embracing and penetrating his mistress, oblivious of the gnomic figure of Picasso, robed and crowned as some grotesque monarch, who looks on with an expression of pained amusement.

What a fate for the artist, to be life's voyeur! Some are perfectly content with that role, as the Balthus exhibition at the Metropolitan Museum makes clear. Balthus' voyeurism has considerable power when it focusses on the pubescent eroticism for which he is best known; when he paints voyeuristic landscapes, with "ominous" light and murky shadows, the effect is merely theatrical in the bad sense—stagy. For all his "Old Master" techniques and references, Balthus is unable to settle for the representation of observed reality. He wishes to create works of art that are autonomous objects—things-in-themselves rather than imitations of "real" things—and in this sense he reflects the central dilemma of twentieth-century art. Abstract art is an attempt to deal directly with this problem. But an abstract painting that is a thing-in-itself does not thereby escape into the real world. The painting may have its origin in a powerful emotion or a mystical revelation, but it ends up on a wall somewhere, an art object in the context of other art objects—something to be looked at by people who, by and large, have more important things to do. Picasso himself drew back from the implications of total abstraction. "Abstract art is only painting," he said in 1935. "What about drama?"

More than any other artist in recent history, Picasso dramatized the problem of art versus life. From 1961, when he married Jacqueline Roque and moved into the villa called Notre-Dame-de-Vie, in Mougins, his life was concentrated almost totally on work. Shielded from the outside world by a much younger wife, he drove himself furiously, and the work he produced suggests that he went slightly mad. Not the

madness of Frenhofer: the eclipsed vision of a perfect masterpiece. There had always been a streak of craziness in Picasso; it cropped up in some of his most important paintings, starting with *Les Demoiselles d'Avignon*. But the madness of his final years went hand in hand with a dreadful clarity. Nearing ninety, he was alert in every sense to the truths of old age and death. Still he worked on, day after day, year after year, in pursuit of the impossible goal of an art beyond art.

(April 16, 1984)

TILTED ARC

The climate of acceptance in which new art flourishes today is deceptive. Although the accepting public is much larger than it used to be, it is still, in relative terms, infinitesimal. Most people have never really accepted modern art, much less its contemporary ("postmodern") manifestation. They acknowledge its existence, but in general they seem to feel that it has nothing to do with them and can therefore be ignored. When a work of contemporary art proves impossible to ignore, the result is sometimes big trouble.

The recent brouhaha over Richard Serra's *Tilted Arc* is a case in point. *Tilted Arc* is a Minimalist sculpture in the form of an enormous steel wall, a hundred and twenty feet long and twelve feet high, that bisects the plaza in front of the Jacob K. Javits Federal Building, in lower Manhattan. Viewed from above—from the height, say, of a tenth-floor office window—it makes a graceful, curving line across the space and sets up a contrapuntal relationship with the plaza's only other feature, a circular fountain that never seems to have water in it. Seen from ground level, the *Arc* is an overwhelming, intimidating mass. The wall's height shuts off the view of Foley Square and its architectural monuments—McKim, Mead & White's soaring Municipal Building, Cass Gilbert's neoclassic United States Courthouse, and other souvenirs of a bygone era. The sculpture is made of Cor-Ten steel, a "weathering"

metal that is supposed to acquire a rich dark-brown patina of rust; in this case, however, the constant battle against graffiti has left the surface mottled and scuffed. The wall is set into the paving stones of the plaza at a slight angle, so that it leans toward the Federal Building. Pedestrians on that side sometimes have the disorienting sensation that it is about to fall on them.

The sculpture was commissioned by the General Services Administration, the federal agency responsible for the construction of all new government office buildings throughout the United States. The G.S.A.'s Art-in-Architecture Program authorizes the spending of one-half of one per cent of a building's construction budget for a work (or works) of art, and Serra's *Arc* was the work chosen for the Federal Building. Following well-established procedures, in 1979 the G.S.A. invited Serra to make a proposal for the plaza. The agency approved his plan for *Tilted Arc*, reaffirmed its approval at all stages of the design-review process, and executed a contract awarding the artist a hundred and seventy-five thousand dollars for the finished work, which was installed in the spring of 1981. Ever since, irate citizens have been trying to get rid of it. Petitions, letters, and other forms of protest have made it clear that a great many people *hate Tilted Arc*. In December, 1984, after nearly four years of agitation, the G.S.A.'s regional administrator for the New York area, William Diamond, decided on his own to schedule public hearings on the issue of the sculpture's "relocation." Thus the stage was set for one of those infrequent battles between the minority that accepts modern art and the majority that does not.

The three days of public hearings, on March 6, 7, and 8, 1985, generated more heat than light. Fifty-six people spoke against the sculpture, voicing complaints that by this time were well known: that it was ugly; that it spoiled the view; that it prevented the plaza from being used for concerts, performances, or social gatherings; that it attracted graffiti; that it made access to the building difficult. One woman, a G.S.A. employee whose job involved the building's security, testified that the *Arc* would make a terrorist bomb attack more destructive: "The sculpture could vent an explosion inward and in an angle toward the buildings," she said. Although Mr. Diamond had reiterated that the G.S.A.'s decision would reflect no "aesthetic judgment" but only "the most effective use of the plaza," the subtext of a great many anti-*Arc* statements was that *Tilted Arc* was not art—it was "that rusted steel wall," that barrier, that piece of junk.

Richard Serra, one of the country's most highly regarded sculptors, had mobilized the international art world to resist the philistines. A hundred and eighteen people rose to defend his sculpture—fellow-artists, writers, musicians, filmmakers, museum curators, and public figures, including Joan Mondale, Senator Howard Metzenbaum, and Mrs. Jacob Javits, the Senator's wife, who read a statement by her husband about art and political freedom. The pro-*Arc* statements were more complicated than the anti-*Arc* ones but no less predictable: Serra was a major artist; he had a legal contract with the G.S.A., which the G.S.A. had no right to renege on; a public hearing was an improper forum, and Mr. Diamond had prejudged the case by making public statements in favor of relocating the sculpture; since *Tilted Arc* was a "site-specific" work, having been designed for that particular space, to relocate it would be to destroy it; important new art was often disturbing at first, and anyway, as the artist Robert Murray put it, "we cannot have public art by plebiscite." Any number of speakers argued that if the G.S.A. gave in to public pressure and removed the work the entire Art-in-Architecture Program would be placed in jeopardy: other communities would demand the removal of government-sponsored art works, and self-respecting artists would refuse to undertake G.S.A. commissions.

Relatively few pro-*Arc* speakers defended the sculpture on aesthetic grounds. Some of Serra's most fervent supporters actually dislike the piece, and feel considerable sympathy for the office workers who have to look at it every day. They argued as they did because of the larger issues that seemed to be involved—issues of artistic freedom and the government's role in support of the arts. Serra, who dressed for the hearings in a heavy wool shirt and workmen's pants, emphasized those issues in his own rostrum-thumping statement at the hearings. As he phrased it, freedom of creative expression implies that once an artist has been selected and commissioned by the government "the artist's work must be uncensored, respected, and tolerated, although deemed abhorrent, or perceived as challenging, or experienced as threatening." The G.S.A. has commissioned more than two hundred works of art during the last twenty years, at a cost of seven million dollars. Some of these works have generated vehement opposition among local groups, but the G.S.A., until now, has stood firmly behind its commissioned artists, and the Art-in-Architecture Program has been widely praised by the professional art establishment for its enlightened and respectful

attitude toward contemporary art. One rumor going around at the hearings was that the entire Art-in-Architecture Program was in trouble, a potential victim of the Reagan Administration's reactionary tilt.

Some of the points, both pro and con, that were raised at the hearings might have been hard to sustain. Had the plaza, a meagre and ungainly space in a noisy, crowded section of town, really been deprived of festive social gatherings by the sombre presence of the *Arc?* Would relocating the sculpture in another setting really destroy it as a work of art? (A great many Renaissance altarpieces now in American museums were originally "site-specific.") In all the verbiage, however, one statement stood out like a beacon. It was by Alvin S. Lane, a lawyer active in a number of arts organizations, and in it he asked several searching questions. "Is the purpose of the Art-in-Architecture Program to benefit the artist or the community?" was one of them. "Should an artist have the right to impose his values and taste on a public that now rejects his taste and values?" was another. "In the selection of art, even the greatest experts will make mistakes from time to time," Lane went on to say. "If it is a private matter, the mistake can be rectified by not showing the work of art. Where it is a public matter, should there be a different standard?" Speaking personally, Lane said that he did not like *Tilted Arc* and would welcome its removal. But Mr. Diamond and the four men he had appointed to preside at the hearings were not, he felt, the right people to rule on that. Instead, he recommended that they use the hearings "for the purpose of formulating recommendations for legislation that would establish a fair procedure for reëvaluating all public works of living artists."

Mr. Lane's questions went unanswered at the hearings, but they bear thinking about. To my knowledge, he was the only speaker to suggest that a work cf art in a public space ought not to be judged by the same criteria that are applied to works of art in museums or in private collections. A great many people have to look at *Tilted Arc* every day, whether they want to or not, and a significant number of them seem to feel that it is an unwelcome imposition on their values and taste. They don't think it's art, and they don't see why they have to put up with it. If asked, they would almost certainly say that in this case the G.S.A. acted for the benefit of the artist, not the community.

It is not enough simply to dismiss this as a philistine attitude. The problem is that today there is no general agreement or understanding about art's social function. During the Renaissance, people might dis-

agree about the relative merits of a new altarpiece or an equestrian statute but they did not question the tradition that placed such works in public places. It is the absence of any such tradition that causes trouble when modern art (which has been largely a private matter) attempts to go public, as it increasingly tends to do these days. More and more artists are being commissioned to provide works for public spaces. Quite a few of them have made serious efforts to think about the social implications of public art, and their thinking has led them, often enough, to jettison the idea of sculpture, monumental or otherwise, in favor of a process of collaboration with architects, designers, landscape architects, engineers, and local community groups of all kinds, with a view to making the public space itself a work of art. The G.S.A.'s Art-in-Architecture Program began, in the early eighties, to move in a similar direction. Before an artist is even approached for a commission now, the G.S.A. tries to establish contact with a broad cross-section of people in the community where the new government building is going up. The mayor's office, local civic and arts organizations, and neighborhood groups are all consulted about the possibility of commissioning a work of art, and recommendations are solicited for people to serve on the design-review panel. Artists who live in the area receive special attention in the selection process, and once an artist has been commissioned the G.S.A. encourages him or her to meet with the local groups, answer their questions, and let them in on the aesthetic thinking behind the work. According to Donald Thalacker, the highly respected director of the Art-in-Architecture Program, this has slowed the whole process down considerably but it has also helped to convince a lot of people that the program is working for the community, not just for the artist.

The community-minded approach to public art is shared by artists with widely divergent interests and methods, among them Siah Armajani, Scott Burton, Nancy Holt, Mary Miss, Elyn Zimmerman, and Richard Fleischner. It is not shared by Richard Serra. In a 1980 interview, Serra stated his position with customary bluntness. "Placing pieces in an urban context is not synonymous with an interest in a large audience even though the work will be seen by many people who wouldn't otherwise look at art," he said. "The work I make does not allow for experience outside the conventions of sculpture as sculpture. My audience is necessarily very limited."

Nobody with a serious interest in contemporary art questions Serra's

reputation as a major artist. His work has consistently advanced the concept of sculpture in powerful and provocative ways. Serra was one of the first artists to explore the contemporary notion of "site-specific" sculpture. His main interest now is in making outdoor urban sculptures that relate in terms of size, scale, placement, and structure to their surroundings. His work is usually so dynamic and so aggressive in its use of heavyweight industrial materials that it significantly alters the way those surroundings look to others, and that is part of the plan. One of Serra's primary goals is to force people to see their surroundings in a new way—to make them experience sculpture as place, and place as sculpture. In another 1980 interview, soon after he had been commissioned to do the piece for the Federal Building, Serra announced that he had "found a way to dislocate or alter the decorative function of the plaza and actively bring people into the sculpture's context." The sculpture, he said, would change the space of the plaza. "After the piece is created, the space will be understood primarily as a function of the sculpture."

On Serra's terms, *Tilted Arc* is a huge success. It certainly changed the plaza, making it wholly subservient to the sculptural context. The trouble is that not many office workers want a sculptural experience twice a day (four times if they go out for lunch). Not this particular sculptural experience, at any rate. As Serra said, his audience is a limited one. And I think it is perfectly legitimate to question whether public spaces and public funds are the right context for work that appeals to so few people—no matter how far it advances the concept of sculpture.

What should be done, then, about *Tilted Arc*? What *has* been done is clearly lamentable—public hearings called by an administrator who had said in advance that he favored the sculpture's removal. Mr. Diamond's panel decided, after deliberating, that the sculpture should be removed, and this recommendation was duly forwarded to Dwight Ink, the G.S.A.'s acting administrator in Washington (the previous acting administrator, Ray Kline, had retired from office the day before the hearings began). Mr. Ink, whom nobody seems to know much about, is to decide on the sculpture's fate. Serra has let it be known that if the G.S.A. decides for removal he will seek an injunction claiming breach of contract. A lot of his time would then be spent in litigation, and a lot of money would be made by lawyers. This sorry state of affairs seems to cry out for redress—something along the lines, perhaps, of Alvin

Lane's suggestion that the G.S.A. set up a fair procedure for reëvaluating its controversial commissions.

Even if you feel, though, that the G.S.A. made a mistake in commissioning *Tilted Arc* (as I think it did), there is something to be said for the hated monster. In its rough, confrontational way, it has pushed the whole notion of public art—what it is, what it could or should be—into clearer focus for a great many people. It is already a landmark, and it will continue to be one for years to come, even if it goes away.

(May 20, 1985)

The dispute over Tilted Arc *goes on and on. The General Services Administration accepted the recommendation of Diamond's panel, and ordered the sculpture removed to a suitable alternative site. Serra then brought suit against the G.S.A., charging it with breach of contract, copyright infringements, and other violations; he also asked for $30 million in damages, for the deprivation of his constitutional rights to free speech and due process of law. In July 1987, a federal judge ruled against Serra, but further litigation appears to be inevitable. Meanwhile, the monolith continues to cast its shadow over Federal Plaza.*

DISCO

Two years ago, the night-club impresarios Steve Rubell and Ian Schrager noticed that a lot of uptown people were going to the East Village to look at art. The East Village—that sector of downtown Manhattan which lies between Fourth Avenue and Avenue A and runs from Fourteenth Street down to Houston Street—was just coming into its own then as the city's newest art ghetto. Dozens of young artists, driven out of SoHo and its environs by rapidly escalating rents, had moved there because rents were still low and tenement apartments were relatively easy to find, in part because the rampant traffic in hard drugs had caused many old-time residents to leave. A sense of neighborhood solidarity

and the frustration of not being able to have their work shown in SoHo galleries combined to produce the new art scene. Artists began turning their storefront studios into part-time galleries, several of which became full-time exhibition spaces. Since the time lag between innovation and discovery in today's art world now stands at approximately thirty-seven seconds, the public quickly appeared in droves. In 1983, there were about a dozen galleries in the area; in 1985, there were at least seventy— exact numbers are unavailable in such a fluid milieu—and on Sunday afternoons, when all the East Village galleries are open, the dingy but rapidly gentrifying streets are choked with uptown collectors, fashion plates of all sexes, and tourists.

The Messrs. Rubell and Schrager observed this phenomenon in its early stages. They also noted the East Village night-club scene, which preceded the gallery scene. A number of small clubs had opened around 1980 in the East Village, run by and frequented mainly by local artists and their friends. Like the Mudd Club, across town on White Street, the East Village night spots—Limbo Lounge, the Pyramid Club, Club 57, and one or two others—featured new-wave rock music, which many of the young visual artists were involved with professionally (doubling as musicians), and live or videotaped "performance art" by the clientele. The freewheeling atmosphere of Club 57, on St. Marks Place, was described to me by Joanne Mayhew-Young, who came to live in the East Village, as an artist, in the late nineteen-seventies. "The whole art thing started in the clubs," she said. "Kenny Scharf and Keith Haring used to hang out at Club 57, and they'd use the space to do incredible things. Something different every night. For example, they'd paint the whole club black, and have a black-light party. The next day, it would be painted over. One night would be movie night, and we'd watch old Tarzan films or something. There were a lot of theme shows. Someone would say, 'This week we're going to do a carnival show,' so everybody would go home and paint carnival pictures. It was like kids' energy." Performance of one sort or another was central to the East Village scene, and to much of the painting and sculpture being done there. It was also central to the work of the Brooklyn and Bronx graffiti writers, whose aesthetic had originated in the dramatically illegal act of spray-painting subway cars. The new-wave artists and the graffiti writers met each other at the clubs, and established an immediate rapport. Some of the new-wave people may even have been inspired by the graffitists'

spray-painted "tags," or nicknames, to make up new names for them-
selves—stage names, so to speak: names like Tina L'Hotsky and Buster
Cleveland and John Sex. Joanne Mayhew-Young wanted a name that
was also a place, and the one she hit on for herself was Gracie Mansion.
Later, this became the name of her highly successful gallery on East
Tenth Street.

And so the East Village, where wave on wave of European immigrants
had fetched up in the final decades of the last century, became quite
suddenly, to the astonishment of old-time residents who had not fled,
a place where young urban professionals, and some older urban profes-
sionals, or Oupies, flocked on weekends to attend gallery openings, to
see what was happening in the clubs, and, increasingly, to buy the
outlandish-looking art that was most definitely for sale, at prices that
increased from the low three figures in 1983 to the high four figures
(or higher) today. And all this was noted by the Messrs. Schrager and
Rubell, who pondered it in their hearts.

The Messrs. Schrager and Rubell had previously conceived and brought
forth Studio 54, the most talked-about New York discothèque of the
nineteen-seventies. They sold it in 1980, because of an inconvenient
obligation on their part to spend some time in the slammer for tax
evasion. At liberty once more, they acquired financial backing for a
hotel venture (Morgan's, which opened in 1984 on Madison Avenue
at Thirty-seventh Street), but their hearts were not really in the hotel
business. The main thrust of their energy went into the conversion of
the cavernous old Academy of Music, on Fourteenth Street, into the
world's most advanced discothèque. In its fifty-nine years on Fourteenth
Street, the Academy of Music had been an opera house, a ballroom,
a burlesque theatre, a movie house, and a rock-music concert hall. An
old friend of mine had one of the formative triumphs of his youth there,
during its burlesque phase. Having journeyed over from Brooklyn to
see the great Gypsy Rose Lee perform, he and a few fellow-aficionados,
none of whom was older than sixteen, waited by the stage door afterward
for a glimpse of the star; when Miss Lee finally came out, swathed in
mink, she noticed the band of gallants, smiled unforgettably, and said,
singling out my friend, "Hiya, man." Since that occasion, the famous
showplace had fallen into decay, but it had never been broken up into
separate units, as so many huge old theatres were. The ornate interior
was immemorially shabby but virtually intact. The new owners, a con-

sortium of businessmen, followed the advice of their "conceptual con-
sultants," Rubell and Schrager, and hired the Japanese architect Arata
Isozaki to turn this enormous space into a discothèque.

Isozaki had no major buildings to his credit in the United States at
the time. (Ground had only just been broken for his Museum of Con-
temporary Art in Los Angeles.) In Japan and elsewhere, however, he
was famous for his unorthodox and somewhat startling solutions to
difficult design problems. On being asked once by an American reporter
why he had designed a country club in the shape of a question mark,
Isozaki replied, "The question is, why they play so much golf?" Isozaki's
solution for the Academy of Music was to leave the interior shell virtually
untouched—eroded plaster, peeling paint, and all—and to erect inside
it a pristine, monumental grid of pilasters and a vast central arch, seven
stories high; he used the old mezzanine for seating space, and brought
in several tons of state-of-the-art lighting, video, and audio equipment
to blow the eye, the mind, and, if anything went wrong, most of the
electrical circuits in Manhattan's lower quadrant.

Success in the discothèque calling, as Rubell and Schrager knew,
was usually a matter of picking up the latest social vibrations. Archi-
tecture aside, the entrepreneurs' vibration sensors were picking up art.
Certain artists had become as celebrated in the nineteen-eighties as rock
stars or fashion designers, and a lot of people, it seemed, wanted to be
part of that celebrity. As Rubell put it in an interview, "people who
used to go to singles bars on First Avenue now go to art-show openings
on Avenue A." Since neither he nor Schrager knew anything about
art, they decided to hire someone who did to advise them, and that
someone turned out to be Henry Geldzahler, the former curator of
twentieth-century art at the Metropolitan Museum and former New
York City Commissioner for Cultural Affairs, currently a free-lance
exhibition organizer, writer, and lecturer on art. Geldzahler has retained
over the years an exceptional ability to respond to the latest trends. After
seeing what Isozaki had done to the Academy of Music (by now renamed
Palladium), he signed on as its salaried "art curator" and began lining
up artists to execute original works there. The first artist he approached
was Francesco Clemente, a highly successful Italian painter who lives
for much of the year in New York and loves New York's night life.
Clemente was excited by the space; he agreed to paint a large fresco on
the walls and ceiling at the top of the main staircase. Geldzahler next

commissioned three New York artists of the youngest generation, all of whom had shown first in East Village galleries: Keith Haring, the former street and subway-station artist, who painted a forty-foot-high canvas that hangs from the ceiling at the back of the dance floor; Kenny Scharf, who covered the basement lounge between the rest rooms with his weird comic-strip characters, Day-Glo splatterings, fake-fur walls, and toy-encrusted telephones; and Jean-Michel Basquiat, the wunderkind of Neo-Expressionism, who contributed two large murals for the upstairs bar and lounge that the owners have named the Mike Todd Room, because Mike Todd is believed to have had an office there at one time.

Palladium opened in May, and became an instant success. Mobs of people lined up at the door almost every night, from eleven o'clock to three or four in the morning, waiting to buy tickets; the management also initiated a brisk business in corporate- and private-party bookings. Paul Goldberger and other architecture critics have praised Isozaki's renovation, with its visual tension between the old and the new, and everybody seems to love the art. To be sure, a few voices have questioned the propriety of artists' lending themselves to the decorating of disco-thèques, but to Geldzahler this sounds like sour grapes. "None of the artists compromised in any way here," he insists. "Basquiat's murals are the best things he's ever done." Each of the artists was paid a fee to cover the cost of materials, and most of the works will go back to the artists after they have been on display at Palladium for six months or longer—the length of time each installation remains there is up to Geldzahler.

The truth is that in this environment the art looks sensationally good. Basquiat is not the only artist to surpass himself; even Haring seems to have risen to a new level, and who would have thought that could happen? Keith Haring began his public career by drawing simple, car-toonlike images in white chalk on the black paper fillers that you see in subway advertising spaces when the advertisement has been removed. He went on to paint the same sort of images, in greater and greater profusion, on canvases, walls, tarpaulins, plaster casts, T-shirts, and other surfaces that could be displayed in galleries or worn to disco-thèques—a progression that expanded horizontally without becoming either better or worse. But his forty-foot canvas at Palladium struck me as something else: decoration of a fairly high order. Clemente's frescoed walls and ceiling are beautiful and witty, and Basquiat's two murals are

not only larger than anything he has done before but significantly better—stronger in the handling of color, more cleverly structured, more honest in acknowledging their debt to Cy Twombly and a few other artists of the older generation. Like Haring's big backdrop, the Basquiats are a match for their surroundings. They hold their own with the hard-rock music, the lighting, the banks of video screens, the architecture, and the gorgeously caparisoned throngs of people who have managed to get in. They also set a standard for disco art, a new form whose time has clearly come.

Palladium's managers can't claim exclusive credit for pioneering this new form. Area, the popular discothèque on Hudson Street, in Tribeca, invited dozens of New York artists to execute works there last May, for a temporary installation called "Art." More than thirty artists did so, including all the Palladium crew, plus such comparatively ancient talents as Alex Katz, Larry Rivers, and Andy Warhol, whose unbroken twenty-year hold on the levers of publicity qualifies him as the reigning grandfather of disco art. Area's four young owners totally redecorate their place every six weeks, and the "Art" installation is now just a memory; but some of the club's earlier décors, on themes such as "Night," "Obelisks," "Elements," and "The Color Red," which were obviously influenced by the artist-created environments at the tiny East Village clubs, can now be seen as precursors of disco art, and it is a foregone conclusion that Area, Limelight, and other commercial discothèques will solicit practicing artists for future installations. "When you call the kids up now, they're doing club art," Warhol told *People* magazine. "They're fighting to be in it."

The interesting thing is that so much of the art on view in East Village galleries looks as though it were done with a discothèque environment in mind. There is no generic East Village style. Most of the tendencies of recent American art are reflected there, from nitwit realism to Minimalist abstraction. But East Village work as a whole does seem to have a raw, no-holds-barred theatricality that the same kind of work elsewhere does not have, or does not have to the same degree. To me, at any rate, this rawness and rowdiness have made East Village work look a little silly outside the East Village—for example, at the svelte uptown Holly Solomon Gallery, which put on a group show of East Village artists in January, 1985, or at the Whitney Museum, where the Biennial exhibition included works by Rodney Alan Greenblat and

David Wojnarowicz, two particularly exuberant young talents who show at Gracie Mansion. I can see now that Greenblat, Wojnarowicz, and any number of other East Village artists would look right at home at Area or Palladium. What we have here is a new branch of public art, which is what the graffiti writers (the serious graffiti writers: the ones who used whole subway cars and occasionally whole trains as background for their previously conceived designs) were after in the first place. Most people would probably agree that it is better to have this sort of work in a discothèque than on the I.R.T. At least, the element of choice is restored to the viewer: nobody *has* to spend time in a discothèque.

In the heroic days of Abstract Expressionism, Mark Rothko once refused to deliver a group of commissioned mural paintings because he found out that they would be hung in the Four Seasons restaurant, where people would eat and drink in front of them. *D'autres temps, d'autres moeurs.* A lot of good artists have been perfectly content in the past to embellish palaces, and I see no need to vilify an artist today for decorating discothèques. High art is not really threatened. Ellsworth Kelly, Jasper Johns, and a few others will continue to tread their difficult private paths, with neither help nor hindrance from Schrager and Rubell. Disco art, meanwhile, building on the early work of Haring, Basquiat, and Scharf, may yet produce a new academy of the baroque while at the same time absolving the art establishment from having to deal with it. There is something to be said, after all, for cakes and ale.

(July 22, 1985)

KNOWING IN ACTION

Is abstract art dying out? For twenty years, the pendulum of innovation has been swinging back toward figurative, more or less representational styles. While abstract work of very high quality continues to be produced, the *idea* of abstraction has lost all momentum. What had come

to be regarded as the twentieth century's most important contribution to the visual arts now strikes many people, artists included, as either a passing phase or a dead end.

The Museum of Modern Art's exhibition "Contrasts of Form: Geometric Abstract Art 1910–1980" does nothing to counter the notion of abstract art's precipitous decline. The show, which is drawn from the gift to the museum of two hundred and forty-nine works of geometric abstract art from the Riklis Collection of the McCrory Corporation (together with some crucial additions from the museum's own holdings), packs most of its excitement into the first few rooms, where we see Malevich, Mondrian, Larionov, Gontcharova, and the other pioneers taking the momentous first steps into an art whose forms bore no relation to the natural world. The development of analytical Cubism had led Picasso and Braque to the edge of total abstraction in 1910, but those essentially pragmatic artists refused to go over the edge. What they lacked, apparently, was an intellectual commitment to utopian ideals. In Russia, the Constructivist movement that grew out of the ideas of Tatlin and Malevich (and the fragmented forms of analytical Cubism) was closely allied to the political and social goals proclaimed by the October Revolution of 1917. In Holland, Mondrian and the other founders of De Stijl believed that their pure art of straight lines, right angles, and primary colors would be the model for a harmonious future society. The fervor of their idealism is everywhere apparent in the paintings and objects of those early years, when the "new reality" of abstraction was being opened up. More than half a century later, we can still feel the crackle of excitement in paintings such as Larionov's *Rayonist Composition: Domination of Red* (1912–13) and Malevich's *Suprematist Composition: Airplane Flying* (1915)—the sense of adventure and optimism.

Unfortunately, the excitement did not last. It was crushed by the state in Russia, along with other aspects of independent thinking. In Europe, events conspired more slowly but just as surely to extinguish the artists' utopian ideals. Economic depression, social turmoil, and the rise of Fascism made it increasingly difficult to believe in the universal harmony envisaged by De Stijl and earnestly sought after at the Bauhaus—where Constructivist principles and geometric abstraction were the basis of an effort to reconcile art and technology. The "pure" (geometric, hard-edge) branch of abstract art gradually ceased to be a

philosophy or a cause. When it settled down to being merely a style, though, the life began to go out of it. Some beautiful abstract painting was done in the nineteen-thirties and forties; there was, above all, the supreme achievement of Mondrian's late paintings, done when he was living in New York in the early forties, and inspired to some degree by his enthusiastic reaction to the "new reality" of this city. But the geometric-abstract-art movement was becoming in the forties what it is now—the safe, unimaginative, academic style of our time. Its greatest influence has been in the fields of graphic design and commercial art. It is much appreciated by the curators of corporate art collections.

Abstraction's other branch—the "organic," expressionist, non-geometric abstraction that appeared for the first time in Kandinsky's painting, in 1910—was marked by an equally strong commitment to ideas outside art. For Kandinsky, art was primarily a spiritual calling, a way to come into contact with the religious impulse hidden beneath the surface of things. Kandinsky's mystical drive (like Mondrian, he was a practicing Theosophist) gave his best paintings a tension that I feel in no other abstract work, with the exception of Paul Klee's, until the Abstract Expressionist breakthrough in the nineteen-forties, when once again a surge of quasi-religious philosophizing invaded art. For Pollock, Rothko, Newman, and several of their colleagues, the numinous element was primitive myths, filtered through the writings of Freud and Jung. Newman's *Stations of the Cross* paintings and the dark abstract canvases in the Rothko Chapel in Houston indicate the extent to which religious feeling became specific in their later work. Rothko claimed that "lots of people" broke down and wept when confronted with his paintings. "The people who weep before my pictures are having the same religious experience I had when I painted them," he told an interviewer in the nineteen-fifties. "And if you, as you say, are moved only by their color relationships then you miss the point." The second generation of Abstract Expressionists could not sustain this sort of claim, or the passion behind it. They simply took over the style, which became, in their highly competent hands, a worldwide cliché. What I am suggesting is that non-objective painting, in whatever form it happens to take, seems to require a superstructure of non-aesthetic ideals. Deprived of that superstructure, relegated to art for art's sake, abstraction succumbs to its inherent weakness and becomes mere decoration. Picasso foresaw that. "Abstract art is only painting," he said. "What about drama?"

Frank Stella, one of the most admired abstract artists of our time, voiced the same doubt in his series of lectures at Harvard in 1983. Stella said that abstract art had not solved its central problem, which was how to compensate for the loss of the human figure. The only way it can do so, he argued, is to create the kind of pictorial drama that Abstract Expressionism achieved at its highest levels—the drama that all painting must have if it is going to be a living thing. Stella clearly believes that the missing pictorial drama can be regained. He thinks he is close to achieving it in his own powerfully dynamic relief constructions. (False modesty is not a Stella trait.) And in his Harvard lectures he said that it need not be based on the kind of metaphysical ideas that inspired Kandinsky, Mondrian, and Malevich. Instead of metaphysics, which Stella associates with Northern European art and thought, he puts his faith in "the tough, stubborn materialism of Cézanne, Monet, and Picasso"—Southern Europeans, whose interest lay primarily in pictorial values rather than in ideas. He may be right. If so, the history of abstract art to date will prove to have been somewhat irrelevant.

A radically different approach to the problem has been proposed by Robert Irwin, an artist who has virtually nothing in common with Stella except the conviction that abstract art has not lived up to its potential. Irwin, who grew up in California, is the most metaphysically inclined artist this side of Tibet. After a series of aesthetic leaps that took him from Abstract Expressionist painting, through increasingly Minimalist stages of painting and object-making, to a final jumping-off point where he simply worked with natural light in empty rooms, Irwin withdrew from the art world. He spent a couple of years reading and thinking. He immersed himself in philosophy, with particular emphasis on the phenomenology of Edmund Husserl. Since his return to the world, in 1977 (his *partial* return; he still spends a lot of his time in a near-empty room in a Las Vegas high rise, overlooking the desert), Irwin has busied himself with proposals for "environmental" works for public spaces, several of which have been realized. These range from an aerial violet-colored V-shaped fence mounted fifteen feet off the ground, in a eucalyptus grove near San Diego, to a set of forty-eight translucent squares suspended in the atrium of the landmark Old Post Office Building, in Washington, D.C. They are difficult to envisage, even in photographs. Irwin's 1985 show at the Pace Gallery here was puzzling in this regard,

because the photographs and drawings, and even the scale models, of his projects gave so little sense of what it was like to experience them in situ. However, Irwin has set forth the thinking behind his recent work in a remarkable essay, which is printed in a catalogue of his environmental projects called *Being and Circumstance: Notes Toward a Conditional Art* (Lapis Press). As a rationale for going beyond art, this one is right up there with Kandinsky and Mondrian.

The true purpose of abstract art, as Irwin sees it, was always to extend art's boundaries. Unless artists live up to the challenge of continuing this process, "the whole enterprise of 'modern art' can slip back (as it is threatening to do) to its lowest common denominator—individual indulgence pawned off as self-expression." Irwin believes that the boundary most in need of being expanded right now is the one that keeps art from dealing with the universal experience of change. Irwin sees the future of art in phenomenological terms as a means of heightening our powers of perception. He wants to wake us up to the phenomenal life we lead at every moment, and of which we are mostly unaware. His method is to set up environmental situations that encourage the viewer to look about him with the eye of an artist. No finite work of art can compare in importance with this individual act of perception, Irwin argues: "There is nothing more real, more interesting, more powerful, more informative, more important, or more beautiful."

No lack of utopian fervor there. Irwin's approach is as metaphysical as Mondrian's, and as socially oriented as Tatlin's—he wants to improve the quality of everyday life. The difference between his approach and theirs lies in his willingness to delegate a major share of responsibility to the observer. Both De Stijl and Constructivism stressed absolute goals—absolute control, absolute purity, absolute harmony—and both tended to view individualism as outmoded. Irwin, the Californian, is more laid back and less authoritarian. Art is, or should be, "knowing in action," he says, and the artist's job now is to provide an opportunity to further that sort of knowing. In a sense, he is echoing the point that Marcel Duchamp made more than thirty years ago. Duchamp said that the artist performed only one part of the creative act. The other part was up to the onlooker, whose response to and interpretation of what the artist had done completed the creative cycle. Irwin goes further than Duchamp, though; like Rothko, he wants artist and onlooker to have the same experience. Art, for Irwin, is not "a conceptualized ideal,

science, or a discipline, but a method, a particularized kind or state of awareness . . . What applied to the artist, now applies to the observer. And in this responsibility of the individual observer we can see the first social implication of a phenomenal art."

It is up to us, then, as specific observers, to validate the future of abstract art. If I knew Irwin's recent work only from photographs, my reaction to this might be different. By chance, though, I have seen two of his completed public projects. One is in Dallas—a Cor-Ten steel wall, as elusive as smoke, that appears and disappears as it slices through the grassy islands in one of those infernally complex urban traffic circles, transforming what should be a hideous non-space into something interesting and slightly mysterious. The other is in Seattle. It is a series of nine outdoor "rooms" on the plaza of the downtown Public Safety Building—square rooms formed by blue fencing material sixteen feet high, each of which contains a large concrete planter with a flowering plum tree. Here, as in Dallas, an uninviting site has been turned into a surprising and oddly beautiful place, a place that invites and rewards the kind of attention that Irwin wants us to pay.

I would like to quote again from *Being and Circumstance*, to suggest the kind of attention that Irwin himself pays when he visits a potential project site:

> This means sitting, watching, and walking through the site, the surrounding areas (where you will enter from and exit to), the city at large or the countryside. Here there are numerous things to consider: what is the site's relation to applied and implied schemes of organization and systems of order, relation, architecture, uses, distances, sense of scale? For example, are we dealing with New York verticals or big sky Montana? What kinds of natural events affect the site—snow, wind, sun angles, sunrise, water, etc.? What is the physical and people density? the sound and visual density (quiet, next-to-quiet, or busy)? What are the qualities of surface, sound, movement, light, etc.? What are the qualities of detail, levels of finish, craft? What are the histories of prior and current uses, present desires, etc.? A quiet distillation of all this—while directly experiencing the site—determines all the facets of the "sculptural response": aesthetic sensibility, levels and kinds of physicality, gesture, dimensions, materials, kind and level of finish,

details, etc.; whether the response should be monumental or ephemeral, aggressive or gentle, useful or useless, sculptural, architectural, or simply the planting of a tree, or maybe even doing nothing at all.

For some time now, it has seemed to me that Irwin's work in public spaces—and the work of a few artists who are involved in similar projects (although with markedly different ideas and approaches)—is far and away the most interesting direction in contemporary art. Until now, I had not thought of their work as a continuation of abstract art, but maybe that is what it is. Certainly none of these artists are involved with representation in any form. Richard Fleischner's landscaped plazas, Siah Armajani's "reading rooms" and vernacular bridges, the waterfront park that Mary Miss, in collaboration with the architectural firm Cooper, Eckstut, has designed for Battery Park City all offer a level of aesthetic pleasure that heightens my sense of awareness, which is something I could say of very few gallery or museum shows in recent years. The fact that Irwin's ideas sound utopian is in his favor. Considering the present art-world climate of careerism and frenzied competition, it may well be the only way out.

(November 11, 1985)

INGRES IN LOVE

The Frick Collection's fiftieth anniversary is being observed with a maximum of restraint. No galas are planned, no monster exhibitions of royal, papal, or pharaonic treasures, no announcements of multimillion-dollar expansion plans. The main event of this anniversary year was the opening, last week, of an exhibition focussed on a single painting in the collection: Ingres's portrait of Louise, the Comtesse d'Haussonville. The show is a brilliantly understated demonstration of why the Frick is indispensable to the art life of this city.

The Frick, of course, is everybody's favorite museum, although not everybody agrees on the reasons. We love the size and scale of the place—the fact that it can be "taken in" during a leisurely two-hour visit. Some people delight in its high-handed regulations: children under ten years of age are not admitted, and those under sixteen must be accompanied by an adult; to get a seat in the Music Room for the Sunday-afternoon concert you still have to write a letter that arrives on the second Monday preceding the desired date, and "no telephone or personal applications can be accepted." The Frick limits admissions to two hundred visitors at any one time, so the galleries are never really crowded; on weekends, when attendance picks up, the waiting line can usually be accommodated in a nobly proportioned chamber that was added for that purpose during the Frick's remarkably discreet (and presumably final) expansion of its premises, in 1977. It is often said that the Frick is such a wonderful place to look at pictures because it is a private house, but this is a dubious point. When Henry Clay Frick built his Fifth Avenue mansion (it was finished in 1914), one of the primary incentives was to show up his former business partner Andrew Carnegie, who had spent more than a million dollars on *his* Fifth Avenue mansion, twenty blocks north, at Ninety-first Street (the house that is now the Cooper-Hewitt Museum). Carnegie and Frick were bitter enemies by this time, and Frick told people he was going to "make Carnegie's place look like a miner's shack." He engaged Carrère & Hastings, the architects of the New York Public Library, to build a neoclassical limestone pavilion that cost him at least five million dollars, and whose interior spaces were designed principally to show off his works of art. Renovated by John Russell Pope before its opening as a public gallery, in 1935, the Frick looks and feels more like a museum than like a private house. The furniture is the kind you look at but don't use—those overwrought and overgilded commodes and *fauteuils* turned out by French *ébénistes* and still inexplicably esteemed by certain collectors. Coldly formal as a house, the Frick is nevertheless a magnificent small museum. The concentration of masterpieces per square yard of wall space is unsurpassed anywhere in the world, and that, of course, is the real point. Supreme quality is what the Frick has to offer.

How it got there is somewhat mysterious. There has never been an adequate biography of Henry Clay Frick, and not much is known about

his relationship to works of art. A farm boy from western Pennsylvania who became one of the most ruthlessly successful industrialists of his era, he seems to have followed his own judgment in buying paintings, instead of relying on expert advice. Often he would keep a prospective purchase on approval for months and then decide not to buy it. He began in Pittsburgh, in the eighteen-eighties, with French salon painting, the approved contemporary art of the time. After helping J. P. Morgan to bring about the historic series of mergers that created the United States Steel Corporation, in 1901, however, Frick withdrew from active business management and devoted a large part of his time to collecting on a grander and more rigorous scale. That year, he acquired his first Turner and the first of his three Vermeers. Gainsborough and the English portrait painters came next, followed in 1905 by El Greco's *Saint Jerome* (of the white beard and the fiery red cloak), Titian's portrait of Pietro Aretino, and Van Dyck's portrait of Ottaviano Canevari. In the fall of 1905, Frick moved his family from Pittsburgh to New York, where he rented George Vanderbilt's house at 640 Fifth Avenue and proceeded to stock it with Rembrandts, Holbeins, Veroneses, and Velázquezes. He bought mainly from Knoedler & Company. It was not until 1910 that he bought a picture from Duveen, who then went on to sell him the fourteen Fragonard panels from the Morgan collection and the eight Boucher *Arts and Sciences* paintings, all of which were earmarked for his new mansion at Fifth Avenue and Seventieth Street. He kept on buying after he moved in, even during the war years—three Goyas, three Whistlers, two more Turners, Degas's *The Rehearsal*, Manet's *Bullfight*, Renoir's *Mother and Children*. His last purchase was Vermeer's *Mistress and Maid*, in 1919, the year he died.

Frick left an endowment of fifteen million dollars to maintain the house as a public museum, but it did not become one until 1935 because his widow lived there until her death, in 1931, and the renovations took four years. He had stipulated in his will that part of the endowment income could be used to purchase additional works of art for the collection, and since 1919 the trustees have added forty-six paintings to the hundred and twenty-six that Frick owned. Most of these additions reflect the founder's taste for large landscapes and life-size portraits—grandly assured, sumptuous pictures ranging from the fifteenth century to the latter part of the nineteenth. The last purchase,

Hans Memling's *Portrait of a Man*, was made in 1968. Since that date, the price of paintings at the Frick's level of quality and importance has exceeded even the Frick's ability to pay. Frick's taste was fairly circumscribed. Explicit nudes of either sex were not welcome, and neither were scenes of life in the lower echelons of society—Goya's *The Forge* was the one great exception. The early Italian Renaissance held little appeal for him, but his successors have stretched the guidelines significantly in this area. A number of exquisite early Italian religious paintings, by Duccio, Gentile da Fabriano, Fra Filippo Lippi, Paolo and Giovanni Veneziano, and Piero della Francesca, were acquired after 1919, largely through the efforts of Helen Clay Frick, the founder's daughter.

Although she remained fanatically loyal to the memory of her father, Miss Frick, who died in 1984, at the age of ninety-six, had a mind and a will of her own. For years, she dominated the board of trustees, who usually deferred to her on aesthetic matters. A tiny, imperious woman who preferred Pittsburgh to New York (her pet spaniel, Bobby, learned to roll over and play dead when Miss Frick said "New York," and then to jump up ecstatically when she said "Pittsburgh"), she has her own monument in the Frick Reference Library, which she founded (in 1920), financed, and supervised for many years. The library's posted rules evoke a world that vanished some time ago ("Women wearing very short skirts, shorts, slacks, or spike heels will not be admitted"), but within the chronological limits of the collection it serves it is, by general agreement, one of the two or three top art reference libraries on this continent. The chronological cutoff point for the collection is 1892, the date of Whistler's portrait of Robert de Montesquiou (who also served as the original for Proust's portrait of the Baron de Charlus). The trustees bought a Monet landscape painted in 1879. They edged further into modernism by acquiring two Cézannes and a very fine Gauguin, but in 1949 they sold those three pictures back to Wildenstein & Company, because, as they reasoned, if you had Cézanne and Gauguin, what was to stop you from having Picasso and Matisse? It seems fair to detect Miss Frick's hand in that decision.

Miss Frick severed her connection with the Frick Collection in the nineteen-fifties. John D. Rockefeller, Jr., whose admiration for the Frick was immense, had offered to give to it several works of art from his own collection. Miss Frick went to have a look at them and decided they

were not good enough—not up to her father's standards. But the trustees overruled her; they voted to accept the gift. The results were painful all around. Miss Frick's brother, Childs Frick, was the chairman of the board; he voted against her, and other members of the family were obliged to take sides. Miss Frick withdrew in anger. Although she continued her active interest in the library, her picture-buying from then on was confined to her own collection. Eventually, she established a Frick Museum in Pittsburgh.

Miss Frick was still very much in command in 1927, however, when the trustees bought Ingres's portrait of the Comtesse d'Haussonville. Would her father have bought this enchanting picture (the sole Ingres in the collection)? My guess is that it might not have endured the old man's rigorously masculine scrutiny. The picture has always fascinated viewers. Many of them ask the Frick's attendants about its subject—the pretty young Countess who regards us so directly and candidly, one hand supporting her chin, a forefinger extended to touch the line of her throat. Ingres had a terrible time finishing the portrait. It took him nearly three years, and required an unusual number of preliminary sketches, many of which have been preserved. This in itself makes the painting an ideal focus for one of the small special exhibitions that the Frick has been putting on, at the rate of one or two a year, since 1977—exhibitions designed to shed new light on particular aspects of the collection. What Edgar Munhall, the Frick's senior curator, originally set out to do was to assemble all the known drawings and sketches for the portrait. So much new material came to light in the course of his research, however, that the exhibition and its accompanying catalogue have turned into something of a landmark in Ingres scholarship. In addition to fifteen of the sixteen recorded preliminary drawings, two of which were virtually unknown, the Frick is showing the abandoned first version of the portrait, which Ingres painted over and gave to an assistant (some years later, the assistant scraped off the overpainting and sold the canvas to the d'Haussonville family), and an unfinished version of Ingres's *Antiochus and Stratonice*, the 1834 historical painting in which Stratonice is shown in the same pose—one hand supporting her chin, the elbow resting on the other hand, which is held at her waist—that Ingres adapted for Louise's portrait. Also on view are a number of

works by Ingres, Degas, and others that were inspired by the d'Haussonville picture. Portraits by other artists of Louise and members of her family, portraits of Ingres, some surprisingly adept watercolors painted by Louise herself, and a wealth of related materials lend historical depth to the exhibition, and excerpts from Louise's memoirs, which surfaced in time to be included in the catalogue, bring the subject into exceptionally clear focus.

Louise d'Haussonville was twenty-four in 1842, when her husband commissioned Ingres to paint her. Brought up in a climate of social and intellectual distinction—her father, the Duc de Broglie, was a writer, a diplomat, and a minister in the government of Louis-Philippe—Louise claimed a particular affinity with her maternal grandmother, Mme. de Staël. Although she never achieved the literary success of her famous relative, Louise wrote a number of books, five of which were published, among them a novel and a biography of Byron. (At her husband's insistence, all were published anonymously.) Her memoirs make lively reading. An intelligent woman with a skeptical and sometimes rebellious turn of mind, she had the French capacity for merciless self-appraisal. Although she describes herself as having been "very pretty indeed" in her youth, with a "veil of innocence" that protected her from many things, she also saw herself as something of a femme fatale. "I was destined to beguile, to attract, to seduce, and in the final reckoning to cause suffering in all those who sought their happiness in me," she writes. Her childlike quality went hand in hand, she tells us, with "ice, aridity, and frivolity." Of her marriage, at eighteen, to the Vicomte (later Comte) d'Haussonville, who came from a family as old and distinguished as her own, she has this to say: "I wanted to marry young and have a brilliant position in society. And that, basically, was the only reason I wanted to marry him."

The young couple had met Ingres in 1840, in Rome, where he was employed as Director of the French Academy. The great classicist was fifty-nine, and somewhat embittered. His genius had met with occasional sharp rebuffs in Paris, and the lack of adequate patronage had made it necessary for him to accept portrait commissions, which he detested. ("A portrait of a woman!" he once exclaimed to a pupil. "Nothing in the world is more difficult, it can't be done.") Ingres painted some of the indelible portraits in Western art, nevertheless, and his portrait of Louise d'Haussonville is one of them. Work on it was in-

terrupted for long periods, and there is evidence that at one point Ingres hoped to get out of the commission by offering, instead of a painting, the three-quarter-length pencil drawing that is now at the Musée Bonnat, in Bayonne—the only drawing that could not be borrowed for the show. At the Frick, we can see the picture's complex evolution: the abandoned first version; a subsequent reversal of the pose, so that Louise faces the viewer's left instead of the right; a change of dress; a transition from a stiff, upright posture to a more yielding side view; the handling of her reflection in the mirror behind her, with its still-life of flowers and Sèvres porcelain; the odd little gesture with the arched forefinger. It is, as Mr. Munhall aptly observes in the catalogue, like watching "a hunter stalking his prey." We see the subject's features come to life as Ingres goes from perfunctory likeness to idiosyncratic character study, and in the process we sense a little of what goes on in the mysterious relationship between artist and subject which a great portrait requires. Ingres complained regularly about his unwelcome labors on the picture, but, in the end, what a triumph! The finished portrait, presented to the d'Haussonville family in June, 1845, was received with what he described as "a storm of approval, starting with the Duc de Broglie, his family, and his numerous friends among the élite." Although Ingres claimed not to be elated, saying, "I don't feel that I conveyed all the graces of that charming model," he was clearly pleased. He took evident delight in being told that a prominent statesman, Louis-Adolphe Thiers, on seeing the portrait in the presence of its subject, had "repeated to her several times this wicked remark: 'M. Ingres must be in love with you to have painted you that way.'"

The portrait, which hangs in the East Gallery at the Frick, separate from the rest of the exhibition, makes Thiers's remark seem more than a pleasantry. Its impeccable clarity of line and shape, the subtly modulated colors, the perfection of detail, the sensuous meeting of silk and bare skin—all the evidence of Ingres's famous technique cannot account for the disturbing *intimacy* of the image. Louise regards us as we regard her: directly, provocatively, with a strong undercurrent of erotic tension. There is very little distance between her and us—much less, for example, than there is in Ingres's portrait of her sister-in-law the Princesse de Broglie, painted in 1853 and now hanging in the Lehman Collection at the Metropolitan. The Princess, an older and more sophisticated beauty, rests securely within the illusionary space of the painting; the

young Countess seems to push forward into our own space. We look at her in a way we can never look at anyone in real life: aware not only of her physical beauty but of her contradictory nature, and aware also— acutely aware—of the artist's avid concentration upon her. Ingres, the cool sensualist whose great subject was the naked female body, often said that a woman's head was "unfeasible." Like Giacometti, he yearned to cram into the painting of a head all the things he knew to be there, visible or not, but if the attempt was doomed to failure it nevertheless opened doors that are closed to most painters. We come away from this exhibition knowing a good deal about Louise d'Haussonville, and considerably more than we knew before about Ingres and about the art of painting.

There is nothing in Louise's memoirs to suggest her feelings about Ingres, and this may very well imply that she had none. She kept the painting all her life, however, and I suspect that it influenced the way she thought about herself. Even if we take Louise d'Haussonville at her own rather unflattering self-evaluation, it is hard not to fall in love with her portrait.

(December 2, 1985)

THE TRUTH
OF APPEARANCES

Thomas Eakins, who was not much appreciated in his own time (1844–1916), is usually referred to these days as the greatest painter this country has produced. Certainly he was the great American realist painter; no one else has ever got American scenes and faces down on canvas with such authority. Eakins was an American original, influenced by no one, and paying no attention whatever to the proliferation of European styles and movements that reached such a climax toward the end of his career. When he died, realist painting more or less died with him. American artists who continued in the realist tradition after the 1913

Armory Show were fighting a rearguard action that was doomed to fail—the century belonged to the avant-garde, and the avant-garde was hellbent to jettison the reality of sight for the reality of insight. Now that the whole idea of the avant-garde has disintegrated, realism is making a comeback. Young and not so young American painters have risen to prominence during the last decade with work that mirrors the real world in all the traditional aesthetic guises—landscapes, portraits, still-lifes, nudes, even pictures that tell moral tales. A haze of confusion and controversy surrounds the trend. Critical vocabularies shaped to deal with a century of abstract, formalist art have proved, understandably, to be inadequate; so far, much of the argument has focussed on the abstract or formalist qualities discerned in the new realism. A better moment could hardly have been found, then, for the great Thomas Eakins exhibition that was on view earlier at the Philadelphia Museum of Art. The gulf between Eakins' realism and the current varieties is a wide one, all right, but it does not appear to be unbridgeable. What is common to them is a commitment—a peculiarly American commitment—to what I would like to call the pragmatic ideal.

Nearly every one of Eakins' mature paintings catches a particular moment—an unrepeatable fragment of real time. "In a big picture you can see what o'clock it is, afternoon or morning, if it's hot or cold, winter or summer, and what kind of people are there, and what they are doing and why they are doing it," he wrote in a letter to his father when he was still a young art student in Paris. When he got home to Philadelphia, where he would live for the rest of his life, Eakins put his theory into practice. In *The Pair-Oared Shell* (1872), one of a series of boating scenes on the Schuylkill River, the position of shadows falling on the water indicates (according to scholars who have made the necessary calculations) that the time of day is just before sunset, and that the day is in either early June or mid-July. There is very little sense of motion in the boating pictures. *Max Schmitt in a Single Scull*, the most famous of them (it hangs in the Metropolitan Museum), has an absolute stillness that can be felt even in reproductions. The rower, Eakins' friend Max Schmitt, has stopped to rest on his oars, whose blades stir small wakes as they drag in the water, while another rower (Eakins himself—his name is painted on his racing shell) pulls away toward the distant bridges. A golden light bathes the scene, etching the precise detail of feathery trees reflected in water and intensifying the

feeling of clarity and silence. *Max Schmitt in a Single Scull* is an almost perfect realization of the pragmatic ideal—of the evocation of the general through the particular. By paying infinitely close attention to precise details—to the way these men in their boats looked at that moment, on that river, in that light—Eakins achieved an image that goes beyond the moment and into the collective consciousness.

The same thing is true of *The Gross Clinic* and *The Agnew Clinic*, the two big medical paintings that were shown together in one room at the Philadelphia Museum. The blood on Dr. Samuel David Gross's scalpel and on his blunt fingers as he pauses in mid-operation to address the watching doctors and students has already started to congeal. It is sticky, and is not pleasant to look at, but it is what our eye goes to first and returns to again and again. Both the Gross and the Agnew pictures are portraits: superb likenesses of great doctors in action—or, rather, at a moment of pause in the highly dramatic action of radical surgery. Dr. Agnew, we are told, protested vigorously about the depiction of blood on *his* fingers, and demanded that Eakins paint it out; and Eakins may indeed have toned it down somewhat. The painted blood had a good deal to do with the fate of the paintings, both of which were rejected for exhibition by fine-arts authorities at the time, and neither of which hangs permanently in a museum. (*The Gross Clinic* belongs to Jefferson Medical College, in Philadelphia, and *The Agnew Clinic* to the University of Pennsylvania.) But, for Eakins, there was no possibility of leaving it out: once he had chosen to paint his subject in the context of an operation—a specific operation on a specific patient—to omit the blood would have been like omitting the oars in a boat painting.

As an artist committed to the particular moment and the precise detail, Eakins was inevitably drawn to photography. He bought his first camera before 1880, became an expert with it, and often used his own and other people's photographs as studies for his paintings. Eakins even took up the camera's selective focus, blurring the shapes in the foreground and the background of certain paintings so that the central image stood out with greater sharpness. In this respect, he pioneered what has become the obsession of present-day realist painters, for many of whom reality is what the camera records. Several of the so-called Photo-Realists work directly from photographs, projecting an image onto canvas and duplicating it there in paint. Chuck Close,

in his painstakingly detailed painted portraits, reproduces the grainy texture and the blurred peripheries of extreme closeup photographs many times enlarged. Audrey Flack's still-lifes create a similar effect. Philip Pearlstein, who does not use photographs, brings the viewer up against his unflattered nudes at such close angles that parts of the bodies are cut off by the painting's edge, in just the manner of a cropped photograph. William Bailey's sharp-focus still-lifes, Neil Welliver's watery forest scenes, the pinpoint landscapes and cityscapes of Richard Haas, Rackstraw Downes, and William Beckman all have the unmistakably photographic look of being "more real than real." The point here, I suppose, is that because we are now conditioned to perceive the world through its reproduction in photographs and films and videotapes artists have a legitimate interest in exploring photographic perception.

The unique moment is photography's stock in trade. What we hardly ever get in a photograph, though, is the imperceptible movement through and beyond the moment, into the timeless present where Max Schmitt rests on his oars and Dr. Gross turns aside to speak. This is no mean undertaking, of course. But the knowledge that it can be done—has been done, in fact, by such a quintessentially pragmatic artist as Eakins—is sufficient to justify the realist revival. Realism dies when it fails to go beyond imitation. For more than a century, artists have felt that it was demeaning to fabricate an illusion of something real. Demeaning and dishonest. "I don't want a picture to look like something it isn't," Robert Rauschenberg said in his younger days. "I want it to look like something it is. And I think a picture is more like the real world when it's made out of the real world." Rauschenberg, the great includer, made "combines" out of trash and old clothes and flashing light bulbs and Coca-Cola bottles, and he made a sculpture out of a stuffed goat with a tire around its middle. Meanwhile, the great excluders were busy taking everything out of painting but the basic elements of color and shape on a flat surface. It must have required some nerve, in the face of these precedents, once again to paint pictures that presented the old illusions, whatever the new modes of perceiving them might be. Enough artists have chosen this course in recent years, though, to suggest that the curse on imitation has been lifted. The problem now is that unless someone comes along fairly soon and raises the stakes—carries the game to a higher level, at which imitation is

simply a means to an end—the whole realist revival could go dead in no time flat.

Any new realist would do well to spend a month or so studying Eakins' portraits. Portraits are the bedrock of his work, and the selection brought together for the Philadelphia exhibition has a stunning cumulative impact. In his early studies of family members and friends, painted without any trace of the conventional sentiment of that era, and even more in the portraits to which he devoted himself almost entirely after 1886, there is a quality that had never been seen before in American art, and only rarely in the art of Europe. It is a quality of the eyes, especially, and of the hands. Eakins hardly ever painted a graceful or a shapely hand. *Lady with a Setter Dog*—a portrait of his wife, Susan Macdowell, whom he had just married—shows her seated in a chair, holding a book with one hand; the other hand lies open on her lap, the fingers upturned, relaxed but awkward-looking, reddened by work, not at all pretty, but so wonderfully painted that the weight of the hand in her lap and the texture of the veins and the gentleness of her touch are immediately evident. Although she was a relatively young woman then (she was thirty-two, he was forty), he has made her look older, almost gaunt, with deep-set eyes that gaze thoughtfully at the viewer. The eyes of William H. Macdowell, Susan's father, blaze out fiercely from the portrait of him that belongs to the Memorial Art Gallery of the University of Rochester. (Eakins painted a number of portraits of his father-in-law.) Some of the other male subjects seem to be looking inward, sifting thoughts that we are not meant to share. It is the women's eyes that tell the most. In the 1899 portrait of Mrs. Eakins, in the two portraits of the Eakinses' close friend Mary Adeline Williams, and in the unforgettable study of Mrs. Edith Mahon we are confronted with faces no longer young, faces that had not, perhaps, been beautiful in youth but now reveal a beauty and a strength that are heartbreaking. This is what Eakins came to, through his passionate immersion in the truth of appearances—this powerful, quiet, indelible vision of the sadness at the core of life. It was his own sadness. For all his gruff good nature and his love of outdoor pleasures, he was a moody and at times a deeply depressed man. Asked for his advice to young artists, Eakins replied that they should "peer deeper into the heart of American life," and that is what he did. He peered as deeply as anyone has, and what he saw finds its parallel in the

work of certain American writers—Hawthorne and Melville come to mind. The haunting presence in so many of his later portraits is the presence of the artist, who has looked so long and so unflinchingly at the surface of things that he has gone right through to the heart of them.

(September 13, 1982)

MEDICIS, INC.

The Equitable Life Assurance Society, a firm with little previous involvement in the fine arts, has just spent seven and a half million dollars on works of art for its new headquarters building, in midtown Manhattan. Mayor Koch and a host of other notables came to the opening-night gala in February, 1986, in Equitable's street-floor lobby, where they saw the unveiling of Scott Burton's *Atrium Furnishment*, a semicircular sculptured marble settee enclosing a circular marble basin full of aquatic plants, and of Roy Lichtenstein's exuberant sixty-eight-foot-high *Mural with Blue Brushstroke*. Elsewhere on the street level of what is billed as Equitable Center, "the largest corporate art complex ever developed," one could admire major works by Sol LeWitt, Sandro Chia, and Barry Flanagan, all of which were commissioned by Equitable; a 1939 bronze sculpture, *Day*, by the late Paul Manship, whose *Prometheus* figure adorns Rockefeller Center (Equitable's directors have said that Rockefeller Center was in many ways the model for Equitable Center); Thomas Hart Benton's ninety-foot series of murals called *America Today*, painted in the nineteen-thirties for the New School for Social Research, and bought by Equitable two years ago for three million four hundred thousand dollars; and a pair of three-thousand-square-foot art galleries, situated on either side of the building's main entrance, on Seventh Avenue between Fifty-first and Fifty-second Streets, which constitute the latest and largest branch of the Whitney Museum of American Art. It was Edward Larrabee Barnes, the building's archi-

tect, who urged his clients to undertake an art program and to get the Whitney to advise them. Barnes recently called the relationship between Equitable and art a symbiotic one—"The company gets a lot from the art program, and the art program gets a lot from the company," he said—and it would be churlish to disagree. I am amazed, nevertheless, by the speed with which we have come to take this symbiosis for granted.

The modern courtship between art and business really took wing in 1959, the year the Chase Manhattan Bank set up its art-buying program. Several American firms had collected or commissioned works of art before that, but it was Chase's commitment—largely inspired by David Rockefeller, who was then the president of the bank, and overseen by a committee of museum professionals which included Alfred Barr, Dorothy Miller, James Johnson Sweeney, Robert B. Hale, and Perry Rathbone—that made a lot of other corporate leaders sit up and take notice. More than eight hundred business organizations in this country now collect art, according to a conservative estimate by the Business Committee for the Arts, a national nonprofit organization. Their holdings cover a wide range, from the Campbell Soup Company's collection of soup tureens to the First National Bank of Chicago's eclectic array of more than four thousand art objects dating from the sixth century B.C. to the present. Most of the collections, however, are in the field of contemporary American art, and this is what boggles my mind. Contemporary art is plentiful and relatively affordable, of course—a big plus, since no corporation, however successful, is going to channel a disproportionate amount of the shareholders' money into art. But the idea that contemporary art can serve the corporate image of so many businesses suggests that there have been some major changes in American art or in American business, or both, during the last two decades.

Benjamin D. Holloway, the man in charge of Equitable's multimillion-dollar real-estate division, has been quite frank about why the company is spending so much on art. According to Holloway, who is also the man mainly responsible for the art program, "we are doing these things because we think that it will attract and hold tenants, and that they will pay us the rents we're looking for." Putting up a high-rent office building on the West Side of midtown was a risk, and Equitable, which financed the construction, plans to occupy only sev-

enteen of the building's fifty-four floors. Lichtenstein, Chia, and Burton can help to sell real estate, it appears, as effectively as Cimabue and Giotto helped to sell Christianity. A number of subtler explanations have been advanced to justify corporate art-buying, of course. Art on the walls of the workplace is said to foster innovative thinking and "creativity" among employees. It is also said to boost morale, impress clients, and attract top-quality personnel. The well-publicized Philip Morris slogan "It takes art to make a company great" might suggest the kind of innovative thinking required by a company that has problems advertising its own major product, but some firms apparently take the idea quite literally. When PepsiCo moved its main office from Manhattan to Westchester, in 1970, it set about acquiring a collection of large-scale outdoor sculpture. Speaking about the collection to a *Times* reporter, Donald M. Kendall, the firm's chairman, said, "This makes us a first-class company."

Company presidents like to talk in general terms about supporting the work of the living artist and thereby contributing to the culture of democracy. This fits in with the modern corporation's wish to be (or to appear to be) socially responsible, and it provides welcome opportunities for self-congratulation. "We business people who support the arts today are like the Medicis and the other collectors and supporters of art in history—only better," Winton M. Blount, the chairman of Blount, Inc., said at the 1984 annual awards dinner of the Business Committee for the Arts. "We all know that making our society fit for the human spirit demands that we contribute to making mankind's burdens lighter and that we lift man's spirits and aspirations." To the best of my knowledge, Mr. Blount's company, which is based in Alabama and deals in construction, engineering, specialty steel, and agri-industrial operations, has not yet become the subject of an art work by Hans Haacke, the German artist who often juxtaposes a firm's cultural pronouncements with his own researched statement concerning the firm's hiring practices, safety conditions, or other, less publicized activities. An exhibition of Haacke's work that was scheduled to open at the Guggenheim Museum in 1971 was cancelled when it turned out that some of the pictures made unflattering references to New York real-estate interests, and he has remained the sort of artist whose work is not in great demand for corporate collections. The way things are going, though, in five years or so he might become perfectly acceptable,

as a kind of corporate "in" joke demonstrating a firm's commitment to maturity, tolerance, and artistic freedom.

Corporate collecting has given work to a whole new professional class of art advisers and curators, some of whom are as knowledgeable as their counterparts in museums. The best collections, however, usually reflect the personal interest and participation of the firm's head man, acting individually rather than in committee. Donald B. Marron, the chairman of PaineWebber, is responsible for that company's strikingly avant-garde collection of paintings and sculptures by contemporary American and European artists. (The firm has moved into Equitable's former office space, in a Sixth Avenue building that connects with Equitable Center to form what Equitable calls "one square block of art.") In 1984, PaineWebber hired Monique Beudert away from the Museum of Modern Art's department of painting and sculpture to be its in-house curator. But Marron, who recently became the president of MOMA's board of directors, and whose private collection stops just short, chronologically, of the up-to-the-minute work that PaineWebber buys (Frank Stella, Jasper Johns, and the first-generation Abstract Expressionists are too expensive now for corporate art budgets), continues to keep a sharp eye on new acquisitions. How do PaineWebber's employees react to Marron's taste in new art? There are occasional complaints, according to Monique Beudert, but there are also employees who bring the wife and kids on weekends to see the art. (It hangs in the corridors and other public areas, not in anyone's private office unless it is specifically requested.) Marron feels that corporate collections are helping to broaden the audience for contemporary art, and are doing so in a way that museums and galleries can't duplicate. "We're not competing with museums, but we have something no museum has, which is unlimited linear space—bare walls," he told me. "Where else can you see such a wide spectrum of recent work?" He would like this aspect of corporate collecting to be developed somehow—the collections to be made available to a larger public—although that would involve difficult questions of security and maintenance. In the meantime, PaineWebber has turned the downstairs lobby into an exhibition space for temporary exhibits by some of the city's smaller museums; the incumbent is the International Center of Photography's show of photographs by Philippe Halsman.

Not many large corporations are as freewheeling as PaineWebber in

their art program. Exxon, which has been active for some years as a sponsor of museum exhibitions and other cultural activities, began buying contemporary art in 1982 and now owns two hundred and seventy-five examples, most of them done since 1980. The firm's highly professional fine-arts consultant, Lois Dickson (who put together the Prudential Insurance Company's collection before she moved to Exxon), works with an acquisitions committee of six Exxon executives, and her selections are also reviewed by the art historians John I. H. Baur and Irving Sandler. As a result of employee complaints about abstract art, realism now has an equal place in the collection. At Equitable, American realist paintings were chosen almost exclusively to decorate the executive dining rooms, on the forty-ninth floor. Nobody wants an art program that makes employees unhappy—especially not a corporation such as Exxon, where of late there have been some reductions in staff. What seems surprising, though, in view of the no-nonsense values that American business stood for only yesterday, is that post-1980 art of any kind now looks right at home in banks, insurance companies, and brokerage firms.

What we are dealing with is a form of patronage that is not altogether certain of its objectives but potentially unlimited in scope. Already, there are a number of galleries here and in other cities that cater mainly or exclusively to corporate clients. Jack Boulton, the art adviser to Chase Manhattan, bought thirteen hundred and five works of art for the Chase collection in 1984. This averages out to more than three a day, and makes it easy to understand why Boulton is a figure of some importance in international art circles. * (The Chase collection now numbers almost eleven thousand works, housed in three hundred and forty-six branches throughout the world.) Boulton, a droll, likable Midwesterner who served from 1972 to 1977 as the director of the Contemporary Art Center in Cincinnati and has also worked in Washington, D.C., for the International Exhibitions Committee, tends to see himself as the art teacher for a town of thirty thousand—approximately the number of people that Chase employs internationally. "I'm multilingual," he says. "I can speak State Department, I can speak corporate, and I can speak *Artforum*. Sometimes corporate and *Artforum* sound a lot alike, come to think of it. At the bank, we never say things

*Jack Boulton's suicide in 1987, at the age of 43, was a great shock to his many friends.

like 'art education'; we talk about 'knowledge-base development.' " Boulton and Merrie Good, the administrative director of the Chase art program, are often called on to advise and educate companies interested in setting up programs of their own. The level of professional competence in the field is much higher than it was a few years ago, and the demand keeps increasing. All this has obviously been a factor in the recent expansion of the art market, although just how large a factor nobody knows; art-world statistics are still fairly neolithic. Has it also affected the kind of art being made today? Boulton and most of his colleagues say it hasn't. "Art is still anti-bourgeois," Boulton says. "That's the irony. Artists as a whole are not interested in corporate taste. They realize that unless you can go beyond selling to corporations you're nowhere. Artists just go ahead with what they do, as Dorothy Miller points out in the catalogue to our collection, and our job is to try and keep up with them."

I would like to believe him, and maybe I do. Art that will never appeal to corporate buyers continues to be made all the time: art with a high degree of political or erotic content, environmental art, video art, performance art. The fact that such tendencies continue to flourish suggests that the corporate influence is by no means a controlling one. But I wonder sometimes whether there may not be a relationship, symbiotic or otherwise, between the huge increase in corporate buying and the return to favor of representational painting during the last ten years. We are all aware by now of the effect that corporate sponsorship has had and continues to have on the exhibition schedules of our major museums—more and more "Treasures of" blockbusters, fewer and fewer small, focussed shows whose public-relations potential does not quite make the grade. It seems possible to me, considering the staggering number of would-be professional artists now on the loose, that the expanding corporate market is similarly helping to foster certain kinds of art. Realism of all kinds, decorative abstraction, photographic and craft work. Art that is bright in color, upbeat, humorous. Just the sort of art, in fact, that we see so much of these days in the East Village and SoHo and at the Whitney Biennials.

Art has not really been anti-bourgeois for a long time, I suspect, and the artists who maintain an anti-bourgeois attitude today may well be in the rear guard of history. Richard Serra's powerhouse retrospective at the Museum of Modern Art probably has less to tell us about the fu-

ture than the Metropolitan's delectable exhibition of François Boucher, an artist who perfectly encapsulated the image that his patrons wished to project.

(April 14, 1986)

REAL AND UNREAL

Mere chance brought the Eric Fischl show to the Whitney Museum at the same time as the Alex Katz retrospective. Organized in 1985 by the Mendel Art Gallery in Saskatoon, Canada, the Fischl show, which had been travelling here and abroad, was supposed to have made its New York appearance at the ill-fated contemporary-art museum that Edward R. Broida, a California real-estate millionaire, was preparing to open in a renovated bakery building in SoHo. Construction delays and other problems caused Broida to cancel his exhibition schedule (he has since abandoned the SoHo project entirely and gone back to California), but the Whitney found room in its exhibition schedule for the Fischl show—not surprisingly, since Fischl has emerged in the last two years as one of the hottest young artists on the international gallery scene. It was great fun to compare the reactions of people looking at Katz's paintings, on the fourth floor, with those of people looking at Fischl's, two flights down. Contented sighs of pleasure above; furrowed brows, furtive looks, earnest scrutiny of the less provocative areas of the paintings below. The two shows certainly demonstrate the wide range of American realist painting, in which there is such a resurgence of interest right now.

Although Alex Katz has been showing in New York since 1954, he was thought of until recently as a peripheral figure—a painter you couldn't ignore but one who was hard to place. Clearly influenced by Abstract Expressionism in his early work, he insisted nevertheless on painting the human face and figure at a time (the nineteen-fifties) when even de Kooning's famous "woman" paintings were accused of being

retardataire. In the sixties, Katz's pictures lost the rough, gestural look of Abstract Expressionism and took on a clean, bright, stripped-down stylishness that owed something to Pop Art and something to billboards and advertising design—the "optic flash" of commercial art, as the writer Edwin Denby put it—but his subject matter remained the same: portraits of friends and of his wife and son; New York rooms with groups of people in them; outdoor scenes painted in Maine, where he has a summer home. The pleasure that these pictures give is immediate and uncomplicated—so much so that Katz's originality is often taken for granted. Many of them are very large, the faces bigger than life. His color is both strong and subtle, his paint smoothly and impersonally applied. Katz's radical suppression of detail (his own adaptation of sixties minimalism) makes everybody look young and physically flawless; there are no wrinkles, no sagging flesh on these poster-perfect faces and bodies. He uses the human figure as a compositional device in paintings that are about as close to abstraction as it is possible to get while using recognizable imagery. Individual features are identifiable, though, and in nearly every painting the fall of light on objects and people is highly specific as to the time of day, the season of the year, and the particular setting.

There is a sureness and a lilt to Katz's paintings which make the viewer feel good about them. Here is an artist who knows precisely what he wants, and who goes about his work with high intelligence and good humor. "I'd like to have style take the place of content, or the style be the content," he said not long ago. He is not a bit interested in social comment or psychological insights. His subjects are simply pretexts for picture-making; Katz uses them because he decided early in his career that he had to "go with what I saw, the objective world," but his use of them is purely pictorial.

With Eric Fischl, on the other hand, we are in the presence of a moralist. A really good moralist is a rarity in visual art—Daumier set the standard here, and he has not yet been seriously challenged. It is too early to tell whether Fischl can become a good one. He does not paint very well as yet; his pictures, with their dry, impatiently brushed surfaces, look better in reproduction than they do in the original. But a moralizing passion clearly underlies each of them, and it is what makes viewers so uncomfortable. In his late thirties, Fischl has it in for contemporary affluent, middle-class American society. He likes to take a viewer by the scruff of the neck, direct his gaze toward some

fairly disagreeable goings-on, and say, in effect, "This is your life."

The first three pictures in the Whitney show were, at first glance, virtually pornographic. *Sleepwalker* (1979), Fischl's breakthrough painting, the one that led him into his current, inquisitorial mode, shows a naked adolescent boy standing in a child's wading pool masturbating. In *Bad Boy* (1981), what could be the same adolescent, clothed, his back to the viewer, contemplates a mature naked woman lying on a rumpled bed, her legs splayed wide apart; with one hand he reaches behind his back to grope inside the woman's purse, which lies open on a table. *Birthday Boy* (1983) has in the foreground a somewhat more opulently mature woman, lying nude on a hotel bed with one leg raised, her gaze directed toward what is probably a television set off to the right, out of the picture; beyond her, also nude, lying across the bed and eyeing the woman, is the ubiquitous male adolescent. Various explanations have been advanced for the narrative content of *Bad Boy* and *Birthday Boy*—none seems required for *Sleepwalker*—but the real subject of all three pictures is clear enough. What is most striking is the treatment of that subject—the light, so to speak, in which the adolescent's discovery of sexuality is depicted. In each case, that light is pitiless, unpleasant, and disturbing. The tacky and impersonal surroundings, the absence of any direct human contact, the "pallid yet harsh colors" (as the art historian Robert Rosenblum aptly described them in an admiring essay on Fischl), and the composition that places the viewer in the position of a somewhat prurient voyeur all suggest that we are to take the scene as a negative object lesson: if this is how young boys come of age in our culture, then we are in big trouble.

Other Fischl pictures are more ambiguous, in ways that pique the onlooker's interest. What on earth is going on, for example, in the 1981 painting called *A Woman Possessed?* A pretty young woman lies unconscious on the ground, on her back, one arm flung out alongside her head. She has on slacks and a white polo shirt, and she is surrounded by five dogs, three of whom nuzzle and lick at her. Behind her are a bicycle and a station wagon, on whose open tailgate a sixth dog lies watching. In the foreground at right, a young boy—older than the one in *Sleepwalker* (I'd guess he is about fourteen)—similarly dressed in jeans and a white shirt, grasps her under the knees in an attempt to move the body. Two of the dogs on the ground look across at him with bared teeth, snarling. Also visible in the foreground are a pile of paperback books and notebooks (his schoolbooks?) and an empty tumbler

lying on its side. Did the car hit the woman? Apparently not, since there is no sign of blood or dented metal. Is she drunk? Passed out? What about the title? Who or what has possessed the woman? No way to figure it out, but the uncertainty keeps us looking and guessing. The plot of *The Old Man's Boat and the Old Man's Dog* (1982) is also unclear. Three men (one a near-adolescent) and two women lounge on the deck of a motorboat adrift on a turbulent sea under a stormy sky—the sea and the sky bring to mind Winslow Homer's painting *The Gulf Stream*. The three men and one of the women are nude; the other woman wears a bikini and a life jacket. A dog—a Dalmatian—barking in excitement, straddles the outstretched leg of the nude woman, who seems to be asleep. None of the human beings appear to be paying the slightest attention to any of the others, which tends to cancel out the suggestion of a marine orgy. Fischl's people have a way of being naked without cause, erotic or otherwise; maybe they are naked only in his mind (and in ours)—sinners in the sight of an angry artist. Somebody has commandeered the old man's boat, but nobody seems to be having much fun, not even the dog.

Nakedness as a metaphor, adolescent sexuality, alienation, dogs, water (swimming pools, the ocean, etc.), and a general sense of anomie recur in one after another of these large, clumsy, storytelling pictures, in which the subject matter is all-important. Fischl's subject matter shocks some people—a considerable accomplishment in itself—and it has discombobulated certain critics, driving them into dense thickets of litspeak. "Fischl's pictures have been generally understood, in a Barthesean way, as nonlinear texts implicating the viewer in an 'unfixed plurality' of meanings," Donald Kuspit writes in the catalogue of the Whitney show. "They are a structure of signifiers belonging to different narrative networks rather than a structure of signifieds issuing in univocal meaning." As is so often the case, however, Fischl himself has explained quite simply what he is up to. In a statement made at the time of his 1982 show at the Edward Thorp Gallery (he left Thorp in 1984, to join the Mary Boone Gallery), he said that the central element in his work was "the feeling of awkwardness and self-consciousness that one experiences in the face of profound emotional events in one's life. These experiences, such as death, or loss, or sexuality, cannot be supported by a life style that has sought so arduously to deny their meaningfulness, and a culture whose fabric is so worn out that its public rituals and attendant symbols do not make for adequate clothing." There, friends,

is the cry of the moralist, calling upon us to repent. Fischl's adolescents are already corrupted by society—most of them are cretinous little monsters with twisted features and a stunted look. The adults, pursuing their expensive pleasures in joyless surroundings, hardly notice them—or one another, either. These are thoroughly nasty pictures, deliberately so, and their undeniable power comes from that. If Fischl painted as well as Katz, his message would not be nearly as effective.

The conjunction of these two exhibitions at the Whitney was a useful reminder that realism now offers unlimited possibilities in visual art. Of course, it could be said that neither Katz nor Fischl is a realist, in the factual sense of that slippery term. We recognize the images in each case, but not the context; Katz's world of flawless surfaces and Fischl's world of naked depths are equally "unreal." But that is just the point. One of the founding beliefs of modernism was that it had become unnecessary and demeaning for art any longer to represent the external world. Instead of painting an imitation of something else—a trick to fool the eye—the modernist yearned to paint something that was real in itself, something that belonged exclusively to the world of art. This notion was one of the stepping stones on the way to pure abstraction, and the argument still seems valid to some artists. Abstract art's inevitability, in fact, had come to be so largely taken for granted that Frank Stella, the leading abstract painter of Katz's generation, has said he grew up thinking that representational art was a thing of the past, used only for commercial purposes. The trouble was, a lot of first-rate twentieth-century artists had stubbornly refused to give up the external world. Picasso was the most telling example. Picasso had gone right up to the edge of total abstraction in his Analytical Cubist phase, around 1911, but then he had drawn back, deliberately and decisively. Matisse's images always had their basis in objective reality. Even Pollock, who seemed for a time to offer proof of abstract art's total victory, allowed references to the human face to surface in some of his late canvases. The represented image was never eclipsed, and its clamorous return to favor in so much contemporary painting here and abroad is what turned out to be inevitable. The charges that were brought against mimesis did not hold up in court. A painting might represent persons or objects in the external world quite accurately and still function as a pictorial invention, an independent "reality" whose truth did not depend on anything outside itself. Conversely, a total abstraction becomes convincingly "real" when we recognize it as a pictorial invention that charts

the movement of an artist's mind. Representation and abstraction have coexisted in visual art from the beginning, at any rate, and they will continue to do so, in varying proportion, as long as visual art continues to exist.

In her book *Life with Picasso*, Françoise Gilot quotes the Master on the essential issue involved here. "You see," he told her, "one of the fundamental points about Cubism is this: Not only did we try to displace reality; reality was no longer in the object. Reality was in the painting . . . We always had the idea that we were realists, but in the sense of the Chinese who said, 'I don't imitate nature; I work like her.' "

(May 12, 1986)

OUT OF TOWN

During the decades when Paris ruled the international art world, it was often pointed out that relatively few of the major School of Paris artists were actually born there—most of them came from the provinces or from other countries. The same thing could be said about New York today. I would be hard put to it to name more than three well-known New York artists who are natives. (Alex Katz, Helen Frankenthaler, Larry Rivers, and who else?) Out of the first generation of Abstract Expressionists—the famous "New York School"—only Adolph Gottlieb and Barnett Newman were New Yorkers. Willem de Kooning came from Rotterdam; Arshile Gorky from Armenia; Philip Guston from Montreal; Franz Kline from Wilkes-Barre; Robert Motherwell from Aberdeen, Washington; Jackson Pollock from Cody, Wyoming; Ad Reinhardt from Buffalo; Mark Rothko from Dvinsk, Russia; and Clyfford Still from Grandin, North Dakota. It was the same with the next generation (Robert Rauschenberg was born in Port Arthur, Texas; Jasper Johns in Augusta, Georgia), and the next after that, and it is the same with the crop of New York artists now hitting their stride. At this point, though, what with an estimated fifteen thousand artists already in situ and fierce competitiveness the necessary condition for sur-

vival, a decision to come here is more complicated than it used to be.

I had this brought home to me in a series of conversations with four young artists who live in Minneapolis. That city is an unusually congenial one for artists. The climate may be trying in winter, but living expenses are reasonable by New York standards, there are two first-rate art museums in town (the Walker Art Center and the Minneapolis Institute of Arts) and also a very fine art school (the Minneapolis College of Art and Design, which just celebrated its hundredth anniversary), and the citizenry has made support of the arts a mark of civic pride. Three local foundations make annual grants to visual artists. The artists I talked with had all won the 1985 Jerome Foundation Fellowship, a five-thousand-dollar grant awarded each year to five young, "emerging" artists. The Jerome program, which is administered by the Minneapolis College of Art and Design, allows its grantees the somewhat dubious privilege of being able to invite three outside critics (or museum curators, or art historians, or what have you) to come to town, visit their studios, and discuss their work. One of the Jerome Fellows had taken his grant money and skipped to the Far East, passing up the visiting critics. The four I met were fairly dissimilar in approach and outlook, as artists tend to be in these pluralistic times. One of the things they had in common, though, was an intermittent struggle with the problem of New York.

Betina, as she calls herself, is a photographer and a performance artist. Her real name is Barbara O'Brien. She grew up in a small town in Kansas, the oldest of five children, and because her father died when she was five she shouldered adult responsibilities early. At the University of Kansas, in Lawrence, she took a B.S. degree in photojournalism and a B.A. in women's studies, "focussing on images of women in art and literature." After graduating, she got married and moved to San Francisco, where she did publicity work and was a gallery director. By then, she was devoting a lot of her spare time to making photographs— formally composed pictures taken with a Polaroid SX-70 camera. Eventually, her photographs became less formal—less like paintings and more like snapshots. Each one was a vignette in a continuing narrative, based on her life and her family. The birth of her first child (she now has two, a boy and a girl) was what nudged her into performance work. "I'd always been sort of quiet and withdrawn," she told me, "more a listener than a talker. Now I found myself wanting to get other people to tell their stories, but to do it in visual rather than verbal terms." Her first public performance, done in San Francisco in 1981, was a group

piece involving her, her son, and a number of other mothers with children under a year old. Soon after that, her husband was offered a job at a nonprofit arts center in St. Paul, and they moved there and bought a house.

Betina's performance work is difficult to describe. It is "mainly personal and autobiographical," she says, "using my body and my experiences." In the fall of 1985, she came to New York for the first time, to perform a work called *Limits of the Heart* at Franklin Furnace, a nonprofit gallery in Tribeca. The subject of the piece was grief and loss. For it, Betina had videotaped a number of women and one man talking about their feelings on being separated from their children. In the performance, these videotaped monologues were shown, alternating with Betina's live body movements and actions. The New York audience's response to the hour-long work was immensely exciting for her. "It was so intense," she said. "They were right with it all the way. It really made me wonder about living in New York."

At present, that prospect appears remote. Her two children have priority, she says, and she and her husband could not afford to rent a decent apartment for them in the New York area. Besides, her work is going well, developing its own direction in ways that might not be possible in New York, with its multiple distractions. The narrative strain in her photographs and her performance work, she believes, reflects her desire "to rediscover the sense of an individual in a consumer society." She feels somewhat ambivalent about using photographs of her children in her work—doing so seems to distance her from them, in a sense, and this is troubling. The images and ideas that she works with come from verbal and visual notebooks that she has kept for years. Whenever she can, she spends two hours or more in the evening writing and drawing in her notebook. (In winter, when the outside temperature stays below zero for weeks at a time, she usually works in bed, so as to save on heating costs.) She is not sure that she could have done what she has done if she had been living in New York. But there is very little understanding of her work in the Twin Cities, she says, and no real audience there for her performance pieces.

Peter Latner grew up in Manhattan, in an apartment on the corner of Central Park West and Ninety-seventh Street. He left home to go to the University of Wisconsin at Oshkosh, and liked the Middle West so much that he decided to stay there. After spending another six months

in Wisconsin as a newspaper reporter, he moved to Minneapolis and got a job in public relations. His interest in photography dates from an evening course he took with Frank Gohlke, a Minneapolis photographer with a national reputation. Now Latner works as a staff photographer for the Walker Art Center, a job that leaves him a fair amount of free time for his own career.

Latner is fascinated by the rituals and set pieces of the American Middle West. He photographs the street life of small towns, parades and local events, social gatherings, ballgames, Sunday outings. He does this in black-and-white, and without tricks—straight, documentary photographs in what he considers to be the tradition of Walker Evans, Robert Frank, and Eugène Atget. "I want to use the camera to do what I think it does best, which is describe the look of things," he told me. He has a sharp yet compassionate eye. Middle-aged men and women at their leisure, many of them overweight and underdressed, retain their essential dignity in these clear and intricately detailed prints. What he catches over and over is a private moment in a public situation— someone lost in thought, isolated in time.

I was impressed by the authenticity of the work, and said so. Latner, a relaxed, friendly, and unassuming young man, wanted to know how I thought it fitted in with the current art scene in New York, and I had to tell him that I didn't think it fitted in at all. The current art scene is full of photographs posing as paintings, four-by-five-foot Cibachrome prints of narrative scenes that have been elaborately concocted in the studio, photography so manipulated that you often feel it might just as well *be* painting—why bother with the lens? This did not surprise Latner. He has little interest in that sort of photography, and no more than a mild curiosity about the New York art scene. He genuinely likes living in Minneapolis, even during the winter. People leave you alone to do your work, he says, and some people even buy it. Although he is not associated with a gallery (Minneapolis has a number of commercial art galleries), he has sold prints to local corporations, and to private collectors as well. He wants to see about getting a book of his photographs published, and he plans to come to New York to look into that. But there is no rush about it. Probably he will come next year.

Lynn Wadsworth, the youngest of the Jerome Fellows, is moving to New York. She will be a student at the Pratt Institute here, and her husband, David Amdur, who is a painter, has been accepted for the

graduate program in painting at Queens College. They have found an apartment in Brooklyn, at something less than the going rates in Tribeca or the East Village. Now they rent the ground floor in a dilapidated but good-sized house in Minneapolis—large enough to provide a separate studio for each of them. Wadsworth is a sculptor. She was born and raised in St. Paul. She started out to be a filmmaker, but the undergraduate program at the State University of New York at Binghamton (a leading center of study for filmmaking as an art form) virtually killed that ambition. She learned how to make structural films, which have much in common with the aesthetics of Minimal and Conceptual art, and she did not see any point in continuing along those lines. At Binghamton, though, she also saw films made by Joseph Cornell, and these led her to the poetic glass-fronted boxes for which Cornell is much better known. Wadsworth lived in Europe for a while after finishing college. In 1981, she came back to St. Paul and began making small, boxlike constructions, on the theme of the Annunciation. Travels in Mexico and Central America followed, and the boxes evolved into stick figures—quirkily human-looking objects whose principal element is usually a tree branch or two that she has picked up and shaped, added to, elaborated with collage elements, and painted in variegated patterns of bright color. In the summer of 1985, she was commissioned to make five of her stick figures in large scale (the largest was fourteen feet high) for a temporary installation in a St. Paul park.

Wadsworth has been in a lot of group shows in the Twin Cities, and she has also found regular work teaching in public schools throughout the state. The Minnesota school system has artist-in-residence programs that last anywhere from a week to a year, and Wadsworth is in demand, because she can teach both sculpture and filmmaking. She and her husband have what appears to be a highly satisfactory setup, in fact, which they are about to exchange for something more difficult and a lot more uncertain. She has no qualms about this, and few illusions, either. "I know how tough it is to live in New York," she said. "And the truth is I like being here. This is such an easy place to live, and so cheap, and we have lots of space to work, and there are all these white-collar buyers and grants and opportunities, and everybody is so *nice*. But I'm also very ambitious. I have a pretty strong sense of myself as an artist. Here in Minneapolis, I guess I know every sculptor in town, and nobody is doing work that's anything like mine. In New York,

there will probably be dozens. I just need to test myself against all that energy and competition."

Judy Kepes came to Minneapolis a few years ago, from San Francisco. Before San Francisco, she was at the Kansas City Art Institute, and before that she was in New York—born in the Bronx, moved to Manhattan. (The place to look for emerging New York artists, I now think, is Minneapolis.) She has a New York look and manner—knowing, direct, unfazed. She has had three one-person shows in San Francisco, two of them at the Quay Gallery, and a New York dealer has been after her recently to show some of the ceramics she made two or three years ago, which are in storage in New Jersey. Kepes seemed more confident than the three other artists I talked with, and also more prone to self-doubt.

Unlike the others, she saw a lot of art while she was growing up. Her parents took her to museums and galleries here and in Europe, and they encouraged her artistic inclinations. After one semester at the Rhode Island School of Design, she decided to study painting at the Kansas City Art Institute, and it was there that she got interested in ceramics. One of her painting teachers tried to discourage this, told her she had to devote herself exclusively to painting; her reaction was to quit the painting program in favor of ceramics. Later, she transferred to the San Francisco Art Institute, which had a more advanced ceramics department. She stayed in San Francisco for several years, getting a bachelor's and a master's degree in fine arts, getting married, and learning about the dangers of early success in the art world. After a highly successful first show of clay sculptures at the Quay Gallery, in 1978, strangers started calling her at home. "Are you the artist who makes those ceramic wall plaques?" one woman wanted to know. Kepes wanted to yell back, "No, I'm not. I made them, but I'm not making them anymore. I'm making something else." The pressure was so intense that she didn't show her work in public again for three years. In the meantime, her personal life went awry. She came to Minneapolis in 1983, to stay for twenty-eight days. "Minnesota is the treatment center of the world," she said. "I came to be treated for a chemical dependency, and I could hardly wait to leave. But then I looked around, and I've been here ever since."

She got a job as an assistant to the chairman of the Fine Arts De-

partment of the Minneapolis College of Art and Design. The salary was low, but it included the use of a big studio in the basement of the administration building, and that is where I saw her work. Two kinds of work: small ceramic pieces (the earlier ones semi-functional—teapots with strange angles and tilted planes—the later ones abstract) and large figurative paintings, oil and acrylic on paper, in which the recurrent images were two nude figures, one female, the other a male with a stag's head and branching antlers. The impetus for the paintings, she said, was a workshop she had attended on sexual abuse of women; also, a book she had read about the King Arthur legend, in which there figured a primitive rite involving the killing of the King Stag. On the wall where the paintings were tacked up there were also some drawings for big ceramic pieces, which she wanted to put together with the paintings in a single installation, but she wasn't sure if this was going to work out. It was an idea she had been thinking about for some time— the kind of high-risk idea that occurs to artists in New York.

Kepes thinks now and then about going back to New York. "I even have a place there," she said, "on Eldridge Street, on the lower East Side. I miss the energy of New York or San Francisco, and the chance to look at other people's work. Maybe ninety per cent of what you see there is bad, but the other ten per cent just blows your head off: Wow, look at that! At the same time, I've got a real hesitation about being down there on Eldridge Street in July—ninety degrees outside and no way to get out of town. I know all about that. I may go back in a year or so, but right now I like being here."

(June 23, 1986)

PASSAGE

Jasper Johns is our sacred cow. The homage paid to him by all sectors of the art community—by critics, museum curators, and collectors, and especially by his fellow-artists—goes virtually unchallenged these days, and his infrequent exhibitions are attended in a spirit of veneration.

All this, however, has not made Johns himself a public figure. He has consistently avoided the publicity machine that keeps threatening to turn contemporary art into a branch of show business, and for thirty years he has sought to maintain a distance between his art and himself. "I have attempted to develop my thinking in such a way that the work I've done is not me," he told an interviewer in 1973. "I didn't want my work to be an exposure of my feelings." In this negative endeavor he has been largely successful. Certain aspects of Johns' complex personality are revealed in his paintings, to be sure, and occasionally some feelings as well, though not necessarily *his* feelings. On the whole, though, he has proved to be a master of concealment. Johns is the most hermetic artist alive, and in many ways the most difficult. In some of his more ambitious paintings, the conflict between his immense talent and his refusal to give it free rein sets up an infuriating tension—you get angry with him for simultaneously seducing you and shutting you out. This happens much less frequently in his prints. Although Johns said once that he found printmaking "an unsatisfactory medium," since 1960 he has made it a significant part of his oeuvre. His mastery of printing techniques has enabled him to do things in a number of different print media—lithography, etching and aquatint, silk screen, woodblock—that had not been done before, and, since most of his prints are related directly to particular Johns paintings or sculptures, he has used them to extend and to explore further the images and ideas that interest him. The retrospective exhibition of his prints at the Museum of Modern Art confirms the generally held view that Johns is the greatest graphic artist of our time. It also suggests why he has continued to devote so much of his time and energy to the "unsatisfactory medium" of prints, where his amazing virtuosity serves so well to cover and obscure his traces.

The MOMA retrospective is not organized chronologically. Riva Castleman, the director of the museum's department of prints and illustrated books, has grouped the prints more or less according to subject, which means that, because Johns often returns to a subject after a lapse of several years, we keep moving backward and forward in time. We begin with the lustrous *Black and White Numerals* and the rainbow-hued *Color Numerals* that Johns did at Gemini G.E.L., in Los Angeles, in 1968 and 1969. These are large prints, and there are ten of each—one for each of the Arabic numerals. Incredibly complex technically, requiring innumerable separate processes and many delicate

redrawings of the same stone, they come across as magisterial portraits of the numbers that we use every day without really seeing them. The Gemini numeral prints are larger and more technically assured than the 1963 series that Johns did at Universal Limited Art Editions, the Long Island studio whose founder, Tatyana Grosman, had introduced Johns to printmaking. The U.L.A.E. series is also on view, and while the subject and its presentation are the same in both cases—each print has one large numeral, centered, under a double row of all ten numerals in smaller scale—the effects are quite different. The U.L.A.E. prints are more painterly in feeling, more exploratory, more like Johns' paintings and drawings of numbers which preceded them. The Gemini prints have greater authority; here the lush, sensuous handling of the lithographic crayons and inks seems wholly calculated and controlled. We are closer to perfection, and further from Johns himself.

Going through this marvellous show, and seeing again the repertory of images that Johns has imposed on us indelibly—numerals, the alphabet, targets, flags, the famous Ballantine ale cans, the flashlight, the electric light bulb, the wire coat hanger—made me wonder whether any other artist has taken such pains to remove himself from his work. The fact that Johns' images have so few emotional overtones has not prevented viewers from reading emotions into them, of course—quite the contrary. The critic Leo Steinberg, in a famous 1962 essay, found in Johns' early paintings "a sense of desolate waiting" and "an implication of . . . human absence from a man-made environment." Others found grim humor, denial, repression, bitterness. They got no encouragement from Johns, who has consistently maintained that he is a very literal artist, who wants "to feel removed from the work, neutral toward it, involved in the making but not involved in the judging of it." What we make of it is our business, not his.

When he first began to use these images, in the mid-nineteen-fifties, the aesthetic climate in this country was still dominated by Abstract Expressionism. Johns and his friend Robert Rauschenberg, who lived on the floor above him in a Pearl Street loft building, did not feel that they were in opposition to Pollock or de Kooning—they both used (and still use) Abstract Expressionist methods and effects in their paintings. Nevertheless, they both wanted to get out from under what they considered the Abstract Expressionists' excessive concentration on the self. Both Rauschenberg and Johns rejected self-expression as an aesthetic

goal; they were also opposed to any sort of illusionism in art. Rau-
schenberg tended to see his own work as a sort of free collaboration
with his materials. "I don't want a painting to look like something it
isn't," he said. "I want it to look like something it is, and I think art is
more like the real world when it's made out of it." Johns' utterly literal
approach was that since a painting is a two-dimensional object he would
paint only two-dimensional subjects—flags, targets, numbers, and so
forth. If he wanted to incorporate a three-dimensional form—a broom
or a plaster cast, for example—he would simply take a real broom or
make a cast and attach it to the picture. This pragmatic attitude, which
the two young painters shared with their friend John Cage, the com-
poser, was to have a powerful influence on the next generation of
American artists. Curiously, it led Johns and Rauschenberg to work in
virtually opposite directions: Rauschenberg became the great includer,
opening his work to every sort of material and immaterial possibility;
Johns, the great excluder, proceeded step by step, one picture leading
him on to the next, into a fabulous maze of his own devising.

Johns once described the images he had chosen to paint as "things
the mind already knows," things that gave him room "to work on other
levels." What other levels? Intellectual and technical levels, presum-
ably. Much has been made of the intellectual connections between
Johns and Marcel Duchamp. Johns and Rauschenberg did not meet
Duchamp, or have an extensive knowledge of his work and his ideas,
until the nineteen-fifties, when they were already launched on their
own careers. Their admiration for the older artist was immense, how-
ever; they both did large paintings in homage to him, and references
to Duchamp, overt and veiled, can be found in any number of other
works by Johns. Certainly Duchamp's conception of art as a mental
act, rather than merely a stimulus to physical sensations, is central to
Johns' approach, and it is in his prints that Johns comes closest to the
Duchampian level of art-as-thought. In Johns' paintings, there is often
too much of a struggle going on between the thinking artist and the
retinal sensualist. Johns, remember, has painted some of the most
gorgeous pictures of our time. One of them is *According to What*, his
1964 homage to Duchamp. The three large painted maps that he did
in the early nineteen-sixties—maps of the United States, painted free-
hand, with all the states in place—are incredibly beautiful pictures; not
surprisingly, he refused several requests to paint another. "In any me-

dium, I've never wanted a seductive quality," Johns told an interviewer in 1969. He has had to work against some of his own strongest impulses in order to keep that quality out, though. Painting, Johns once said, "maintains its original clumsiness for me." The prints, beautiful and tactile as some of them are, lack the seductive physicality of the paintings. They allow us to follow the movement of Johns' mind more easily, because the thinking Johns is more firmly in control.

Not that he has seemed to be eager for us to follow his thinking. When questioned about his work, Johns usually replies in such a literal way that the questions sound inane. He resists all attempts to pin him down. Early in his career, though, in 1964, he did make a statement that was not at all literal. "I am concerned with a thing's not being what it was," he told the writer G. R. Swenson, "with its becoming something other than what it is, with any moment in which one identifies a thing precisely and with the slipping away of that moment, with at any moment seeing or saying and letting it go at that." Not much has been made of this puzzling declaration in the critical literature on Johns. Nowadays, of course, it is unfashionable for critics to take seriously what an artist says about his work. Artists are not a separate species, and they talk as much nonsense as the rest of us. Johns is an artist of formidable intelligence, however, and this particular statement has always struck me as revealing. But how? What did he mean, exactly, by "with any moment in which one identifies a thing precisely and with the slipping away of that moment"? I found myself wondering about this again at the MOMA show. I was standing in front of a 1966 lithograph called *Passage I*, and something about the title rang a bell. Johns' titles are either literal (*Target, Ale Cans*) or mystifying (*Decoy, According to What*); this was clearly in the second category. The print, which is not large, has turbulently brushed areas of gray and black; stencilled letters spelling out the names of colors; the image of a plaster cast of a man's legs, cut off above the knee and pinioned, upside down, by a wooden peg; and, in the upper right-hand corner, two unequal rectangles, one red and one yellow, each of which contains an indecipherable dark-blue horizontal shape. There are a number of other details, but nothing to suggest a clue to the title. Hanging next to it in the show is *Passage II*, a negative image of the same print with the tones reversed, on black paper.

Connoisseurs like to use the word *passage* (with the French pronunciation) in referring to a certain area in a painting where one tone blends

into another. Contemporary art historians have used it in a more precise and complex sense, to describe the Cubist method, derived from Cézanne, of depicting planes that appear to be simultaneously behind and in front of adjoining planes. Neither of these uses seemed applicable to Johns' print. Looking at it, though, I suddenly remembered a conversation I had had many years before with Matta, the Chilean-born Surrealist, on the subject of Duchamp. Matta was convinced that Duchamp had once addressed himself to an entirely new problem in art: how to paint the moment of change—change itself. This was early in Duchamp's career, before the First World War. The Cubists had concerned themselves with the problem of objects in space, Matta said, and the Futurists with the problem of objects in motion. Duchamp had wanted to paint the actual experience of transformation, and he had done so, according to Matta, in a painting called *Le Passage de la Vierge à la Mariée* ("The Passage from Virgin to Bride"). The Museum of Modern Art has owned this picture since 1945, and it is well known to every artist in New York. When I went to the second floor of the museum to look at it, I was once again perplexed and delighted by its strange, abstract elements—what Duchamp called his "juxtaposition of mechanical elements and visceral forms." You will be relieved to hear that I did not discover in it any striking iconographic links to Johns' *Passage I*; nevertheless, my own sense of the Duchamp-Johns connection was enhanced. It seemed to me that Matta's idea applied to Johns as well as to Duchamp. The indeterminate moment of change, or "passage," and the slipping away of that moment—what better terrain could there be for a highly cerebral artist who wanted, almost above all, to conceal his own tracks?

Duchamp investigated the territory briefly and then moved on, as he invariably did, to other interests. Johns, who is neither as cynical nor as lighthearted as Duchamp, does not let go of anything. And I suspect that he is still mapping and measuring that elusive moment. The 1985 print *Ventriloquist*, for example, achieves a kind of focus on the space between two things—specifically, between two Johns flags, whose edges appear at the right and left margins of the print. The same sort of "between" focus occurs in *Device—Black State* (1972), *Untitled* (1980), and several other works in the show. The many versions of *Voice*, with their subtle counterplay of stencilled letters and brushy color areas, situate the viewer in a shifting area somewhere between speaking and writing, between language and color. The crosshatch motif that Johns

began using in 1972 (an abstract pattern of parallel colored strokes that he had seen, for a second, painted on a car he passed on a Long Island highway) turned out to be the medium for a decade of further investigation. *Scent, Corpse and Mirror, The Dutch Wives, Usuyuki,* and other prints done in this style seem to shift and change as we look at them. The division of space into three equal parts (six parts in the larger prints) and the manifold variations in technique set up mirror reflections that keep the eye flickering back and forth across the surface. Every inch of this surface is subtly articulated, and yet the movement is nowhere perceptible. Conversely, everything is still, and on the verge of motion. A great many other aesthetic events are going on in these prints, needless to say, but none of them is conclusive. At any moment, Johns' art is becoming something other than what it is.

(August 4, 1986)

BETWEEN NEO-
AND POST-

The new art package has arrived. It has set off a sort of feeding frenzy among the trendier dealers and collectors, some of whom had very little advance knowledge of the contents. If you had been really attuned, of course, you would have known about a year and a half ago that something was up—another swing of the pendulum, the emergence of a new sensibility, which looked with scorn upon Neo-Expressionism, graffiti, and other recent art packages. Now it's here, turning up all over town, and if you want to get in on it you are probably too late. The question of what to call the new thing has not been settled. "Neo-geo," the catchiest title, may not stick, because it refers only to one ingredient of the package—the geometric abstract painting that mimics and comments on earlier geometric abstract painting. "Neo-conceptualism," "neo-minimalism," and "neo-Pop" are broad enough to take in the assemblages and the manufactured commercial objects that some

of the other artists go in for, but as titles they lack pizzazz. (They also call attention to the fact that nothing here is new, only "neo.") Even without a suitable name, though, the stuff is getting major attention as it moves out of the East Village and into the international mainstream. The big event of the downtown art season was the opening of a four-artist show of the new work at the Sonnabend Gallery, in SoHo. The show sold out so quickly that Ileana Sonnabend's only problem has been placating the collectors who were too slow in placing their orders. The four young artists—Peter Halley, Ashley Bickerton, Jeff Koons, and Meyer Vaisman—can write their own tickets in terms of future gallery representation. Sonnabend will take on Koons and Bickerton, and she will share Vaisman with her colleague (and former husband) Leo Castelli, who, for his part, plans to show several other new artists in collaboration with Pat Hearn, the current doyenne of East Village dealers. The situation at the moment is highly "fluid," as Ileana Son-nabend puts it, and quite touchy. Sonnabend and Castelli do not wish to be seen as corporate raiders, capitalizing on the groundwork of small East Village galleries; they are willing, they say, to coöperate with the artists' original dealers on future exhibitions and on sales. But some of the artists, having scaled ambition's ladder, seem to feel that the East Village is now behind them. A number of friendships have been strained as a result.

Much of the talk about the new artists centers on their own aggressive self-marketing. Meyer Vaisman, twenty-six, born in Venezuela and a fairly recent graduate of the Parsons School of Design, is a dealer as well as an artist: he is a co-owner of International with Monument, the East Village gallery that shows Halley and Koons. Jeff Koons, who supported himself for five years as a highly successful commodities broker with Smith Barney, Harris Upham & Co., Inc., is said to be as adept at promoting his art work as he was at selling cotton futures. "These artists actually do the things I was accused of doing," Mary Boone said to me the other day, in amusement. (The Mary Boone Gallery, in SoHo, launched Julian Schnabel, David Salle, and other stars of the Neo-Expressionist wave; she represented Koons briefly, but he left her for another SoHo gallery, which he also left.) One especially effective ploy that has reportedly been used is to let on that Charles Saatchi has just bought your latest work. Saatchi, the British advertising and public-relations executive who is also the world's most active buyer

of contemporary art, began acquiring works by Koons, Halley, and others in the group about a year ago, and his purchases galvanized the market for them. Another factor in their meteoric rise has been the rather strident enthusiasm of Estelle Schwartz, a private New York art adviser who exerts an uncanny influence over a small group of collectors. It was Estelle Schwartz who got Ileana Sonnabend to look at the new work.

What with all the talk of escalating prices and rampant self-promotion, it is a surprise to find the new art so agreeable and (relatively) unassuming. Halley paints multi-panel pictures in which a few simple shapes—squares or rectangles—occupy large areas of Day-Glo color. Vaisman uses very large surfaces whose over-all design pattern is a photographic blowup of the weave of a piece of canvas. Bickerton makes eccentric wall constructions with eccentric images on them—the outline of a subway map, for example, or an array of gaudily painted simulated rocks. Koons buys kitschy objects from decorative-art outlets or souvenir wholesalers and has them cast in stainless steel. At least, this is what they did for the Sonnabend show; with the exception of Halley, who has been painting in the same vein since 1983, the others have done very different work in the past, and they might easily do very different work in the future. (Koons told me he probably would not do anything more in stainless steel.) What we have, then, is neither a movement nor a common style but a very loose group of artists ("barely even a group," Sonnabend says) who share certain attitudes and influences. The primary influences appear to be Pop art, with its ironic use of vulgar or commercial imagery, and Conceptual art, in which the physical art object or image is simply a vehicle for the communication of aesthetic, philosophical, or social ideas. The new work is cool, unemotional, and frequently enigmatic—not the sort of thing to incite collectors to frenzy, you might think. On the other hand, it has a fresh, cheerful look that comes as a relief from the primal screaming of Neo-Expressionism, and it does seem to plug right into recent art history.

Ah, but wait. Art history these days is reckoned not in decades but in years or months. Although the primary influences may be Pop and Conceptual, the immediate antecedent of the new work is something called "appropriation," which I had rather hoped I could ignore. Artists have always appropriated the work and the ideas of other artists, needless to say, in the sense of building on previous achievements, but the term entered art jargon and assumed a new dimension in the work of a

number of recent American artists, the most widely exhibited of whom is Sherrie Levine. Levine made a name for herself in 1981 by rephotographing some art-book reproductions of vintage photographs by Edward Weston, having prints made from these negatives, and hanging them, unaltered except for the addition of her signature, in a show at Metro Pictures. She went on to make exact copies in watercolor of art-book reproductions of pictures by Egon Schiele, El Lissitzky, Joan Miró, Piet Mondrian, and Kasimir Malevich, which she exhibited under her name with titles such as "After Joan Miró" and "After Piet Mondrian." These "appropriations" were received with considerable awe, by certain critics, as Conceptual works that questioned and commented on the issue of originality in art. Having gained a measure of fame as an appropriationist, Levine has now decided that appropriation is no longer enough for her, according to a recent article in ARTnews, and she has gone on to paint geometric abstractions (stripes and checkerboard patterns) and to exhibit pieces of plywood untreated except for the knot-holes, which she has painted gold. These works, she has said, "are about death in a way: the uneasy death of modernism."

Thirteen years ago, two people writing under the name Cheryl Bernstein published an essay on a fictitious artist named Hank Herron, whose work consisted of making exact copies of paintings by Frank Stella. The essay, which appeared in a widely distributed anthology called Idea Art (Dutton; 1973), argued that Herron's copies introduced "a radically new and philosophical element . . . that is precluded in the work of Mr. Stella, i.e., the denial of originality." This sly spoof went unrecognized as one at the time, and now, according to Thomas Crow, a critic who discusses it in the catalogue of a current group show of Halley, Koons, and others at the Institute of Contemporary Art in Boston, it is being rediscovered and cited as prophetic. And so it is, to my chagrin. I had gone on naïvely assuming that appropriation itself was a more or less amusing hoax, but no such luck—it turns out that Sherrie Levine's efforts (if not Hank Herron's) are in deadly earnest, and, worse still, that they are tied up with French post-structuralist philosophy, an exceptionally glum line of thought which also informs some of the newest art. I have no doubt that Charles Saatchi and his fellow-collectors are close students of post-structuralism, and are therefore in a better position than I am to understand the new work. They have surely mastered the notion of the simulacrum, for example. Jean Baudrillard, one of the top-drawer post-structuralists, has advised us that we live in a world of

simulacra, by which he means, I think, a world of signs that have become detached from the real things they supposedly represent. As a result of the overwhelming power of advertising, television, and the media in general, we no longer inhabit a world of real things, according to Baudrillard; reality has been replaced by the signs and images that refer to it. And art—well, art has been replaced by its simulacrum, too. The artist can no longer make art; he or she can only refer to it, and one way of doing so is by appropriating or mimicking previous art. In the process, the artist Peter Halley has written, the elements of modernism "are reduced to their pure formal state and are denuded of any last vestiges of life or meaning."

Halley, in his mid-thirties, has done a lot of thinking about these matters, and he has published a number of essays on the intellectual underpinnings of the new work. He comes from one of those New York families that take ideas seriously. His father, Rudolph Halley, served as chief counsel to the Kefauver committee that investigated organized crime in the nineteen-fifties, and also served for two years as president of the City Council. Peter went to Andover, a school whose highly professional art program helped him decide to become an artist. At Andover, he learned about Minimal art, which was developing great strength in those years (the late nineteen-sixties), and was firmly grounded in aesthetic theories. At Yale, where he went after Andover, the art program seemed to him much more conservative, with an emphasis on figurative painting which made him feel out of tune with the other students—so much so that he decided to do his graduate work at the University of New Orleans. The wave of figurative, expressionist painting that swept over the art world in the early eighties seemed to Halley wholly irrelevant, backward, and uninteresting. "I felt that Frank Stella was right when he said that systems, repetitive shapes, and non-relational work were what was interesting now," Halley told me last month. "But suddenly all these artists seemed to have gone back to an interest in composition, which is related to an older, European state of mind." By 1980, Halley was living in Manhattan again. He was painting Minimalist abstractions, and he had started to meet some young artists who were using images from TV and other media in their work. Barbara Kruger, one of these artists, introduced him to the writings of Jean Baudrillard, whose ideas seemed to clarify his own. "My work had tended to vacillate between an interest in Pop Art and an interest in artists like Rothko and Newman, who dealt in existential or transcen-

dental themes," Halley said. "But now my belief in transcendental themes broke down. I began to see that my work was no longer either abstract or minimal, it was *about* those things. The same kind of issue was turning up in the work of media-oriented artists like Barbara Kruger and Jenny Holzer, and it was also turning up in music—David Byrne, for example. Byrne is a musical version of Pop and Minimalism combined."

Halley found himself painting geometric abstractions in which a few vertical lines within a square block of color suggested "cells"—he saw them both as images of confinement and as cellular units in the scientific sense. Often the cell blocks were connected to one another by heavy black lines, which he called "conduits," signifying either spatial corridors or electrical connections. These images of confinement and interconnection had social implications for Halley; they suggested the condition of the individual in a media-controlled, post-industrial world. The highly reflective Day-Glo colors he was using were the "hyper-realized simulated equivalent" of color, he wrote.

Halley is the house intellectual—few of the artists with whom he is associated are so steeped in post-structuralist theory. Jeff Koons told me that Halley says Koons' work is very much in line with Baudrillard's thinking; this is O.K. with Koons, who has not read any Baudrillard. In his own much-discussed 1985 show at International with Monument, Koons offered three separate but related classes of simulacra: large advertising posters for Nike athletic shoes; bronze casts of aquatic equipment (Aqualung, snorkel, rowboat); and large aquariums containing regulation basketballs that had been filled with enough fluid (either water or mercury) so that they remained partly or completely submerged. He has also exhibited brand-new vacuum cleaners encased in Plexiglas, and, earlier this fall, at International with Monument, poster-size liquor ads (made from the commercial originals, with permission) and stainless-steel replicas of novelty liquor decanters and other aids to alcoholic consumption. All this has something to do, I surmise, with ideas about our consumer culture and the desire for status. I must say, though, that the vacuum cleaners and the basketballs mysteriously hovering in tanks of water were indelible images—something I have not yet discovered in the work of Vaisman or Bickerton.

There are a number of new artists I haven't mentioned. Haim Steinbach does installations of commercially manufactured items in strange com-

binations—for example, a portable radio–tape player on a shelf with a pair of latex "Yoda" masks. Peter Schuyff, Ti Shan Hsu, and Mary Heilmann paint geometric abstractions. Ross Bleckner, an artist who has been showing since 1979 at the Mary Boone Gallery, began in 1981 to show stripe paintings that referred directly to the Op-art movement of the nineteen-sixties and reëstablished Bleckner as an important influence on the current scene. The Europeans Helmut Federle, John M. Armleder, and Gerwald Rockenschaub have turned up in group shows of the new abstraction here, and most of the Americans are now starting to show in Europe.

The most curious case, however, and, in my view, the most interesting artist of this new generation, is Philip Taaffe. Although Taaffe's paintings are nearly all "appropriations" of the work of certain twentieth-century artists—Barnett Newman and Bridget Riley are his current models—he does not seem to attach any post-structuralist significance to this fact. And, indeed, the superficial resemblance is deceiving, for Taaffe's paintings differ in many ways from the "originals." For one thing, virtually all of them are collages. When Taaffe makes an Op-art painting with an undulating stripe pattern which mimics the work of the British artist Bridget Riley, for example, he uses an obsessively complex technical process that is entirely his own. First, he hand-prints the wavy stripes from linoleum blocks, cuts them out, and glues them to the canvas; next, he paints over the entire surface; he then scrapes the paint down to retrieve the outlines of the stripes. There are many more steps in the process, and they give the finished picture a dense, handmade look that is the antithesis of Riley's smooth, impersonal surface. (Reproductions of Taaffe's work do not show this aspect at all.) When Riley was in town for the opening of her first New York show in several years, at the Jeffrey Hoffeld Gallery, on Madison Avenue, Taaffe went to the opening, introduced himself, and invited her to his studio. She accepted the invitation, and, according to Taaffe, her reaction to his reworked Rileys was by no means unfavorable. "You mean she took it as a compliment rather than a ripoff?" I asked him. He nodded, but a moment later he said that, to be honest, what he was doing was not simply a compliment to an artist he admired. "I do admire her work a lot, but unfortunately there's always some violence involved in taking another artist's work and making it your own," he said. "What I think I'm doing is romanticizing the space of Op art.

There isn't much room for the imagination to move around in Op, but in my paintings, I think, there is."

Taaffe, who is in his early thirties, has kept somewhat aloof from the East Village artists. He did not participate in group discussions that Halley and others used to have fairly regularly in the apartment of Tricia Collins and Richard Milazzo, two young critics who have written about the new work and organized a number of group exhibitions of it. He does not even live downtown; his present studio and living quarters are in a midtown commercial building on Broadway. Nor does Taaffe share the pessimism of post-structuralist thought. He decided to be a painter when he was a young child growing up in Elizabeth, New Jersey, and his emotional and intellectual commitment to painting is untouched by philosophical doubts. He feels that painting can still have a powerful effect on society, in the sense that the sort of concentration and integrity that it requires can be a model for how one leads one's life. And his use of other artists' work as the basis for his own does not strike him as being any different from, say, Manet's use of Giorgione in *Le Déjeuner sur l'Herbe*, or Picasso's use of Delacroix and other Old Masters.

Taaffe is intensely bothered, moreover, by the accusations of commercialism, cynicism, and hype which have been levelled against the new abstract art. "That kind of talk makes me furious," he told me. "It makes me want to say, 'Just wait until I do the paintings I have in my head.' " He shows with Pat Hearn, and he is not in negotiation with Sonnabend, Castelli, or any other gallery. The furor that now exists about his work and the work of Halley, Koons, and one or two others is just so much noise in the background, he says, which he tries to ignore as best he can.

"If only art could accomplish the magic act of its own disappearance! But it continues to make believe it is disappearing when it is already gone." That's Jean Baudrillard, quoted in *Flash Art*, a magazine that keeps in close touch with the latest trends. Taaffe isn't buying this line. In a panel discussion at the Pat Hearn Gallery (he is not *totally* aloof), he said with the invigorating arrogance of the young, "I think we've gotten to the point now where it's been proven that painting cannot be killed . . . It won't die, and we have to accept that fact."

(November 24, 1986)

AFTERWORD

Looking back, it strikes me that the major question hovering over so many of these pieces has not been answered. The absurd term "post-modernism" has passed into general use, to be sure, but is modern art truly defunct? Is what goes on today essentially different from what went on twenty years ago, or a hundred? I am not convinced that it is. The tradition of the new (in Harold Rosenberg's memorable phrase) may be so firmly established by now that shifts of emphasis are mistaken for seismic events.

As for the most visible and, to many people, the most disturbing shift—the apparently unlimited flow of money into the market for contemporary art—does it really signify a whole new ball game? The art world continues to expand along lines charted in the nineteen-fifties as it forms more intimate alliances with the worlds of fashion, finance, public relations, real estate, and social ambition. Whether this is a good thing or a bad thing is not, to my mind, a crucial question. We get the art we deserve, I am fairly sure of that; what we do with it is another matter. What we seem to be doing with it at the moment is valuing it more highly as a commodity than as a guidepost, but this has happened before in history. Maybe the art of our time is nothing more than a commodity. The last two decades have produced no artists on the level of Pollock and de Kooning, much less Picasso and Matisse. As Duchamp reminded us, though, it is posterity that makes the masterpiece, and posterity is assuredly going about things in its usual way. Meanwhile, contemporary art is in no danger of being ignored.